The Legend of Zelda: Ocarina of Time

Studies in Game Sound and Music

Series editors: Melanie Fritsch, Michiel Kamp, Tim Summers, Mark Sweeney

Intellect's Studies in Game Sound and Music publishes accessible, detailed books that provide in-depth academic explorations of topics and texts in video game audio. The books present detailed analysis, historical investigation and treatment of conceptual and theoretical issues related to game audio.

The series does not seal game audio into a scholarly suburb but is instead outward-looking: it seeks to engage game audio practitioners and researchers from a range of disciplines, including anthropology, performance studies, computer science, media studies, psychology, sociology and sound studies, as well as musicology.

The Legend of Zelda: Ocarina of Time

A Game Music Companion

Tim Summers

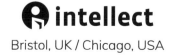

Bristol, UK / Chicago, USA

First published in the UK in 2021 by
Intellect, The Mill, Parnall Road, Fishponds, Bristol, BS16 3JG, UK

First published in the USA in 2021 by
Intellect, The University of Chicago Press, 1427 E. 60th Street,
Chicago, IL 60637, USA

Copyright © 2021 Intellect Ltd

All rights reserved. No part of this publication may be reproduced, stored in a retrieval system, or transmitted, in any form or by any means, electronic, mechanical, photocopying, recording, or otherwise, without written permission.

A catalogue record for this book is available from
the British Library.

Cover designers: Adam St. Leger-Honeybone and Holly Rose
Copy editor: Newgen KnowledgeWorks
Production manager: Emma Berrill
Typesetting: Newgen KnowledgeWorks

Hardback ISBN 978-1-78938-227-3
Paperback ISBN 978-1-78938-567-0
ePDF ISBN 978-1-78938-229-7
ePub ISBN 978-1-78938-228-0

Series: Studies in Game Sound and Music
ISSN: 2633-065

Printed and bound by Short Run, UK.

To find out about all our publications, please visit
www.intellectbooks.com
There you can subscribe to our e-newsletter,
browse or download our current catalogue,
and buy any titles that are in print.

This is a work of independent, peer-reviewed scholarship and is not
an official Nintendo product.

For Mum and Dad.

Contents

List of Figures	ix
List of Tables	xv
Acknowledgements	xvii
A Note on Terminology	xix
Introduction	1
1. The Music of *Ocarina of Time* in Context	4
Nintendo's Game Franchises	4
Kondo's Approach to Music in *The Legend of Zelda*	9
Music on the Nintendo 64	12
Music in *Ocarina of Time*	16
2. The Ocarina and Link's Musical Performances	21
The Ocarina	21
The Songs	35
Zelda's Lullaby – Confounding Musical Signs of Power	35
The Song of Time – Musically Evoking the Past	38
Epona's Song – A Simple Song of Loss	40
The Sun's Song – A Fragmentary New Start	42
Saria's Song – A Link Between Worlds	43
The Song of Storms – A Little Bit of History Repeating	46
Prelude of Light – Subtle Forward Motion	50
Minuet of Forest – Blending Age and Liveliness	51
Bolero of Fire – Motion and Passion	53
The Serenade of Water – Two Characters, Two Perspectives	55
Nocturne of Shadow – Mystery and Ambiguity	56

Requiem of Spirit – Religion and Spirits	59
The Scarecrow's Song and Other Performances	62
Musical Performance in Ocarina of Time	69
The Function of Musical Performance in Games	71

3. Location Cues — 78
 Hyrule Field: A Familiar Tune — 81
 Location Cues Featuring Ocarina Songs — 104
 Dungeon Cues — 111
 Towns — 145
 Recurring Types of Location — 160

4. Character Themes and Cutscenes — 179
 Character Themes — 179
 Other Cutscenes — 192

5. Ludic Cues — 215
 Combat Music — 215
 Cues for Treasure and Challenges — 227

6. Interfaces and Sound Effects — 251
 Earcons for Interfaces — 251
 Musicality and Magic — 259
 Sound and Motion — 261
 Enemy Sound Effects — 262
 Conclusions — 263

7. Ocarina Afterlives — 274
 Later Games — 274
 Decontextualizing Music — 278
 A Multivalent Musical Medium — 280

Epilogue — 288

Bibliography — 291
Index — 303
Index of Cues — 312

Figures

1.1:	The author's long-serving Nintendo 64 console with the *Ocarina of Time* cartridge loaded.	13
2.1:	A Nintendo 64 controller.	27
2.2:	Link playing the ocarina.	27
2.3:	The pitches and controller buttons used when Link plays the ocarina.	28
2.4:	The underside of the Nintendo 64 controller, shown here with the Rumble Pak loaded.	29
2.5:	Link playing the ocarina in the 3DS remake of *Ocarina of Time*.	30
2.6:	Link learning an ocarina melody.	32
2.7:	The pause menu showing the incomplete collection of melodies.	34
2.8:	The melody of Zelda's Lullaby, showing the phrases and scale degrees.	37
2.9:	The Triforce symbol on the ground indicates where Link must play Zelda's Lullaby.	38
2.10:	The Song of Time showing the implied tonality.	39
2.11:	Malon singing at Lon Lon Ranch.	41
2.12:	Epona's Song, with the three descending gestures marked.	42
2.13:	The Sun's Song, showing the fragmentary construction of the melody.	42
2.14:	Saria's Song, heard in the Lost Woods, with the implied IV–I (plagal) movement marked.	43
2.15:	Link befriends a Skull Kid by playing music with him.	46
2.16:	The Song of Storms showing the phrase structure and implied harmony.	47
2.17:	The organ grinder inside the Kakariko Village windmill.	47
2.18:	Prelude of Light, showing the structure and harmonic movement.	51
2.19:	The accompaniment and melody parts of the Minuet of Forest showing the chord structure and regular accompaniment pattern.	52
2.20:	The mechanistic repeated figure of the Bolero of Fire (opening phrase only shown).	53

2.21:	The snare drum accompaniment pattern for the Bolero of Fire.	53
2.22:	The Serenade of Water, showing the harmonic underpinning.	55
2.23:	After Nicholas Gervais, a reduction of the chords concluding the Serenade of Water, showing the smooth stepwise movement of the notes.	56
2.24:	The melody of the Nocturne of Shadow, showing the 'smoothing' of the melody as it is repeated and altered.	58
2.25:	Nocturne of Shadow opening phrase, showing the melody and string accompaniment.	58
2.26:	Requiem of Spirit showing the chord structure, suspension and use of a cantus firmus.	60
2.27:	Pierre and Bonooru.	63
2.28:	Link performs for the Fabulous Five Froggish Tenors.	65
2.29:	Link plays a music memorization game with a pair of Skull Kids.	67
3.1:	Hyrule Field, showing Hyrule Castle to the left of the image, and Death Mountain to the right.	82
3.2:	The characteristic accompaniment for Hyrule Field, showing the rhythmic interplay between parts.	85
3.3:	The 'Legend of Zelda' theme, showing the location of characteristic figures.	85
3.4:	Brame's characteristic figures from the 'Legend of Zelda' theme.	86
3.5:	Brass melody in Day Variation 2, alluding to the 'Zelda theme'.	86
3.6:	String melody in Day Variation 6, Battle Variation 1 (and similar melody used in Reflective Variation 4), alluding to the 'Zelda theme'.	87
3.7:	Each of the reflective tags alludes to the 'Zelda theme'.	98
3.8:	The accompaniment pattern to Epona's Song in the location cue for Lon Lon Ranch, showing the influence from country music (excerpt).	105
3.9:	The gothic architecture of the Temple of Time.	107
3.10:	The oom-pah-pah accompaniment to the Song of Storms in the Kakariko Village windmill, showing the harmonic movement (excerpt).	109
3.11:	Accompaniment for the Lost Woods cue (excerpt).	110
3.12:	Inside the Deku Tree, showing the organic textures of the dungeon.	113
3.13:	Pitch set of the Deku Tree dungeon cue.	114
3.14:	Spectrogram of the first pitch of the Deku Tree dungeon cue, lasting 9 seconds.	115
3.15:	Inside Dodongo's Cavern, showing the stone and lava textures of the dungeon.	116
3.16:	The piscine interior of Jabu-Jabu's Belly.	118
3.17:	The heartbeat rhythm of Jabu-Jabu's Belly.	118
3.18:	The string ostinato of Jabu-Jabu's Belly	119
3.19:	The entry to the wood-themed Forest Temple.	120

FIGURES

3.20:	A selection of the 'bird call' fragments of the Forest Temple dungeon cue.	121
3.21:	The Fire Temple, with some of the fiery dangers pictured.	122
3.22:	The Ice Cavern, showing the clear, icy design of the mini-dungeon.	126
3.23:	A spectrogram of one note of the bell chimes in the Ice Cavern cue.	127
3.24:	Chiming chords of the Ice Cavern.	127
3.25:	The Desert Colossus (top, exterior) which houses the Spirit Temple (bottom, interior).	133
3.26:	Approximate transcription of the reeded melody part of the Spirit Temple. The lines above the notes indicate fluctuations in pitch.	134
3.27:	The waveform of the rattle and whistle sound heard in Ganon's Castle, showing the swelling dynamic profile of the sound.	137
3.28:	A spectrogram of the rattle and whistle sound heard in Ganon's Castle, showing the rising pitch of the whistle alongside the descending rasping rattle.	138
3.29:	The chords that start Ganondorf's organ performance.	139
3.30:	An iteration of the rising sequence from Ganon's Castle (Tower), illustrating the lumbering rhythm, sequence pattern and the dissonance.	139
3.31:	Ganondorf at the organ.	141
3.32:	The bucolic Kokiri Forest.	146
3.33:	The ornamented melody of Kokiri Forest.	146
3.34:	The Castle Town Market, showing the lively and busy location.	148
3.35:	An extract from the first main melody of the Market cue, showing the accentuation of the compound metre by the rhythm in both the percussion and melody.	149
3.36:	The apocalyptic scene in the Market in the future time zone.	150
3.37:	Goron City, showing the prominent wooden, clay and rope textures.	154
3.38:	The interlocking untuned percussion accompaniment of the Goron City cue.	154
3.39:	The aquatic world of Zora's Domain.	156
3.40:	The clapping ostinato parts of the Gerudo Valley cue.	158
3.41:	An excerpt of the house cue, indicating the interplay between parts.	165
3.42:	Accompaniment rhythm for the Potion Shop cue. The final triplet figure alternates between two different articulations with each repetition, though the rhythm is the same.	166
3.43:	The inside of a Fairy Fountain.	168
3.44:	The rhythmic interplay of the Fairy Fountain harp parts.	168
3.45:	Outline harmony of the Fairy Fountain cue.	169

4.1:	In Zelda's Theme, the rhythm of Zelda's Lullaby is complemented by the accompaniment arpeggio, so each part moves while the other is held (excerpt shown).	180
4.2:	Link meets Zelda, both as a youth (top pictures) and as a young adult (lower pictures). In both time zones, Zelda plays the ocarina.	181
4.3:	Ganondorf is revealed behind Link, when they encounter each other outside Hyrule Castle.	183
4.4:	The opening phrases of Sheik's theme, with the melody in the uppermost part. Note the pentatonic design of the melody and the harmonic support of every note of the melody.	185
4.5:	Link meets Sheik.	186
4.6:	The melody of Kaepora Gaebora's theme, with the repeated rhythmic patterns of each section indicated.	187
4.7:	The Great Deku Tree's theme, illustrating the organum-like texture and indicating the repeated phrase.	189
4.8:	Excerpt of Koume and Kotake's theme, showing the interplay between the flute parts.	191
4.9:	Link rides Epona across Hyrule Field as dawn breaks, in the opening of *Ocarina of Time*.	193
4.10:	The repeating chord sequence that begins the opening of *Ocarina of Time*.	194
4.11:	The repeating chord sequence that underpins Erik Satie's *Gymnopédie No. 1*.	194
4.12:	The opening melody of the Introduction to *Ocarina of Time*, with the bracketed theme representing a quotation from the first *Zelda* game.	195
4.13:	The 'Press Start' arpeggiated chord.	195
4.14:	Accompaniment ostinato for the Legends of Hyrule and Sacred Realm cutscenes. Harp octave doubling at 0.1 second delay not shown.	198
4.15:	The moment in the Legends of Hyrule cue when all of the vocal parts coalesce and produce a musical quotation. The harp and glockenspiel parts are not shown. The three voices here split into four at the end.	198
4.16:	An excerpt from the title screen to *A Link to the Past*.	199
4.17:	Variation on the 'Zelda theme' heard for escaping the ranch.	203
5.1:	The ostinato and melody parts of the Ganondorf battle cue, showing the rhythmic/melodic interaction between parts.	220
5.2:	The boss victory cue, showing the parallel chordal movement.	225
5.3:	The treasure chest cue design. Each of the continuation cues are also heard separately.	228
5.4:	Link opens a treasure chest.	229
5.5:	The object acquisition cue, showing the chord voicing.	230

5.6:	Heart piece and gold skulltula token acquisition fanfare, showing the chord progression.	231
5.7:	Link obtaining the Master Sword.	233
5.8:	Reduction of the Master Sword cue, showing the two sections and the contrary motion of the final chord sequence.	234
5.9:	A reduction of the Spiritual Stone acquisition cue. The harp (not shown) provides arpeggios on the chords.	235
5.10:	A reduction of the Medallion cue showing the harmonic movement.	236
5.11:	The short motifs heard in sequence when collecting the silver rupees.	238
5.12:	Puzzle solution/secret cue.	239
5.13:	The waveform of the puzzle solution cue, showing the distinctive square wave shape.	239
5.14:	Correct action arpeggio.	240
5.15:	A reduction of the game over cue with the chords marked.	241
6.1:	The musical phrases of the pause menu in *Ocarina of Time*, showing the symmetry and coherence of pitch choices.	254
6.2:	Harp cues for the presentation of dialogue in *Ocarina of Time*, showing the pitch trajectories.	255
6.3:	The rhythm of the low health 'heartbeat' sound played in a sawtooth wave.	256
6.4:	The pitch profile of the Wolfos creature's 'hit' sound effect.	263
6.5:	The pitch profile of the Redead creature's 'hit' sound effect.	264
6.6:	The pitch profile of the Baby Dodongo creature's 'hit' sound effect.	265
6.7:	The pitch profile of the Bongo Bongo boss's 'hit' sound effect.	266
6.8:	The pitch profile of the Armos creature 'die' sound effect.	267
6.9:	The pitch profile of the Dead Hand creature 'die' sound effect.	268
6.10:	The pitch profile of the Freezard creature 'die' sound effect.	269
6.11:	The pitch profile of the Twinrova creature 'die' sound effect.	270
7.1:	Two excerpts from the Outset Island cue from *The Wind Waker*, first alluding to (a), then quoting (b) the Kokiri Forest theme from *Ocarina of Time*.	277

Tables

2.1:	Comparison of the ocarina's notes with D major, minor and modern dorian.	28
2.2:	The melodies of *Ocarina of Time* with categories and functions.	37
2.3:	The structure of the warp songs.	49
2.4:	Harmonic conclusion to the Serenade of Water.	56
2.5:	Harmonic conclusion to the Nocturne of Shadow.	59
3.1:	Tags of the Hyrule Field cue.	83
3.2:	Allusions to the 'Zelda theme' in Hyrule Field.	88
3.3:	Opening tags of the Hyrule Field cue. These effectively serve as the first variation of the 'Day' material, since they are only heard during daytime.	91
3.4:	The 'Day' tags of the Hyrule Field cue.	95
3.5:	Reflective tags of the Hyrule Field cue.	97
3.6:	Battle tags of the Hyrule Field cue.	101
3.7:	The lyrics and translation of the Fire Temple vocal sample.	123
3.8:	A comparison of dungeon and town cues.	161
3.9:	The tonal journey presented by warp songs and destination background cues.	173
4.1:	The varied orchestration of Zelda's Theme in the fourth part of the credits sequence (first phase).	205
4.2:	The varied orchestration of Zelda's Theme in the fourth part of the credits sequence (second phase, a tone higher).	206
5.1:	Combat theme ostinatos.	218
5.2:	The rhythmic accents of the ostinato and melodic parts of the Ganondorf battle cue.	220
6.1:	Musical sounds for the main menu.	252

Acknowledgements

This book would not have been possible without the support of staff and students at Royal Holloway University of London and University College Dublin. I am particularly grateful to the advice I have received from my wonderful colleagues at these two institutions, especially Julie Brown, Ciarán Crilly, Steve Downes, Daniel Elphick, Jonathan Godsall, Wolfgang Marx, Stephen Rose, Henry Stobart, Shzr Ee Tan and Peter Tregear. Many of the ideas in this book were developed in tandem with teaching. It has been a privilege to participate in discussions with students, especially those on the 'Music and Video Games' course at Royal Holloway, and all of the undergraduate and postgraduate students who have taken the time to engage so enthusiastically with the subject and ideas on this topic. I must especially recognize the valuable discussions with Will Farmer, Olivia Fitton-Brown, Donal Fullam, Milly Hale, Joshua Johnson and Stephen Tatlow, all of whom helped to inform this volume in innumerable ways.

I am beyond fortunate to be part of a generous and supportive community of researchers who investigate game and film music. In particular, Michael Austin, Stephen Baysted, Karen Cook, Kevin Donnelly, William Gibbons, Elizabeth Hambleton, Andra Ivănescu, Anahid Kassabian, Elizabeth Medina-Gray, Miguel Mera, Guy Michelmore, James Newman, Dave Raybould, Richard Stevens, Isabella van Elferen and Ben Winters have encouraged and inspired this volume. Peter Franklin and Guido Heldt continue to be academic mentors and dear friends.

At Intellect Publishing, huge thanks are due to Jelena Stanovnik for her unwavering support and passion for this project since its proposal. She has also been incredibly patient through the unexpected delays of this volume. I am also grateful to Emma Berrill for her superb work shepherding this book through production and Anish Joseph Chacko for meticulous and diligent copyediting. Stephanie Lind generously reviewed the manuscript, along with another anonymous reviewer, and both sets of comments helped to significantly refine and improve the book.

One of the joys of my academic life is collaborating with the other 'Ludomusicology group' members: Melanie Fritsch, Michiel Kamp and Mark

Sweeney. These wonderful scholars continue shape every aspect of my thinking and academic activity. Explicitly and implicitly, their influence is evident throughout book. I am especially grateful to Michiel Kamp, who gave wise and insightful advice, commenting in detail on large proportions of the manuscript close to the submission deadline.

This book would not have been possible without my friends and family. Olivia Hassell, Katie Henderson, Jamie McIntyre, Hannah Patrick, Guy Wells and Craig Williams all listened with sympathetic ears and gave great emotional support. Yes, Katie, I'm happy to report that the *Zelda* book is finally done! My family, including Anne, Huw, Mary, Andy, Sarah, Sophie and Chris have been enthused and interested, while Mochi, Ganymede and Bertie have provided much-needed perspective. Final and huge thanks must go to my partner, Adam, who has given me love, advice and encouragement beyond description throughout the long journey of this book.

A Note on Terminology

This book primarily uses British musical terms. For readers more familiar with other terms, here are some explanations:

Semibreve: whole note
Minim: half note
Crotchet: quarter note
Quaver: eighth note
Semiquaver: sixteenth note
Bar: measure
Semitone: half-step
Tone: whole step
mm.: [Mälzel's] metronome mark (in beats per minute)

Introduction

Hey!
Listen!
Navi, my fairy companion, exclaims.
Again.

There isn't much recorded speech in *The Legend of Zelda: Ocarina of Time*, but Navi has a voice. She is given a limited set of important phrases. These few words spoken by our hero's sidekick are repeated so often that they become etched into the player's memory.

Navi exhorts me to 'Listen!' She wants to give me advice about the next destination on my quest. But she might as well be telling me to keep my ears open and 'listen' to the game's music. So significant is music to *Ocarina of Time* that listening is a core part of the experience of playing the game. As we shall see in this book, the rich musicality of *Ocarina of Time* means that there is much fun to be had when we heed Navi's advice and listen as we play.

More than twenty years after its creation, *The Legend of Zelda: Ocarina of Time* is still held in the highest critical regard as one of the finest examples of the video game medium.[1] The same is true of the game's music, whose superlative reception continues to be evident, whether in the context of the game, or in recordings and orchestral concerts of the game's music.

Given music's well-established significance for the video game form, it is no coincidence that music is at the forefront of this most lauded and loved of games. In *Ocarina of Time*, music connects and unifies all aspects of the game, from the narrative conceit to the interactive mechanics, from the characters to the virtual worlds. It even extends into the activity of legions of fans and gamers, who play, replay and reconfigure the music in an enduring cultural site that has *Ocarina of Time* at its centre.

This book is a companion to the music in the 1998 Nintendo 64 video game *Ocarina of Time*. By exploring the game's music, and the ways players engage with music in the game, the book is also a companion to game music more

generally. It illustrates the ways in which music contributes to video gaming through the lens of *Ocarina of Time*. The study serves three primary purposes: first, it provides a critical account of the music of an important video game text; second, it uses this investigation to explore wider issues concerning music in the medium; and third, it serves as a model for future in depth studies of video game music.

There is a legitimate criticism that can be made of this book's premise. Since the mid-1980s, musicologists have been keenly conscious of implicitly or explicitly perpetuating certain value systems through their research. We have become particularly concerned with the problematic notions of 'great works', which promote one set of aesthetic values over another and exclude certain identities and kinds of music.[2] Game music studies should be conscious of not replicating the mistakes of the past by being exclusively concerned with 'great works' by 'geniuses'. This book could be understood as slipping into old habits, since it inevitably celebrates a particular game with music by one composer. To be clear, however, I am not interested in claiming that the game's composer, Koji Kondo, is a 'genius', nor that *Ocarina of Time* has some quality of 'greatness'. The study is instead motivated by *Ocarina of Time*'s popularity and the game's novel uses of music rather than belief in its quality in any universal sense.

My aim is to explore in depth the music of a single game, to illustrate the multifaceted musicality of gaming and to explain the musical processes of a game which has great cultural reach and influence. The fame of *Ocarina of Time* is useful. It serves as a touchstone or common point of reference for the discussion of music in games. It is helpful to use examples with which many people are familiar in order to discuss, illustrate and debate game music. The diversity of musical materials and approaches to sound in *Ocarina of Time* make it a good candidate for this purpose. The majority of this book takes the form of examining the cues written by Koji Kondo for the game. It will explore the techniques and functions of the game's music, matching musical detail with more conceptual ideas.

Music is important in every *Zelda* game, but none more so than *Ocarina of Time*. By encompassing so many different approaches to music and allowing players a huge variety of ways to interact with music, *Ocarina of Time* is an extraordinary case study of music's significance for gaming.

The book's title, 'A Game Music Companion' has a double meaning – it is both a companion to *Ocarina of Time* and a companion to game music as well. It aims to illuminate *Ocarina of Time* while also using that discussion to inform our understanding of music and gaming in a broader sense.

Just like Navi is Link's companion on an adventure of exploration filled with music, so this book aims to be yours. We both have the same message: Hey! Listen!

NOTES

1. *Ocarina of Time* maintains a high ranking on review aggregate sites like GameRankings and MetaCritic: https://www.gamerankings.com/browse.html, https://www.metacritic.com/browse/games/score/metascore/all/all/filtered?sort=desc. A survey of contemporary and recent reviews is hosted at MobyGames: https://www.mobygames.com/game/legend-of-zelda-ocarina-of-time/mobyrank.

 The game typically features in the upper ranks of 'Greatest Games of All Time' lists. See, e.g., lists published by *Time* (ranked third, 2016), *IGN* (ranked second, 2018), *Power Unlimited* (ranked second, 2018), *Game Informer* (ranked third, 2018): https://time.com/4458554/best-video-games-all-time/, https://uk.ign.com/lists/top-100-games/25, https://www.pu.nl/artikelen/feature/top-100-games-aller-tijden/, https://www.gameinformer.com/b/features/archive/2018/03/19/readers-choice-top-300-games-of-all-time.aspx [all accessed 9 August 2019].

2. There is an extensive body of literature on this topic, but important contributions to debates include, on classical music, Carl Dahlhaus, *Foundations of Music History*, trans. by J. B. Robinson (Cambridge: Cambridge University Press, 1983), 92–109; on the exclusion of women in the classical music canon, Marcia J. Citron, *Gender and the Musical Canon* (Cambridge: Cambridge University Press, 1993) and 'Women and the Western Art Canon: Where Are We Now?', *Notes*, 64 (2007), 209–15; and on popular music, Anne Desler, 'History without Royalty? Queen and the Strata of the Popular Music Canon', *Popular Music*, 32 (2013), 385–405.

1

The Music of *Ocarina of Time* in Context

Nintendo's Game Franchises

Before examining the music of *Ocarina of Time*, it is helpful to set the game within its corporate, historical and technological context. Throughout this book, we will see how the music of *Ocarina of Time* shapes, and is shaped by, the rest of the *Zelda* game franchise and Nintendo's creative/commercial activity. *The Legend of Zelda: Ocarina of Time* was developed for the Nintendo 64 (N64) by the in-house staff in Japan at Nintendo. *The Legend of Zelda* franchise is one of the game company's most prized assets and sits at the heart of Nintendo's corporate strategy.

Nintendo started life as a company producing Hanafuda playing cards in the late-nineteenth century and began manufacturing toys and games in the 1960s.[1] In 1977, Nintendo (in collaboration with Mitsubishi) produced a set of home video game consoles, the Color TV-Game series, and invested in coin-operated arcade gaming, with hits including *Radar Scope* (1979) and *Donkey Kong* (1981). *Donkey Kong* introduced millions of players to the character who would go on to serve as Nintendo's mascot: Mario. *Donkey Kong* became one of the best-selling coin-operated arcade games, shipping around 60,000 machines by mid-1982.[2]

With the development and release of the home console, the Famicom (1985), presented outside Japan as the Nintendo Entertainment System (1986), Nintendo came to dominate the so-called second generation of video gaming.[3] Fuelled by the appeal of games like *Super Mario Bros.* (1985), *Tetris* (1988) and the first two *Legend of Zelda* games (1986, 1987), the Nintendo Entertainment System found its way into 62 million homes.[4] The company became so indelibly associated with video games in the public imagination that in the United States, 'playing Nintendo' became a generic name for any kind of home video gaming.

Nintendo's fortunes have since waxed and waned, but it has continued to be one of the most important game companies in the world. Central to Nintendo's success has been the long-term investment in well-defined intellectual properties and characters, like Mario, Donkey Kong, Metroid and Zelda. By carefully

producing games of high quality with these characters, players are encouraged to return to new games time after time. Nintendo has also emphasized rigorous quality control over these games, and the company is often able to design hardware and software in tandem with each other.

Nintendo's success was the result of the hard labour of many individuals and a sometimes ruthless approach to business. Nevertheless, a number of long-serving Nintendo staff have been credited with significant contributions to Nintendo's prosperity. Two such characters are designer Shigeru Miyamoto and composer Koji Kondo.

Game designer Shigeru Miyamoto is a charismatic figure in the game industry and has often acted as the public face of Nintendo's creative ambitions. He joined the company in 1977 and served as a leading force in designing *Donkey Kong* and *Super Mario Bros.* Along with Takashi Tezuka, Miyamoto was one of the two main creators of the original *Legend of Zelda* game and he would serve as producer and supervisor for *Ocarina of Time*. Given Nintendo's emphasis on recurring characters, it is no coincidence that the designer of some of the company's most precious game franchises should also be its most famous representative. Miyamoto has been influential in developing and articulating Nintendo's philosophy of game development and design.[5]

Miyamoto's work is generally light-hearted and family-friendly in tone. His working process typically involves building a game around a particular set of gameplay mechanics, rather than starting from a story concept. Narrative and progression occur through spatial exploration and evolving gameplay mechanics. The result is the sense of an adventure that is primarily enacted by the player rather than narrated to them in text or long non-interactive cutscenes (though these elements certainly feature to some degree in Miyamoto's games). Miyamoto's approach is emblematic of what James Newman describes as Nintendo's 'core design principles of player advocacy, inclusivity and accessibility', where the experience of the player is engineered 'by gradually introducing and ramping up challenges' and the levels try not to 'deliberately antagonize the player or punish them repeatedly'.[6] Miyamoto has a long-standing interest in music, often speaking passionately about the topic. Himself a guitarist and banjo player, Miyamoto's musical tastes are eclectic, from The Beatles to marches and country music.[7] Even though he does not claim to have a high level of skill or knowledge about music, it is clear that he is deeply invested in music and excited by the possibilities of music and play.[8]

Beyond Miyamoto's perfectionism, Nintendo uses game franchises to refine, expand, adapt and reimagine successful aspects of games. Most Nintendo franchises are not just sequels or linear evolutions but instead form a messy cluster of games with recurring features and characters. Games within the same Nintendo franchise can have significant differences and lack overall consistency. Marilyn

Sugiarto suggests that a Nintendo franchise, like *The Legend of Zelda*, should be understood as an 'interconnected network of shared ideas, concepts, and designs',[9] which allows Nintendo great freedom to innovate, while capitalizing on players' positive attitudes to earlier games in the series. Music, as we shall see, plays a part in creating the web of the franchise.

The Legend of Zelda

The Legend of Zelda games take place in a fantastic world. It is a universe of magical spells, mystical powers and outlandish creatures. The game's generic setting is similar to 'sword and sorcery' high fantasy which takes its cue from novels like *The Lord of the Rings*. Most of the games of *The Legend of Zelda* series are set on the continent of Hyrule. In keeping with much popular fantasy literature, this world is pre-industrial and has the trappings of a vaguely medieval time period, with castles, simple mechanical technology and an all-powerful monarchy to which regional races and fiefdoms pledge allegiance (or plot rebellion). Within this world lurk monstrous forces and enemies.

The Legend of Zelda games are part of a significant tradition of medievalism and fantasy in popular culture. Fantasy settings became quickly established in early video gaming through the legacy of tabletop or 'pen and paper' role-playing games (RPGs) like *Dungeons and Dragons*. These games inspired many early computer RPGs including *Ultima* (1981), *Wizardry* (1981) and *The Black Onyx* (1984). *The Legend of Zelda* games lack the statistical levelling system typical of RPGs; nevertheless, the fantasy setting and maze-like, enemy-filled dangerous dungeons of the *Zelda* games clearly have their ancestry in the RPG tradition. Tison Pugh and Angela Jane Weisl suggest a connection between the structure of 'medieval fantasy' quest-based video games and the plots of the sources from which they draw inspiration. They write, 'On a narratological level, many "medieval" videogames descend directly from the romance tradition in which knightly protagonists dispatch various monsters and villains before triumphing over a final enemy.'[10] Despite this similarity of approach to plot, 'the *Zelda* games rely more on the [linear challenge-focused] narrative structures of medieval romance than on allusions to specific texts'.[11]

In most of the games of the *Zelda* series, the player can choose the name of their avatar. Conventionally, however, he is known as Link, which is the name we will use to refer to the character throughout this book. Link traditionally wears a green tunic with brown boots and wields swords, slingshots, boomerangs, bows and arrows. In both attire and equipment, Link resembles popular depictions of Robin Hood, another cultural icon which can be traced to the Middle Ages. This similarity to Robin Hood, as we shall see, is not without significance for the music of the game.

The Zelda of the game's title is the Princess of Hyrule, who serves as a (usually non-playable) protagonist of the game plots. As royalty, she wields magical power and is the custodian of precious magical artefacts. In the earliest *Zelda* games, the Princess is depicted as a passive 'damsel in distress' for the player's character to rescue from her captor, Ganon, the perennial antagonist of the series. Recent games have attempted to reframe Zelda's character a little by emphasizing her independence and power. Ganon is the personification of evil in the franchise; Ganon (in beast form) or Ganondorf (in humanoid form) seeks world domination though a combination of ruthless force and stealing objects of power. Link, Zelda and Ganon(dorf) are the main characters of the franchise, but each instalment tells a discrete and separate story. *The Legend of Zelda* series does not form a strict chronology, and the games avoid specific, explicit references to each other. The overall mythology of the series suggests that the characters of Link, Zelda and Ganon(dorf) are reincarnated across time and space, which allows the series great flexibility in storyline and setting.[12]

Games of the *Zelda* series are emblematic of Nintendo's corporate strategy. Each *Legend of Zelda* game is a mix of previously introduced characters, locations, creatures and items with new elements and gameplay possibilities. This approach rewards players who are familiar with the series by referring to earlier games, but the independence of each game eliminates any barriers to new players, since previous knowledge of the series is not required. New gamers do not need to know the series history before jumping directly into the latest *Zelda* game. The music of *The Legend of Zelda* series is a microcosm of Nintendo's attitude to franchises. Music unique to each *Zelda* game is balanced by musical material that is reprised from earlier games (reworked to greater or lesser extents). In the process, music becomes part of the fabric of the franchise, linking together games across the series, some of which may be visually very different.

The Story of *Ocarina of Time*

Ocarina of Time begins in Koriki Forest, a sleepy corner of Hyrule, where we meet Link as a young boy. The forest guardian, the Great Deku Tree, has been attacked by evil forces. With his fairy companion, Navi, Link breaks the curse on the Tree, but the mystery of the attacker remains. To investigate, Link leaves Kokiri Forest to seek out the Royal Family. Before Link departs, his friend Saria gives him a parting gift: an ocarina.

Link finds Princess Zelda, who fears that Ganondorf, a man from the West, is trying to conquer Hyrule. Zelda decides to unlock an ancient artefact, the

Triforce, to prevent him from doing so. To access this power, Link must visit the volcanic Goron lands and the water-themed Zora territory and gain tokens of trust from the local people. Link completes labyrinthine, enemy-filled dungeons as acts of chivalry in each region: he rids the Gorons of a monster and he rescues the Zora Princess from inside a giant fish. In the course of solving these problems, he hears stories of the same evil man who cursed the Deku Tree – and who we quickly guess is Ganondorf. After completing the dungeons, Link heads back to Zelda.

Link's return to Zelda marks the end of the first section of the game. As he approaches the castle, Link witnesses Zelda and Impa (her guard) fleeing on horseback, pursued by Ganondorf. As Zelda rides past Link, she tosses an ocarina towards him, which is revealed to be the titular Ocarina of Time. Zelda telepathically teaches Link the Song of Time and instructs him to play it at the Temple of Time. Link obeys and gains access to a secret room that houses a pedestal with a sword in it. When Link draws the sword, he is transported seven years into the future and has been transformed into an adult.

In this future, under the rule of Ganondorf, despair and destruction have come to dominate Hyrule. It falls to Link to mount a rebellion. His challenge is to awaken the Seven Sages, a group of mystical elemental beings who will help Link defeat Ganondorf. Link recruits the Sages by journeying through temples (more dungeons), which each culminate in a battle with a challenging foe and the freeing of one of the trapped Sages. The temples are thematically distinct, matched to the element represented by the spirit within. The Fire Temple, for instance, emphasizes enemies that attack with flames and traps which threaten to combust our intrepid hero, while the Water Temple features aquatic enemies and puzzles involving changing water levels. To aid him in his efforts to release the Sages, Link is guided by Sheik, a mysterious but friendly character who gives Link advice and teaches him important ocarina songs using Sheik's own musical instrument, a lyre.

Link is able to travel between the 'child' and 'adult' time zones, and actions in the past affect the future. Certain locations are accessible either only as an adult or child, which necessitates a hopping back and forth through time. Link completes major dungeon challenges and additional sidequests, which typically result in a reward (currency, additional health or useful objects). Most sidequests do not have to be completed at a particular point in the overall storyline. It is through these secondary missions that Link encounters much of the supporting cast of the game; minor characters set challenges for him, enriching the world and culture of Hyrule.

Once Link completes the Forest Temple, Fire Temple, Ice Cavern, Water Temple, Shadow Temple and Spirit Temple dungeons, he has freed all of the Sages and prepares to face Ganondorf. Sheik reveals that he is actually Zelda in

disguise, only to be captured by Ganondorf. Link faces his final challenge. Link climbs the tower of Ganondorf's castle to face the villain, who he finds playing his pipe organ. Link defeats Ganondorf, releases Zelda, and quickly escapes the castle while it crumbles around them. Outside, Link is challenged to one more final challenge: Ganondorf transforms into the evil demon Ganon. After slaying the demon, Zelda and the Sages are able to imprison Ganon in another dimension. The people of Hyrule celebrate the end of Ganondorf's reign of terror. Link returns to his original time and age, where he meets Princess Zelda. The game ends with a freeze-frame that recaptures an earlier moment near the start of the game. It implies that Link warns Zelda of the impending danger of Ganondorf, thereby averting the chain of events that would lead to his dominance. Peace has been ensured in both timelines, thanks to the intrepid efforts of Link (with a little help from the player).

Kondo's Approach to Music in The Legend of Zelda

Just as Nintendo has invested in long-standing franchises, so it often invests in long-serving staff. Out of the seven credited 'directors' of *Ocarina of Time*, with one exception, all have worked for Nintendo across a period of more than 25 years. The composer for *Ocarina of Time*, Koji Kondo, has also spent his working life at the company.

Koji Kondo joined Nintendo slightly later than Miyamoto and was recruited from university in 1984.[13] Kondo is an accomplished keyboard player (which he distinguishes from piano) with an interest in a wide variety of genres but with a particular passion for jazz and prog rock.[14] It is clear from his compositions that he is something of a stylistic omnivore, with his work taking influences from a diverse range of sources. After starting work at Nintendo, Kondo's first projects included *Super Mario Bros.* and the original *Legend of Zelda*. Though he has by no means scored all of the *Mario* or *Zelda* games, he has been continually involved in these franchises and often worked closely with Miyamoto. In *The Legend of Zelda: Ocarina of Time*, the fifth *Zelda* game to be produced, Kondo is credited as the sole composer.

When Kondo wrote the music for the first *Legend of Zelda*, he created musical materials that have been indelibly associated with the series ever since. While his music has echoed throughout the franchise, Kondo's personal involvement in the *Zelda* series has varied. Sometimes, in the case of games like *A Link to the Past* (1991), *Ocarina of Time* and *Majora's Mask* (2002), all of the music is credited to Kondo. In contrast, for some games, Kondo is not listed

as a composer at all: he is not credited for composition in games including *A Link Between Worlds* (2013) and *Breath of the Wild* (2017), even though these games include adaptations of his music. Even when Kondo's name is included among the list of composers, his role is ambiguous. For *Skyward Sword* (2011), Kondo is named as one of the composers, but he only composed one cue for the game,[15] with another composer, Hajime Wakai, acting as the music supervisor and lead composer.[16] Kondo's music has been adapted extensively in spin-offs from the *Zelda* franchise, like *Hyrule Warriors* (2014) and *Cadence of Hyrule* (2019), and his music was retained in the remake of *Ocarina of Time* for the handheld Nintendo 3DS console (2011). Even though Kondo has not been actively involved as a composer for every *Zelda* game, he is nevertheless central to the series' sonic identity.

Many of Kondo's public statements about his music for *Zelda* draw contrasts with his work for the *Mario* games. In particular, he talks about the differences of musical style and his approach to composition. In the *Mario* games, which have relatively little plot and are focused on jumping and fast movement, Kondo suggests that the music's role is to enhance the interactive connection between the player and the kinetic movement of Mario.[17] For *Mario*, Kondo noticed that the rhythm of the soundtrack and rhythm of the gameplay could be precisely synchronized. As Roger Moseley notes, 'Kondo's music for *Super Mario Bros.* was composed after he had played the game intensively to gauge how Mario ran and jumped, entraining the character's rhythmic motions in order to create a satisfying counterpoint between music and gameplay.'[18]

In his work for *Zelda*, however, Kondo's priorities lie elsewhere, as he has repeatedly explained:

> With *Mario*, the music is inspired by the game controls, and its purpose is to heighten the feeling of how the game controls. With *Zelda*, I was trying to enhance the atmosphere of the environments and locations.[19]
>
> *Mario*'s an action game, so it's vital that the music sync up directly with game control. In *Zelda*, however, it's more important that music match up with each environment and create the atmosphere of each location.[20]
>
> What's most important to me when making music for *The Legend of Zelda* is generating an ambience expressing the situation and scene [...] Link is your other self in the *Legend of Zelda* games, but in a *Super Mario Bros.* game, you control Mario, a character on the screen. [...] Link is you. So it feels like you are in him when you play.[21]

Kondo is less concerned with the physical movement of Link, or the interactive mechanics of the game, and, instead, his focus is on player identification with the character of Link and the depiction of compelling environments.

This goal is directly connected to the musical styles of the *Zelda* games. While, as we shall see, even a single game encompasses a wide variety of musical influences, at the stylistic heart of the games is an orchestral soundworld, which is supplemented, contrasted with, and varied by, instruments and styles adapted from other musical traditions.

Kondo says that orchestral music is well suited to *Zelda* games, though most of the games use synthesized approximations of orchestral sounds rather than recordings of actual orchestral performance.[22] I have elsewhere suggested that Kondo's main 'Zelda theme', originally composed as music for the first game, is stylistically similar to orchestral Hollywood film music.[23] The rhythmic gallop and shape of the melody are akin to the horn-led fanfares that were characteristic of adventure film music of the 1940s. These scores established the heroic topic of film music, which has since been repeated and solidified in cinema. Perhaps the archetypal example of this style is the score for *The Adventures of Robin Hood* (1938) by Erich Wolfgang Korngold.[24] The green-clad, arrow-wielding, brown-booted swashbuckling heroes of *Zelda* and *Robin Hood*, for all of their chronological distance, are accompanied by similar music. This 'classic Hollywood' style was later revived by John Williams in the 1970s and 1980s for modern Hollywood blockbusters. The march-like elements of Kondo's original 'Zelda theme' also resonate with John Williams's frequent use of a symphonic march style in association with heroes (such those for the main themes for *Indiana Jones* and *Superman*).[25] These musical styles help to imply the heroic status of Link, the epic quest that he undertakes and, by extension, the player's involvement in the 'legendary' adventure.

In the games, the orchestral styles are most often associated with neutral locations or parts of the game that deal with the main plot. Elsewhere, however, Kondo uses very different musical materials to give the game settings their distinctive qualities. Just like each game presents a new variation on the familiar fictional universe, each game comes with a varied musical soundworld. Kondo says,

> You may have noticed that the music for each game in the *Zelda* series has a slightly different vibe. *Majora's Mask* had an exotic Chinese-opera sound; and *Wind Waker* had sort of an Irish influence on its music. [...] Creating *Zelda* music always involves learning for me, since I can't create all of the music for the wide variety of environments based simply on what's already inside my head. I always do extensive research and soak up as much music as I can to expand

my vision. Then, after all of that, I always find it much easier to create music that I couldn't before.[26]

Kondo again contrasts this approach with *Mario*:

> The sound of *Mario* is kind of like popular music, and *Zelda* is like… a kind of music you've never heard before. So I try to incorporate many different types of music to create an otherworldly feel.[27]

Kondo is open to sonically challenging his audience, especially through incorporating instruments (or approximations of instruments) very different from the symphonic orchestral style. Given this musical diversity, beyond specific recurring pieces of music, it is difficult to definitively pinpoint a *Zelda* musical style that operates consistently across the series. Even if the approach to composition is broadly the same in all of the *Zelda* games, the games encompass great musical variety. Though the musical *processes* are similar, the games may sound very different. As this book progresses, we will come to understand the strategies Kondo uses to build the player's connection with Link and how his music gives life to the world of Hyrule.

Music on the Nintendo 64

Ocarina of Time was designed for the N64, and while there have been remakes and ports (conversions) of the game to other platforms, the N64 version remains the definitive edition. Though there will be some discussions of other versions, especially the 2011 remake for the Nintendo 3DS handheld console, this book is based primarily on the N64 edition of *Ocarina of Time*. Specifically, the analysis is mostly based on the PAL European version.[28] Because of the context of its creation, the history and form of *Ocarina of Time* are directly connected to the N64 console.

Ocarina of Time was one of the flagship games for Nintendo's home console, the N64 (Figure 1.1). The N64 launched in 1996 and the last official game was released in 2002. During this time, the N64 competed with the Sony PlayStation and Sega Saturn as part of the so-called fifth generation of video game consoles. As well as increases in processing power from the previous generation of consoles, this was a period in gaming marked by the rapid rise of 3D environments, CD-quality audio and full-motion video.

Though the N64, as a 64-bit console, was more powerful than the 32-bit PlayStation, it did not attain the same popularity and sales as Sony's platform. This is rather ironic, given that the PlayStation originated as a collaboration between

FIGURE 1.1: The author's long-serving Nintendo 64 console with the *Ocarina of Time* cartridge loaded.

the two companies to develop a successor to Nintendo's previous console.[29] Despite failing to match the financial success of the Sony console, the N64 was, and remains, an important landmark of video gaming because of the strength of its software library. It was high-quality N64-exclusive games like *Ocarina of Time* (which sold 7.6 million copies)[30] that fuelled player attraction and dedication to the console.

The N64 is a cartridge-based system, rather than CD-based, like the PlayStation and Sega Saturn. Compared with CDs, the cartridges facilitated faster access, the ability to store user data and inhibited piracy. Cartridges could also vary from game to game, based on the circuits contained within them. However, cartridges had less storage space and were more costly to produce than CDs. These differences in format had implications for the music.

Composers and programmers for this generation of consoles had three main ways of deploying music in games. The first was to play music directly off the same disc as the game. This is why, for some PlayStation game discs (such as *The Lost World: Jurassic Park*, 1997), the game music can be played in a regular audio CD player, just like an album. Since the N64 did not use CDs, this option was not available for that console. The second approach was to store the audio as waveform data, like an acoustic recording, in a format similar to an MP3 or WAV file. This was available to both CD and cartridge-based systems and was the main way of recording sound effects and character voices. The third approach to music was by using MIDI data. Rather than recording the sonic vibrations of the whole piece of music, the music instead is programmed on a note-by-note level, detailing the instruments in the piece, and the notes each instrument should play

to produce the piece of music. The N64 used both of these latter two methods of storing music.

The N64's native audio system can be understood as having two main parts.[31] One software element served to play back recorded waveforms (the 'Sound Player') primarily designed for sound effects and voice. A second was dedicated to MIDI sequences (the 'Sequence Player'), primarily designed for music.

The N64's 'Sound Player' software played recorded waveform files. These files, however, took up a large amount of computer space per second of sound, even when the audio was of low quality. The relatively large files represented a significant proportion of the precious limited space available on the cartridge. As such, this approach had to be used judiciously, especially if long pieces of music were planned to be played as wave files through the Sound Player. An instructive example is the N64 game *Star Wars: Shadows of the Empire* (1996). Though the programmers had originally planned to play the music as MIDI sequences, after teething problems with the new system, it was decided to play the music as audio wave files instead. The game uses looped snippets of orchestral recordings to accompany the gameplay, including music taken from the scores of the original *Star Wars* films composed by John Williams.[32] These acoustic recordings, however, despite their short length, took up a large amount of space on the cartridge. As the senior programmer for the game recalled,

> After a little persuasion, Nintendo generously agreed to increase the amount of cartridge space from 8MB to 12MB. This allowed us to include approximately 15 minutes of 16-bit, 11khz, mono music that sounded surprisingly good. Considering that most users would listen to the music through their televisions (rather than a sophisticated audio system), the results were close to that of an audio CD, thereby justifying the extra cartridge space required.[33]

It is worth noting the proportional change that this musical decision prompted – a 50 per cent increase in cartridge size of the *entire* game. N64 games would continue to use recorded music, such as pop music in the *Tony Hawk's Pro Skater* games (2000, 2001, 2002), though it is unsurprising that N64 games tended to emphasize MIDI music, especially when the game demanded a large amount of musical material, as opposed to hearing the same songs or pieces repeatedly.

The programmer's guide for the N64 implies that it is expected that composers use MIDI for creating music. It says, 'The audio system for the N64 is composed of a Sound Player (for playing single samples, such as sound effects) and a Sequence [MIDI] Player (for playing music).'[34] Using the Sound Player for long pieces of recorded music clearly was not what the designers had intended. *Ocarina of Time*

follows the designers' expected pattern, storing most of its sound effects and some very short cues using MP3-style waveform recordings, but most music is programmed as MIDI.

MIDI data works like a pianola/player piano or a musician reading sheet music: the notated instructions are interpreted as the piece plays out. Very short audio fragments of individual instrument notes are manipulated according to the MIDI instructions to create the performance. This approach has the advantages of a very small file size and great flexibility to respond to game action, but the triggering and manipulation of instrument samples can lead to unrealistic sounds and inexpressive performance.

When using the N64's Sequence Player, programmers/composers would assign the sounds they wanted to use to play the music (stored as MIDI), thus forming the instruments for the compositions. The programmer's guide explains,

> When the game starts up, it creates and initializes [...] a sound player and a sequence player. It then assigns a bank of sound effects to the sound player, and assigns a bank of instruments and a bank of MIDI sequences to the sequence player. To play a sound effect, the game sends a message to the sound player, telling it what sound effect to set [...] and then sends another message to the sound player, telling it to play [...]. To play a MIDI sequence, the game must load the sequence data, then attach the sequence to the sequence player [connecting the sounds to the music], and then send a message to the sequence player to start playing the music.[35]

The N64 played both traditional MIDI and a format of MIDI specific to the N64 that easily facilitated complicated looping and repetition structures. The 'messages' from the game to start playing MIDI could also include more complicated commands to alter the game music, as we shall see later.

The N64 holds the MIDI music sequences (i.e. the note data) separately from the sounds used to perform that music (i.e. the instrumental samples). It is akin to having the sheet music for a piece and then assigning performers to play each instrument in the composition. This approach of applying sets of sounds to the MIDI sequences was space-efficient, flexible and allowed composers a vast array of sonic possibilities, since they could easily define their own instruments. It also meant that composers could include a huge amount of music in a game without the problems of space encountered by the *Shadows of the Empire* team.

One of the less obvious ways that the N64 departed from previous consoles was by allowing programmers more agency in how they used the power of the console. Rather than using a large number of dedicated chips (e.g. specific chips

for producing sound), the N64 instead provided a significant amount of central processing power, and programmers allocated system resources using software controls. This meant that, on the one hand, a large proportion of the system resources could be allocated to audio. One the other, it meant that audio was always in contention with other elements of the game for those same resources. As Aaron Marks and Jeannie Novak note, 'with this particular system, the developer had to carefully plan their use [of audio resources] – each audio channel consumed 1% of the [overall processing] resources. A typical game used 16–24 channels.'[36]

The N64 console was not an easy console to work with for audio professionals, especially in its default Sound Player/Sequence Player configuration, but the potential of the console was considerable. A consequence of the flexible architecture was that it could be customized (albeit with some difficulty). The situation prompted some companies to produce new drivers to make the most of the console's capabilities. One such example is the MusyX system by Factor 5, which provided a new software tool to make the most of the shared processor power. MusyX was used in games including *Star Wars Episode I – Battle for Naboo* (2000). Yet the same essential factors remained: the N64 had limited potential for deploying extensive stretches of recorded audio and was far better suited to MIDI creations. It is no surprise, then, that *Ocarina of Time* should play to the console's strengths.

Music in Ocarina of Time

Most of the music in *Ocarina of Time* is programmed as MIDI music. Following the tradition of media music industry and scholarship, I will refer to individual pieces of music in the game as 'cues'. There are some very short cues that are programmed as recorded waveforms (of which more later), though these remain in the minority.

Planning the Music for a Game

When a game is being created, the designers, programmers and composers will decide when and how the music should sound in the game. This will include discussing the game conditions that prompt a piece to start and end and how a cue might respond to the game action. Of course, these choices are subject to revision as the project develops, but a general musical strategy will normally be decided upon early in the production process. One of the main factors influencing

> this decision will be the precedent set by earlier games in the series, or games of the same interactive genre. In game culture and production, the term 'genre' mostly refers not to narrative genres like 'fantasy', 'wild west' or 'sci-fi' but to the mode of interaction with the game – such as a first-person shooter, RPG or puzzle game. Composers and theorists have long recognized that games of the same interactive genre tend to deploy music in similar ways, even if the setting of the action is very different.[37]

Following the precedent of both other action-adventure games and previous entries in *The Legend of Zelda* series, it is primarily Link's location that determines which music sounds at any one time. This location cue serves as default music, which is then interrupted by other cues, either through triggering a game event or moving to a new area. *Ocarina of Time*'s score can be categorized into several different types (with some slight overlap). These categories will be used as the basis for the rest of this book.

- Performance cues – musical performances within the world of the game, including the songs Link learns and plays on the ocarina, directed by the player. He may also play the ocarina independently of the set ocarina songs.
- Location cues – which sound depending on Link's location in the virtual world, with different areas linked to particular looping cues.
- Cutscene cues – which accompany non-gameplay sequences that propel the story forward.
- Ludic event cues – which are triggered by events that are significant in terms of the game's challenges. These relate to success, defeat or other involvement with the rule-based gameplay: these include, for example, music for combat, cues that indicate solving a puzzle, the 'game over' cues and so on.
- Sound effects, earcons and auditory icons – which musicalize engaging with the game interface.

This organization of music follows the broad pattern of earlier *Zelda* games, which also primarily used Link's location as the main factor for triggering the music. The approach also connects *Zelda* with RPGs with similar musical strategies. Games like *Ultima*, *Dragon Quest* and *Final Fantasy*, for all of their difference from *Zelda*, also cue music primarily based on the avatar's location and the danger of battle.[38]

This book considers each type of cue in turn, before examining the life of the music beyond the game. We begin with what is perhaps the most obvious musical element of the game – the ocarina of the game's title, and the musical performances that the instrument facilitates.

NOTES

1. Jeff Ryan, *Super Mario: How Nintendo Conquered America* (New York: Portfolio, 2012), pp. 10, 12.
2. Steven L. Kent, *The Ultimate History of Video Games* (New York: Three Rivers, 2001), p. 215.
3. For a comprehensive discussion of the Famicom and the Nintendo Entertainment System, see Nathan Altice, *I Am Error: The Nintendo Family Computer/Entertainment System Platform* (Cambridge, MA: MIT Press, 2015).
4. Nintendo, 'Consolidated Sales by Region', *Nintendo.co.jp* (2010), http://www.nintendo.co.jp/ir/library/historical_data/pdf/consolidated_sales_e0912.pdf, retrieved from https://www.webcitation.org/5nXieXX2B [accessed 2 January 2019]. The first *Legend of Zelda* was produced for the Famicom with the Disk System add-on, but the version for the Nintendo Entertainment System did not require the add-on.
5. Jennifer deWinter, *Shigeru Miyamoto: Super Mario Bros., Donkey Kong, The Legend of Zelda* (New York: Bloomsbury, 2015).
6. James Newman, 'Kaizo Mario Maker: ROM Hacking, Abusive Game Design and Nintendo's Super Mario Maker', *Convergence*, 24 (2018), 339–56 (p. 340, pp. 345–47).
7. Chris Kohler, *Power-Up: How Japanese Video Games Gave the World an Extra Life* (Indianapolis, IN: BradyGames, 2005), p. 27.
8. See, e.g., his conversations with Satoru Iwata about *Wii Music* (2008): 'Iwata Asks: Wii Music', *Nintendo*, 16 December, https://www.nintendo.co.uk/Iwata-Asks/Iwata-Asks-Wii-Music/Volume-1-The-Joy-Of-Playing-Music-For-All/1-Shigeru-Miyamoto-s-Early-Encounters-with-Music/1-Shigeru-Miyamoto-s-Early-Encounters-with-Music-236997.html [accessed 2 January 2019], and following web pages.
9. Marilyn Sugiarto, 'A Rhizomatic Reimagining of Nintendo's Hardware and Software History' (MA dissertation, Concordia University Montreal, 2017), p. 73.
10. Tison Pugh and Angela Jane Weisl, *Medievalisms: Making the Past in the Present* (London: Routledge, 2013), p. 123. Notable studies on medievalism in game music include Karen Cook, 'Beyond (the) Halo: Plainchant in Video Games', in *Studies in Medievalism XXVII: Authenticity, Medievalism, Music*, ed. by Karl Fugelso (Cambridge: D.S. Brewer, 2018), pp. 183–200; James Cook, 'Playing with the Past in the Imagined Middle Ages: Music and Soundscape in Video Game', *Sounding Out!*, 3 (2016), https://soundstudiesblog.com/2016/10/03/playing-with-the-past-in-the-imagined-middle-ages-music-and-soundscape-in-video-game/ [accessed 11 March 2020]; and Brendan Lamb and Barnabas Smith, 'From Skyrim to Skellige: Fantasy Video Game Music within a Neo-Mediaevalist Paradigm', *Musicology Australia*, 40/2 (2019), 79–100.
11. Pugh and Weisl, *Medievalisms*, p. 125.
12. Much of this mythology is presented in books and other paratexts beyond the games themselves. See, e.g., Akinori Sao, Ginko Tatsumi, Chisato Mikame and Ben Gelinas, *The Legend of Zelda Encyclopedia* (Milwaukie, OR: Dark Horse, 2018).

13. Andrew Schartmann, *Koji Kondo's Super Mario Bros. Soundtrack* (New York: Bloomsbury, 2015), p. 28.
14. Koji Kondo [and anon. interviewer], 'Natural Rhythms of Hyrule', *Nintendo Power*, 195 (2005), 56–58.
15. Richard George, 'Behind the Scenes of Zelda: Skyward Sword', *IGN*, 10 November 2011, https://uk.ign.com/articles/2011/11/11/behind-the-scenes-of-zelda-skyward-sword [accessed 19 August 2019].
16. Jayson Napolitano, 'Koji Kondo Talks Ocarina of Time, Gives Details on Skyward Sword', *Original Sound Version*, 21 June 2011, http://www.originalsoundversion.com/koji-kondo-talks-ocarina-of-time-gives-details-on-skyward-sword/ [accessed 19 August 2019].
17. Schartmann, *Super Mario Bros.*, p. 33.
18. Roger Moseley, *Keys to Play: Music as a Ludic Medium from Apollo to Nintendo* (Berkeley: University of California Press, 2016), p. 249. For more on the connection between Mario's movement and the score, see Neil Lerner, 'Mario's Dynamic Leaps: Musical Innovations (and the Specter of Early Cinema) in *Donkey Kong* and *Super Mario Bros.*', in *Music in Video Games*, ed. by K. J. Donnelly, William Gibbons and Neil Lerner (New York: Routledge, 2014), pp. 1–29; and Schartmann, *Super Mario Bros*.
19. Chris Kohler, 'VGL: Koji Kondo Interview', *Wired.com* (2007), https://www.wired.com/2007/03/vgl-koji-kondo-/ [accessed 5 January 2019].
20. Kondo, 'Rhythms of Hyrule', p. 57.
21. Satoru Iwata, 'Iwata Asks: The Legend of Zelda: Ocarina of Time 3D – 5. "I'm Envious of First-Time Players!" ', *Nintendo*, 27 July 2011, https://www.nintendo.co.uk/Iwata-Asks/Iwata-Asks-The-Legend-of-Zelda-Ocarina-of-Time-3D/Vol-1-Sound/5-I-m-Envious-of-First-Time-Players-/5-I-m-Envious-of-First-Time-Players--231463.html [accessed 14 April 2019].
22. Satoru Iwata, 'Iwata Asks: The Legend of Zelda: Ocarina of Time 3D – Bonus: Zelda 25th Anniversary Concert', *Nintendo*, 27 July 2011, https://www.nintendo.co.uk/Iwata-Asks/Iwata-Asks-The-Legend-of-Zelda-Ocarina-of-Time-3D/Vol-5-Mr-Shigeru-Miyamoto/Bonus-Zelda-25th-Anniversary-Symphony-Concert/Bonus-Zelda-25th-Anniversary-Symphony-Concert-224892.html [accessed 14 April 2019].
23. Tim Summers, *Understanding Video Game Music* (Cambridge: Cambridge University Press, 2016), pp. 148–49.
24. Ben Winters, *Erich Wolfgang Korngold's The Adventures of Robin Hood* (Lanham, MD: Scarecrow, 2007).
25. Emilio Audissino, *John Williams's Film Music* (Madison: University of Wisconsin Press, 2014), p. 157. I am grateful to Michiel Kamp for his suggestion for developing this line of thought in terms of the march topic. So appropriate is this Hollywood-heroic topic that music for commercials for *Ocarina of Time* (and reprised for its 3D remake) was written by Basil Pouledouris, based on material from his score to *Conan the Barbarian* (1982). Anon, 'Upcoming Assignments', *Film Score Monthly*, 3 (1998), 9–10.

26. Kondo, 'Rhythms of Hyrule', p. 58.
27. Kohler, 'Koji Kondo Interview'. Ellipsis original.
28. This is the edition of the game known as PAL 1.1, roughly equivalent to the NTSC 1.2 version. The specific copy used as the primary reference for the majority of this project was purchased in May 1999 from an Electronics Boutique shop in South Wales, United Kingdom.
29. The story of this corporate partnership is entertainingly told in Ryan, *Super Mario*.
30. Mathieu Manent, *Nintendo 64 Anthology*, trans. by Cain Garnham and Jade Roxanne Garnham (Paris: Geeks Line, 2016), p. 42.
31. This description has been simplified to avoid unnecessary detail. Interested readers are encouraged to read the *Nintendo 64 Programming Manual* (np: Nintendo, 1996 [1995]).
32. The game also includes music by Joel McNeely, from his orchestral CD *Star Wars: Shadows of the Empire*, written as a soundtrack to the *Shadows of the Empire* novel.
33. Mark Haigh-Hutchinson, 'Classic Postmortem: Star Wars: Shadows of the Empire', *Gamasutra.com* (April 2009 [1997]), http://www.gamasutra.com/view/news/114010/Classic_Postmortem_Star_Wars_Shadows_Of_The_Empire.php [accessed 4 January 2018].
34. Nintendo, *Nintendo 64 Programming Manual*, p. 450.
35. Ibid.
36. Aaron Marks and Jeannie Novak, *Game Audio Development* (Clifton Park, NY: Delmar, 2009), p. 10. The *Programming Manual* provides more detail:

> Obviously, the more voices, the more processing time needed, and the higher the audio playback rate, the more time needed. As a rough guideline, it is estimated that 1% of [processor] time is needed for each voice, when playing at 44.1k. So, if the audio is given 20% [of] processing time, then fifteen to twenty voices will be possible. However, if the audio is given 40% of processing time, then 30 to 40 voices will be possible. Remember that a lower output playback rate reduces processing time, thus increasing the number of voices available for playback. (p. 454)

37. Paul Hoffert, *Music for New Media* (Boston, MA: Berklee Press, 2007), p. 16; Richard Stevens and Dave Raybould, *The Game Audio Tutorial* (Burlington, MA: Focal, 2011), pp. 162–63.
38. See, for more on musical traditions in the RPGs, William Gibbons, 'Music, Genre and Nationality in the Postmillennial Fantasy Role-Playing Game', in *The Routledge Companion to Screen Music and Sound*, ed. by Miguel Mera, Ronald Sadoff and Ben Winters (New York: Routledge, 2017), pp. 412–27.

2

The Ocarina and Link's Musical Performances

The Ocarina

Though it's not a magic flute,
There's a fascinatin' toot,
It's not exactly beautiful,
It's sort-a like-a,
I don't know,
I guess you'd call it
Cute.
(Bing Crosby describes the ocarina in
'The Sweet Potato Piper' from *Road to Singapore* 1940)

Even before players have started *Ocarina of Time*, it is clear that music is important to this game. Just by naming a musical instrument in the title, the game establishes the significance of music and teases gamers with the suggestion of interacting with music in the course of playing the game.

The Legend of Zelda games have often included musical instruments. Link is quite the musician, playing recorders, drums, guitars, pipes, harps and flutes. Link even played an ocarina in the immediate predecessor game to *Ocarina of Time*, *Link's Awakening*, and he found an ocarina-shaped instrument referred to as a 'flute' in *A Link to the Past*. He would play the same instrument again following *Ocarina of Time*, most notably in the sequel, *Majora's Mask*. None of the other instruments, nor the previous 'ocarinas', however, have quite the same significance for the plot and gameplay as in *Ocarina of Time*. In this chapter, we shall consider the most obvious kind of 'musicking' in the game: playing the titular flute. Out of all of the potential instruments that could have been chosen for the game, why should an ocarina be appropriate?

Music, Verb?

'Musicking' is a term popularized by Christopher Small. He uses it to emphasize the variety of ways in which we interact with music, balancing music as a noun for a 'thing' with music as a verb – 'to music'. Small defines the term as 'tak[ing] part, in any capacity, in a musical performance, whether by performing, by listening, by rehearsing or practicing, by providing material for performance [...] or by dancing'.[1] Games are rife with diverse opportunities for musicking, and such moments for engaging with music are particularly obvious in games like *Ocarina of Time* that explicitly emphasize listening to, and playing, music.

Why an Ocarina?

The ocarina is a type of flute, most often made out of clay (though ocarinas have also been crafted from wood, plastic, bone and shell).[2] There are many different kinds of ocarina, modern and ancient, spread across a huge geographic area. The ocarina is distinct from the orchestral flute, recorder or whistle in the nature of its vibrations. Many acoustic musical instruments create sound through vibration in a linear shape: on the strings of a violin, harp or guitar, for example, the vibrating length of the string primarily determines the note it sounds. In the ocarina, however, rather than a tube shape of vibration, the vibration is globular as the body of air inside the body of the instrument vibrates together as one. This mass vibration produces the sonorous soft open quality of the ocarina's sound. Ray and Lee Dessy describe the ocarina's sound production process like this:

> When you blow into the [mouthpiece], it creates an in/out air motion. [...] An alternating air pressure is created in the vessel's volume [...] [which] affects the air [...] moving it in and out, just like the piston in a car. [...] The bigger the vessel (a weaker spring), the lower the frequency of the sound. The bigger the tone-hole-area (a bigger, heavier piston), the higher the frequency.[3]

Given that ocarinas can be created from hollowed-out natural materials, it is unsurprising that ocarina-like instruments have been created independently in different cultures. There are long histories of ocarina instruments in Central and South America, East Asia and Africa.[4]

The Chinese xun is an ocarina-style instrument. Examples of xun ocarinas have been traced back to pre-4000 BCE at Neolithic sites, such as those near Jiuquan in

Gansu Province or Jingcun near Wanrong in Shanxi Province.[5] These instruments are sometimes decoratively carved and are typically egg-shaped. They continue to be used in traditional ceremonial activities, such as those at the Taipei Confucius Temple. Other East Asian ocarina instruments include the tsuchibue from Japan, hun from Korea and the huân from Vietnam, all similar to the xun.[6] While these instruments are likely to be directly related, similar instruments are evident in distant cultures which have no historical evidence of contact with each other. In the traditional culture of the Venda in northern South Africa, ethnomusicologists have described an instrument called the tshipotoliyo, an ocarina made from the hardened shells of fruits.[7] This 'venda ocarina' is played in duets by boys, and as part of cheeky playful interaction.[8]

The ocarina has a long history in very different parts of the world and it is not uncommon for ocarinas to be made in elaborate forms. Clay ocarinas have survived from the Maya Civilization in Central America, many of which are sculpted to anthropomorphic or zoomorphic forms: humans, bats, birds, turtles, fish and even supernatural creatures.[9] The pre-Columbian Tairona civilization in South America created ocarinas in the shape of humans and animals (such as frogs, snakes, birds, bats and jaguars). The ethnomusicologist Dale Olsen has suggested that these instruments served as 'tools for providing magical protection from malevolent supernatural forces'[10] and that 'the musical instruments take on dimensions that are important in the native life-death cycle. These were instruments for power.'[11] As we shall see, Link's ocarina is similarly powerful.

Despite the long history of the ocarina, the style of ocarina played by Link in *Ocarina of Time* is a relatively recent design that stems from nineteenth-century Italy. In the early 1850s, Giuseppe Donati created the characteristic shape of the modern ocarina, with its protruding mouthpiece. The term 'ocarina', meaning 'little goose', alludes to the shape of this design. The Italian ocarinas of the nineteenth century were produced with a variety of tunings, sizes and holes, encouraging ensemble playing. The ocarina's portability, in addition to cheap methods of manufacture, meant that it became firmly associated with folk groups and amateur performance. In the following decades, the Italian-style ocarinas spread throughout the United States, Europe and Japan.

In the United States, production in the twentieth century prompted mass distribution of ocarinas, often aimed at children or as novelty toys. An ocarina features in the Scarecrow's song, 'If I Only Had a Brain', in *The Wizard of Oz* (1939), as a sonic representation of the character's ditziness. The ocarina was sometimes known as a 'sweet potato', a name that betrays the amateur and 'low' status of the instrument. The 1940 Bob Hope and Bing Crosby film, *Road to Singapore*, featured a comedic musical number celebrating the ocarina, 'The Sweet Potato Piper'. Since they were inexpensive and easy to transport, Bakelite ocarinas were produced for American servicemen abroad during the Second World War, further aiding their mass distribution.[12]

The ocarina was also produced in the homeland of Nintendo. In the 1920s, Japan saw the Donati ocarina develop further, with the addition of small holes to increase the number of notes that the instrument could play. This innovation is typically attributed to Takashi Aketagawa in his efforts to expand the instrument's capabilities.[13] There have since been periodic resurgences in the popularity of the instrument in Japan, with artists like Nomura Sojiro continuing to champion the ocarina. Some ocarinas, old and modern, have introduced multiple resonating chambers, and it continues to be an instrument that attracts experimentation in design.[14]

Ocarinas have also found considerable use in music teaching, especially as an instrument for those without any previous experience of playing instruments. Ocarinas are less prone to overblowing, squeaks and the (de)tuning problems that beginner wind instrument performers often encounter. Teachers are also attracted to ocarinas, since the rounded timbre of the instrument is far kinder to the ear than more abrasive-sounding instruments like whistles or recorders.[15] The size of each hole on an ocarina, rather than its location on the instrument, determines its effect on the pitch; educational ocarinas can therefore be produced where the holes are accessible to children's smaller hands and the fingering relies on the number of holes covered, rather than their position.

Though not a well-known instrument, the ocarina has permeated into popular musical culture. The timbre may be familiar from the ocarina solo on The Troggs's 'Wild Thing' (1966), or from Ennio Morricone's score for *The Good, the Bad and the Ugly* (1966), where a bass ocarina is associated with the villain.[16] While the ocarina has not featured extensively in orchestral concert repertoire, when it is heard, it is all the more striking. Most composers tend to use it in association with either, on the one hand, folk and traditional musical cultures or, on the other, as a way of evoking spiritual/supernatural phenomena. In terms of the former, Janácek's set of children's rhymes *Rikadla* (1926) uses an ocarina as one of its ten instruments. Similarly, Ligeti used ocarinas to refer to alternative tuning systems and folk traditions in his Piano Concerto (1985–88) and Violin Concerto (1989–93).[17] The association of the ocarina timbre with some kind of supernatural or otherworldly quality is evident in other concert works. Penderecki uses four ocarinas in his opera *Paradise Lost* (1978), twelve in *The Awakening of Jacob/The Dream of Jacob* (1974) and a choir playing a mass of fifty ocarinas in *Symphony 8: 'Songs of Transience'* (2004–05).[18] All of these pieces deal with religious or spiritual themes. Similarly, Paweł Łukaszewski uses eleven ocarinas at a crucial moment of Jesus's death in his *Via Crucis* (Way of the Cross) (2000). One musicologist recently described how the timbre of the ocarina ensemble 'seems to transport the listener into a sacral dimension, referring to that which is distant and unreal'.[19] It seems that the ocarina's ability to evoke some kind of supernatural or

mystical reality (even as transportation) is still evident in the twenty-first century, much like it was in pre-Columbian South America.

The ocarina is the perfect choice of instrument for Link. It is deeply embedded in long histories of musical culture across the world, yet it is hardly commonplace and remains attractively unusual. Given that the game must appeal to players all over the globe, the ocarina is handily able to occupy a similar cultural meaning of 'ancient, traditional and unusual' but 'vaguely familiar' to diverse audiences. Because the ocarina has existed for such a long time, but it has undergone continual reinvention, it remains chronologically unspecific: able to invoke historicism but without being explicitly old-fashioned or consigned to the past.

The ocarina in the game is a powerful magical instrument so the existing connotations (both ancient and modern) of the ocarina with religion and mysticism are entirely apt. Perhaps the sonorous rounded timbre of the instrument, with its not-quite-vocal quality, may play some part in this indelible association with the supernatural.

The instrument's physical properties have made it attractive for young musicians to play (again, in a variety of different cultures). Suitable, then, for our youthful hero, who must learn the instrument in the course of the game. The easy accessibility of the instrument also allows gamers enthused by the virtual music-making to seek out ocarinas in their 'real' world and learn to play and perform for themselves.

As in the lyrics quoted above, Bing Crosby struggled to define the ocarina in 'The Sweet Potato Piper', which is unsurprising. After all, the ocarina is a paradoxical instrument: both historical and contemporary, professional and amateur, supernatural but commonplace, associated with serious ritual and youths at play. It is perfectly matched to the game's attempt to balance those same factors, since *Ocarina of Time* features a youngster dealing with mystical prophecies, magical powers and apocalyptic stakes, and yet the game includes goofy humour and showcases technological innovation.

There is also perhaps another motivation for the choice of ocarina. The open tone of the ocarina, with its limited harmonics and relatively simple timbre, allows for the kind of solo instrument sound easily emulated by the Nintendo 64 in MIDI mode. Link's ocarinas produce a tone not dissimilar to that of a real instrument, whereas other instrumental timbres, such as solo brass and bowed string instruments, are less realistically sonically rendered. While the sound of the ocarina is reasonably close to the real instrument, the way that it is played by the gamer is quite different.

Playing Link's Ocarina

Link acquires his first ocarina, the Fairy Ocarina, after completing the first dungeon in the game. Before he leaves Kokiri Forest on his quest to find Princess Zelda,

his friend Saria gives him the instrument as a gift. It is surrounded by a halo of twinkling lights, indicating its magical aura. At their bittersweet parting, Saria says,

> I want you to have this Ocarina [...] Please take good care of it. When you play my Ocarina, I hope you will think of me and come back to the forest to visit.

Text appears on the screen providing the player with instructions on how to use the ocarina.

> You received the Fairy Ocarina! This is a memento from Saria. Set it to (C) and press (C) to start playing it! [...] You can play different notes with (A) and the four (C) Buttons. Press (B) to quit playing, or to start your song over again.

The function of the ocarina in the game is not immediately clear, though from this moment, players are free to improvise and play all of the available notes. The ocarina's power is gradually revealed as Link learns songs.

In the game, Link plays two ocarinas: the Fairy Ocarina and later, Zelda gives him custody of the more powerful Ocarina of Time. This instrument has abilities beyond that of the Fairy Ocarina and supersedes the first instrument. The game's description of the latter reads: 'You found the Ocarina of Time! This is the Royal Family's hidden treasure which Zelda left behind. It glows with a mystical light [...]'. Both use the same sounds and interface. Particular notes on the instrument are mapped to buttons on the controller (Figures 2.1–2.3).

After assigning the ocarina to a yellow C button of their choice, players can press that button to make Link draw the ocarina, put it to his lips and start the ocarina's 'play' mode (Figure 2.2). The background audio dips in volume when this happens, to make sonic space for Link's performance.

The player uses five fundamental buttons to control the ocarina: the four yellow C buttons and the blue A button, all on the right-hand side of the controller. Players will typically hold the controller by the middle and right prongs, and likely use their right thumb to press the ocarina buttons. Each of these buttons is mapped to a particular discrete pitch on the ocarina. Pressing the button will cause Link to play that note. He will sustain the pitch, gradually getting quieter, until either the player releases the button or Link runs out of breath (approximately 3.6 seconds). The five fundamental ocarina pitches, D5, F5, A5, B5 and a higher D6 are shown in Figure 2.3.

The five pitches of the ocarina form a four-note (tetratonic) scale, since the highest and lowest pitches are the same (D). The pitch set sits ambiguously between clearly major or minor (Table 2.1): D major would require an F#, but the set also does not include a B♭, which would indicate D minor. Instead, taken together, the

THE OCARINA AND LINK'S MUSICAL PERFORMANCES

FIGURE 2.1: A Nintendo 64 controller.

FIGURE 2.2: Link playing the ocarina.

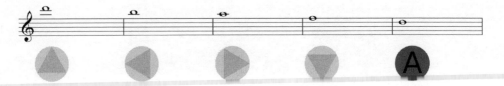

FIGURE 2.3: The pitches and controller buttons used when Link plays the ocarina.

Ocarina	D		F		A	B	
D major	D	E	F♯	G	A	B	C♯
D minor	D	E	F	G	A	B♭	C
D Dorian	D	E	F	G	A	B	C

TABLE 2.1: Comparison of the ocarina's notes with D major, minor and modern Dorian.

pitches evoke modal musical organization: these particular pitches fit a modern D Dorian mode, or ancient Greek Phrygian mode.

There are both symbolic and practical reasons why this organization is suitable for the game. In using a limited set of pitches and one that does not fit neatly into the major/minor patterns listeners may expect from modern popular musics, the game evokes traditional, ancient and Global musical cultures. As we have seen, that is entirely in keeping with the ocarina instrument, and the fantasy world of Hyrule. Second, this organization does not limit the performance to one mode – by using a subset of the notes, melodies with different profiles can be played. Indeed, out of the twelve predefined melodies in the game, none asks the player to use all five pitches to trigger the melody; nine use only three different notes, while three use only four notes. We will return to those melodies in a moment, but it is important to consider the other possibilities that the game provides for playing the ocarina.

Beyond the Four Notes

The game tells players to use the buttons in Figure 2.3 to play the ocarina. Only these notes are required to trigger the songs in the game. However, if gamers experiment with the controller, they can quickly find other pitches.

When Link plays a note on the ocarina, if the control stick in the middle of the controller is moved up or down, the note can be 'pitch bent' higher or lower, up to a tone (the equivalent of two piano keys). Taking advantage of the gradated movement of the control stick, the further the player pushes the stick, the greater the pitch bend. Since this alters the note in a continuous way, it sounds all of the intermediate non-discrete pitches in between the extremes. This opens up the possibility of playing more notes than just the twelve particular pitches typically emphasized in Western pop and classical music (perhaps another way of alluding to musical practices from around the world). That said, sustaining intermediate pitches is tricky, and the control stick is primarily useful for simply pitch bending to the next tone up or down.

More control is given by two other buttons – the Z-button trigger, located on the underside of the controller, below the control stick, and the right-hand shoulder button (R), which is perpendicular to the yellow C buttons (see Figures 2.1 and 2.4). The Z and R buttons also raise and lower the sounding pitch, but by semitones (equivalent of one piano key). These alterations are discrete, on or off, rather than the gradation provided by the control stick. The two sets of pitch alteration controls can be used in tandem, too: players can both rise the note by a tone using the control stick and a further semitone by R. The upshot of these features is that the game actually provides a far greater range of pitches than is immediately apparent.

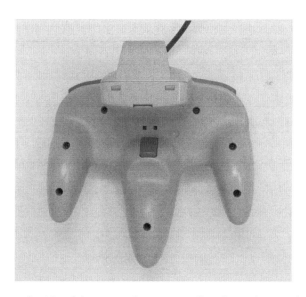

FIGURE 2.4: The underside of the Nintendo 64 controller, shown here with the Rumble Pak loaded.

In the remake of *Ocarina of Time* for the Nintendo 3DS (Figure 2.5), the ocarina pitches are adapted to the hardware of the handheld console. As well as reassigning the notes to different buttons,[20] gamers can also trigger the notes by pressing the touch-sensitive lower screen of the console. The main control stick, however, functions in the same way as the N64's stick, pitch bending and providing vibrato. On the 3DS, the four-way 'D-pad' beneath the control stick also alters the musical notes. The left and right arrows produce vibrato, and the up and down arrows copy the L/R shoulder buttons by shifting the pitch by semitones.

On either platform, by using a combination of the two pitch-altering options, the player has access to a full set of notes, from B4 below the lower D5 to F6 above the higher D6. This chromatic set is the same as one would expect to find on an instrument like a piano. Link's ocarina has a greater range of musical notes than many traditional ocarinas. The player is also given another opportunity to alter the performance – the left and right movement on the control stick allows Link to provide vibrato (a wavering expressive effect) to the note. This effect is difficult to achieve on a 'real' ocarina, because of the manner of sound production described

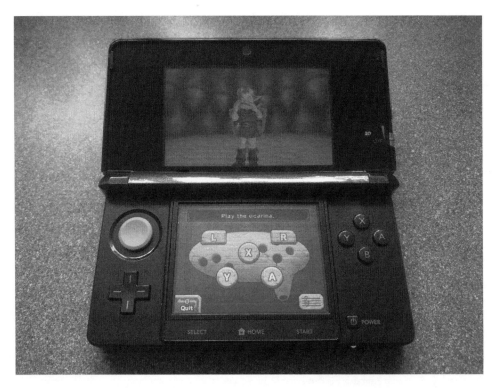

FIGURE 2.5: Link playing the ocarina in the 3DS remake of *Ocarina of Time*.

above. For all of its virtual incarnation, Link's ocarina has more musical possibilities than many physical ocarinas would allow.

The access to the complete set of pitches relies on players experimenting with the game. Especially with a high-profile game like a *Zelda* title, the creators know that the game will be the subject of a great deal of investigation, as keen players seek to find every secret or possibility that the game holds. These additional notes reward exploration of the game's interface. The extended capability allows players to take their musical performances beyond the set notes and melodies in the game. As the player discovers the additional notes, using the Z and R buttons on the N64 controller, they come closer to holding the controller like an ocarina, wrapping their hands around the gamepad. Players here physically emulate Link's gestures, bringing gamer and avatar into closer physical correspondence.

The additional notes and vibrato serve no function in the game. They are simply created for the sheer joy of playful musical performance. They allow the player a little more performative expression and these options imply that the ocarina songs are not just a series of button presses like a cheat code but are instead to be understood as melodies.

Learning the Ocarina Songs

In *Ocarina of Time*, Link's ocarina produces magical effects within the world of the game. On his adventure, Link is taught twelve melodies by characters, or, in one case, found written on a stone (Figure 2.6). When Link encounters a new melody in the game, the initial phrase is played to the gamer while the correct button sequence appears, note-by-note, on a musical staff at the bottom of the screen. Normally, this is sounded by another character, who either sings (Malon, the farmer's daughter), whistles (Impa), or plays it on another instrument to Link (Sheik plays the lyre, Zelda and Saria play ocarinas, while the organ grinder of Kakariko Windmill plays a hand-cranked organ).

The initial phrase is shown twice, before the player must perform the melodic phrase for themselves. The correct notes/buttons are on the staff in grey, gaining colour when correctly performed. If the player does so correctly, they are rewarded with the game's default rising 'correct action' arpeggio (see Chapter 5), and if a note in the sequence is incorrect, a dull metallic 'dong' like a cracked bell sounds, and they must start again. In this way, the game copies the process of musical rehearsal so common to instrumental performers – play correctly, or start again. It is this opening phrase that is crucial to triggering the whole melody. These all-important first notes are indicated in the musical examples that follow.

Once he correctly plays the start of the melody, Link (typically in duet with the character teaching him the song) will perform the whole melody, not just the

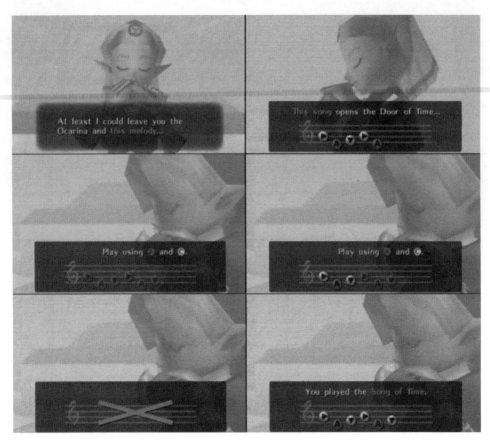

FIGURE 2.6: Link learning an ocarina melody. The bottom left image shows the result of a wrong performance.

opening phrase. For some songs (the 'warp songs') this performance is accompanied by other instruments, sounding from some unseen location, magically summoned to complete the performance. Now that Link has learned the piece, he may subsequently perform it (as directed by the player), whenever he wishes, in order to unleash the power of the melody.

On his adventure, Link intermittently encounters a wise owl. This character dispenses advice about how to play the game. After Link learns a song from Saria, the owl appears and explains how to use and deploy the melodies:

> Did you learn an Ocarina song from Saria? That melody seems to have some mysterious power. There may be some other mysterious songs like this that you can learn in Hyrule. If you hold the Ocarina with C where a melody is necessary,

a musical staff will appear. I recommend that you play a song you know. I also suggest that you play even when a score is not displayed. [...] Melodies you have learned will be recorded on the Quest Status Subscreen [menu]. You should memorize those melodies.

The player triggers a melody by using the pitch interface to play the opening phrase of the melody, just as they have been taught. To play the song correctly, players do not have to keep to the correct timing of the melodic phrase. By omitting the need for rhythmic accuracy, the game avoids additional complications for both player and programmers. If the rhythms of the player's ocarina performances were to be assessed, another element of programming would be required. A demand for rhythmic precision may also potentially cause frustration for players, especially since it takes practice to achieve rhythmic accuracy using the pitch-mapped buttons on the N64 controller.

When retriggering the melody in a new context, Link performs the characteristic pitches of the initial phrase of the melody, and the short 'correct action' arpeggio sounds (see Chapter 5), to indicate that the melody has been recognized. Then, akin to an 'autocorrect' function, Link will then play the correct melody in its entirety, from start to end, with the accurate rhythm, sometimes with added expression. Some songs cause a mystical vortex of light, conjured by the ocarina's power, to swirl around Link.[21]

The game does not recognize the melodies as correctly performed if the player alters the pitches by using the L and R buttons, or vertical axis of the control stick. It does, however, accept the phrase if the player merely uses expressive vibrato in performing the melody. Players can put their own stamp on the performance by adding vibrato or altering the rhythmic input, but the correct melodies require the specific pitches to unlock their magical properties. Here again, the game encourages players to understand their activity as a musical performance, not simply a series of abstract button presses. Between the necessity of correct pitches and the teaching sequence, the game (despite avoiding rhythmic precision) goes to lengths to emulate a musical-educational process. It is not just Link who is 'taught' the pieces, but, by extension, the player, too.

As the owl explains, after Link has collected a melody, the notation is added to the list of songs in the menu, where it can also be played again, to aid the player's memory. Link must have learned a melody from a character for it to be unlocked; even if he plays the phrase of a yet-to-be-discovered song, it will have no effect. Melodies also stand as a kind of achievement, charting the player's progression through the game, rewarding their success and, like a power-up, giving Link new abilities. Even before the player has collected all of the melodies, they are able to see the twelve spaces for melodies on the menu, so it serves as a kind of indicator

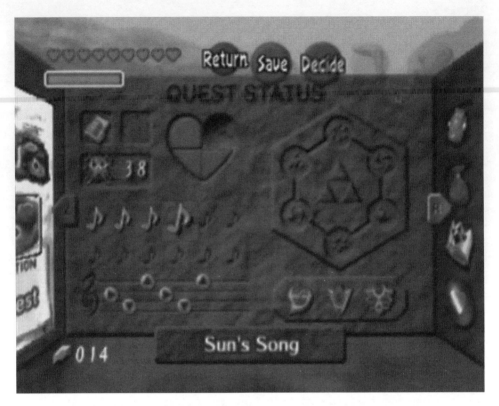

FIGURE 2.7: The pause menu showing the incomplete collection of melodies.

of the player's journey (Figure 2.7). Reviewing the melody, players are reminded of their achievements, and looking to the future, they see how many there are still yet to find (and, implicitly, how much more of the game's plot there is left to conquer).

Perhaps this strategy of distributing the melodies over the course of the entire game helps to add an emotional dimension to the experience. Nostalgia comes from the retrospective 'looking back' on past places and events. As the songs are learned, used and reused, they chart the long time and space of the game. When the songs sound, they allow players to reflect on Link's epic quest, calling to mind the places, characters and accomplishments facilitated by the songs. This is not only motivated by sentimentalism; considering past uses of a song is an important way of identifying future opportunities for its use. Even the characters refer to the connection between music and memory – when Saria gives Link the Fairy Ocarina, she says that she hopes it will remind him of her. The accumulated meanings of the melodies can make them particularly emotionally charged, because of this prompted reflection on the past. Such emotional power extends beyond the playing time of the game (see Chapter 7).

The Songs

There are twelve songs for the player to learn in the game, and a further melody that players compose themselves. Stephanie Lind categorizes the songs based on the three functions that the pieces fulfil in the game. She writes,

> First, some ocarina melodies unlock doors, reveal hidden areas, or trigger interactions with non-player characters, thereby *advancing the plot*. Second, some ocarina melodies reveal bonus areas, treasure, or call for help from a friend, thus *assisting the player* beyond the basic gameplay. Last, the remaining ocarina melodies allow the player to fast-travel (or 'warp') to specific locations.[22]

We can use Lind's designations to characterize the melodies as shown in Table 2.2. The game itself also indicates division of the songs based on function – on the menu, the warp songs are indicated by coloured notes, distinguishing them from the others indicated by white notes.

We will here examine each melody in turn. This will include discussion of the meanings of the song in the game, a brief analysis of the melodic line and consideration of how the song is rendered in the full performance of the tune. Sometimes these themes recur in the underscore, but we will deal those instances elsewhere.

Plot-Advancing and Assistance Melodies

The plot-advancing and assistance melodies serve a variety of purposes in the game. Link plays these melodies unaccompanied on his ocarina.

Zelda's Lullaby – Confounding Musical Signs of Power

Zelda's Lullaby is one of the most important and frequently used melodies in the game. The piece is associated with Princess Zelda and her family. It is taught to Link near the start of the game by Impa, Zelda's bodyguard, who whistles the piece to him. As befits a 'lullaby', this is a gentle, triple-metre, quiet legato theme characterized by arch-shaped phrases. Yet in this world, it is the most powerful melody, associated with royalty and revered as precious cultural material. Impa tells Link that the melody, beyond being used as Zelda's lullaby, is

> [A]n ancient melody passed down by the Royal Family [and] has some mysterious power. Only Royal Family members are allowed to learn this song. Remember, it will help to prove your connection with the Royal Family.

Song	Song Type	Function
Zelda's Lullaby	Plot-advancing	Various, especially as a force for moving or changing barriers (e.g. raising and lowering water level in Water Temple, opening sealed or obscured pathways). Places to use the song are often indicated by a Triforce sign on the floor.
Song of Time	Plot-advancing	Used to open 'Door of Time', to allow access to the Master Sword and the time travel mechanic. Also transports particular stone blocks in dungeons.
Epona's Song	Assistance melody and optional plot-advancing	Summons Link's horse.
Sun's Song	Assistance melody	Changes night to day or vice versa.
Saria's Song	Assistance and plot-advancing	Communicates with Link's friend, Saria, for plot hints; opens path to Sacred Forest Meadow; can be used to obtain additional bonus items by entertaining non-playable characters (NPCs).
Song of Storms	Assistance and optional plot-advancing	Water-themed agency, such as draining the well in Kakariko Village, creating a desert oasis and summoning a fairy. Required to obtain Lens of Truth, a powerful, but not essential, object. Also opens up bonus grotto areas.
Prelude of Light	Warp melody	Transports Link to the Temple of Time.
Minuet of Forest	Warp melody	Transports Link to Sacred Forest Meadow.
Bolero of Fire	Warp melody	Transports Link to Death Mountain Crater.
Serenade of Water	Warp melody	Transports Link to Lake Hylia.
Nocturne of Shadow	Warp melody and plot-advancing	Transports Link to Kakariko Graveyard (required to access the Shadow Temple dungeon).

(*continued*)

THE OCARINA AND LINK'S MUSICAL PERFORMANCES

Song	Song Type	Function
Requiem of Spirit	Warp melody and plot-advancing	Transports Link to the Desert Colossus (required for child access to Spirit Temple dungeon).

TABLE 2.2: The Melodies of *Ocarina of Time* with categories and functions.

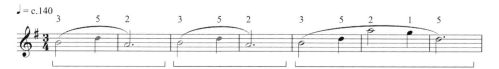

FIGURE 2.8: The melody of Zelda's Lullaby, showing the phrases and scale degrees. Notated an octave lower than sounding pitch.

The piece is a lilting three-time piece in G major, which begins with a three-note pattern (B–D–A), heard twice. This phrase finishes on A (the second degree of the scale) rather than the home tonic pitch of G, so it sounds unfinished. The melody moves onwards, landing on D (the fifth degree), which sounds more resolved, if not completely finished, perhaps implying modulation to D (Figure 2.8). It seems to want to continue, ever seeking proper resolution, lending a melancholy and restless mood to the melody.[23]

The combination of the musical style and the in-world meanings of the piece play against traditional associations of music and heroism, power and value. We might normally expect musical power to be depicted by strident, loud and gesturally outgoing fanfares, not a lilting lullaby with arch-shaped melodies.[24]

To play the triggering phrase of the melody, the player presses three of the yellow C arrow buttons, in the order of left, up and right. This combination of arrows (and the outline of the musical gesture it produces) resembles the icon of the Triforce that is central to Hyrule's mythology and the symbol of the Royal Family. The game alludes to this connection: certain locations where the player should perform Zelda's Lullaby are indicated by a marking on the ground in the form of the Triforce symbol (Figure 2.9).

The melody of Zelda's Lullaby was heard in a game prior to *Ocarina of Time*, as music associated with Princess Zelda in *A Link to the Past*. Thus, the melody has a history both in the fictional world of Hyrule and in our world. The theme extends beyond *Ocarina of Time*, recurring in sequel games such as *The Wind Waker*, *Twilight Princess* and *A Link Between Worlds*, all the while continuing to accumulate meaning and tying together the franchise.

FIGURE 2.9: The Triforce symbol on the ground indicates where Link must play Zelda's Lullaby.

This melody is regularly used across most of the long duration of *Ocarina of Time*. It is performed particularly frequently in the Water Temple dungeon where it is essential to solving the puzzles by changing the water level. Using the piece repeatedly and over a long span of time helps to anchor the piece in the player's mind. Stephanie Lind also notes that the piece, like the other assistance melodies, uses a three-note phrase that is directly repeated, which serves as another level of repetition to help memorability.[25] Even though the melody does not readily deploy common musical signs of heroism, it is one of the pieces most often associated with Link's quest. Indeed, some players have become so enamoured with this piece that they have chosen to have the melody represented as a tattoo.[26]

The Song of Time – Musically Evoking the Past

The Song of Time is another powerful song in the game, a partner to Zelda's Lullaby. The song is telepathically taught to Link by Zelda, after she has fled Hyrule

Castle to escape Ganondorf. Link is able to use the song to unlock a chamber within the church-like Temple of Time and gain access to the time travel mechanic that is fundamental to the second part of the game.

This melody uses a moderate tempo, evoking a sombre mood that exudes ancient mystery. Like all 'assistance' melodies, the song begins with a repeated three-note initial phrase. A second wandering phrase descends, charting the notes of a scale. Earlier, we noted how the notes of the ocarina could imply a modern D Dorian mode. The latter part of the Song of Time makes this explicit by covering all of the pitches of the Dorian mode. Modal tonality is often associated with the past, because of its use in very old musical traditions, evoking a time before the dominance of major/minor keys. In particular, modal harmony is a characteristic feature of Christian religious plainchant, which dates at least from the ninth century. The Song of Time uses modal tonality to draw on musical signs of the historically exotic – perfectly apt for a song associated with an ancient mystical power (Figure 2.10). This connection is further reinforced when the melody is heard in the Temple of Time, sung by a low-voiced chorus in long held pitches, again echoing the tradition of religious chant (as we shall see later).

The Song of Time is also used by Link to move large stone blocks that bar his way in dungeons. These blocks typically rematerialize in other nearby locations. While there is nothing particularly inventive about this game mechanic, and the logic of the transporting blocks is never explained, the association of the piece with time travel implies that these blocks are somehow moving to a location they occupied at a different point in time. A simple game puzzle is made richer through the application of the previous meanings of this melody.

Learning this melody represents a major milestone in Link's adventure, since it is required to access the time-travelling portion of the game. In *Ocarina of Time*, players are given a degree of freedom about the order in which some quests are carried out. To structure the game, several other strategies are used to limit the player's progress. In this case, the melody ensures players cannot access the future time zone until they have completed the first three dungeons. The teaching of the melodies is one of the many mechanisms that the designers use to control the player's journey through the game's world and story.

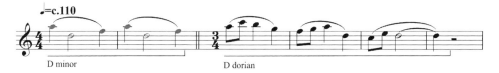

FIGURE 2.10: The Song of Time showing the implied tonality.

Epona's Song – A Simple Song of Loss

Epona's Song serves a straightforward function: it summons Link's horse, Epona, to him. The melody also prompts cows in the game to produce milk that Link may drink to restore his health.

Epona's Song plays a part in advancing a subplot of the game. Link learns the song in the 'past' portion of the game from the ranch owner's daughter, Malon, who attributes the song to her mother (who does not appear in the game and is implied to have passed away). The piece is shown to have a calming effect on animals. Link can only tame the rebellious horse called Epona by playing this song. Without the song, the horse will run away from him. In the 'future' time, the villainous Ingo has taken over Lon Lon Ranch, humiliating Malon and her father. By challenging Ingo to a horse race, and besting him using Epona, tamed by the song, Link is able to win the horse and return the ranch to its rightful owners. From then on, Link can summon Epona using the tune and ride her around Hyrule. The other use for the song is collecting milk: when Link finds a cow, playing the song prompts the cows to produce milk for Link, because the song (the cows say) reminds them of the pasture.

The way that the player first hears Epona's Song will vary depending on their actions. After Link leaves Kokiri Forest, players are told to go to the castle to find Princess Zelda. If they continue on this adventure, they will encounter Malon on the way to the castle, looking for her lost father. At night, she is heard singing this tune, using an open vowel sound. However, players may instead visit Lon Lon Ranch before going to the castle. This melody serves as the main melodic material of the location cue for the ranch, played on a violin. Once Malon has found her father, she returns to the ranch, where Link can meet her again.

When she is at Lon Lon Ranch, Malon sings Epona's Song along with the underscore: as Link approaches her in the middle of the ranch, her vocal part fades in, perfectly synchronizing with the underscore accompaniment (Figure 2.11). On a technical level, this effect is achieved through fading in Malon's sung voice, while the violin fades out, so the melody is seamlessly handed from one to the other, with only a very small amount of overlap. The game makes clear that it is Malon who is singing along with the accompaniment: when Link speaks with her, Malon's voice part ceases while she talks to Link. The accompaniment continues to sound, and Malon will take up the melody again once the conversation with Link has ended. Malon sings an extended version of Epona's Song as part of the Lon Lon Ranch cue, though only the first four bars are played by Link on the ocarina.

Epona's Song begins with another three-note repeated phrase (Figure 2.12). The repeated descending phrase appears to imply D major, in a relaxed andante

THE OCARINA AND LINK'S MUSICAL PERFORMANCES

FIGURE 2.11: Malon singing at Lon Lon Ranch.

tempo. We will discuss the harmonic framing of the melody further when we return to Lon Lon Ranch in the discussion of location cues, but for now, we can note that the melody has a bittersweet folk and lullaby-like quality, achieved by combining the major mode with the descending phrases, three-time pulse and repeated accompaniment pattern. The melody is consistently associated with loss in the game – it reminds the cows of the pasture, and Malon of her mother and of her missing father (if she is encountered during the night at the castle). When the villain, Ingo, has taken over the ranch, at night, Malon sings the tune, remembering her mother and a happier past. She asks Link not to tell Ingo that she sings the song, presumably fearing retaliation.

Like Zelda's Lullaby, Epona's Song is shown to have significant agency in the world, even if it does not adhere to traditional musical signifiers of power. It tames and summons animals, and is used by Malon to defy her oppressor. The expressive properties of this tune are accentuated in Link's computer-controlled performance of the full melody – he adds expressive vibrato over the held A notes, perhaps imitating the gentle vibrato that Malon uses when singing the song.

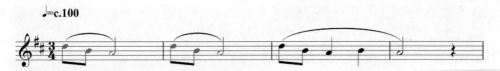

FIGURE 2.12: Epona's Song, with the three descending gestures marked. Notated an octave lower than sounding pitch.

The Sun's Song – A Fragmentary New Start

The Sun's Song is a short piece. When Link plays the melody on the ocarina in the game during the day, the piece causes night to fall, and when played during night, it bids the sun to rise. The Sun's Song is optional for completing the game, but it is very useful to players in their progress through the game. Given that many of the game properties vary depending on the time of day, it is helpful to be able to change day to night (or vice versa) on demand, rather than simply waiting for the daily cycle to progress at its own pace.

Unlike most of the ocarina melodies, which use balanced phrases and sound like they could be songs designed to be sung, the Sun's Song is fragmentary. It consists of two very different sections (Figure 2.13). The first phrase outlines a D minor triad, but the rising scale to land on the repeating G outlines C major. The Sun's Song sounds the most incomplete of the game's ocarina melodies. The ritardando, gradually slowing the tempo towards the end of the melody, is also unique among the pieces.

The reason that this melody seems so atypical for the ocarina songs is because it is taken from the introduction to another cue. The melody is borrowed from the piccolo that begins the Hyrule Field cue during sunrise (see Chapter 3). The player will almost certainly have heard the melody in underscore before learning the ocarina melody. In any case, they will hear it so frequently throughout the game that the Sun's Song becomes one of the game's most memorable melodies, both because it is musically distinct and because the association is reinforced for the player each time the sun rises on Hyrule Field.

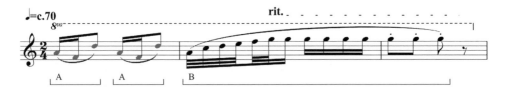

FIGURE 2.13: The Sun's Song, showing the fragmentary construction of the melody.

The repeated notes and rapid movement seem to imitate birdsong. In the context of Hyrule Field, this is part of the introduction to the main Hyrule Field music. The lack of a closed structural shape is apt for a piece that signifies beginnings, whether in the new day on Hyrule Field or a new night in which Link will undertake adventures. When using the melody to cause the sun to rise on Hyrule Field, it almost seems like Link is jump-starting the underscore by playing the phrase that the unseen orchestra then imitates.

The Sun's Song is another part of how the mythology of the Royal Family, and the power of music, are portrayed in the game. Link can encounter the ghosts of two royal court composers, brothers Sharp the Elder and Flat the Younger, authors of the Sun's Song. They describe their activity as composition and research. As they explain to Link, the composers were 'assigned to study the hereditary mystic powers of the [Royal] family' and completed a 'study of controlling time with the tones of ocarinas', specifically through creating compositions to summon the sun and moon. The composers sacrificed themselves, rather than let the powerful melody fall into the hands of the evil Ganondorf. After gaining access to the royal mausoleum using Zelda's Lullaby, Link finds the Sun's Song etched on the royal tombstone. The game continually associates music as powerful, mystical, but also the product of personal effort and able to be harnessed by those with instruments and a willingness to play. It mediates between the world of the living and magical forces.

Saria's Song – A Link Between Worlds

In contrast with the Sun's Song, Saria's Song has rather ambiguous meanings and functions. It is associated with Link's childhood friend, Saria. Saria teaches Link the melody on her own ocarina when they meet in the Lost Woods.

The jolly, effervescent, up-tempo melody of Saria's Song uses a repeated initial phrase which is then elaborated and extended (Figure 2.14). The opening rising phrases on F are followed by a descending gesture that seems to imply C major, creating a plagal (IV–I) cadence in C major, giving the piece a sense of conclusion since it finishes on the tonic home key (I), though because the melody lands on

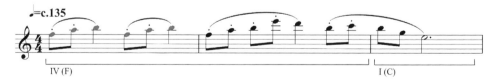

FIGURE 2.14: Saria's Song, heard in the Lost Woods, with the implied IV–I (plagal) movement marked.

E (not C), it still suggests a musical continuation. It sounds simultaneously both incomplete (surface melody) and complete (underlying harmony) at once. That, however, is only the beginning of the song's paradoxes.

Diegetic and Non-Diegetic Music

Film music scholarship has often sought to distinguish between music that occurs in the fictional world of the characters and that which comes from outside. This is used to explain why we hear orchestras accompanying film action when there is no realistic way that an orchestra could be in the same space as the characters. As Royal S. Brown puts it, 'Diegetic music theoretically comes from a source within the diegesis [the story world] – a radio, a phonograph [...] and the characters in the film can theoretically hear that music [...] Nondiegetic music theoretically exists for the audience alone and is not supposed to enter in any way into the universe of the filmic narrative and its characters.'[27] More recent scholarship has attempted to downplay this division and instead emphasizes that filmic reality is not the same as our world, so normal rules of realism do not necessarily apply.[28]

Saria's Song seems to bleed between levels of reality, as part of the mystery and magic of the Lost Woods. The location cue for the Lost Woods uses an extended version of Saria's Song as its main melody, played on an ocarina, with a group of accompanying instruments. Upon entering the woods, players would likely assume that the music was non-diegetic. However, it becomes apparent that the situation is more complicated.

The Lost Woods is a woodland maze that players navigate by listening to the music. As Link's owl guide says to him, 'I can hear a mysterious tune …. You should listen for that tune too [...] Just follow your ears and listen to the sounds coming from the forest!' He seems to refer to the background musical cue that we have assumed is non-diegetic.

As players follow the correct route through the maze, the cue is heard with all of the instrumental parts sounding, but as they stray from that path, fewer instruments are audible. By listening at each crossroads in the maze, and following the route from which the music sounds loudest and with the most instruments, players can find their way through the Lost Woods.

Isabella van Elferen has discussed how games complicate film models of diegesis. She suggests that much video game music can be called 'supradiegetic'

because it crosses so many levels of reality.[29] Even if we assume an avatar character cannot hear non-diegetic music, the player *can* hear that music, which influences how the character acts. Saria's Song exemplifies this effect. Music seems tied to the specific geography of the Lost Woods (the diegetic world) but has no logical specific source (non-diegetic), though we can hear it coming from speakers and headphones into our world, which affects how we control Link in the diegetic gameworld. The music links and binds together these different worlds.

Upon reaching the end of the maze, the players find that the ocarina we have heard is being played by Saria herself (though no other performers are visible). She then teaches Link her song. We will return to the musical characteristics of the Lost Woods cue in Chapter 3, but for Saria's Song specifically, it is worthwhile noting that the song melody will be familiar to players long before it is introduced as a playable piece and that we are directed to listen to it in the forest maze.

Saria's Song is used in several ways in the game, all related to the connection of friendship. It is presented to characters who are suspicious of Link as evidence of Saria's endorsement of his character. Playing the lively piece also allows Link to telepathically consult Saria for advice.

The melody is used to create friendships. In Goron City, Link encounters Darunia, the leader of the Gorons, who has become despondent since his city was placed under siege by Ganondorf. Link must use Saria's song to bond with Darunia, gain an important item and progress the story. Playing the upbeat tune on the ocarina energizes Darunia to dance and rouses him from his depression. While Link initially sounds the melody on his ocarina as a solo, in this case, the full Lost Woods cue begins, as Darunia dances. Link has gained Saria's power to conjure, and play along with, the invisible magic ensemble.

Saria's Song can be used in two other situations in the Lost Woods, as part of optional side quests. In the Lost Woods, Link encounters the mischievous 'Skull Kids', pixie-like creatures resembling scarecrows. They are shown dancing and playing flutes, held in the same way as an orchestral flute. One shy Skull Kid disappears if Link approaches him directly. Navi suggests building a relationship with him. By playing Saria's Song, Link can forge a friendship with the Skull Kid and receives a reward in return (Figure 2.15). Saria's Song does not have the same degree of function as some of the other songs in the game; its 'magic' often seems to simply be the joy of performance (with Darunia and Skull Kid). In doing so, however, it presents music as creating and preserving ties of friendship – the same power music holds in our world. Even though they may be fictional, players are also sharing playing and enjoying music with the characters in the game, building their connection with the world and characters of *Ocarina of Time*.

FIGURE 2.15: Link befriends a Skull Kid by playing music with him.

The Song of Storms – A Little Bit of History Repeating

The Song of Storms is associated with the windmill that looms over Kakariko Village. Inside, Link meets an organ grinder. This curious figure is obsessed with repetition. He operates an instrument that appears to be a combination of a hand-cranked organ and a phonograph. He winds the handle and the horn whirls around his head, producing music at a very loud volume. The melody of the Song of Storms is part of this composition. The organ grinder tells Link that he is 'trying to come up with a piece inspired by this windmill […] going around and around and around!!!' (Figures 2.16 and 2.17).

The Song of Storms is associated with water, weather and rain in the game. The melody's most notable function occurs in Kakariko Village. In the 'past' time zone, Link can play the piece to cause the windmill to rotate faster and drain the village's well, allowing him to access the secret chamber hidden beneath. To do so, Link enters the windmill and plays the tune in the presence of the organ grinder. The melody causes a rainstorm to begin and the windmill to rotate more quickly. As this happens, the organ-grinder's music increases in tempo and its pitch detunes as it speeds up. The process here is not dissimilar to the Sun's Song: the player observes an occurrence in the world (the sun rising, the windmill turning), which is accompanied by musical material. Then, by learning the melody in question,

THE OCARINA AND LINK'S MUSICAL PERFORMANCES

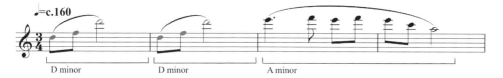

FIGURE 2.16: The Song of Storms showing the phrase structure and implied harmony.

FIGURE 2.17: The organ grinder inside the Kakariko Village windmill.

they can actively prompt that action to happen, or become intensified. The access to the bottom of the well is not strictly necessary to complete the game, though the treasure items within are very useful. Elsewhere, the song prompts rainfall with helpful side effects. The song can be used in this way to create an oasis in the desert, irrigate planted seeds with water and charm stone totems that are scattered throughout Hyrule. All of these actions result in the production of health-restoring fairies.

The Song of Storms sits in a causal loop (a 'bootstrap paradox') in *Ocarina of Time*'s narrative. In the 'future' time, the organ grinder teaches Link the Song of Storms. In doing so, he explains that he encountered the tune when a young boy

played the piece and caused the windmill to spin out of control. Having learned the piece, Link travels back in time and acts as the very same boy who introduces the song to the organ grinder. Even more curiously, the melody of the Song of Storms is that of the music already playing in the windmill at any point in the timeline, and which even seems to issue from the organ grinder's instrument. At the very least, the music seems to sound in the world, connected to the movement of the windmill. This is yet another paradox without clear explanation, though perhaps the organ grinder's apparent obsession with repetition is connected to him mistaking something familiar for a new piece.

The melody of the 'Song of Storms' follows the template we have observed in other songs: a repeated initial gesture that outlines an arpeggio, followed by a third separate phrase. Here, the rising initial gesture, implying D minor, is answered by a longer ornamented descent resolving to the fifth pitch (A) of D. Harmonically, the melody outlines a move from D minor to A minor, but, as we shall see later, the accompaniment complicates matters. Because of the frequent direct repetition of the melody in the location cue for the windmill and its paradoxical presentation in the plot, this melody is memorable, even if it is not used frequently by the player.

* * *

So far, we have discussed the six 'assistance' melodies that are used to aid Link and advance the plot (sometimes in optional ways). All of these melodies begin with a repeated three-note pattern, potentially to aid memorability. The three-note pattern gives way to a second, slightly longer musical phrase which is often based on an extension of the original three-note phrase.

The assistance songs are quite diverse. All of the melodies double up as themes for important location cues (across a range of styles), when they are heard as played by a larger group of musicians. These themes are contextualized, developed and orchestrated elsewhere, unlike the rest of the songs that Link plays, the 'warp songs', which are only heard in the context of his performance.

Warp Songs

The assistance and plot-advancing melodies contrast with the other six 'warp songs' that transport Link from one part of Hyrule to another. They are all learned in the second half of the game, in the 'future'/'adult' era. Each is taught to Link by Sheik, who uses a lyre to play the melody. They are normally encountered when Link reaches a new area that has been difficult to access and to which the piece now serves as a shortcut. Each of the warp cues is named after a genre of

historical, primarily European music, though the degree to which each conforms to the named tradition varies considerably.

Drawing on historical musical genres for the warp songs, both in the musical styles of the pieces, and through references in the in-game text, has several consequences. It is yet another way that the game asserts that playing the melodies should be understood as musical performances of distinct pieces, rather than merely as some kind of cheat code. By emulating previous musical practices, Link situates his (and the player's) musical activity in this historical tradition. The diverse selection of genres provides variety to the musical styles encountered in the game, and the game is enriched by drawing on the wider associations of the musical genres, at least, for those players familiar with such associations.

The warp melodies are likely to be infrequently used by players. As with all of the songs, once Link plays the triggering phrase, the whole melody is heard in full. When this happens, with the warp songs, other unseen instruments join in Link's ocarina performance. These warp songs all have the same structure. The initial phrase is heard on Sheik's lyre (which sounds as a harp) and then repeated on Link's ocarina. A further section serves as the conclusion of the whole piece. We can call this form AAB, or perhaps presentation, repetition, continuation and cadence (Table 2.3).[30] Throughout the AAB structure, the music features instruments other than the lyre and ocarina as accompaniment and sometimes they take over the melody for the B section.

Unlike the assistance and plot-advancing cues, these warp melodies are not heard elsewhere in the game. Perhaps it is for this reason that they occur with musical accompaniments: the additional orchestration helps to round out the musical signification beyond the solo melodic line. This is especially useful when the accompaniment can refer to other musical genres or traditions.

Nicholas Gervais has studied the harmonic construction of a number of the warp songs in *Ocarina of Time*.[31] He suggests that Kondo substitutes unusual chords into cadence patterns. Conventional Western harmonic logic would suggest

A (Triggering Phrase)	A	B
Presentation	Repetition	Continuation and cadence
Sheik (lyre)	Link (ocarina)	
Other instruments providing accompaniment throughout.		

TABLE 2.3: The structure of the warp songs.

we expect the conclusion of a piece to form a V–I (dominant–tonic) cadence. Instead, in the warp songs, Kondo substitutes a chromatically altered chord for V.[32] The result, Gervais suggests, are 'unorthodox progressions that sound harmonically satisfying'.[33] We will discuss examples of Kondo's harmonies below, but more generally this 'unorthodox' approach is representative of how Kondo uses historical musical genres: the pieces invoke established conventions, yet they are suffused with distinctly unconventional and non-traditional musical processes.

Prelude of Light – Subtle Forward Motion

The most frequently used of the warp songs is likely to be the Prelude of Light, because it is so useful. It transports Link back to the Temple of Time, where he can change time zones or quickly reach the game's central hub of Hyrule Field. It is taught to Link in the Temple of Time, after completing the first main dungeon of the 'adult' era. Like all of the warp cues, the teaching sequence only features Link's ocarina and Sheik's lyre, and once the piece has been taught, it summons accompanying instruments to round out the ensemble. Here, the piece is accompanied by a shimmering trilling glockenspiel and lower strings in sustained chords. Kondo gives the piece a sense of gentle propulsion by offsetting the accompaniment chord changes and the melody: even though the chords change once per bar, the last note of the melodic phrase lands just before the start of the next bar, giving a subtle drive to the performance.

The Prelude of Light features a significant emphasis on seventh chords and the so-called Neapolitan flavour (the ♭II chord). The piece is in D major and the B section uses the progression ii7 (Em7), ♭IIM7 (E♭M7) finishing with a held IM7 (DM7) (Figure 2.18). Because of the wide spacing of the notes, the dissonance is delicate and creates a sense of not being entirely resolved. As Gervais notes, for the final chord, 'each pitch moves down by semitone […] This generates a sense of cadential arrival, despite the lack of a clear dominant chord.'[34]

The prelude is a common musical designation in Western art music and has few specific defining characteristics, other than the association that it should announce a beginning (**pre**-lude), either by depicting a beginning or preceding other music. Some preludes originated as ways of checking the tuning of an instrument, introducing the tonality of a subsequent piece, exploring a particular technical device, or serving as a way to attract attention as an ostentatious display of ability.[35]

The notion of a beginning perhaps applies to the Prelude of Light, since it anticipates Link's ongoing adventures in the long second part of the game. The Prelude finishes with a held D major 7 chord, while the Temple of Time's background cue, which will be heard next, is in D Dorian, providing a degree of tonal continuity.

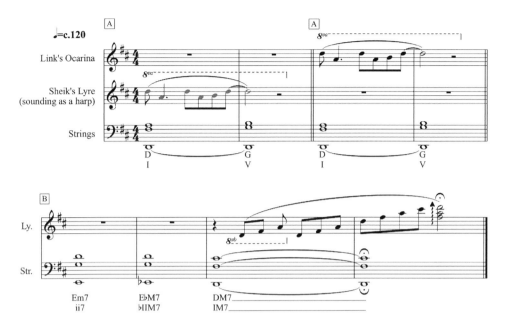

FIGURE 2.18: Prelude of Light, showing the structure and harmonic movement.

Perhaps the clearest connection to the game context comes from the origins of the word 'prelude', drawing on the Latin word 'ludus', meaning before play. Thus, the Prelude of Light subtly notes the connection between musical play and game play that the piece, and the game as a whole, emphasizes. The Prelude of Light serves as a prelude because it has a sense of forward motion and expectation. This anticipation is created by offsetting the chord changes from the melody and the use of unresolved seventh chords.

Minuet of Forest – Blending Age and Liveliness

The Minuet of Forest is a warp song that transports Link to the Sacred Forest Meadow, a mysterious site of ritual suffused with magic and dangerous creatures. By referring to a historical tradition of dance, the Minuet of Forest blends signs of age and stateliness with the playful rhythmic quality of dance.

The minuet is a slow, three-time dance, particularly associated with court dancing of the seventeenth and eighteenth centuries. As Eric McKee notes, the minuet was 'the most important social dance of the eighteenth century'.[36] After proliferating in suites of music for dancing, the minuet style also began to be used in instrumental music like symphonies and sonatas, primarily written for listening

rather than dancing. The traditional minuet groups the three-time dance into two-bar units.[37] McKee writes,

> A step-unit is a collection of individual steps, hops or springs, and involves at least two changes of weight from one foot to another. In the minuet, the principal step-unit is the pas de menuet which contains four changes of weight, always beginning with the right foot (RLRL). The pas de menuet takes six beats in 3/4 time to complete and begins on the upbeat with a bending of the knees.[38]

Julia Sutton, outlining the history of the form, also notes that 'the minuet in its heyday, whatever its variants were, was characterized by some basic features specific to it [including]: a step-pattern of four changes of weight in six beats'.[39]

While the Minuet of Forest is too short to accommodate any substantial dancing, it nevertheless uses characteristic rhythmic features of the minuet. It is in three-time, at a moderate tempo, and articulates two-bar groups: A (2 bars) A (2 bars) B (2+2 bars).

The Minuet of Forest uses a clear 'melody and accompaniment' texture, and the accompaniment pattern is consistent, marking every crotchet beat of the bar and emphasizing the start of the bar (Figure 2.19). A low drum quietly reinforces this first beat of each bar. The main melodic phrase could easily accommodate the four changes of weight that McKee and Sutton describe. Minuets did not necessarily require any specific matching of rhythmic pattern to steps;[40] instead, more important was the two-bar unit and the articulation of the three-time rhythm.

Aside from these rhythmic features, the Minuet of Forest also uses a harmonic process that is appropriate to the minuet's historical period. The Minuet of Forest is in E minor, but unexpectedly, rather than ending where we started, the piece finishes on an E major chord, in a harmonic moment known as a *tierce de Picardie*. This is a common musical device of sixteenth-century and seventeenth-century

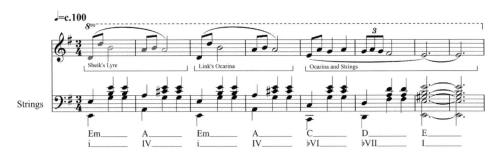

FIGURE 2.19: The accompaniment and melody parts of the Minuet of Forest showing the chord structure and regular accompaniment pattern.

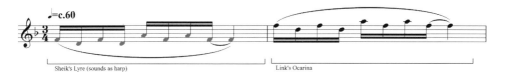

FIGURE 2.20: The mechanistic repeated figure of the Bolero of Fire (opening phrase only shown).

'baroque' classical music, where a piece written in a minor key will finish with a major chord to provide a sense of resolution.[41] Yet, as Gervais notes, the progression of arriving at the conclusion, through ♭VI, ♭VII, I, is hardly stylistically typical, instead providing an unusual way of finishing the piece.[42]

The Minuet of Forest is able to invoke the minuet primarily because of its strong rhythmic profile, appropriate tempo and metre, and the emphasis on two-bar units bolstered by the clear accompaniment pattern. Even if not every aspect of the piece's harmony is stylistically appropriate for the minuet,[43] it nevertheless invokes seventeenth-century musical practice through the *tierce de Picardie*. These musical features help to imply an older musical tradition, and perhaps even the ritual of formal dance. Yet the rhythmic topic provides an energy to the mood. It is thus perfect for the Meadow: ancient, but very much full of life.

Bolero of Fire – Motion and Passion

Like the Minuet of Forest, the Bolero of Fire also makes use of a distinct rhythmic profile from dance music (Figure 2.20). This melody allows Link to warp to the volcanic Death Mountain Crater. The Bolero of Fire maintains the moderate tempo and triple metre typical of the bolero genre. In particular, the piece mirrors the AAB format of the Spanish bolero.[44] The most characteristic aspect of the bolero dance, however, is the accompanying rhythm. The Bolero of Fire is accompanied by a snare drum (see Figure 2.21), which plays a repeated pattern. This rhythmic pattern is appropriate for the bolero, especially the contrast between the rapid repetition of the triplet rhythm and the slower quavers.

This accompaniment pattern, however, has a longer legacy. It is identical to the snare drum part in Ravel's orchestral piece *Boléro*. The piece, originally written for a 1928 ballet, features this same pattern repeated constantly by the snare drum throughout the work's *c.*10-minute duration and serves as one of its most

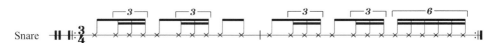

FIGURE 2.21: The snare drum accompaniment pattern for the Bolero of Fire.

distinguishing features. Though Ravel's tempo marking of mm=72 is faster than the Bolero of Fire, which is mm=c.60, the rhythmic resemblance is clear. Like many of the warp pieces, the ocarina and lyre exchange in the Bolero of Fire is accompanied with strings. The lower strings play pizzicato (plucking, rather than bowing the strings) to mark each beat of the three time rhythm, in a pattern very similar to the opening of Ravel's *Boléro*.

Ravel's *Boléro* was created with two elements at its heart: mechanistic qualities (because of its insistent repetition) and stereotypes of Spanish-Arabian romantic passion.[45] These two existing connotations of the piece are entirely concordant with *Boléro*'s use as a model for the Bolero of Fire. The video game context and the clear functionality of this melody mesh with the mechanistic association. At the same time, Sheik introduces the song to Link in rather more romantic and passionate terms. He says,

> It is something that grows over time … a true friendship. A feeling in the heart that becomes even stronger over time … The passion of friendship will soon blossom into a righteous power and through it, you will know which way to go … This song is dedicated to the power of the heart … Listen to the Bolero of Fire …

Beyond this rather allusive description and the 'flames of passion' trope, the text alludes to the developing relationship between Sheik and Link, articulated through these sequences playing duets together. This could be read as an unexpected allusion to queer romance, especially given that Sheik is presenting as male.

The Bolero of Fire is melodically distinct, built almost entirely around the central idea of two alternating notes (see Figure 2.20). This alternating figure is repeated in sequence (first rising, then descending) to create the B section. This economy of melodic material and repetition of similar figures enhances the repetitious and mechanistic quality of the song. Unlike melodies that are used in underscore, this piece will only be heard intermittently by players, and thus the danger of such repetition becoming annoying is minimal.

Ravel's *Boléro* has a particular significance for *Zelda* – *Boléro* had been programmed as the title theme for the first *Zelda* game.[46] *Boléro* seems apt for *Zelda*, especially considering the piece's associations: mechanistic repetition, implication of movement and exciting exoticism. After discovering that it was still under copyright, Kondo wrote a new piece in a very short time, which became the main title theme that came to stand as the series' signature.[47]

By using the model of the Spanish bolero, especially through the frame of Ravel's well-known ballet work, the Bolero of Fire draws on apt existing musical associations. In the Bolero and other warp melodies, by using clear models from

art music, it helps to cast the melodies as distinct pieces of music (albeit very brief ones), rather than just abstract tunes. This is significant for the warp melodies, because they do not gain the extended musical sounding and larger orchestration that is given to the assistance and plot-advancing melodies.

The Serenade of Water – Two Characters, Two Perspectives

The Serenade of Water allows Link to warp to Lake Hylia, near the entrance of the Water Temple. It is a graceful piece, in three-time at a moderate tempo (mm=*c*.90) and characterized by a lyrical rising phrase in a steady rhythm that serves as the trigger for the piece.

While the term 'serenade' is widely used in classical musical repertoire, it does not denote musical features as specifically as the bolero or minuet. Instead, it refers to a more general concept of genre or musical mood. Hubert Unverricht and Cliff Eisen explain that the term 'serenade', 'originally signified a musical greeting, usually performed out of doors in the evening, to a beloved or a person of rank'.[48] It is from this context that we receive the popular romantic image of a besotted lover, lute in hand, singing in the evening, with the aim of wooing a balcony-bound beauty. The serenade had closer associations with fun entertainment than concert works like symphonies or concerti.[49]

Serenades are particularly associated with plucked string instruments, so Sheik's lyre certainly qualifies as a serenade-appropriate instrument. Given the connotations of the genre, the Serenade of Water seems well-titled, given the piece's moderate steady tempo, song-like melody and an accompaniment pattern that is rhythmically consistent and textually clear (Figure 2.22). The use of a gentle serenade also implies a romantic colour to the musical activity, as Link and Sheik play to each other.

The Water Temple is notoriously challenging, because it requires Link to repeatedly change the water level in the dungeon, in order to facilitate access to different areas. The Serenade of Water is harmonically interesting and seems to flip between different harmonic perspectives, just like changing the water level provides different geographical perspectives in the Temple. The piece is primarily centred on D minor (though it uses B natural in the melody to give a Dorian modal inflection).

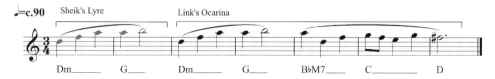

FIGURE 2.22: The Serenade of Water, showing the harmonic underpinning.

Concluding chords of 'Serenade of Water'	B♭ major 7	C major	D major
In D minor	♭VI	♭VII	I (with *tierce de Picardie*)
In F major	IV	V	VI

TABLE 2.4: Harmonic conclusion to the Serenade of Water.

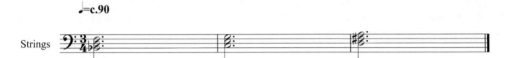

FIGURE 2.23: After Nicholas Gervais, a reduction of the chords concluding the Serenade of Water, showing the smooth stepwise movement of the notes.

However, the chords of the concluding sequence belong to two different keys at once, and so, because of the different functions of the chords within those keys, it sounds both conclusive and unresolved at once. Table 2.4 shows that the conclusion can be 'heard' as coming back home in D minor (with a *tierce de Picardie*, like the Minuet of Forest and Bolero of Fire) or awaiting resolution in F major. Gervais notes that, while the chord progression is unusual, it sounds coherent because of the voice leading – that is, the notes move by step to arrive at the final chord. Even if the overall chord sequence is unusual, this smoothness provides coherence to the conclusion.[50] The result means the ending sounds surprising, but finished, though not entirely resolved either (Figure 2.23). This is rather apt for a dungeon that can also be interpreted in two different states. The Serenade matches both the dualism of the two serenading characters, and the duality of the dungeon.

Nocturne of Shadow – Mystery and Ambiguity

In contrast with the clarity and balance of the elegant Serenade of Water, the Nocturne of Shadow is harmonically and melodically far less predictable and coherent. This warp melody gives access to the Shadow Temple. After Link and Sheik are attacked by an 'evil shadow spirit', he teaches Link the melody to provide access to the Shadow Temple in order to pursue the attacker.

As the name implies, nocturnes have traditionally been associated with night (like the serenade) and are primarily solo piano pieces. The genre came to prominence in the early nineteenth century. As Julian Rushton explains,

> The nocturne was developed from earlier pianistic idioms which crystallised in the work of the Irish composer John Field (1782–1837) [...]. The archetype [is], a languid melody, richly ornamented, over a widely spaced arpeggiated left hand [...]. The genre imposes no conditions upon tempo (usually slow), nor upon metre, and can coalesce with other genres[51]

It was in Chopin that the nocturne found its greatest advocate, and, as Rushton notes, for Chopin, 'the genre becomes more erotic than playful, and may evoke a broken heart [...] [or] broken dream'.[52] Some nocturnes 'attempt to capture the fevered visions and dreams of the night or to evoke its natural sound world in musical terms that may be very far from those of the drawing-room'.[53] Certainly, then, the nocturne is a good match for a graveyard in an apocalyptic future, where a world of shadow awaits. Sheik describes the piece by saying, 'This is the melody that will draw you into the infinite darkness that absorbs even time ... Listen to this, the Nocturne of Shadow!!' So far, so nocturnal.

Nocturnes often feature song-like vocal lines, though it is the accompaniment that is particularly telling in the nocturne style. As 'private meditations',[54] these reflective pieces often engaged in bold and unusual harmonies articulated by the accompaniment. But beyond that, the nocturne has a technological connection, related to the accompaniment, since the complex piano textures were facilitated by then-new innovations of the piano sustain pedal.[55]

The melodic line of the Nocturne of Shadow is rather angular and not particularly song-like, nor ornamented. The initial two-bar phrase is played by the lyre/harp and ocarina. The answering 'B' phrase is created by repeating the first bar of the phrase, with the melody transposed (and some subtle adjustment of the intervals). The melodic phrase is heard four times in total during the piece. The first two times are the same, but the third and fourth versions are slightly different. By adjusting the pitches, each subsequent iteration of the melody smooths out the melodic contour into more consonant intervals (Figure 2.24), while keeping the same shape, providing coherence and progression to the piece.[56]

The harmonic accompaniment consists of sustained minim chords in the strings. Apart from the final conclusion, the accompaniment chords are based on open fifths and added fourths. So, for example, the first four chords are built upon a bass pitch, upon which sounds a fifth, the octave and then an added fourth. As the bass note moves chromatically (F#, G, G#, G), the chords are created the same way in

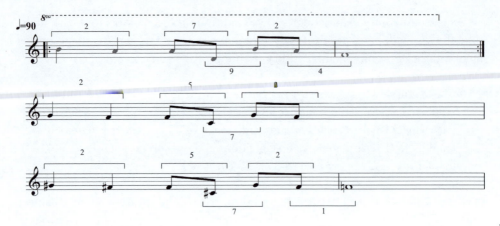

FIGURE 2.24: The melody of the Nocturne of Shadow, showing the 'smoothing' of the melody as it is repeated and altered.

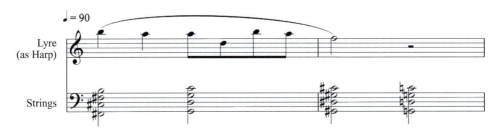

FIGURE 2.25: Nocturne of Shadow opening phrase, showing the melody and string accompaniment.

each case (Figure 2.25). This sparse open harmony is unusual both in its unclear tonality and that there is little evidence of a specific progression: it simply moves in strict parallel motion.[57] It is mysterious in its ambiguity.

The final phrase of the Nocturne adds upper strings that harmonize the melody. In doing so, the harmony is rounded out, melody and accompaniment are bound more closely together, and we achieve a coherent, secure and satisfying conclusion to the piece. Kondo here deploys the same harmonic technique used in the Serenade of Water and Minuet of Forest, where the ending can be interpreted in two keys at once, balancing resolution with inconclusiveness (Table 2.5). Jason Brame has elsewhere described Kondo's fondness for the ♭VI–♭VII–I cadence, which is sometimes known as the 'Mario cadence' because of the frequency and prominence of the cadence in music of the *Mario* series.[58] Perhaps this duality explains part of its appeal for Kondo.

The Nocturne of Shadow uses an angular melody and ambiguous harmonies to evoke the mystery and darkness of the dungeon to come. Even if we can connect the

Concluding chords of 'Nocturne of Shadow'	A major 7	B major	C# major
In C# minor	♭VI	♭VII	I (with *tierce de Picardie*)
In E major	IV	V	VI

TABLE 2.5: Harmonic conclusion to the Nocturne of Shadow.

harmonically unusual strategy of the piece with the tradition of experimental harmony and chromaticism in the history of the nocturne, the Nocturne of Shadow is far from the expected musical features of the historical nocturne, though it does evoke a mood appropriate for night-time reflection. The Nocturne sits in neat contrast with the Prelude of Light: the latter's bright, defined major harmony and mid-range strings serve as opposites to the Nocturne, which uses similar orchestration, accompaniment pattern and metre but with an awkward melody, deeper low strings and ambiguous harmony. Though the Nocturne's connection with the historical genre may be tenuous, it articulates similar associations through more general musical signifiers.

Requiem of Spirit – Religion and Spirits

The title of the Requiem of Spirit is different from the names of the other warp songs. While it undoubtedly invokes an older musical practice, the word 'requiem' refers to a very particular kind of sacred music: that used during the memorial of the dead in Catholic Christianity. Though some instrumental requiems have been written (e.g. Hans Werner Henze's Requiem, Benjamin Britten's Sinfonia da Requiem, etc.), the genre is primarily distinguished by the treatment of the set text of the requiem mass. A 'requiem' is defined primarily by its utility, and there are few specific musical features of a requiem, though we might expect some sonic connection with religious musical practice.

The Requiem of Spirit is the warp song to the Desert Colossus, which houses the Spirit Temple dungeon. While Link can access the dungeon on foot as an adult, to complete the game, he must also visit as a child. The warp song is the only way to reach the temple as a child, and so the song is necessary for completing the game. Sheik alludes to this function when he introduces the song to Link with the words:

> To restore the Desert Colossus and enter the Spirit Temple, you must travel back through time's flow … Listen to this Requiem of Spirit … This melody will lead a child back to the desert.

The main melody of the four-time, andante piece outlines a D minor triad. The piece is created from three soundings of this two-bar motif in the strings, doubled with different instruments: first with the lyre, second the ocarina and finally a glockenspiel. Unlike the AAB form of the other warp pieces, we might instead characterize this piece as an AAA' model, with the distinctly different harmonization of the motif in the final sounding.

As shown in Figure 2.26, the first two soundings of the motif use the same harmonic pattern and rhythm (the second time is slightly more explicit in the harmony because of the added strings which round out the chords). The final version, though, is set over G minor, and a suspension that resolves to D major. We again find a *tierce de Picardie* and the pattern is a IV–I cadence, providing a defined finish.

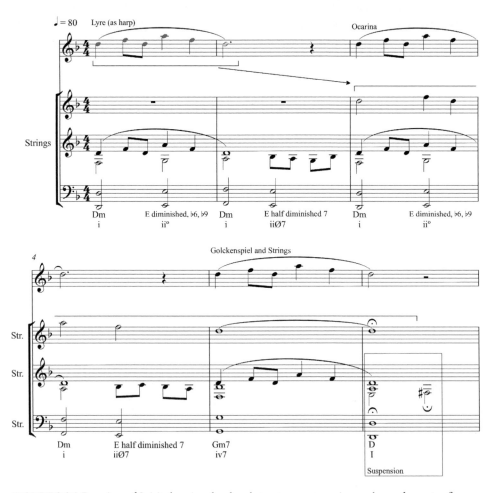

FIGURE 2.26: Requiem of Spirit showing the chord structure, suspension and use of a cantus firmus.

> ## Suspensions
>
> Sometimes, in order to create harmonic interest, a harmonic technique is used called a 'suspension'. Here, a chord is sounded that seems to have one or more clashing (dissonant) notes. Then, while the other notes are held, the dissonant notes move, normally by one step, to new pitches that fit with the chord. It is particularly common and sonically obvious in Baroque choral writing, though the technique is widespread.

Though the Requiem of Spirit does not use a religious text, it still refers to liturgical musical culture. It does so through three techniques. First, it uses a IV–I concluding plagal cadence. This is sometimes known as the 'Amen' cadence because of its popular association with the text of 'Amen' in Christian musical traditions. Second, it uses a suspension, common for such cadences in the same kind of choral music. Thirdly, the piece refers to the tradition of the cantus firmus. During the second and third statements of the main motif, the upper strings play a version of the same motif with all of the note lengths doubled and an octave higher. This has the effect of both providing a contrapuntal (interweaving) countermelody but also referring to the medieval/renaissance tradition of the cantus firmus. In this musical technique, often found in religious music, a particular pre-existing melodic fragment was used as the basis of a new composition, frequently adapted through rhythmic augmentation, extending the length of each note, like the process used here.

Even though the 'requiem' as a musical genre is stylistically unspecific, the Requiem of Spirit still succeeds in making reference to musical practices closely connected with the typical intended context of the requiem. This sits perfectly with a piece associated with religious notions of the 'Spirit'.

* * *

The warp songs sit as a distinct subset of the ocarina songs in *Ocarina of Time*. Unlike the other songs, triggering the warp melodies prompts a performance of the melody with a larger ensemble accompanying the ocarina and lyre. In all of the warp songs, after Link has triggered the melody, the first phrase of the performance is played by a lyre and only subsequently imitated by Link on the ocarina. This is curious, since, apart from when Link is initially taught the song, Sheik is not present. Perhaps, then, this is a way of reinforcing Link's relationship with Sheik, a sonic reminder of their connection, even if Sheik is absent.

The warp songs use a progressive AAB or AAA' structure, often finishing with a *tierce de Picardie* or a harmonic conclusion that balances resolution with inconclusiveness or surprise. Since the moment of transportation is both a departure and arrival, this structural approach is apt: Link's geographical journey is matched by a harmonic and structural journey. The music of the warp songs is not reused elsewhere, so the pieces must stand as complete mini-compositions in themselves. The additional orchestral accompaniment helps to achieve this, contextualizing the melody and providing it with additional connotations. Kondo's goal is not to create historically accurate pieces but instead use those musical precedents to create distinctive, contrasting pieces (perhaps aiding the memorability of the songs). Even if the musical styles are not entirely concordant with the historical models, they connect Link's music making with bona fide musical traditions, as well as introducing variety into Link's performances.

The Scarecrow's Song and Other Performances

There is one further song that features as part of Link's repertoire in the game. Unlike the other melodies in the game, this one is not predefined. It is the player's own composition.

As a child, Link may find two scarecrows, Bonooru and Pierre (Figure 2.27), basking in the temperate climate of the shores of Lake Hylia. Pierre speaks of his desire to travel the world in search of 'soul-moving sounds'. Both of these characters will respond to Link if he plays the ocarina in front of them. When Link draws out his ocarina, a stave is shown at the bottom of the screen, and, as the player performs, the matching notation appears. Both of the scarecrows dance in response to the ocarina performance.

Bonooru is famed for his musical memory. His dialogue is written to imply an almost hippie-like personality: he greets Link with 'Hey, baby!', refers to him as a 'dude' and asks him to 'lay a tune on me'. A character that finishes most of his sentences with 'baby' is rather at odds with the medieval-fantasy world of Hyrule, but it marks Bonooru as distinctly different from most of the inhabitants and shows his enthusiasm for music.

Players can compose a melody, eight notes in length, to play to Bonooru. He will remember the notes and rhythm, though the vibrato, pitch-bending and extended notes are not available. The player has to create an original melody, rather than using one of the existing songs, and Bonooru will not accept a melody that is simply the same repeated pitch. Once Link travels though time, he may return to the lake as an adult. Pierre has disappeared, but Bonooru has not moved

THE OCARINA AND LINK'S MUSICAL PERFORMANCES

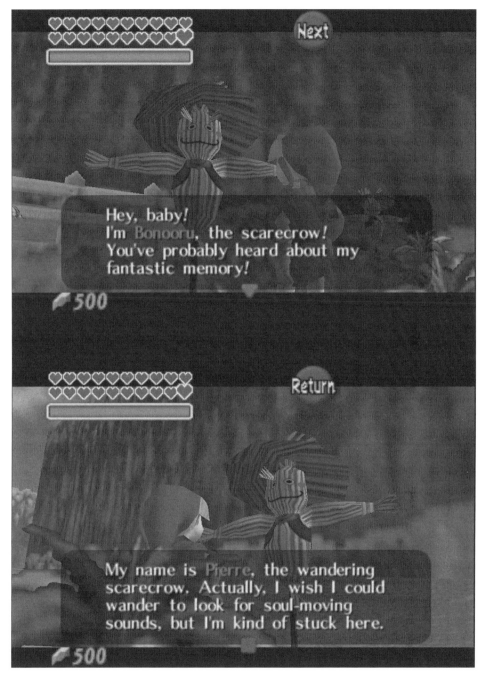

FIGURE 2.27: Pierre and Bonooru.

and asks to hear the same melody from the past. If Link obliges, the player-composed melody becomes established as the Scarecrow's Song. As a reward for playing the song, Bonooru offers Link the services of Pierre.

In the future time zone, Pierre achieved his aim of leaving the lakeside to travel the world. In certain places throughout Hyrule, Link can play the Scarecrow's Song to summon Pierre, who will appear to provide assistance by allowing Link to access otherwise difficult (or impossible) to reach areas. Unlike other melodies, the Scarecrow's Song is not listed on the menu screens. Instead, players have to remember their composition, or revisit Bonooru in the past to hear, or replace, the melody. Creating and using the Scarecrow's Song is optional to reaching the end of the game, though it is required to obtain all of the items.

Unlike the predetermined pieces in the game, the player must perform the full eight notes of the Scarecrow's Song to trigger the piece (though again, the rhythm does not need to be accurate). When the piece is activated, like the other established melodies, Link plays the piece 'automatically', keeping the timing originally performed for Bonooru when he was a child.

The Scarecrow's Song is noteworthy in *Ocarina of Time*, not because the power it grants is particularly significant, but because it invites players to become composers, with their melody fixed into the game memory: they are not just performing the preset music but are also given the ability to define a composition for themselves. During my own experience of playing the game, I remembered my own Scarecrow Song as a musical motif: even when I forgot the particular buttons required to play the piece, I was able to recall the tune and experiment with the ocarina until I recreated the song and successfully summoned Pierre.[59]

We might criticize the Scarecrow's Song for limiting the number of pitches available and the length of the melody. These restrictions are probably made for reasons of practicality in helping players to recall their melodies. In another context, those limits are relaxed.

In the past time, Link can play his ocarina to the groovy scarecrow Pierre, who has yet to depart on his travels. Again, a musical staff appears at the bottom of the screen, which displays the buttons as they are pressed by the player. Unlike performing for Bonooru, when playing for Pierre, players can use vibrato, pitch-bends and the additional pitches available through the R-shoulder and Z-trigger buttons. They are also given a significantly longer musical canvas to use – more than four times the length of the Scarecrow's Song. Pierre will remember the piece and play it back to the player, when prompted, complete with the additional pitches and expression that they used. Of course, players can perform on the ocarina without these restrictions throughout the game, but this moment is an opportunity for the players to have their music noticed, 'fixed' and recorded by the game, with more freedom than the Scarecrow's Song. Unlike the Scarecrow's Song, this performance

for Pierre does not serve any practical function in terms of the game. Other opportunities to perform for inhabitants of Hyrule do, however, provide specific rewards.

The Fabulous Five Froggish Tenors

While exploring Zora's River, which connects Hyrule Field to Zora's Domain, Link can make friends with a group of multicoloured musically minded frogs, who call themselves the Fabulous Five Froggish Tenors. In the middle of the river, there is a semi-submerged log with a tree stump that forms a small platform into the centre of the stream, which seems to invite some kind of action. If Link stands on the stump, the five frogs will jump out of the water and arrange themselves as an audience for Link's performance (Figure 2.28).

When Link plays notes on the ocarina, the frogs will croak in tune with the pitches. Each one of the five frogs corresponds to one of the main pitches on the ocarina. With every note that Link plays, one of the frogs croaks and jumps in the air. These frogs are a discerning audience. While they respond to each note that Link plays, it is only with performing one of the six non-warp ocarina songs that they will provide Link with a cash tip. For each of Epona's Song, Zelda's Lullaby, Sun's Song, the Song of Time and Saria's Song, the frogs will reward Link with currency and one of the five will grow in size. Once players witness the frogs growing in size, it becomes obvious that five tunes have to be played to the frogs, until all of them have been transformed. The aquatic animals that they are, the frogs are

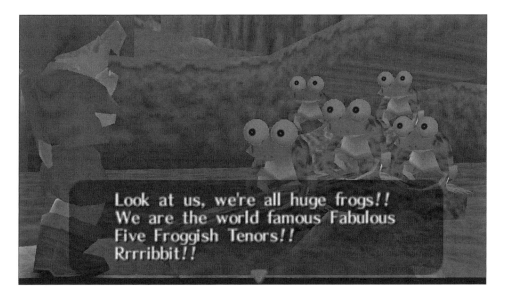

FIGURE 2.28: Link performs for the Fabulous Five Froggish Tenors.

particularly keen on the Song of Storms (the remaining non-warp song). If Link plays this song, prompting rain to fall, the frogs say,

> Wow, that melody is so cool! Ribbit! Siiiiingin' in the raaaaaain, Oh what a feeling! Rrrrrrlbbbit!! Please take this as a token of our froggish gratitude, ribbit! All right. See you, ribbit!

These Gene Kelly-loving frogs then give Link a valuable 'piece of heart'. Once all six of the non-warp songs have been performed for the frogs, a further minigame is unlocked. In order to win a further 'piece of heart', the player has to take their musical directions from the amphibian musical aficionados.

The frogs jump in response to each note that Link plays. Link's challenge is to use the ocarina to make particular frogs jump at the right moment to catch a butterfly that appears above each frog in turn. With each frog mapped to a particular ocarina note (which the player has to work out for themselves), the player has to play the note that corresponds to the appropriate frog, as indicated by the butterfly. If Link plays the wrong note, or takes too long, he has to start again. The order of the frog pattern does not change from attempt to attempt, so the player is also taught a melody in the process, especially as the tempo of performance means that the player quickly learns to memorize some of the pattern.

Playing for the Fabulous Five Froggish Tenors may not be as musically creative as the Scarecrow's Song. Nevertheless, in order to complete the second 'piece of heart', players must listen carefully to the ocarina and work out the correspondence between the pitches and the frogs. It is also another moment at which the properties of the songs and instrument are explored in terms of musical performance.

The Skull Kids

Apart from the encounter with the Fabulous Five Froggish Tenors, there is another performance sequence in the game involving NPCs. In the Lost Woods, players may encounter a formation in the environment that looks primed for some kind of action or performance (Figure 2.29).

If Link stands on the log platform, two Skull Kids materialize, flutes in hand. They challenge Link to a musical imitation game. The Kid on the left plays a three-note musical phrase in equal crotchets, while a stave at the bottom of the screen shows the ocarina notation, one note at a time. The phrase is imitated by the Kid on the right. The notation disappears and it is Link's turn. The player must remember the notes played by the other two characters. A tambourine provides a regular pulse to help Link to maintain a steady rhythm, since Link has to respond reasonably rhythmically accurately. If Link is successful, the first Kid plays again,

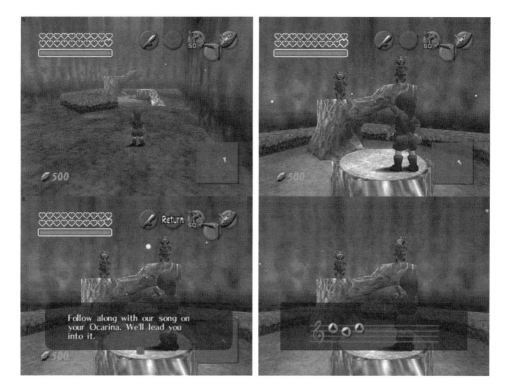

FIGURE 2.29: Link plays a music memorization game with a pair of Skull Kids.

adding an extra note to the end of the melody. This process continues until the melody is complete (initially five notes long), and Link is rewarded with in-game currency. Link can complete this whole process three times, for progressively more valuable rewards, each time, requiring a longer musical melody before the prize is won: the first melody is five notes, the second six and finally eight notes.

This is not a particularly tricky minigame and the musical memory game is nothing that has not already been seen in countless other forms. Yet, here, it is an element of a broader project, in collaboration with the other performances discussed in this chapter. It is part of the way that the game weaves music making into its playing experience, both in terms of play mechanics and as the significance of music in the fictional world. Little musical moments like these present music making as part of cultural activity in Hyrule and one in which the player can engage, sharing musical performance with the characters of the fiction. 'Real' or not, Link – and the gamer – get to play music together with the other inhabitants, making the experience all the richer.

Unsurprisingly, the ocarina is an enormously significant part of *Ocarina of Time*. In this chapter, we have explored how the instrument is represented in the game and the music it plays. To finish, we will consider the importance of the instrument, both for *Ocarina of Time* and for music in games more generally.

The ocarina is an unusual instrument but an appropriate choice for the game's purposes. The instrument has a long history and yet has associations with youth culture, all the while remaining attached to contexts of ritual and mysticism. Ocarina-like instruments are evident across the globe and so balance familiarity with unfamiliarity. The ocarina is appealing from a technical perspective because it is easier to emulate than some other instruments – it only plays one pitch at a time (monophonic) and the timbre is straightforward to replicate. The notes of Link's ocarina were chosen to provide flexibility within a limited selection, but players who experiment with the interface are rewarded with an extended range of pitches and options for expressive effects (vibrato and pitch bends). With these abilities, Link's ocarina has more musical facility than many real ocarinas.

On the ocarina, Link can play predefined songs, a piece composed by the user or he can simply improvise. His performance can be functional, to achieve a particular goal, or non-functional and performed just for the pleasure of playing.

Within Link's repertoire of songs, the warp songs are clearly distinct. These warp songs are given instrumental accompaniment, tend to use broad phrases and routinely feature striking or unusual harmonic resolutions. The other songs do not receive instrumental accompaniment when played by Link. These are constructed from the repetition of small groups of notes rather than longer phrases and are often more fragmentary. The non-warp songs are later heard as underscore cues, which helps to explain why the ocarina versions tend towards incompleteness and fragmentation.

Most of the song structures imply a sense of progression or journey, especially when harmonically unusual endings are used, or the song seems to expect continuation. The rhythmic and melodic profiles are used to portray the mood of the song, from the jolly upbeat Saria's Song to the stately Minuet of Forest, or the brooding Nocturne of Shadow. Harmonic processes often emphasize surprise resolutions or duality, which is appropriate for a game with parallel timelines, shifting perspectives and characters with multiple identities. The warp songs' references to other musical styles help to distinguish the pieces from each other, thus providing diversity across the set of songs. By situating these pieces within existing musical traditions, the game asserts that these are genuine musical compositions, not just arbitrary assortments of notes.

The game also provides other opportunities for performance, such as for the frogs and the Skull Kids. The Scarecrows are particularly notable, since they allow

the player's performance in two respects – both for functional ends (the Scarecrow's Song) and for non-functional improvisation (playing for Pierre).

Beyond the specifics of the songs and minigames, we might ask, what is the significance of the ocarina in the game? What effects does it create and what meanings does it present to players? Why did the developers even bother with such a complication?

Musical Performance in Ocarina of Time

To play *Ocarina of Time* is to play music. Glitches aside, players cannot get very far through the story without playing music, and it is certainly not possible to complete the game without performing on the ocarina. Playing the virtual ocarina is an important part of playing the game.

Because the ocarina is central to the game's story and play mechanics, *Ocarina of Time* cannot help but have an educational dimension. It teaches gamers how to play its virtual ocarina, and how to listen attentively to music.

In the course of *Ocarina of Time*, players learn how to play a musical instrument. Yes, this instrument (the ocarina) is virtual, and it is distinctly different from a normal ocarina, but it produces 'real' music. As we have seen, through the ocarina, players are taught to perform, learn the songs, listen discerningly to the performance of others and compose. They even perform with, and for, other characters. These characters may be fictional and virtual, but they still listen to, remember and respond to the player's performance and composition.

Beyond the specifics of learning the ocarina, the game sets challenges that encourage players' musical skills. It asks us to:

- listen carefully to songs and music – especially in the memory and note-matching games;
- remember pieces – players will sometimes remember a song, and sometimes consult the notation on the menu to refresh their memory;
- compose music – for the scarecrows; and
- interpret music – by matching the melodies' meanings and functions to their deployment in the world and remembering how songs functioned in previous situations.

Because the ocarina songs are presented in very functional terms in *Ocarina of Time*, the game implicitly tells players about the significance, power and diverse uses of music, both within the game and beyond. Three aspects are especially apparent: music and space/time, music and identity, and music and expression.

Though the game illustrates these aspects of music in very literal and magical ways, the same is true of music in our world, albeit in less fantastical incarnations.

The game suggests that music has the ability to affect our connection with space and time. The ocarina songs are able to change the time of day and transport Link across Hyrule. The songs are associated with places and stages of Link's journey; even beyond the warp songs, players are encouraged to look back upon their past experience to inform future uses of the songs. In our world, music can change our perception of time – that phenomenon is clear to anyone who has lost track of time while being completely absorbed in listening.[60] Music frequently prompts episodic memories of times and places from our past, often with significant (especially nostalgic) emotional responses.[61] In doing so, music links the past and present. When we hear music being performed that is associated with another time and place, it is both present in that moment but also appears as something from the past and elsewhere. Music, if only in our imagination, connects us with other places and times (even if we cannot physically transport in the way that Link can). In another sense, music mediates between the physical and abstract. In the game, musical performance prompts physical changes in Hyrule, whether through transportation of people and objects or changing the time/weather. In our world, though music is physically present as sound waves, it remains largely intangible. Yet it charts and affects our physical existence (whether through physiological effects, neurological responses or just marking our movement through the space and time of the world).[62] Music sits between the concrete and abstract in both realities.

Ocarina of Time often uses the ocarina songs in relation to identity. Saria's Song is used to identify Link as a friend of Saria, while Zelda's Lullaby serves as Link's musical 'ID' for association with the Royal Family. At the same time, both of these songs are expressive of the characters they name. Outside games, music is routinely used as part of the formation of identity, whether those are communities of taste, national identities, racial identity, sexual identity and so on. This is why music sociologist Tia DeNora refers to music as a 'technology of the self', because it is used to help us define and articulate our own identities.[63]

Musical performance in *Ocarina of Time* is shown as an expressive act. Players can compose and improvise using the ocarina, while other characters describe the ocarina's music as expressive – this is particularly notable in Sheik's comments about the warp melodies, such as his description of the Bolero of Fire quoted above. Malon also uses musical performance as an expression of her sadness and as an act of defiance against her mean boss. Though the expression of the ocarina is sometimes presented as serious and powerful, at other times, it is simply playful and frivolous. Beyond *Ocarina of Time*, personal expression is one of the main motivations for playing music. As Simon Frith notes, music serves as a way of

mediating between personal emotions and public expression.[64] *Ocarina of Time* highlights the diversity of musical modes of such expression: in the game, music is sacred, powerful and religious, but at other times, it is for entertainment, fun and dancing. Moments of musical expression are valuable in *Ocarina of Time* – other characters reward Link with prizes for playing the ocarina. Rather than competing visions of musical value – art versus entertainment, utility versus purposeless, sacred versus profane, composed versus improvisation – by rewarding all of these modes, the game illustrates that the same instrument, performer and songs can do all kinds of musical expression, and that all are valuable.

Ocarina of Time's titular instrument showcases the significance of music. Yet, for all of these conceptual claims that I have argued the game makes, it still uses simple melodies on a humble instrument. The game says that even if the songs and instruments are not complicated, the power of music still stands. And that anyone can participate – musical agency is not restricted to those with formal education, virtuosic ability or expensive instruments. With a handful of notes and a dozen tunes, a whole world of musical power awaits. Not bad for a 'fascinatin' toot', as Bing put it.

The Function of Musical Performance in Games

Clearly, integrating the ocarina into the game was a huge undertaking. What is the function and benefit of a mechanic like this for the game as a whole?

Several reasons suggest themselves:

- The ocarina provides another expressive mode for players and another dimension of play in the game.
- Performing to, and with, other characters helps to build and articulate the player's relationship with NPCs in a way that does not rely on a large amount of text.
- Devising puzzles that rely on playing the ocarina makes simple challenges more interesting.
- The ocarina and its melodies helps to make the world more culturally rich, varied and vivid for the player.
- It provides a mode of interaction with the game that is simultaneously meaningful in terms of the game's fiction (stories/worlds/characters) and gameplay mechanics/rules.
- It is a way of structuring the game that links the limits of progression with the fiction, so that the rule-based architecture seems more organic and less arbitrary. Progression based on learning the songs binds the rules and fiction

together, especially when Link has to be taught the meanings of the song in terms of the fictional world in order for him to use it.

Perhaps the most important function, though, is the way that the ocarina connects the player to the game's world and characters, helping to enrich the playing experience.

Katherine Isbister has suggested that because humans have an 'innate tendency to respond to social cues as if they were real', such 'social signals' are used by games to prompt 'strong feelings' and 'deep socially-based emotions triggered by choice and consequence'.[65] *Ocarina of Time* uses musical performance as this kind of 'social cue' – we perform with, and to, other characters, even learning and teaching songs as we engage with the social fabric of Hyrule. Playing the ocarina leverages exactly the kind of virtual social activity, and the associated emotional connection, that Isbister describes.

Stephanie Lind has used Karen Collins's exploration of 'kinesonic congruence' (the connection between the player's gestures and sound) in relation to *Ocarina of Time*.[66] She argues that *Ocarina of Time* enhances player engagement when they hear music in the game and prompt it again through physically engaging with the medium and playing the melody on the ocarina. We can widen Lind's observation even beyond this situation of hearing and repeating the music, because the sound of the ocarina is not limited to Link's universe – we can hear it too.

When the gamer plays the ocarina, it sounds both in the virtual world of the game and in our world. We hear it, just as Link does. It is a 'real' performance, even if it starts in a virtual world. Earlier, following Isabella van Elferen, we noted how video game music easily operates across different levels of diegesis. This music is able to cross the boundary between the worlds. In doing so, we are able to share listening, performing and composing music with Link and the other characters. When music crosses realities, it brings them closer together. Musicologist Ben Winters has argued the same for musical performance in film. He writes,

> When character and audience are offered the chance to share the same musical experience [...] music's power in cinema is realized (as an emotional tool that helps us engage with fictional characters). [...] It may allow us to feel what other characters feel in a way that is peculiarly affecting, leads to greater understanding of others, and is based on a shared experience of the music.[67]

In a video game, however, the interactivity adds another dimension. We play the ocarina through Link. It connects our physical movements on the controller with his physical movements. This especially true when using the extended notes: our

hands more closely imitate the position of his. The ocarina performance binds us very closely to our avatar because of the playing mechanic that produces music which crosses the threshold between worlds. We are physically, sonically, connected to Link and his world through the ocarina.

Above, I mentioned Christopher Small's notion of musicking. Examining the ocarina has shown how the game provides access to opportunities for musicking. It also highlights ways that we engage with music outside games. In *Ocarina of Time*, musicking is part of how we play the game, but, as we shall see in the next chapter, the significance of music in this game goes well beyond the titular instrument.

NOTES

1. Christopher Small, *Musicking: The Meanings of Performance and Listening* (Middletown, CT: Wesleyan University Press, 1998), p. 9.
2. Jan Bouterse, 'A Wooden Ocarina', *FoMRHI Quarterly*, 113 (2009), 19–23.
3. Ray Dessy and Lee Dessy, 'The Clay Pot That Sings', *American Recorder*, 42 (2001), 9–14 (pp. 10–11).
4. Though the particular word, 'ocarina', stems from nineteenth-century Italy, which is geographically and chronologically far from some ancient 'ocarinas', nevertheless the physical similarity of the musical instruments is clear.
5. Kin-Woon Tong, 'Shang Musical Instruments: Part Two', *Asian Music*, 15 (1983), 102–84 (pp. 153–56).
6. David Liggins, 'Ocarina', *Grove Music Online* (2001), https://doi.org/10.1093/gmo/9781561592630.article.20239.
7. John Blacking, 'Problems of Pitch, Pattern and Harmony in the Ocarina Music of the Venda', *African Music*, 2 (1959), 15–23 (pp. 15–16).
8. John Blacking, 'Towards a Theory of Musical Competence', in *Man: Anthropological Essays Presented to O. F. Raum*, ed. by E. J. de Jager (Cape Town: C. Struik, 1971), pp. 19–34 (p. 28).
9. Jared Katz, 'Digitized Maya Music: The Creation of a 3D Database of Maya Musical Artifacts', *Digital Applications in Archaeology and Cultural Heritage*, 6 (2017), 29–37. On ocarinas in pre-Columbian Honduras, see Paul F. Healy, Carrie L. Dennett, Mary Hill Harris, and Arnd Adje Both, 'A Musical Nature: Pre-Columbian Ceramic Flutes of Northeast Honduras', in *Musical Perceptions – Past and Present*, ed. by Ricardo Eichmann, Ellen Hickmann, and Lars-Christian Koch (Rahden: Verlag Marie Leidorf, 2010), pp. 189–212. See also Kristina Nielsen and Christophe Helmke, 'A Case Study of Maya Avian Ocarinas from Pook's Hill, Belize', in *Flower World – Mundo Florido, Vol 4.*, ed. by Matthias Stöckli and Mark Howell (Berlin: Ekho Verlag, 2015), pp. 79–98.
10. Dale Olsen, 'The Flutes of El Dorado: Musical Effigy Figurines', *Imago Musicae*, 3 (1987), 79–102 (p. 81).

11. Ibid., p. 102.
12. David Liggins and Christa Liggins, *The Ocarina: A Pictorial History* (Kettering: Ocarina Workshop, 2003), p. 19.
13. Ibid., p. 29.
14. See, e.g., modern ocarinas made by Sharon Rowell or Susan Rawcliffe.
15. David Liggins, 'Ocarinas: The Secret to 3D Sounds', *Music Mark*, 4 (2014), 13–15.
16. Charles Leinberger, *Ennio Morricone's The Good, the Bad and the Ugly: A Film Score Guide* (Lanham, MD: Scarecrow, 2004), p. 71.
17. Peter Edwards, 'The Music of György Ligeti and His Violin Concerto: A Study in Analysis, Reception and the Listening Experience' (Ph.D. thesis, University of Oslo, 2005), p. 55, pp. 98–99.
18. Ocarinas are also used as alternatives to conches in Penderecki's earlier *Canticum Canticorum Salomonis* (1973).
19. Renata Borowiecka, 'Via Crucis and Resurrectio by Paweł Łukaszewski: In the Circle of Christian Culture', in *Sounds, Societies, Significations*, ed. by Rima Povilionienė (Cham: Springer, 2017), pp. 97–114 (p. 109).
20. On the 3DS the button to pitch mappings are: L=D5, R=F5, Y=A5, X=B5, A=D6.
21. The swirling vortex appears for all of the non-warp songs, while warp songs gain the accompaniment from off-screen instruments.
22. Stephanie Lind, 'Active Interfaces and Thematic Events in *The Legend of Zelda: Ocarina of Time*', in *Music Video Games*, ed. by Michael Austin (New York: Bloomsbury, 2016), pp. 83–106 (pp. 88–89). Emphasis original.
23. The decision to create a theme which continues to seem unresolved may relate to the original creation of the melody, when it had to loop, and thus the point of resolution would always be delayed. Similarly, the melody is used in a looping cue for Zelda's courtyard (see Chapter 5).
24. For a summary of stereotypical gendered musical representation in film, see Janet K. Halfyard and Victoria Hancock, 'Scoring Fantasy Girls: Music and Female Agency in Indiana Jones and the Mummy Films', in *The Music of Fantasy Cinema*, ed. by Janet K. Halfyard (Sheffield: Equinox, 2014), pp. 175–192.
25. Lind, 'Active Interfaces', p. 90.
26. See, for five different variations: https://imgur.com/r/tattoos/lfw7ZEk, https://imgur.com/gallery/BsFJGtA, https://www.pinterest.co.uk/pin/374361787769660469, https://cz.pinterest.com/pin/62768988532081932/, https://www.pinterest.co.uk/pin/411727590904057849 [all accessed 20 August 2019].
27. Royal S. Brown, *Overtones and Undertones* (Berkeley: University of California Press, 1994), p. 67.
28. Ben Winters, 'The Non-Diegetic Fallacy: Film, Music, and Narrative Space', *Music and Letters*, 91 (2010), 224–44.

29. Isabella van Elferen, '¡Un Forastero! Issues of Virtuality and Diegesis in Videogame Music', *Music and the Moving Image*, 4 (2011), 30–39 (p. 35).
30. For a clear introduction to phrase structure using this terminology, see William E. Caplin, *Analyzing Classical Form* (New York: Oxford University Press, 2013), pp. 33–72.
31. Nicholas Gervais, 'Harmonic Language in *The Legend of Zelda: Ocarina of Time*', *Nota Bene: Canadian Undergraduate Journal of Musicology*, 8 (2015), 26–42.
32. Ibid., p. 29.
33. Ibid., p. 41.
34. Ibid., p. 36.
35. David Ledbetter and Howard Ferguson, 'Prelude', *Grove Music Dictionary of Music and Musicians Online* (2014 [2001]), https://doi.org/10.1093/gmo/9781561592630.article.43302.
36. Eric McKee, 'Influences of the Early Eighteenth-Century Social Minuet on the Minuets from J. S. Bach's French Suites, BWV 812–17', *Music Analysis*, 18/2 (1999), 235–60 (p. 236).
37. J. Sutton, 'The Minuet: an Elegant Phoenix', *Dance Chronicle*, 8 (1985), 119–52 (pp. 120–21).
38. McKee, 'Social Minuet', p. 236.
39. Sutton, 'The Minuet', p. 141.
40. Tilden A. Russell, 'The Unconventional Dance Minuet: Choreographies of the Menuet d'Exaudet', *Acta Musicologica*, 64 (1992), 118–38 (p. 127).
41. Julian Rushton, 'Tierce de Picardie', *Grove Music Dictionary of Music and Musicians Online* (2001), https://doi.org/10.1093/gmo/9781561592630.article.27946.
42. Gervais, 'Harmonic Language', p. 34.
43. The Minuet of Forest concludes with a VI–VII–I progression which, while common in video game music, is hardly typical of the courtly minuet.
44. Willi Katz and Israel J. Katz, 'Bolero', *Grove Music Dictionary of Music and Musicians Online* (2001), https://doi.org/10.1093/gmo/9781561592630.article.03444.
45. Deborah Mawer, *The Ballets of Maurice Ravel: Creation and Interpretation* (Aldershot: Ashgate, 2006), p. 215.
46. Akinori Sao, 'Developer Interview: The Legend of Zelda', *Nintendo.com* (c.2016), https://www.nintendo.com/nes-classic/the-legend-of-zelda-developer-interview [accessed 9 January 2019].
47. Ibid.
48. Hubert Unverricht and Cliff Eisen, 'Serenade', *Grove Music Dictionary of Music and Musicians Online* (2001), https://doi.org/10.1093/gmo/9781561592630.article.25454.
49. Giorgio Pestelli, *The Age of Mozart and Beethoven*, trans. by Eric Cross (Cambridge: Cambridge University Press, 1984), p. 150. Later, a serenade came to refer to longer instrumental works for larger ensembles with multiple movements. These serenades sit as a middle ground between small chamber music pieces and large symphonies.

50. Gervais, 'Harmonic Langauge', pp. 36–37.
51. Julian Rushton, 'Music and the Poetic', in *The Cambridge History of Nineteenth Century Music*, ed. by Jim Samson (Cambridge: Cambridge University Press, 2001), pp. 151–77 (p. 168).
52. Ibid., p. 168.
53. Maurice J. E. Brown and Kenneth L. Hamilton, 'Nocturne (i)', *Grove Music Dictionary of Music and Musicians Online* (2001), https://doi.org/10.1093/gmo/9781561592630.article.20012.
54. Charles Rosen, *The Romantic Generation* (Cambridge, MA: Harvard University Press, 1995), p. 385.
55. Nicholas Temperley, 'John Field and the First Nocturne', *Music & Letters*, 56 (1975), 335–40 (pp. 336–37); and David Rowland, 'The Nocturne: Development of a New Style', in *The Cambridge Companion to Chopin*, ed. by Jim Samson (Cambridge: Cambridge University Press, 1992), pp. 32–49 (p. 39).
56. I am grateful to Stephanie Lind for her observation of this process.
57. The melody line implies the tonality a little further (F# minor and G major in the first bar, G# major and G minor in the second), but this implication is not felt strongly.
58. Jason Brame, 'Examining Non-Linear Forms: Techniques for the Analysis of Scores Found in Video Games' (Master of Music thesis, Texas Tech University, 2009).
59. Some players report hearing their Scarecrow's Song after the end credits of the game. I have not personally been able to replicate this effect.
60. For one among many discussions of the perception of time when listening to music, see Jeff Pressing, 'Relations between Music and Scientific Properties of Time', *Contemporary Music Review*, 7 (1993), 105–22.
61. See Patrik N. Juslin, 'Seven Ways in Which the Brain Can Evoke Emotions from Sounds', in *Sound, Mind and Emotion*, ed. by Frans Mossberg (Lund: Sound Environment Centre, 2009), pp. 9–36.
62. On physiological responses, see, for one example among many, Emily Lynar, Erin Cvejic, Emery Schubert, and Ute Vollmer-Conna, 'The Joy of Heartfelt Music: An Examination of Emotional and Physiological Responses', *International Journal of Psychophysiology*, 120 (2017), 118–25. For an accessible introduction to music and the brain, see Daniel J. Levitin, *This Is Your Brain on Music* (London: Atlantic, 2006).
63. Tia DeNora, *Music in Everyday Life* (Cambridge: Cambridge University Press, 2000), p. 47.
64. Simon Frith, 'Towards an Aesthetic of Popular Music', in *Music and Society*, ed. by Susan McClary and Richard Leppert (Cambridge: Cambridge University Press, 1987), pp. 133–50 (pp. 141–43).

65. Katherine Isbister, *How Games Move Us: Emotion by Design* (Cambridge, MA: MIT Press, 2017), p. 41, p. 131, p. 10.
66. Karen Collins, *Playing With Sound* (Cambridge, MA: MIT Press, 2013), p. 35; Lind, 'Active Interfaces', pp. 99–101.
67. Ben Winters, *Music, Performance and the Realities of Film* (New York: Routledge, 2014), pp. 66, 186, 188.

3

Location Cues

Location is one of the main factors that determines how music is deployed in *Ocarina of Time*. The game takes place in the sprawling virtual world of Hyrule. Link begins his adventure in the benign Kokiri Forest, but on his quest, he will travel the length and breadth of Hyrule: he will scale the volcanic Death Mountain in the north and dive beneath the surface of Lake Hylia in the south. He will run errands in the bustling Castle Town and cross the desolate Haunted Wasteland desert. Part of what makes Hyrule so attractive is the variety of environments, all linked together as a complete and coherent universe. These geographic archetypes (lakes, deserts, forest, etc.) recur in several *Zelda* games, though the specifics of the geography are particular to each game. While moving through the world from area to area is not seamless (we see a 'fade out' as Link exits one area and a 'fade in' as he is shown entering another), a fully connected world is depicted.

Music is one of the ways that the world of Hyrule is made compelling and interesting to players. The areas of the virtual geography are all assigned particular pieces of music. Just as Link moves from place to place, so he traverses and explores the musical geography of Hyrule. While music seems to be ever-present in the world, we do not normally see the instruments that are playing the location-specific cues (unlike, for example, when Link plays the ocarina and the musical source is clearly visible). Instead, these geographically specific cues are a paradox: the music is distinctly linked to the locations within the gameworld, and yet the instruments making the music are nowhere to be seen. In some cases, we might imagine that musicians are present but out of sight: perhaps, for instance, the music in the market square is played by a busker who sits just beyond the frame of the image. For most location-specific cues, however, gamers accept that the music is part of the environment, but it does not necessarily come from a specific source. When we hear the orchestral music of Hyrule Field, we do not conceive of an orchestra following Link, apparently always close, yet always unseen. But neither do we look for a diegetic source. We accept that music is 'in the air' of the virtual world, just as we

do not question the on-screen user interface. The lack of an obvious instrumental source does not detract from the close connection of music and place.

We might be tempted to call these cues 'background' music, especially since they do not appear to have a specific visual source. But the music is mixed at such a high volume that the term 'background' does not fit comfortably. With very little recorded dialogue, the sonic output of the game is dominated by music and sound effects. Even in sequences that do not show instruments, music is a very prominent component of the audiovisual experience of the game.

Music is part of the construction of the world, an element of the way that Hyrule is made present to our senses. Rather than just an add-on or accompaniment to the visual images, music is fundamental to our perception of these worlds – a constitutional part of our understanding of the locations. Brian Massumi suggests that the 'virtual' is a dimension of reality that we cannot sense directly.[1] We are not able to engage with Link's universe in the same way as our normal reality – we cannot see, touch, smell, taste or hear the virtual world first-hand because it is not concrete like 'our' reality (it is on the 'other side' of the screen). Instead, the virtual world is projected for us using intermediate means we *can* sense (i.e. sound, image, text, and so on, depending on the media at hand). In the case of games like *Ocarina of Time*, music is one of these factors used to create the virtual world.

Music is used by games to project beyond what we see on the purely visual plane; the music rounds out our perceptual understanding of the virtual locations, evoking the world beyond the restricted areas and graphical limitations. In *Ocarina of Time*, music helps us to understand the areas of the world: the serene waterworld of Zora's Domain would be less tranquil without its background cue, the ranch less wistful without its folksy bittersweet cue, the dungeons less gloomy without their brooding growling music and so on.

The location cues often use musical timbres that connote particular locations, drawn from real-world musical practice (and/or established tropes and stereotypes). The Zora waterworld, for example, uses the steel drum, which is apt given the instrument's development in the island nations of Trinidad and Tobago, while the Forest Temple uses approximations of angklungs: tuned bamboo percussion instruments typically associated with Java. Beyond these kinds of geographic associations, the cues also guide how we should react to the areas: music tells me that I can relax in Kakariko Village but that I should be on my guard in the dangerous Fire Temple. The score bolsters my sense of adventure when confronted with the wide-open terrain of Hyrule Field. Music uses sonic signs in the depiction of these places in terms of communicating information, but it also helps to prompt an emotional response.

The musical contrasts between locations helps to accentuate the diversity of the fictional world of Hyrule, even though the underlying technical construction of the

world is similar throughout. More specifically, musical difference is mapped on to geographic distance. When moving from one area to another, if the background geographic cue changes, it accentuates the impression of moving into a distinctly different area: for example, Kokiri Forest and the Lost Woods are visually similar and border each other. Walking into the Lost Woods from the Forest, however, prompts a musical contrast as the Forest cue fades out and the distinctly different Woods music begins to sound. This musical change enhances the impression of these locations as having different qualities and features, even if the visual contrast is not particularly striking. The opposite also holds true: when Link moves through areas of Kokiri Forest where the music does not change, this implies the geographic similarity and connectedness of the areas, because a musical boundary has not been crossed. Elizabeth Medina-Gray has written about the same process of musical change to mark geographic borders in another *Zelda* game, *The Wind Waker*. She describes the experience of sailing across the sea and encountering an island:

> [Musical] disjunction distinguishes between the two neighboring pieces of music and therefore their associated environments. Indeed, [in *Wind Waker*] this musical disjunction is the only indication that the player has moved from one area of the game to another, since *Wind Waker* provides no other cues (visual, aural, or tactile) to mark the boundary between island and open ocean. The music is here entirely in charge of creating this boundary (a boundary which occurs, indeed, in the water surrounding the island). In short, it is the music that most clearly defines this part of the game's virtual landscape for the player.[2]

Similarly, in *Ocarina of Time*, music is used to articulate the geography of the world by using musical contrast and consistency to demarcate borders and emphasize connectedness. Exploration is encouraged in the game, and when discovering new areas, players are rewarded with a new location cue. As the game progresses, and access to new locations becomes possible, the new music is part of the developing aesthetic experience of the game.

The central time-hopping mechanic of *Ocarina of Time* means that Link revisits the same locations in different time zones. In general, the same location cues are retained across the two time periods. This helps to imply that the world is consistent, that past and future are connected, and that changes in the former may affect the latter.

The decision to use location-based music is influenced partly by the precedent set by earlier *Zelda* games, and those of similar or related interactive genres, such as *Ultima III* (1983) and the *Dragon Quest* (1986–) and *Final Fantasy* (1987–) series. That history recognized, however, the practice would not have been maintained

simply for the sake of tradition. Location-based cues remain an important factor in creating a compelling gameworld for players. They do not function just as musical signposts but also mediate the player's relationship with the world, whether that be geographic, ludic or aesthetic.

This chapter is in five parts. It first examines Hyrule Field, which serves as the main overworld theme for the game, before discussing location cues that borrow the melodies of ocarina songs. The third and fourth section discuss particular dungeons and towns, before the last section considers cues that recur across Hyrule for particular types of places.

Hyrule Field: A Familiar Tune

When investigating the relationship between music and location, a useful place to start is with one of the most frequently heard cues of the game. Geographically, the Kingdom of Hyrule is arranged so that the contrasting environments branch off the central hub of Hyrule Field. From the field, we can head to the mountains to the north, the lake to the south, desert to the west and forest to the east. There are further shortcuts, sub-areas, dungeons and so on, but the overall pattern of the world puts Hyrule Field as the central node (Figure 3.1). The design means that moving from one part of the world to another is quicker and less tedious than a linear arrangement, but it also causes the player to spend a lot of time on the field over the course of the game.

Hyrule Field has continuous music during the day, but not during the night, though the game's standard battle cue sounds in the night, if Link is attacked (see Chapter 5). The player will visit the field frequently and often for a considerable duration at a time, especially in the 'past', when they do not have access to the horse to reduce travel time across the field. The Hyrule Field music extends across much of the game's virtual space. It reaches north to Zora's River and south to Lake Hylia (though it stops short here in the past time zone). It also recurs for other areas of the world, often for areas between distinct destinations, such as

- Death Mountain Trail between Kakariko Village and Death Mountain Crater;
- Hyrule Castle approach between the Market and the Castle Courtyard (past time zone only); and
- Zora's Fountain and Zora's River.

Gamers will find themselves listening to this environmental music regularly and extensively.

THE LEGEND OF ZELDA

FIGURE 3.1: Hyrule Field, showing Hyrule Castle to the left of the image, and Death Mountain to the right.

With this player experience in mind, the composer and programmers devised a way to combat boredom and musical fatigue. Dungeon cues (of which more later) tend to use sparse and fragmented soundscapes to avoid the risk of annoyance when the cue is likely to be heard for an extended duration. However, the same approach would not be well matched to the sunny and relatively safe Hyrule Field.

Tags

Game music cues are often designed to respond to the action of the game. One approach to creating such music is to write cues that are made up of chunks or separate elements, so that musical sections can be triggered and silenced as needed, rather than simply having one inflexible stretch of music. These components of cues are often known as 'stems' or 'tags'. Together they comprise the whole 'cue'.

LOCATION CUES

The environmental cue for Hyrule Field is far longer than most location cues, but it is also segmented into different passages (tags) that are heard in an indeterminate order. While the cue sounds as a continuous musical fabric, without breaks from sunrise to sunset, it is assembled on the fly by the music system, which orders the tags. As Karen Collins notes,

> Since the player must spend a considerable amount of time running across Hyrule field to gain access to other important gameplay areas, and a standard repeated loop would become too repetitive, a series of cues [tags] are selected based on a random-number generator to maintain interest and diversity. Every time the game is played, the song played during the Hyrule field parts of gameplay plays back differently.[3]

While, as Collins notes, the specific order of tags is indeterminate, there are different factors that affect the game's selection of tags in any one situation. Table 3.1 details the tags that make up the Hyrule Field cue. After playing one of two possible opening tags, the cue selects tags from one of three banks of variations. If Link is moving, perhaps running across the field or riding Epona, but not under threat, the 'Day Variations' play. If Link is near an enemy, the 'Battle Variations' play, and if Link is both unthreatened and standing still, the 'Reflective Variations' sound.

	Tag	Duration
Introduction	Sunrise and Day Variation 1	15 bars: Introduction 7 bars at mm=100; Main section: 8 bars at mm=150
	Entering the Field and Day Variation 1	1 crotchet upbeat; 8 bars at mm=150 (identical to second part of Sunrise tag)
Safe, Link moving	Day Variations 2–12	8 bars at mm=150
Link near enemy	Battle Variations 1–5	8 bars at mm=150
Link not moving	Reflective Variations 1–4	8 bars at mm=138

TABLE 3.1: Tags of the Hyrule Field cue.

There are several compositional challenges that come with the creation of a modular music system such as the one used for Hyrule Field.[4] One of the key factors concerns the granularity of the system – how long each tag should be and how it should relate to the others. In Hyrule Field, each of the tags is eight bars long in 4/4, at either 150 or 138 beats per minute (giving each tag the duration of 12.8 or 14 seconds), and only one tag is ever playing at any one time.

This kind of design is sometimes referred to as 'horizontal resequencing',[5] since the randomization and game parameters alter the order in which the episodes of music are heard. In the horizontal resequencing model, the smaller each individual segment, the higher granularity of the system. With shorter tags, the musical reaction to in-game events is quicker, because there is less time until a new tag can begin to sound.

Here, Kondo has chosen the length of the tags as a compromise between delaying the change to a new tag, and yet each tag being long enough to permit a substantial musical statement. Each tag is a variation, balancing consistency with novelty: a new thematic fragmentation, a new accompaniment pattern or new harmonic approach. Yet, the cue as a whole maintains a sense of cohesion by using some musical elements repeatedly across variations, such as the accompaniment in Figure 3.2 which sounds throughout all of the 'Day' tags. Kondo's design of eight-bar segments provide space to articulate these variations while still providing timely musical response to the game action. The cue is also unified by the recurring references to a particularly significant piece of pre-existing music.

A Familiar Tune

The Hyrule Field cue features variations on a theme central to the *Zelda* series. As described earlier, Kondo wrote a distinctive cue for the first *Legend of Zelda* game. In the 1986 game, this theme (melody shown in Figure 3.3) is heard as part of the game's introduction and reprised when Link is roaming the main landscape (so-called overworld) of the game. The theme is also used, in whole or in part, in the overworld themes for *A Link to the Past*, *Link's Awakening*, *Majora's Mask*, *A Link Between Worlds* and *Oracle of Seasons/Ages*. Even games that do not directly use the theme often allude to it in some way. This piece is an important part of the *Zelda* franchise identity. Games that take place in Hyrule, which was the setting for the first game, are particularly likely to use the theme. Here we shall call this the 'Zelda theme', because of its centrality to the franchise, though it might more properly be called the 'overworld' theme, given that it is so frequently used for this purpose.

Jason Brame has examined the development and use of the 'Zelda theme' across several *Zelda* games. Brame identifies several characteristic features of the

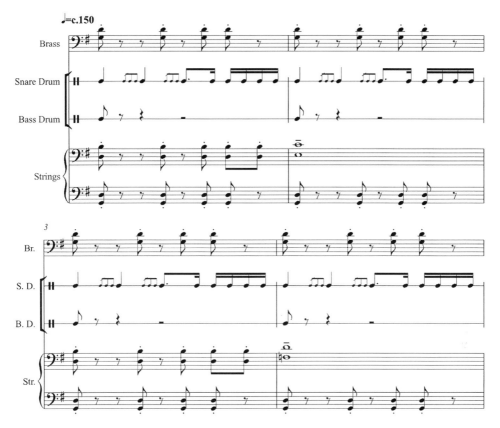

FIGURE 3.2: The characteristic accompaniment for Hyrule Field, showing the rhythmic interplay between parts.

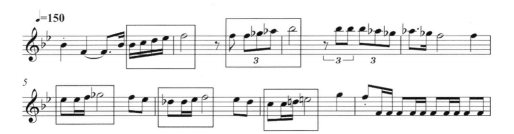

FIGURE 3.3: The 'Legend of Zelda' theme, showing the location of characteristic figures.

FIGURE 3.4: Brame's characteristic figures from the 'Legend of Zelda' theme.

FIGURE 3.5: Brass melody in Day Variation 2, alluding to the 'Zelda theme'.

theme which are used to allude to the music without directly quoting it. These elements (Figure 3.4) are fragmented and recur, often with some form of development, across different entries in the *Zelda* series.[6] He also emphasizes the harmonic qualities of the melody, noting that 'Kondo frequently switches between the two modes of the key, freely using the major third while using a minor sixth and seventh scale degree'.[7] Indeed, the elements that Brame identifies can be understood as fragments of the same ascending scale which alters the major scale by flattening the sixth and seventh degrees (producing a scale sometimes known as the 'Mixolydian flat-six', or more informally but more tellingly, the 'major-minor scale').

Ocarina of Time does not include a direct statement of the 'Zelda theme', but Hyrule Field provides variations on the material, by using tonal allusions, similar melodic outlines and micro-quotations. Hyrule Field is the perfect place to deploy such musical connections: the 'Zelda theme' was first sounded in the fictional same location, serving the same game function, albeit some twelve years prior.

Brame comments that the Hyrule Field cue, centred on G major, makes frequent use of the pitch of F natural, in keeping with the unusual modality of the original theme. Especially in the 'safe' cues, Kondo often uses the F natural to add a modal (Mixolydian) inflection, much like the modal tonalities we have already noted elsewhere in the game.

Beyond a similar use of a modal tonality, Kondo also uses melodies that have a similar outline to that of the well-known 'Zelda theme'. For example, the brass melody in Day 2 (Figure 3.5) 'starts with the descent of a fourth from tonic to dominant, then back. Through an octave displacement of the tonic, and some passing motion, we arrive back at the dominant.'[8] The first battle variation also uses a similar technique, using rhythmic features and melodic shapes from the original in different combinations (Figure 3.6). Indeed, tags that start with a descending fourth typically accent these notes to help imply a connection to the 'Zelda theme'.

FIGURE 3.6: String melody in Day Variation 6, Battle Variation 1 (and similar melody used in Reflective Variation 4), alluding to the 'Zelda theme'.

The result is a melodic outline that is reminiscent of the 'Zelda theme' without actually quoting it.

The small motifs that Brame identifies are used in the Hyrule Field to provide a sonic connection to earlier *Zelda* games but primarily avoid direct quotation. The whole cue is suffused with a generalized stylistic aptness though the use of the micro motifs (Table 3.2). Kondo may be making such compositional choices deliberately, or he might simply be writing music that he thinks is 'Zelda-like' in style, which manifests as these motivic echoes.

Part of Nintendo's success has come from careful cultivation of players' affection for, and loyalty to, particular long-running franchises. It is unsurprising that games like *Zelda* make reference to their own histories, rewarding long-time players and leveraging the nostalgic power these franchises hold. Music is one of the ways that a game connects with its predecessor (and successor) titles. But why did Kondo choose to create allusions to his 'Zelda theme', rather than stating the material directly? Certainly there seems no technological reason why this piece could not have been used (*Majora's Mask* would use the theme for that game's equivalent of Hyrule Field). One review of *Ocarina of Time* published when the game was released even expressed surprise and disappointment that the 'Zelda theme' was not included in an explicit way.[9]

Several reasons present themselves. Even though *Ocarina of Time* is set in (apparently) the same Hyrule as previous games, and features Zelda and Link, the characters and world are visually and geographically different. Each time a *Zelda* game is created, the familiar characters and places are differently formed. This is particularly striking when art styles change radically between prequel and sequel. The *Legend of Zelda* series has always had a flexible and ill-defined chronology; any attempts to fit the games into a coherent timeline have resulted in explanations involving multiple timelines and reincarnation. In *Ocarina of Time*, we have a world and set of characters that are familiar, yet distinctly new. Just as characters are reincarnated in different guises, we find a similar process here: the treatment of the theme reflects the 'new' but 'familiar' relationship of the game with its series siblings.

Ocarina of Time was the first Zelda game created in 3D and had a significant emphasis on new technology and the promise of a constitutionally different kind of

Brame's Motivic Elements

Tags	a)	b)	c)
Sunrise	As part of flute introduction		
Day 2	bb.3–4; bb.7–8, rising scale sequence in strings		bb.3,4 in brass bb.6,7 rhythm only in brass
Day 4	bb.1,3,5,7 in clarinet – pitches altered but rhythm and gesture similar		
Day 6	b.1 Strings		bb.2,4 in strings in inversion
Day 7	bb.2,4 part of piccolo ornamentation		
Day 8	bb.2,4 part of piccolo ornamentation		bb.1,3,5,7 rhythm in strings
Reflective 1	bb.2,4 part of piccolo ornamentation		
Reflective 3		bb.6–7 rhythmically augmented in strings	

Reflective 4	b.1 strings	bb.2,4 rhythm in strings
Battle 1	b.1 strings	b.2 rhythm in strings
Battle 3		bb.1,2,3 used as basis of sequence across brass in imitation
Battle 4	b.5 brass	bb.2–3 brass: triplet and minim rhythm in constant pitch
Battle 5		bb.3–4, 6–7 brass: triplet and minim rhythm in constant pitch

TABLE 3.2: Allusions to the 'Zelda theme' in Hyrule Field.

Zelda experience. Perhaps this impulse for newness and innovation also extended to the drive for new music, rather than simple repetition of the existing theme.

More practically, Kondo may have avoided a strict quotation of the theme precisely because it is already familiar and known to players. As noted earlier, the player will spend a lot of time on Hyrule Field. Even with a relatively lengthy musical cue, the same music will be heard repeatedly by the player. An ear-catching and distinct melody runs the risk of prompting players to recognize the repetition and modularity of the musical cue, perhaps inducing listener fatigue. As game composer Winifred Phillips writes, 'Repetition fatigue occurs when a memorable or recognizable melody ceases to be entertaining and becomes an annoyance.'[10] She warns that, when creating a looped piece (which she characterizes as walking in circles),

> Melodic recurrences that are too similar to the original statement only compound the sensation of repetition we [the composers] have been trying to avoid. A distinctly recognizable 'chorus' [or other part of a cue] that returns in its original state also has the potential to become an attention-grabbing landmark along the curving path, further drawing notice to the fact that the walk is proceeding in circles.[11]

Certainly a theme as well-known as the 'Zelda theme' has the potential to be an 'attention-grabbing landmark'. The integration of the theme into fragmented and varied material is a way to avoid this risk while still incorporating musical material that sounds apt for the series' musical history. Kondo's approach, then, is likely informed by both technical and practical considerations and textual/aesthetic concerns.

Introduction

The music on Hyrule Field may start in one of two ways (Table 3.3). If Link is standing on the field when the sun rises, the 'sunrise' introduction is heard. This tag plays whether the sunrise occurs as part of the general progression of time in the game or prompted by the Sun's Song on the ocarina. In this tag, the cue begins with the Sun's Song played by a solo piccolo. This melody is followed by a series of rapid rising scales decorated with trills and repeated notes, evoking birdsong, and accompanied by strings and a horn. The ensemble lands on a held D7 chord, acting as chord V when the main section of the cue begins in G major, with the characteristic accompaniment of the Hyrule Field cue. If, however, Link enters the field while the sun is already shining, the cue simply uses a one beat to begin. Here, instruments play a scale so that they land on the notes for a G major chord.

LOCATION CUES

Tag	Duration	Melodic/Thematic	Harmonic	Accompaniment
Sunrise	Introduction: 7 bars at mm=100 Main section: 8 bars at mm=150	Introduction variation on 'Sun's Song' melody. Main section: ornamented descending figure played in thirds in woodwind:	Introduction: implies D minor, then moves to G before landing on a held D7 Main section: Alternates tonic (G) and subdominant (C). Ends with F major 7 and E♭ major 7 to propel into next tag	Introduction: Sustained horn and strings Main section: as Figure 3.2
Entering the field	1 crotchet upbeat; 8 bars at mm=150 (duplicates 'Sunrise' main section)	As 'Sunrise' main section	As 'Sunrise' main section	As Figure 3.2

TABLE 3.3: Opening tags of the Hyrule Field cue. These effectively serve as the first variation of the 'Day' material, since they are only heard during daytime.

After this opening flourish, the 'Sunrise' and 'Entering the Field' tags are identical and introduce the defining musical elements of the overall cue: a sprightly four-time tempo (mm=150) with a distinct snare drum rhythm and string accompaniment pattern (Figure 3.2). This propulsive rhythmic profile is apt for a providing a sense of motion and drive, especially when crossing the field has the potential to become tedious. The snare rhythm calls to mind military drum patterns but also seems to approximate a galloping rhythm (all the more fitting when Link is crossing the field on his horse).

Day Tags

Most of the time on Hyrule Field, Link will be moving but not under attack. The player will then hear music from the 'day' set of tags (Table 3.4). There are long sequences which involve crossing Hyrule Field on foot, and little else happening; enemies are sparse and can often be simply outrun by Link, while any plot development must wait until Link reaches his destination. Unsurprisingly, then, this game state has the largest number of tags with the greatest variety, so as to avoid listener fatigue from repetition. These sequences seem to bring the music into the forefront of the player's attention: gamers drive Link forward and listen to the music while the landscape unfolds around them. The energetic music also seems to provide a sense of motion and action for sequences which might otherwise easily become tedious and boring.

All of the day tags use the snare and bass drum rhythms established in the opening of the cue. These provide a constant sense of marked motion to the cue. Most use the accompaniment pattern shown in Figure 3.2, and sometimes, the lower strings also play fast repeated notes in a rhythm similar to the snare drum, further adding to the musical motion. Even if Link is not running very quickly, the rhythm of the cues help to connote movement.

The day tags are often characterized by brass fanfare-like melodies that invoke a heroic topic. Such melodic lines tend to be wide ranging and leaping in gesture, again giving a sense of movement. As mentioned earlier, the general musical style of the game often draws on Hollywood film music, and this is particularly clear in the orchestral cues like Hyrule Field that allude to the fanfares and rhythmically intricate music of Korngold's action music from the 1930s and 1940s.[12] When Link runs onto Hyrule Field, adventure awaits him – the music both responds to his movement and propels him onward, asserting that there are new quests to fulfil and new enemies to conquer in this world of exciting possibility.

The day tags are centred on G major, often, as noted above, using F natural. In any modular system, the start and end of tags are particularly important, so that they provide musical continuity between tags. Most of the day tags begin

Tag	Melodic/Thematic	Harmonic	Accompaniment
Var. 2	Two statements of a brass fanfare evoking 'Zelda theme':	Alternates G major (I), F major (♭VII) every bar	Snare drum, bass drum and lower strings as Figure 3.2
Var. 3	Two statements of a brass fanfare evoking 'Zelda theme':	As Var. 2	As Var. 2, plus lower strings with snare part
Var. 4	Four slightly varied statements of a phrase by clarinet and strings:	Initially alternates G major (I), F major (♭VII), then chromatic sequence E♭, D minor, D♭, finishing on D major (V)	As Var. 3, plus brass doubling string rhythms from Figure 3.2 and sustained brass chords

(continued)

Tag	Melodic/Thematic	Harmonic	Accompaniment
Var. 5	bb.1–4, legato wave-shaped arpeggiated figure in strings: bb.5–8, pizzicato syncopated upper strings:	Initially alternates G major (I) and C major (IV), then circle of fifths of B, E minor, A minor, finishing on D major (V)	As Var. 2, plus sustained horns
Var. 6	Variation of 'Zelda theme':	'Zelda theme' reharmonized. Ends on D major (V)	As Var. 5
Var. 7	Brass motif, subsequently fragmented into a sequence:	Alternates C major (IV) and D major (V). Ends with E minor (vi), C (IV), D (V)	As Var. 2, plus rapid repeated pitches in trumpets, doubled by percussion

Var. 8	String melody in thirds, based on Var. 6: [musical notation]	As Var. 7	Snare, bass drum and lower strings as Figure 3.2
Var. 9	Fanfare figure, initially in brass, then strings and woodwind: [musical notation]	As Var. 2	As Var. 2.
Var. 10	Rapid-fire rising sequence in brass: [musical notation] Concludes with fragment of Day Var. 2's variation of 'Zelda theme'.	Chord progression outlines a G diminished 7 chord: G, B♭, D♭, F, G. Finishes on F (♭VII)	As Var. 3
Var. 11	Rapid-fire rising sequence in brass: [musical notation] Concludes with fragment of Day Var. 2's variation of 'Zelda theme'.	Chord changes every two bars: A♭ (♭ii), C (IV), F (♭VII), G (I)	As Var. 2
Var. 12	As 'Sunrise' main section.	As 'Sunrise' main section	

TABLE 3.4: The 'Day' tags of the Hyrule Field cue.

harmonically on G major[13] and finish mostly on F major or D major. When landing on D, as the dominant (fifth) of G, the tag forms a V–I cadence with the start of the next tag. When landing on F, the tag forms a ♭VII–I cadence, a modal inflected resolution common in pop.[14] Sometimes this is approached by a longer harmonic sequence (as in day tags 5, 6 and 7), but in each case, the aim is to link up the beginning of one tag with the start of another, so that it helps to create the ongoing musical fabric of Hyrule Field. By overlaying the harmonic arrival with the start of a new melodic variation, the tags are interwoven to provide the sense of a continuing piece of music, disguising its atomized creation.

The set of day tags, taken as a whole, provide greater musical variety than the reflective or battle tags. Even if the accompaniment may be similar throughout the set, there is a diversity of melodic materials (sometimes very close to the 'Zelda theme', sometimes with little resemblance), featured solo instruments (strings, brass, woodwind) and harmonic movement (from alternating between two chords to more adventurous chromatic progressions). Throughout the whole cue, Kondo balances variety and consistency to avoid either incoherence or monotony.

Reflective Tags

Link may not always be in motion on the field. Players may be waiting until night time, planning their course of action, puzzling over a problem, getting their bearings on the field or even just admiring the landscape around them. When Link is not moving, a different set of tags plays (Table 3.5). The most obvious points of contrast between these tags and others of the cue are rhythmic and timbral.

One of the advantages of a sequential approach for ordering the cues is that they do not have to synchronize with any other music that may be playing simultaneously. So long as the end of the cue prepares the next segment appropriately, each cue can chart its own rhythmic and harmonic journey. This allows Kondo to use a slightly slower tempo for the 'reflective' tags (mm=138), and he is not confined to the same harmonic progression for each eight-bar tag.

When Link stops moving, the music responds to his action by adopting a more leisurely tempo. The percussion section stops playing and the characteristic string rhythm from Figure 3.2 evaporates. The omnipresent galloping rhythm from Figure 3.2 is replaced by a new pattern: throughout these tags, a harp plays a triplet-crotchet rising arpeggio to form an accompaniment. Certainly, this rhythm conveys motion, but not with the same insistence as the other tags. Dotted rhythms are absent from all parts in these tags, and instead the sense of motion is provided by the steadier triplet rhythms. While the cue still has a sense of movement, the lack of the percussive attack of the snare drum and the drive of the strings diminishes any sense of urgency. If the players wish to stop and take in the panorama

Tag	Melodic/Thematic	Harmonic	Accompaniment
Var. 1	'Zelda theme' variation, as Day Var. 7, in woodwind and strings but ends with descending gesture	G major, starts on C (IV), ends on D7 (V7)	No percussion. Harp accompaniment in consistent rhythmic pattern, always as rising gesture:
Var. 2	'Zelda theme' rhythmically augmented in strings and woodwind:	G major, starts on G (I), ends on D7 (V7)	
Var. 3	'Zelda theme' variation, contour 'flattened' with smaller intervals, in portamento strings sliding between notes:	G major, starts on C (IV), ends on D7 (V7)	
Var. 4	'Zelda theme' variation, as Day Var. 6, in strings	G major, starts on G (I), ends on D7 (V7)	

TABLE 3.5: Reflective tags of the Hyrule Field cue.

of Hyrule Field, the music does not seem in a hurry to move them on. The relaxed tempo and less abrasive timbres invite reflection before the adventure continues.

The reflective tags bring woodwind and strings to the fore. Brass is only present in the form of horns playing sustained chords to support the harmony. The long, legato melodic lines are played by double reeds (variation 1), pan flute (variation 2), and violin (variations 3 and 4), which contrast with the brassy timbres often highlighted in the tags for active states. These cues all clearly refer to the 'Zelda theme' (Figure 3.7). Here, however, the fanfare-like topic and vaulting phrase is defused. The original theme (Figure 3.4) featured a descending, then rising, fourth, followed by a scale up to a fifth above the original note, before rising further to end up an octave above the first pitch. All of the reflective tags replicate some of this contour, though choose different points to halt the rise. Reflective tags 1, 3 and 4 all copy the descending, then rising, fourth of the original theme, while tag 2 keeps the same contour as the original but reduces the interval to a minor third. These changes allude to the theme but temper the exuberance of the original, perfectly apt when Link has stopped moving.

Harmonically, harsh dissonance is avoided in the reflective tags and they maintain a tonal centre of G major. All of the reflective cues finish on D or D7 (the dominant of G), so they end ready to begin another tag by cadencing back to G, like many of the day tags. Two of the tags begin on G, while two start on C (as the fourth chord of G major). When the D moves to G, it sounds as a moment of

FIGURE 3.7: Each of the reflective tags alludes to the 'Zelda theme'.

arrival (perfect cadence, V–I); when the D moves to C (V–IV), it delays the sense of conclusion, setting off another harmonic progression. Even though the tags are in G, they avoid using the G major chord: it is not heard in two of the four tags, and in the other two, it is heard only once in root position, at the very start of the tag. This avoidance of the tonic results in a subtle feeling of perpetual motion: not aimless but continually roaming.

Battle Tags

When Link is near enemies, the 'battle' tags are cued to play. These tags obviously musically contrast with both the 'day' and 'reflective' tags, so players are far more likely to notice the relationship between musical change and the game action.

The battle tags (Table 3.6) are striking. They introduce dissonant and ear-catching musical elements to a musical cue that has remained otherwise consonant and harmonious. Variation 1 is always the first battle tag to play. Because this tag begins like Day Variation 6, only to be interrupted by dissonant brass, it serves as a link between the day and battle tags. Most of the battle tags are created from small musical fragments that are repeated and imitated across the ensemble. These include the insistent 'alarm' rising string scales in battle tags 4 and 5 or the dissonant intervals in tag 2. A new accompaniment pattern features in battle tags (apart from tag 1), which further distinguishes these cues from the other sets, as does the introduction of percussion instruments other than the snare and bass drum – the set of toms that play a quick descending figure and serves as a classic Hollywood signifier of danger.

These battle tags tend to prioritize brass instruments, either holding dissonant pitches or playing repeated fanfare figures at cross rhythms with the accompaniment. The repetition of the fanfare figures and the new accompaniment section all add up to a rhythmically dense texture, the opposite of the less rhythmically marked change for the reflective tags. Variations 1, 3 and 4 contain musical allusions to the 'Zelda theme', which helps to provide a sense of continuity, despite the dramatically different affect.

The battle tags, with their cross rhythms, dissonance, extreme pitches and ear-catching gestures, contrast with the 'day' and 'reflective' tags and serve as neat musical signifiers for the presence of danger. Cinema, television and other games have taught players to recognize these musical properties as associated with danger, and *Ocarina of Time* itself serves as another chain in that re-inscription of musical-cultural meanings.

Five tags are used for battle to ensure variety. These aurally striking battle tags can afford to be more musically ear-catching than others of the set. They are less likely to be heard for extended periods – Link will likely quickly defeat or run

THE LEGEND OF ZELDA

Tag	Melodic/Thematic	Harmonic	Accompaniment
Var. 1	As Day Var. 6 but interrupted (b.4) by staccato repeated brass chords. Later echoed by oboe, horn and clarinet in turn:	As Day Var. 6, but interruption introduces dissonant element	As Day Var. 2, plus tom drums
Var. 2	bb.1–4, overlapping brass parts playing dissonant two-note descending figures at varying intervals bb.5–8, dominant seventh chords exchanged across woodwind and brass:	G open fifth throughout	Percussion and lower strings: non-syncopated, rapid straight rhythms
Var. 3	bb.1–4, sequential imitative figures across brass: bb.4–8, arpeggio in marimba and tuba:	Open fifths. Initially on G, then transposes to match the starting pitch of arpeggio in bb.4–8	As Battle Var. 2

Var. 4	bb.1–4 three brass parts enter in sequence, playing repeated notes in triplets and building up a chord: b.5 opening phrase of 'Zelda theme' in brass; bb.6–8 ornamented figure imitated across other parts:	Opening fifth on G, switching briefly to open fifth on G# at the start of every other bar	As Battle Var. 2 Five-note crushed scale sounds every second and fourth beat in upper strings and harp
Var. 5	As Battle Var. 4 bb.1–4 but repeated	As Battle Var. 4	As Battle Var. 4

TABLE 3.6: Battle tags of the Hyrule Field cue.

away from the enemy. In addition, the lack of subtlety is part of the tags' purpose: alerting players to the danger.

The battle tags may sound even before the player realizes that Link is threatened, so the tags can warn players to watch out for danger. Even if I have yet to notice the enemy, music warns me that danger is close at hand. When I am in combat, the music sympathetically responds to the chaotic danger and Link's frantic slashing at the monsters.

Because the Hyrule Field cue can only change tags at the end of each eight-bar unit, the music does not react immediately to game action and often lags behind the action: battle music can continue to sound after an enemy is defeated, and 'safe music' can accompany a skirmish. Given the relative brevity of the cues, however, the musical changes are not mismatched with the action for long, and Kondo prioritizes musical coherence over the speed of musical reaction.

Music, the Player and Geography

The music for Hyrule Field responds to Link's location, his actions and the nearby enemies. In doing so, it binds together geography, character, events and the player (who is ultimately responsible for Link's location and actions). The music programming does not make obvious precisely how it responds to the game action, unlike elsewhere in the game, when musical reactions are immediate. Players may not notice that the segments of the cue sound in an indeterminate order. The variation for the 'danger' music is most likely to be identified by players, because of the ear-catching dissonance, but the relationship between Link's movement and the reflective tags is less immediately apparent.[15]

Hyrule Field's music is always appropriate for the action, but it avoids the risk of breaking the fantasy of that magical aptness that might come from revealing the mechanics of the music system. Martin O'Donnell, composer for the initial games of the *Halo* series, expresses much the same of his motivations:

> I want people to play through a level or play through a game or play through a section or whatever and actually think that somehow the music just happened to be scored for their experience [...] I don't want people to be aware that the music is actually adapting or interacting with their interaction, I want people to think that it's just a linear piece of music that seemed to somehow fit what they were doing and they had a good experience. If they are aware that they are changing the music then I think I've failed.[16]

Hyrule Field does much the same. Even without being aware of the musical programming, if I stop and admire the beauty of the landscape, the reflective cues

begin, with long expressive lines that seem to indulge and support my aesthetic appreciation of Hyrule.

Mark Sweeney has investigated music and landscape in games. He writes, 'Landscape, in this context, is a subjective experience, and not merely an objective geographic location. This implies that the subject-position of the beholder is more than simply a point from which their perspective radiates, rather it also frames certain qualities [of the landscape].'[17] Here, the subject-position is that of Link. On Hyrule Field, the world, and its music, is in tune with our hero. Even though this music is geographically centred, it is connected to Link and responds to his, and by extension the player's, actions. In binding world, player and avatar, this cue makes audible the relationship between all three. While our perspective in *Ocarina of Time* is primarily third-person, we are locked to Link and experience the world through his journey; we are 'focalized' through him. The music responds to the specific bodily action of Link – whether corporeal threat from monsters, or his movement. His (virtual) physicality is recognized and accentuated by the music. When the music responds to Link, prompted by the player's actions, Link and the player are shown to be musically important – the music pays attention to him and us. This may imply Link's heroism and the significance of this quest.

Sweeney describes how music seems to evoke landscapes when it balances stasis and motion – music that features a continuous sense of movement but emphasizes repetition, rather than development. He explains,

> This sense of movement within stasis sets up a particular subject position from which the landscape is surveyed. In addition to this, a particular time is created. The principal musical process is that of repetition, which by its very nature does not progress, develop or change. Even the larger scale structure is a form of repetition [...] providing some contrast but with a strong sense of continuation. [...] [An] aesthetic sense of time and space [is] created by the music, and this aesthetic is well suited to the phenomenological experience of exploring the virtual world. Moments like this in [a] game – the music powerfully coinciding with a particularly picturesque vista – are often arresting in the sense that they demand the player's time and indulgence.[18]

Hyrule Field, with its repetition of units, but sense of motion (especially the accompaniment) and variety between repeated units, perfectly fulfils this 'aesthetic sense of time and space' suited to 'exploring the virtual world'. Further, in anchoring those changes to Link, we are connected to a particular subject position for experiencing the virtual world. Sweeney writes of the powerful effect of connecting this kind of music with the landscape. This is exactly the kind of sense of possibility, exploration and wonder players feel when launching onto Hyrule Field. It is

achieved since the whole cue balances paradoxes: motion but stasis, change but repetition, familiar but new. These musical properties are:

- repetition through the units of music that are heard repeatedly;
- music that seems to be always changing through the randomized states and variations;
- rhythmic propulsion and sense of movement, but with continual repetition;
- focalization through Link by changing based on his (and the player's) actions;
- signs and connotations of heroic adventure through Hollywood orchestral music; and
- similarity and difference from the established 'Zelda theme'.

These features all help transform Hyrule Field from a tedious intermission between play into an important part of the aesthetic experience of the adventure of Link.

Location Cues Featuring Ocarina Songs

We have already discussed the melodies that Link plays on his ocarina. Some of these melodies are used as the foundations of location cues, such as those for Lon Lon Ranch, the Lost Woods, the Temple of Time and the Windmill in Kakariko Village. As well as quoting the ocarina melodies, these looping cues draw on distinctive musical styles. These pieces fuse the melodies (and their in-game associations) with musical genres (and their associations outside the game), making the environments and ocarina melodies richer in meaning.

Epona's Song and Lon Lon Ranch – Associations of Ranch Life

In the middle of Hyrule Field is Lon Lon Ranch, a calm and serene location with friendly inhabitants, frolicking horses and mooing cows that produce magical milk. We hear Epona's Song at Lon Lon Ranch, where it provides the main melody for the location cue. Here, it is presented as a ballad in the style of American country music. The melody is played by a violin and sung by Malon, who stands in the middle of the ranch, while the accompaniment is primarily provided by guitars (Figure 2.11).

As soon as we enter Lon Lon Ranch and hear the music, we know that this is a safe and friendly area. The moderate tempo and lack of percussion imply an absence of urgency, and there are no harsh timbres, dissonant harmonies or musical gestures that might be interpreted as alerts or warnings. Where musical

changes do occur, they are gradual: in the latter part of the cue, strings begin to play in held chords to support the harmony. They, too, contribute to the soft, sustained soundscape of the cue.

The Lon Lon Ranch cue interleaves the 'Epona's Song' melody in D major with new material. Two different four-bar continuations of Epona's Song are heard, making a form of ABAC, where 'A' is Epona's Song and B/C the new responses. Then, this whole section is followed by a new passage that uses entirely new material in a DEDF form but copies the rhythms of Epona's Song to provide continuity. The cue balances the new and familiar to extend the melody while still retaining the association with the ocarina tune.

The country music genre is most obviously implied by the instrumentation and accompaniment patterns of the cue. When Malon is not within Link's earshot, the melody is played by a raspy-sounding violin – far closer to a country or folk fiddle than the pristine violin sound of classical art music. Both Malon and the violin are accompanied by two guitars, one playing lolloping arpeggios in swung time and a second steel slide guitar that plays chords that 'slur' in pitch (Figure 3.8).

As Timothy Miller writes, 'Amplified steel guitars became a mainstay of country music styles such as western swing and honky tonk, and an important signifier of country music in other genres.'[19] The introduction of the steel slide guitar into American country music most likely came through Hawaiian guitarists visiting the southern states in the early decades of the twentieth century, which then fused with other musical traditions.[20] Jimmie Rodgers, one of the early country music stars, would feature the Hawaiian steel guitar on many of his recordings. By virtue of his fame, Rodgers established the instrument as part of the country music lexicon. Daniel Neill has noted, 'The steel guitar's ability to emulate "singing", "whining", and "crying" fit perfectly with the sentiments of many of Rodgers' recordings […] [and] would eventually be a key cathartic element in contemporary country

FIGURE 3.8: The accompaniment pattern to Epona's Song in the location cue for Lon Lon Ranch, showing the influence from country music (excerpt).

music.'[21] The plaintive aspect of the style sits perfectly with the 'sighing' motion of the slide guitar and Malon, singing to remember her deceased mother or lost father.

Country music and ranch life are connected in the popular imagination, not least through the imagery of rural America common in the lyrics and presentation of the songs. By invoking country music, the cue calls to mind these established associations, even if Hyrule seems to be a world away from the United States. Lon Lon Ranch's music uses a particular musical style to help depict the location, both in terms of its fictional characterization (as a ranch) and its significance of gameplay (a friendly location). It does so while integrating the important Epona's Song into the sonic fabric, linking place, mood and association with characters.

The Temple of Time and the Song of Time – Cathedral Soundscape

The Temple of Time is an important, frequently visited location; this is where Link transports through time. The Temple has the appearance of a gothic European church (Figure 3.9). The tall building has a polished patterned floor and ceilings so high that they cannot properly be seen. Light streams in from the windows to illuminate the bare stone interior, which features an altar for the presentation of precious artefacts. A further room is revealed beyond the altar, where Link teleports between time zones.

At first glance, the Temple of Time location cue is very simple. It consists of two repetitions of the Song of Time melody, performed in mid-range (apparently male) voices. It is followed by four shorter phrases, all of which end on the same note (D) that the Song of Time melody uses as its tonal centre. These additional phrases keep within the range of the main melody and largely consist of the same rhythmic patterns. Both the original 'Song of Time' melody and the new phrases avoid large leaps to enhance the impression of a plainchant-like song. The cue uses an ancient Phrygian or modern Dorian mode, which again alludes to an older musical tradition that predates the establishment of modern major/minor tonality.

The (unseen) vocalists sing at a slow tempo which is not governed by a constant time signature. Together with the pauses at the end of phrases, the impression is one of monastic vocal music, just as early monophonic vocal church music did not rely on strict rhythm. We know that we are in a place of religious sanctity and tradition because of these musical qualities.

The location cue for the Temple of Time provides a very distinct sense of sonic space. While the cue appears to sound only as a single melodic line, the cue is programmed with two tracks of the same music but offset by about 0.4 of a second. The result is that an echoing effect is created, which sounds like the reverb in a

LOCATION CUES

FIGURE 3.9: The gothic architecture of the Temple of Time.

large cathedral-like space, further cementing the religious associations of the melody and providing an implied acoustic three-dimensional space for the music to resonate in.

This location cue uses technical programming (the echo effect) and musical processes to invoke an old religious tradition in a particular kind of sonic space. These features help to create the projected virtual location of the temple for us. As Link finds out, this is a place filled with supernatural power from Hyrule's mythology.

Windmill and the Song of Storms – Strange Circularity

As discussed earlier, the inside of the windmill in Kakariko Village is the site of a temporal paradox (see Figure 2.17). Here, Link is taught the 'Song of Storms' in the future, only to go back in time in order to teach it to the very person who would later play the song to him in the future. The Song of Storms is the main musical material for the location cue for the inside of the windmill. The further paradox is that the music appears to be (at least partly) produced by the eccentric organ grinder who resides in the windmill, so why would he need Link to teach him a musical tune that he is already playing? The circular logic of the narrative as well as the musical repetition of the piece help to give the impression that this windmill is a curious place, stuck in an amnesiac loop of time and memory.

The Song of Storms is given an answering phrase, to produce a melody in the form of ABAB', firmly in D minor. This complete melody is heard twice to form the looping cue. The density of repetition means that the player will hear the Song of Storms four times before the cue even starts to repeat.

Though the musical material of the melody is not changed in the repetition, it is presented in different instruments: the first time with a high tin whistle and reed organ (appropriate for the organ grinder) and the second time with a glockenspiel in place of the whistle. Direct repetition of the theme is apt for a piece that, as the organ grinder explains, is inspired by the rotation of the windmill. The accompaniment to the melody has a repeating characteristic pattern (Figure 3.10) played on an accordion. This style implies folk traditions, not least in its oom-pah-pah rhythm which has long been associated with Germanic dance. The accompaniment also features a tambourine which adds rhythmic interest by avoiding the first beat of the bar and accentuating the offbeats.

The harmony of the cue is based on D minor, as implied by the main melody, and each statement cadences VI–V–i back to assert the tonic. For much of the cue, the accompaniment often moves in a stepwise circle, Dm–Em–F–Em–Dm (i–ii–III–ii–i), yet another loop in this site of circularity. Though it sometimes deviates from

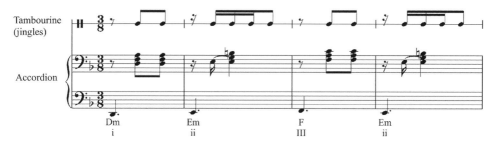

FIGURE 3.10: The oom-pah-pah accompaniment to the Song of Storms in the Kakariko Village windmill, showing the harmonic movement (excerpt).

this pattern, the accompaniment plays E minor against the D minor implied by the melody. The effect is subtle, but adds to the off-kilter impression of the location.

The location cue for the windmill not only introduces the important melodic material (the Song of Storms) but also links that music with the specific location in the virtual world. Simultaneously, it helps to portray the circularity and strangeness of this paradoxical space, along with its obsessive inhabitant. The dance rhythms and folky topic give the piece a whimsical upbeat affect, but the minor mode, insistent repetition and subtle harmonic mismatching belie the fact that something very strange is happening at this windmill.

Saria's Song and the Lost Woods – Jolly Repetition and Misdirection

Saria's Song is a jaunty melody that is used as the basis of the cue for the Lost Woods. The Lost Woods form a maze that border Kokiri Forest. We have already noted that Saria's Song is used to guide players through the maze of the Lost Woods, encouraging them to listen to the music carefully. After cementing the association of this location and the memorable music, the game uses the connection elsewhere. The magical Lost Woods have paths that lead as shortcuts to other parts of Hyrule. When Link finds the path that connects the Lost Woods to Goron City, for instance, the music of the Lost Woods is heard to come from the passage. The player does not need to enter the shortcut to find out where the path leads – the music tells them all they need to know.

Like the windmill cue, the Lost Woods sets the ocarina melody in a dance topic. As noted earlier, the farther that Link strays from the correct path through the maze, the fewer the instruments are heard. The foundational element which continues to sound throughout is the tambourine, which mostly repeats the rhythm in Figure 3.11. On the fourth beat of the pattern, the tambourine is struck on the

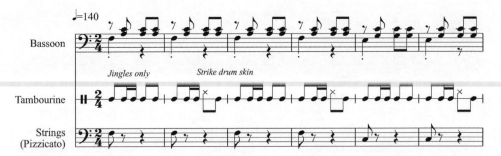

FIGURE 3.11: Accompaniment for the Lost Woods cue (excerpt).

skin. We would normally expect an accent to fall on the first or third beat of the bar, but here, the unexpected emphasis gives the cue exciting movement. This tambourine part provides a sonic thread through the level, even if the player avoids the 'correct' path. It creates a sense of motion, but the light and bright timbre help to give a mood of jolly mischief rather than danger.[22]

The whole accompaniment for the cue helps to create this mood of exciting dance (Figure 3.11). Apart from the tambourine, and the ocarina playing the melody, the cue also uses oboe, bassoons and pizzicato strings. The strings are plucked on the first beat of each bar, while the bassoons fill in each quaver, making a steady rhythm that keeps a sense of movement, even if the player goes the 'wrong' way.

The accompaniment instruments fill in the harmony. Saria's Song is here accompanied by two chords, F major and C major (IV–I), even though the melody does not finish on a C, giving the cue its continually unresolved feel.

After two statements of Saria's Song (with a slight variation in the endings), the second half of the cue is based on a rising sequence over a repeated ii–V–I–vi progression, first heard by oboe, then in harmony in thirds with the ocarina. The string accompaniment now plays a larger role, as pizzicato strings play every quaver, giving the cue an even more bouncy gait.

Just like the woods are confusing in layout, so Kondo subtly misdirects our ears. After three cycles of the ii–V–I–vi progression, an extended rising sequence in thirds lands on E major and holds this chord before the cue starts again and we loop back to Saria's Song. Initially, we heard Saria's Song as in C major, starting with F major and C major chords as IV–I. However, coming back to the melody with F after the held E major chord makes it sound for a moment like a V–VI progression in A minor instead. Like Link walking in circles in the Woods, we find ourselves back where we started, though looking at it from another perspective.

The piece does not use symphonic brass or bowed strings, which avoids implying art music, in favour of less formal music making traditions. The jaunty accompaniment and tambourine pattern is appropriate for the dancing creatures

that Link finds in the woods and the cue even seems to encourage Link to keep moving and exploring the maze of the Woods.

These four location cues use ocarina songs as their melodies. In each case, the location cue is heard before the song is 'taught' to Link. Additionally, these background cues present an extended version of each ocarina melody with new material. All of these location cues have ambiguous sources in the world: Malon sings with an unseen band, an invisible choir sings in the Temple of Time, the organ grinder seems to play the Song of Storms but does not seem to know the tune and Saria's Song emanates from particular spatial locations in the Lost Woods maze, but its full origin is never fully revealed. These are mysterious, magical pieces, not confined to one level of reality.

Each of the cues presents the melody clearly, most often as melody-and-accompaniment texture, so that the song can be easily identified. These cues connect the performance of songs and the construction of the world. The melodies help to characterize the locations (the solemn Temple of Time, serene ranch, paradoxical windmill and the tricksy Woods). The locations enrich the melodies through this association, both with the location and the musical styles that are drawn upon in the cues. Music is woven through the fabric of Hyrule. This is a magical world saturated with music.

Dungeon Cues

Tackling a dungeon is a significant undertaking; one dungeon can take quite some time to conquer. In my recent play-through of the game, it was not uncommon for me to take an hour or more to complete a dungeon, during which time, I would be listening to the dungeon location cue over and over again. The looped cues for these locations help create the spooky worlds of the dungeons, while also being suitable for long listening sessions.

So far, much of our detailed discussion of the music in *Ocarina of Time* has emphasized melodic themes. For the dungeon cues, however, this approach may not be the most appropriate. Musical properties other than distinct themes and songs are more important in these cues.

Soundscape

The term 'soundscape' is used to refer to the sonic environment of a place, like a sound equivalent of 'landscape'.[23] As well as being used to describe sonic

> qualities of particular sites, it can also refer to artistic creations that construct such environments.[24] Megan E. Hill refers to a 'soundscape' as 'the entire mosaic of sounds heard in a specific area',[25] and 'mosaic-like' compositions are often understood as soundscapes. The term is especially common for works that challenge traditional divisions between sound effects and music.

In dungeon cues, rather than creating distinct melodies and themes, Kondo conjures soundscapes. These cues feature highly fragmentary melodies, sparse textures, unusual timbres, unpredictable rhythms, ambiguous structures and little sense of constant pulse. By creating a musical fabric that is difficult to follow as a whole (unlike, say, the distinct sections of Lon Lon Ranch's cue), Kondo disguises the looping of the cues. As argued earlier, avoiding ear-catching materials helps to decrease the risk that the cue may become annoying for players. These qualities are part of how Kondo is able to effectively deploy a small duration of music to accompany extended periods of gameplay. Though the dungeons are all broadly similar, music is part of the way that these locations are varied and given their own distinct character for players.

Inside the Deku Tree – Organic Timbres

The first dungeon that Link encounters is set within a gigantic tree; much of the action takes place in and around the hollow trunk which forms a huge, gloomy, earthen cavern (Figure 3.12). Kondo's music for the first dungeon is similar to the approach he takes for dungeons throughout the game: he uses a disjointed musical texture and avoids easily recognizable melodies in a bid to combat the threat of listener fatigue. Here, the cue consists of only one instrument – a sonorous synthesizer sound. After a 10-second introduction, the central loop lasts 67 seconds and continues to repeat, until it is interrupted by another cue.

The cue sounds like an improvisation. It consists of isolated musical phrases that run up and down a scale. The phrases begin by rising up a scale and then either the phrase breaks off, or it descends down the scale again. Though the cue is fixed as a loop, since the individual phrases begin at irregular intervals, they sound as though they are indeterminate in timing. The rhythms are not consistent and the phrases vary in duration and range.

The danger with an approach to writing a cue like this is that it sounds incoherent and purely random. Alongside the irregular rhythm, asymmetrical melodic shapes and ambiguous pulse, Kondo uses constraints to avoid the music becoming too haphazard. As already noted, the cue uses only one instrument, providing coherence of timbre, and Kondo restricts himself to four notes, F#, A, B and D#,

LOCATION CUES

FIGURE 3.12: Inside the Deku Tree, showing the organic textures of the dungeon.

which are duplicated across octaves to give a full set of nine pitches (Figure 3.13). These notes form a B dominant 7 chord, creating an expectation of resolution, which never appears. The cue starts with a repeated F# in the bass, which serves as a pedal pitch throughout the cue. This bass F# is the lowest note in the cue and provides a foundation for the cue's gestures. The set of pitches are not always heard in sequential order, but by and large, the improvisations tend to sound each pitch of the set as the gestures move up and down the range. Melodic coherence is achieved without producing a memorable or distinct melody or 'theme'.

Spectrograms and Timbre

One of the ways in which timbre can be analyzed is with the assistance of spectrographic analysis. This kind of audio analysis shows time as on the horizontal axis, much like a typical waveform editor, while the vertical axis shows components

> of the sounds that are heard simultaneously. As Nicholas Cook explains, 'spectrograms show pitches as several parallel lines because they include not just the fundamental (the frequency that corresponds to the pitch we usually hear) but also the individual harmonics'.[26] It is these individual harmonics, which are not consciously heard, that help to give the note its timbre. Examining the spectrogram of a sound provides more ways to describe and analyse the timbre.

The pitches in Figure 3.13 are, however, only part of the story. Perhaps the most immediately characteristic aspect of this cue is the timbre of the instrument used to play the pitches. Figure 3.14 is taken from a spectrogram of the opening of the 'Inside the Deku Tree' dungeon cue, showing the single pitch, the opening F#, sounded once. Such spectrograms allow us to see qualities of the timbre, and I here follow the descriptions of timbres proposed by Megan L. Lavengood.[27]

The Deku Tree's characteristic timbre is noisy, rather than a clean, well-defined sound. It is sonorous and fluctuating, shown by the band of the fundamental frequency (the lowest, brightest band) being wide. Above the fundamental, vertically up the diagram, the bands are close together and still very bright and wide; this indicates that both the fundamental and overtones are sounded loudly, which we interpret as a full, rich timbre. Reading from left to right, as time progresses, the shape is not constant, which creates a wavering sound. The regular light and dark sections within the shapes indicate a beating, or pulsating quality to the sound. The edges of the shape are rounded, which means that the starts and ends of the note – the attack and release – are gradual. The sound does not abruptly start or finish, which generates a soft timbre.

The overall impression of the timbre as soft, wavering, resonant, noisy, is entirely apt for the dungeon setting. No clean mechanistic location, this is a natural environment, with a dark and dank interior. It is rich and full but unclear and breathy. The organic associations are perfectly reflected in the rounded shapes of the sound which fluctuate and pulse in a quasi-biological way. It sounds alive. Even with just the sound of one note, Kondo is here using music to help project the virtual environment, encapsulating the inside of the Deku Tree through the use of timbre. The dungeon cue for the Deku Tree returns for the House of Skulltula in Kakariko Village and for secret underground grottos. Like the Deku Tree, these are musty

FIGURE 3.13: Pitch set of the Deku Tree dungeon cue.

LOCATION CUES

FIGURE 3.14: Spectrogram of the first pitch of the Deku Tree dungeon cue, lasting 9 seconds.

places with little daylight, decorated with spiders' webs. Aptly enough, when the organic material textures encountered in the Deku Tree recur, so does the music.

Dodongo's Cavern – Audio Textures of Metal and Stone

The second dungeon of the game is situated in the mountainous area of Hyrule and is set inside a vast rocky cavern. The challenges in this dungeon revolve around setting off bombs, avoiding lava pits, battling fire-breathing monsters and negotiating moving stone platforms (Figure 3.15).

The Deku Tree dungeon cue balances fragmentation and coherence by restricting the materials to only one timbre, and a limited number of pitches, even if the timing and gestures are not easily predictable. Dodongo's Cavern uses a different set of limitations.

Unlike the Deku Tree cue, here a variety of different timbres are used, none of which would be recognizable as a musical instrument in the traditional sense.

THE LEGEND OF ZELDA

FIGURE 3.15: Inside Dodongo's Cavern, showing the stone and lava textures of the dungeon.

Instead, we are dealing with scrapes, wind noises and clangs. There are four sonic elements to the cue:

- a low rumbling drone;
- a dull, slightly metallic percussive knocking;
- a screeching sound that pitches upwards combined with a raspy rattle; and
- a sound that sounds like a distant but huge object clanging and scraping, like rusty machinery.

Though Kondo limits himself to these four elements, they are manipulated to sound at different pitches – so the screech/rattle element sometimes sounds at a high pitch and quickly, and sometimes significantly lower, when the individual ticks of the rattle can be more clearly heard.

Like in the Temple of Time, a long and prominent echo on the sounds implies a vast space. The sounds are also mixed quietly, though they are deep and, as such, imply size, so we have the sonic impression of vast objects and threats sounding from elsewhere in the dungeon. The cue for Dodongo's Cavern lasts 90 seconds,

but the repeat is disguised by the reverb: the end of the loop continues to echo over the start of the cue.

Kondo gives the cue a sense of continuity and structure by having the low rumbling drone continue throughout, changing pitch regularly every 3.75 seconds. This is no accompaniment riff, however: the pitch pattern does not repeat until the whole cue loops, and the other sonic elements are carefully misaligned with the changing drone note. No musical element is triggered to start at the same time as another, so none begins with the changing drone pitch. The drone serves as a sonic backdrop, binding the elements together, but Kondo's strategy avoids the risk that this drone provides too much of a structured frame for the carefully random-sounding cue.

One of the useful properties of the fragmentary approach to musical texture is that the sonic space left in the cue allows players to hear other important sounds. It is particularly noticeable in Dodongo's Cavern because we can hear the approach of enemies and the movement of obstacles.

The cue links clearly with the theme of the dungeon – the sonic clanging, scraping and rumbling resonates with the stone and metallic materials we find in the cavern. It is an audio translation of the visual textures. Andrew Goodwin suggests that, when we listen to music, we often imagine the instruments producing the sound.[28] Here, the timbres of the instruments conjure images of percussive interaction with the material textures we see on screen, each reinforcing the other.[29]

Dodongo's Cavern uses rhythmic misalignment, echoes and unusual timbres to present an aural image of the dangerous environment. Like the Deku Tree, the balance of coherence and apparent randomness is key.

Inside Jabu-Jabu's Belly – Fishy Rumblings

The deity and protector of the river-dwelling Zora people is a huge fish, Lord Jabu-Jabu. He has become unwell after being cursed by Ganondorf. Link must go into the belly of the beast to investigate. The inside of Lord Jabu-Jabu serves as the setting for the third dungeon of the game. As one would expect, it is themed around water-dwelling enemies and emphasizes organic shapes and fleshy or aquatic colours in its design (Figure 3.16).

Compared to Dodongo's Cavern, Jabu-Jabu has a far less sparse soundscape, though we are again dealing with a limited selection of instruments: a drum kit, strings, a quiet low constant background rumbling and a percussive element that sounds like distant burping. The drum kit provides a constant one-bar repeating pattern on snare and bass drum (Figure 3.17). Though the rhythm repeats without alteration, it is a lurching rhythm that approximates a stylized heartbeat. A heartbeat does not simply sound uniform constant beats; the pulsation is produced by

FIGURE 3.16: The piscine interior of Jabu-Jabu's Belly.

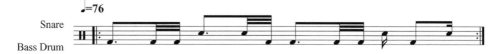

FIGURE 3.17: The heartbeat rhythm of Jabu-Jabu's Belly.

a rhythm that intersperses close-spaced beats with longer periods without a contraction.[30] The background rhythm here is not the same as a human heartbeat (not least given the syncopation), but that is hardly unsurprising, since Link is inside a giant fish, and a rather unwell one at that.[31] Yet a pulsating but unusual heartbeat helps to emphasize the dungeon setting.

The sixteen-bar cue (*c*.50 seconds) for Jabu-Jabu's Belly also features a repeating ostinato in the strings, which sustain a soft chord for a bar at a time. The ostinato is eight bars, providing two complete soundings for every repetition of the cue. The ostinato (Figure 3.18) uses chords made up of a note harmonized by a major second and a tritone, which move in strict parallel motion. The chord is dissonant, but not abrasively so, especially when held in a quiet sustain. Much

FIGURE 3.18: The string ostinato of Jabu-Jabu's Belly.

like Kondo's technique elsewhere in the game, the string part implicitly seeks resolution, though the conclusion is never achieved. Together with the drum track, the cue creates a more consistent musical fabric than the fragmented sound of Dodongo's Cavern.

The most distinctive component of the cue is the burp-like percussion that sounds intermittently over the drum track, drone and string ostinato. This sonic indigestion rasps and echoes throughout the dungeon. The rumblings of the trapped wind vary between higher and lower pitches, longer and shorter sustained rasps, and louder and quieter dynamic levels. It has an irregular rhythmic pattern, offset from the main musical pulse, remaining independent of the other parts of the musical texture. Though the musical burping is humorous, it also serves a practical purpose, emphasizing the scale and setting of the dungeon, as well as combating the potential tedium from the heartbeat and string ostinato parts.

As Dodongo's Cavern blurs the lines between the sound of moving stones and musical percussion, Jabu-Jabu's Belly blurs the distinction between bodily noises and rhythms, and musical percussion. We are constantly sonically reminded of the ill fish that it is Link's job to cure.

Forest Temple – Sounds of the Forest

The Forest Temple is the first of the adult dungeons. It is visually similar to the Deku Tree, since it is set in dense woodland, though this is a considerably more challenging and extensive dungeon (Figure 3.19). Kondo uses three musical elements in this cue, each with very distinct timbres: angklungs, an ethereal synthesizer pad (a sustained slow-developing synthesized background sound that adds to, enriches and coheres the texture) and a further woodwind part that sounds like an animal call. All of the parts operate rhythmically independently.

The angklungs form a constant echoing through the cue. Angklungs are bamboo percussion instruments from South East Asia and are especially associated with Java. These instruments are shaken to produce a wooden rattle tuned to a particular pitch. With West Java notable for its agriculture and forests, the association is apt for the Forest Temple. These angklungs resonate in octaves and have a delay effect applied, so that they seem to swirl around the soundscape in echo.

FIGURE 3.19: The entry to the wood-themed Forest Temple.

Apart from the angklungs, an ethereal synthesizer pad forms a gentle timbre with a sustained resonance and almost vocal quality, but the beginning of each pitch has a subtle metallic chime to it. This part alternates between two chords: E–G#–B (E major) and F–A–D (D minor), always heard in the same octave. Though the synthesizer is simply swapping between those chords, a sense of variety is provided by varying the rhythm and note order, as the chords shift, apparently unconnected to the tempo and pulse of the other parts.

The final, and most aurally startling, element to the cue is the woodwind part. This instrument sounds similar to a bamboo flute but with a reedy and brittle quality to the timbre. It is not dissimilar to flutes with buzzing resonators like the dizi. It is a noisy timbre, not a clean, pure tone, dark rather than resonant, and wavering throughout the note. The start of each pitch is distinct, with a strong attack, but fades in and out of the texture, almost like a bird or creature swooping through the forest space, initially coming towards, and then away, from the point of hearing. This is another instance of Kondo projecting virtual sonic space through the music.

FIGURE 3.20: A selection of the 'bird call' fragments of the Forest Temple dungeon cue.

This flute part plays repeated figures in triplets. Figure 3.20 shows a selection of the figures that are played by this instrument throughout the cue. The repetition is regular when written in notation, but it phases in and out of synchronization with the other parts of the texture. The flute seems to suggest bird calls. In the latter part of the cue, the large quick leaps have a curious timbral effect – they become similar to an ooh-aah vocal effect, more like a monkey. Though the E, G# and D match the accompaniment chords, the F# clashes with the F-natural, with a subtle dissonance. This is a strange, dangerous place, in which we seem to hear creatures that materialize out of the soundscape and disappear again. Perhaps Link is being watched.

The Forest Temple cue uses timbres from musical traditions that will be less familiar to the majority of players. These unusual timbres are used to lend an 'exotic' flavour to the location, marking it as special and unfamiliar, especially in contrast to the orchestral materials that dominate elsewhere in the score.

Fire Temple – Voices Heard and Unheard

The second adult dungeon is the Fire Temple, the harder and longer cousin of Dodongo's Cavern. The Fire Temple is set within a volcano and features obstacles of molten rock, mazes made of walls of fire and enemies with a taste for the pyrotechnic (Figure 3.21).

Like the drone in Dodongo's Cavern and the background rumbling in Jabu-Jabu's Belly, the Fire Temple deploys a constant low sound as a sonic carpet for the rest of the music. Here, it takes the form of a distant howling wind, undulating

FIGURE 3.21: The Fire Temple, with some of the fiery dangers pictured.

in pitch as the air swirls. Even if we cannot feel the breeze, the audio portrays this aspect of the world for us.

Beyond the wind, the cue also uses a tambourine, marimba, vocal parts and a glockenspiel-like chime. The inclusion of the marimba, which is also featured prominently in the Goron City cue, serves as a sonic connection between the two places: Goron City is nearby and Link has to rescue several Gorons as part of the completion of the dungeon.

The parts are adjusted in the mix as the 98-second-long cue unfolds, sometimes louder and more prominent, sometimes distant and fading out. The deep wooden marimba contrasts with the high metallic glockenspiel. These accompaniment parts all synchronize to a four-time beat, unlike most dungeon cues, where the parts do not align. This group of instruments contrast with the vocal parts, which come to dominate the second half of the cue.

The music of the Fire Temple is a hot topic in Zelda fandom. Players have long noticed that there are subtle differences between different versions of *Ocarina of Time*. This is not uncommon in video games. Mostly, alterations to video games

either serve to fix bugs or localize the game for release in different countries. In the earliest-released versions of *Ocarina of Time*, the Fire Temple music includes a vocal part that is absent from later versions.

The original music for the Fire Temple featured sampled vocals. These are particularly unusual as they are the only sung voices in the game where words can be heard. Though the text is not particularly clear, it is decipherable. The sample is a solo male voice with significant echo and amplified effects singing in free time, in extended and wide-ranging phrases. In the cue, the sample is repeated, overlapping itself, creating a complex musical texture that is distinctly out of synchronization with the rest of the ensemble. The sample involves the repetition of short phrases within the overall vocal line, lending it an almost hypnotic quality. The mixing fades the voice in and out, coalescing out of the sonic fog and receding back into it.

The samples use a religious Arabic text, as translated in Table 3.7. The text consists of quotations of the Quran. These only sound in the first editions of the game.

Accepted fan wisdom suggests that Nintendo had changed the music as a result of public criticism following the release of the game. However, completion dates of the *Ocarina of Time* cartridges indicate that all of the versions of *Ocarina of Time* were finished before any games were sold.[32] This means that the music was changed before the game was released, though the earlier production runs, with some glitches and other minor unpatched issues, were still released and sold first.

The topic was addressed by Nintendo in an email of 29 April 2012 when the Nintendo Customer Service responded to a request from game website *Game Trailers*, writing,

> [T]he background sound effects originally used in the Fire Temple section of The Legend of Zelda: Ocarina of Time were originally chosen from a library of commercially available musical and sound effect programs. Our game developers

Text	Translation
بسم الله الرحمن الرحيم	In the name of Allah the most gracious the most merciful
قل هو الله أحد	He is Allah, the One and Only
الله الصمد	Allah, the Eternal, Absolute
الله أكبر ولله الحمد	Allah is the greatest and praise be to Allah

TABLE 3.7: The lyrics and translation of the Fire Temple vocal sample.

did not know that the sounds used in the game had Islamic references. Once we were informed that there were Islamic musical references in this section of the game, the music was removed from all subsequent production runs of The Legend of Zelda: Ocarina of Time.[33]

The same sample is used in other games, including, for example, the Egypt Stage of *Cruis'n World* (1998), which predated *Ocarina of Time*'s release. The sample is likely to have originated from a library called Voice Spectral (Volume 1), which was released by Best Service, a company specializing in the production of sample libraries for commercial composition.

The sample continued to feature in games after *Ocarina of Time*. It caused a significant problem for Microsoft when it was included in the fighting game *Kakuto Chojin* (2002), and the use of the sample escalated into a significant PR issue for the company. The negative publicity around the perceived cultural insensitivity of Microsoft was so significant that the company eventually chose to recall the product entirely, in all regions of its release, and it was not reissued.[34] *Ocarina of Time* was fortunate: the opportunity to correct the mistake was available, the decision was made swiftly and the presentation of the chant comes at a relatively advanced stage of the game where it is less aurally obvious than in *Kakuto Chojin*. Even in 2017, the same sample was causing problems, this time for a downloadable add-on for *Street Fighter 5*.[35] Here, again, the music was replaced.

Part of the Fire Temple involves rescuing Gorons from their imprisonment throughout the dungeon. It is easy to interpret the echoing voices of the sample as an evocative expression of the Gorons' despair. When coupled with the meaning of the prayer, addressing a higher power, the blasphemous potential of the context is particularly unfortunate even as much as it is apt.

We might marvel at the longevity of the sample as well as the composers'/producers' repeated failure to consider the appropriateness of the sung text. But why would this sample thought to be apt for *Ocarina of Time*? The visual style of the Fire Temple, with carved rock and serpent motifs, appears to take its inspiration from ancient civilizations, including those in modern-day Arabic-speaking countries like the Assyrian Empire and Ancient Egypt. Perhaps the musical soundscape of the region would be thought to complement the historical imagery found in this same area.

In the revised version of the cue, the chant is replaced by textless synthesized voices. The pitch contours from the original samples have been generally retained, with the internal repetition and sliding pitches. However, the specifics of the words and the timbral variety of a texted and amplified voice have given way to a more

generalized sound. Listening to the revised cue after the original, one can still hear the legacy of the controversial samples, though a listener without that frame of reference would be far less likely to make the connection to the tradition of Islamic religious recitation.

Like the other dungeon cues, Kondo aims to create a texture that is sonically coherent but sufficiently fragmented to avoid tedium of repetition. More than the other dungeon cues, the texture is remarkably homogenous. Instead, the variety and fragmentation comes from the voices and the mixing of the cue, which allows parts to fade in and out of the texture. In the original version, the vocal parts were rhythmically, harmonically and timbrally very distinct from the rest of the musical texture, while the revised version diminishes this effect somewhat, since the sonic contrast is less stark than with the samples. Nevertheless, Kondo's revised cue is still able to maintain some of the qualities of the sample that made it useful as a disruptive element in the cue.

Ice Cavern – Crystalline Chimes

In the adult time zone, the water-themed region of Hyrule, home to the Zora people, has been cursed with freezing temperatures. The Zora Fountain is deserted and the lake where Jabu-Jabu once stood is icy and filled with icebergs. Here, Link finds the Ice Cavern, an essential but small mini-dungeon.

The Ice Cavern is a glittering cave filled with sharp icicles, enemies that freeze Link and puzzles involving blocks that skate over the icy surfaces. This mini-dungeon's cue emphasizes the crystalline world that Link explores (Figure 3.22).

The Ice Cavern is a short dungeon, so does not require a cue as lengthy as those of the other dungeons. Here the loop only lasts approximately 35 seconds. Apart from the howling wind (representing a physical sensation, like in Dodongo's Cavern), the cue sounds as involving only one instrument, a set of chimes.

As the spectrogram in Figure 3.23 shows, the sound is highly resonant (the harmonics are widely spaced and extend high up the image), giving a bright timbre, but relatively narrow, so that the tone is clear. It has a sharp attack and long sustain, like a struck bell.

The cue consists of a series of chords, sounded as arpeggiated chords – that is, not all notes of the chord sound at once, but instead, they are played in quick succession in short groups. It is similar to a handbell choir in effect. The timing of the chords avoids an easily predictable pattern by using a constantly changing rhythm.

With the exception of one pitch in a briefly sounded chord, the entirety of the Ice Cavern cue is created from parallel ninth chords: they all have four pitches sounding the tonic, third, sixth and ninth of the chord (Figure 3.24 shows the first

THE LEGEND OF ZELDA

FIGURE 3.22: The Ice Cavern, showing the clear, icy design of the mini-dungeon.

few bars of the cue to illustrate the harmonic effect). The result is a rich sonority, but not one that is dissonant or specifically aches for resolution. For this reason, the music for the Ice Cavern is serene. The chords move in direct parallel, either up or down by a tone, so there is no particular sense of a harmonic progression, which again helps to avoid tedium in repetition: no trajectory of departure and arrival is articulated that might threaten to become annoying as the loop repeats.

Though the cue appears to consist only of one instrument, the track is programmed so that multiple copies of the instrument actually play at the same time. To give the impression of a ringing echoing sound, the instrument is duplicated and particular pitches from each chord in the main track are repeated at a delay, sometimes sounding multiple times across parts, creating the virtual acoustic space of the cavern.

Kondo's cue for the Ice Cavern manages to evoke the acoustic space of this bright cavern, as well as drawing on sonic signifiers of brittle crystal iciness, all the while fulfilling the demands of avoiding musical features that might become tedious through repetition. After gaining the Iron Boots in the Ice Cavern, Link is

LOCATION CUES

FIGURE 3.23: A spectrogram of one note of the bell chimes in the Ice Cavern cue.

FIGURE 3.24: Chiming chords of the Ice Cavern.

able to make his way to the Water Temple, where some of these similar bell-like sonorities will again find use, albeit in a very different musical context.

Water Temple – A Dungeon on the Danube?

The Water Temple is a difficult dungeon. Players can expect to spend a long time in this area. To match, Kondo writes one of the longest dungeon cues, lasting a little over two and a half minutes. The background cue for the Water Temple combines two distinct musical features – first, musical allusions to water, and, second, influences from a traditional musical culture.

The cue emphasizes bright metallic sounds like the Ice Cavern. The accompaniment consists of a set of chimes, a glockenspiel and a synthesizer that uses a shimmering, rippling timbre with rapid echo. That synthesizer part, which is busy with fluctuations and resonances, plays a descending pentatonic scale in one of three variations, always starting on B or B♭ and ending on G. It is imitated by the glockenspiel in a dotted rhythm that picks out notes from the scale at a delay. The overall effect is one of a cascading descending gesture – entirely appropriate for a temple in which Link will frequently adjust the water levels.

Chimes add a colouristic effect at irregular moments throughout the cue. These parts are all underpinned by a clear, warm synthesizer pad playing single pitches or two-note chords. All of the registers of these instruments are high: even the synthesizer pad that sits at the bottom of the texture only descends to E♭3. The result is a fluid and bright musical texture.

Over this accompaniment, two other solo musical instrumental parts are heard – a flute-like instrument and a cimbalom (a struck string instrument). They seem to 'improvise' over a particular scale in a limited range, with significant rubato that separates them from the rest of the ensemble. The choice of instruments and the melodic material implies an association with Hungarian music.

Both of the solo instruments improvise on a scale consisting of G–A–B♭–C#–D–E♭–F#–G.[36] This scale is an alteration of the conventional minor harmonic scale by raising the fourth pitch. The scale has a long history in European art music as a signifier of the exotic racial other – it is often called the 'gypsy scale' or 'Hungarian minor scale', though more properly, it should be known as the 'verbunkos minor scale' since it draws on the music of Romani bands in Hungary known as 'verbunkos'.[37] Liszt is perhaps the most famous composer to incorporate explicit verbunkos references into his work, but it has been traced through a great variety of Western art music, often as part of a 'hongroise' style that treats Hungary and Romani peoples in stereotype as exciting, dangerous 'others' to Western culture.

The choice of the instruments also fits associations with Hungarian music. The cimbalom is an instrument consisting of metal strings that are stretched over a soundboard and played by striking the strings with small hammers. Here, it is heard playing the characteristic rapidly repeated notes of the style, made by bouncing the hammer on the string. The cimbalom, and this style of playing, has also been featured as part of the 'hongroise' topic.[38] The flute timbre is less obviously unusual, though it is clearly not an orchestral flute and is perhaps a reference to the Hungarian flute, the tárogató, also often found in verbunkos ensembles along with the cimbalom.

Beyond the instruments and scales, and the improvisatory, rubato performance, there are other resonances of verbunkos music in this cue. Shay Loya has discussed how elements of verbunkos were integrated into European art music of the eighteenth and nineteenth centuries, as part of an impulse for exotic flavour.[39] We can find some of the same features here. These include:

- Embellished and long phrases with melodic turns that emphasize the characteristic scales
 o Evident in the cimbalom and flute parts.
- Tonal stasis and little harmonic direction
 o The solo parts maintain the same scale throughout and the accompaniment repeats three subtle alterations of a pentatonic scale on G, without providing a sense of progression.
- Ostinatos and repeated pedal pitches, often causing subtle harmonic dissonance
 o The 'cascading' accompaniment parts repeat constantly throughout, always landing on G. Sometimes the pentatonic scale creates minor second dissonance with the supporting synthesizer pad or the solo parts.
- Repetition at 'all levels'
 o This cue has several layers of repetition: the looped cue, the cimbalom part which repeats directly and the accompaniment that consists of three different bar-long phrases.

Perhaps this Hungarian musical style is appropriate because of the significance of the river Danube in Hungary. Budapest in particular has a longstanding association with water, dating back at least to the Roman establishment of the city of Aquincum in modern-day Budapest, partly motivated by the thermal springs. Archaeologists have found evidence of hydraulic technology from the city, including a water-powered organ.

Unlike the ill-fated attempts to invoke another culture in the Fire Temple, here, Kondo has been able to avoid musical exoticism that is too obvious. Rather than directly replicating material from another culture, he borrows processes and

instrumentation. He combines these properties with sonic allusions to the watery theme of the dungeon.

Shadow Temple and the Bottom of the Well – Voices and Drums from the Depths

Kakariko Village in *Ocarina of Time* is one of the game's safe areas. In the child time zone, it is a peaceful village where Link may run errands and engage in several sidequests. In the adult timeline, refugees from Ganondorf's destruction find safe harbour in the village.

This positive and welcoming area, however, holds a dark secret – it is built upon the remains of Hyrule's painful past. Link visits two locations under Kakariko Village. As a child, Link may drain the well in Kakariko Village to access the optional mini-dungeon, the Bottom of the Well, and as an adult, Link must conquer the Shadow Temple, situated under the graveyard on the outskirts of the village. Both of these locations share the same architectural style and musical cue.

Though all of the dungeons in *Ocarina of Time* are mysterious, none more explicitly engage in horror tropes than the pair below Kakariko Village. These environments feature bloodstained walls, skeletal remains, guillotines and torture devices. The creatures in these locations often play on body horror tropes: disembodied hands, zombie-like mummies, bloodied organic masses with protruding skeletal features and so on. The music, too, draws on conventional signifiers of horror.

The dungeon cue follows a similar fundamental approach to that observed in the music for other dungeons – a drone and drum part provide a foundation over which other sonic elements fade in and out of the soundscape in an irregular manner. A djembe drum supplies the percussive underpinning for the cue. By taking advantage of the different sounds of the djembe – the deep 'bass', midrange 'tone' and high 'slap', a dance-like rhythm is created, and this part fades in and out.

The drumming has a significance which is only revealed at the end of the dungeon: the boss battle for the Shadow Temple takes place on the top of a giant drum. The boss, Bongo Bongo, takes the form of a pair of giant hands, controlled by a central neck and single eye that hangs from the ceiling. The hands beat the drum, causing Link to bounce across the surface, making it challenging to aim weapons. The hands attempt to crush, grab and swipe at Link. In between attacks against Link, the hands play the drum and, while the rhythm is far simpler than the djembe part of the background cue, the implication is still that the boss is the source of the drumming that players have been hearing all through the dungeon.

The Shadow Temple cue draws on musical techniques long evident in horror film, specifically a harpsichord, sung and chanting voices, and metallic scrapes

and rattles. The harpsichord has long been a staple of the gothic, accompanying supernatural threat.[40] Here, the harpsichord plays repetitive figures in a steady semiquaver rhythm, aimlessly repeating chromatic gestures within a limited range – between E4 and B3. The harpsichord is particularly useful here, since the brittle timbre pierces the murky soundscape.

There are three vocal elements in the cue – a set of open vowel sounds sung by bass voices, a further part in alto voices and a chanting sample. The use of textless/wordless voices as a representation of the supernatural or ineffable has a long heritage in film, from at least *The Wizard of Oz* (1939) to *Frozen II* (2019).[41] It even occurs in art music repertoire, such as for Neptune in Holst's *Planets*, the dreamlike Arcadia of Ravel's *Daphnis et Chloé*, Debussy's sirens in the third movement of his *Nocturnes* and the ethereal chorus which accompanies the Celtic goddess Kaito in d'Indy's *Fervaal*. Of course, the textless chorus is not in itself demonic: we can think of the wordless chorus of a Hollywood ending (e.g. *Gone with the Wind*), but the dissonance and portamento here, sliding between notes, helps to give the cue its subtle horror. The alto parts often sing in clashing minor or major seconds and are independent of the bass parts which hold open fourths or fifths in a low register. These vocal parts are all treated to pitch bends, shifting uncomfortably between notes, giving a wailing and distorted quality to the sound, sitting awkwardly between solid tuning. Later in the cue, a sample is used of indistinct low voices.

The cue draws on the trope of the demonic choir, in which the line between screaming and singing is blurred.[42] The voices resemble the choir in Jerry Goldsmith's score for *The Omen*: dissonant voices that slide between notes and seem to sit between singing, speaking and screaming. Unlike the sample originally used for the Fire Temple, the chanting in the Shadow Temple is too sonically indistinct to concretely refer to any one musical tradition and instead sounds like a cult chanting a mysterious spell or incantation.

These voices are mentioned by Navi. At certain moments in both the Bottom of the Well and the Shadow Temple, she says, 'I can hear the spirits whispering in this room.' This most often happens when encountering a skeleton or demonic portrait on the wall. Navi then proceeds to give Link an enigmatic clue depending on his location in the dungeons. It seems as though she is referring to the voices in the score, adding to the sense of mystery and danger; these voices are communicative but precisely what they say remains impossible to decipher.

Noël Carroll has suggested that interstitiality – the awkward and unsettling condition between two distinct states – is an important component of horror as found in art and entertainment.[43] Here, the vocal parts are able to do just that – both with their detuned notes and by blurring the line between singing, screaming and chanting. The indeterminate scrapes and rattles in the cue also sit in a long line

of horror signification, where metallic clanging, rumbling, grating and droning have been used throughout film and television as sonic sounds of horror.[44]

The cue for the Shadow Temple and Bottom of the Well uses a variety of musical references which have an established pedigree in horror scoring. By integrating the chorus and drums into the narrative of the world (though Navi's discussion of the voices and the Bongo Bongo boss), the musical choices are not arbitrary or erratic but tied specifically to the world and story they accompany.

Spirit Temple – Geographic Allusions

Deep in the desert, Link finds a dungeon that is set within a huge statue – the Desert Colossus (Figure 3.25). This dungeon must be visited both as a child and as an adult. The statue is symmetrical, with one half visited by young Link and the other by the adult. Inside, the temple is created from bright yellow stone. Shafts of light illuminate the sandy floors and carvings on the walls. The temple features recurring visual motifs of a snake and a smiling sun's face. In the N64 version of the game, the temple frequently uses a crescent and star design, though the image was replaced in subsequent versions because of its similarity to the symbol often used to represent Islam.

Like the Water Temple, since players can expect to spend a long time in this dungeon (visiting both as adult and child), the location cue is long. The cue has 2 minutes 44 seconds of music, of which the first $c.58$ seconds serve as an introduction not repeated in the loop.

The cue opens with gongs and chimes over an organ playing open fifths and strings playing open fourths moving in parallel. The strings and organ all use the pitches of G–A♭–B♭–C–D–E♭–F, which forms a Phrygian mode or Neapolitan minor scale. The majority of the cue consists of a solo double reed instrument playing improvisatory gestures over a string accompaniment in open fifths and a steady drum pattern. With the exception of some very occasional chromatic alteration, the solo instrument and the accompaniment all conform to the same Neapolitan scale.[45]

The dominant timbre of the Spirit Temple is the solo reeded melody instrument. To give the impression of an echo effect, the part is double tracked, with a duplicate of the instrument playing at a fixed delay. The result is a reverb, implying the sonic space, as we have seen with the Ice Cavern and Temple of Time. The melody improvises around the scale, especially focusing on G to anchor the scale, as well as the B♭, A♭ and D, to emphasize the Neapolitan flavour of the harmony. Though the focus is on the pitches of the scale, the performance also uses pitch-bends to provide stylistic colour to the performance and emphasize difference from 'Western' classical musical tradition. It is temporally unlocked from the percussion

LOCATION CUES

FIGURE 3.25: The Desert Colossus (top, exterior) which houses the Spirit Temple (bottom, interior).

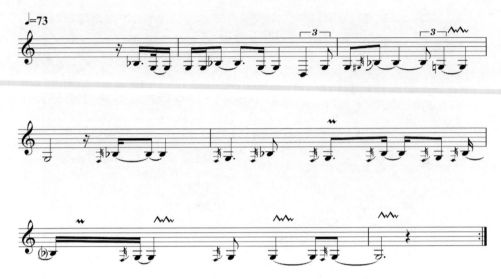

FIGURE 3.26: Approximate transcription of the reeded melody part of the Spirit Temple. The lines above the notes indicate fluctuations in pitch.

and seems to float above the accompaniment, not starting or ending phrases in synchronization with the drums. There is significant use of ornamentation, some of which involve large leaps, decorating the melodic lines. Figure 3.26 shows an approximate transcription of the final bars of the cue, just before the loop point, illustrating the use of repeated gestures and embellishments in a way that does not conform to the pulse.

While this melody part is the focus of aural attention, the low strings provide an accompaniment ostinato consisting of open fifths, moving in parallel and conforming to the pitches of the primary scale outlined above. There is a second melody part, in the higher strings, formed of slower pitches that also circle the same scale as the reed part. The two melody parts sometimes interfere with each other, but the overall dissonance is constrained by the parts conforming to the same set of notes. The other accompaniment element of the cue is the steady drum accompaniment, which repeats the same four-time pattern throughout the main loop.

In this cue, Kondo again seems to draw inspiration from music of another culture. First, the main double reed instrument has a timbre that is similar to a śahnāī, an instrument used in the music of India, Bangladesh and Pakistan. It is a little like the orchestral oboe, and the śahnāī is also related to several other instruments from co-existing or neighbouring regions and traditions. We are here dealing with a synthesized timbre, so there are several candidates for instruments that are similar to the particular instrumental sound used in the game. Nevertheless, the śahnāī is a good fit for the Spirit Temple's solo instrument, not just because of the

similarity of timbre, but also because of the musical material it plays. As Reis Flora explains, concerning the śahnāī,

> When the fingers are gently rocked to open and close the finger-holes the performer is able subtly to shade the pitch, and also to produce extended glissandos which, together with intricately tongued phrases are characteristic of the instrument. Other characteristics include the [...] instrument's ability to play sustained notes.[46]

The pitch bends, unusual roving phrases and the long, held notes all imply a correspondence between the śahnāī and the solo part in the Spirit Temple.

Second, Kondo also seems to refer to Indian music in the drum parts. The drum timbre is similar to the mridangam drum. This drum is notable for the variety of tones that it can produce and the complex beat patterns that it uses. Though the pattern in the Spirit Temple is relatively simple, the cue still evokes the mridangam because of the taut timbre of the drum, the sounding of different tones and the rapid repetition of strikes on the skin of the drum.

Finally, by using the scale notated above, which forms the fundamental organizing principle of the cue, Kondo seems to refer to Indian classical music. There is not space here for an in-depth examination of the complex scalic system of Indian classical music here, but, in outline, the tradition uses rāgas which are both scales and melodies: sets of pitches which form the foundational melodic material of a piece. Each rāga comes with particular associations, including mythic or supernatural connections. Kondo adopts a scale which is sonically equivalent to the mela Hanumatodi of Carnatic South Indian classical music and the Bhairavi thaat of Hindustani North Indian music.

Kondo by no means presents his music as an explicit representation of Indian music; rather, he appears to have drawn inspiration from this musical tradition to provide variation and colour into the music. Aspects of Indian classical music are compatible with Kondo's approach to dungeon cues: both use a limited set of materials and a consistent accompaniment, over which solo instrumentation creates improvisatory gestures. The dungeon's style does not have a particularly obvious connection with the real-world geographies with which this music is associated. That noted, the figures of the colossus in the game holds some similarity to representations of Shiva, especially with the recurring image of the snake and the crescent moon common to both. The huge statue of Lord Shiva near Bijapur, for instance, bears more than a passing resemblance to the statue of the desert colossus (Figure 3.25).

The cue for the Spirit Temple exhibits many of Kondo's tested methods of creating dungeon cues, particularly the balance between improvisation and musical constraints. Kondo also seems to draw upon a musical tradition that uses similar

processes: the instrumentation and melodic processes of Indian classical music. Kondo accentuates the distinct nature of this location by referring to a geographically specific musical practice, but he is still able to use the same techniques for creating dungeon cues that he deploys elsewhere in the game.

Ganon's Castle

The final dungeon is Ganon's Castle, standing on the former site of the Royal Family's Hyrule Castle. Link must first conquer the basement rooms of the castle, before ascending the tower to face Ganondorf. The basement consists of five small areas. Each area is modelled after a previously conquered dungeon (forest, fire, ice, etc.). The tower is constructed from a spiral staircase that connects a series of rooms that eventually lead to the battle with Ganondorf at the top. There are two different cues in the dungeon – one for the basement and one for the tower.

Castle Basement – Generalized Murky Threat

Kondo deploys an arsenal of generalized sonic signifiers of threat, in order to emphasize the mystery. The castle basement features a low rumbling which serves as the ostinato for the cue, cycling open fifths on B, C and D.[47] The rumbling is so low, however, that the pitching is nearly indistinguishable. A very low vocal part also growls in chromatic pitches, adding to the murkiness of the whole sequence.

Above this accompaniment, Kondo deploys some unusual percussive sounds. These include distant clanging and scraping sounds, which are sometimes treated to pitch bending. One notable sound is a rattle combined with a whistle, heard at a variety of pitches and tempi, similar to one of the elements of Dodongo's Cavern. This complex sound is shown in Figures 3.26 and 3.27. The sound has a bulging dynamic profile as the sound surges through the soundscape and a contrary pitch profile, since the whistle rises as the rattles descend in pitch. The effect is to have a sound that emerges and recedes through the soundscape. It is of mysterious origin and location.

The most prominent part of the cue is the piano. Kondo uses his previous strategy of 'double tracking' to provide a sense of a large acoustic space, but here, he ups the ante even further. Though we only hear the piano as playing what sounds like one chord at a time, the part is programmed to repeat the same chord quickly at a quieter dynamic. In addition to this echoing within one part, the piano track is duplicated at a delay. One chord, then, sounds four times. The result is an echo effect that sounds like a huge space with reflective surface – entirely apt for a castle with stone walls. The piano plays irregular intermittent two-note chords

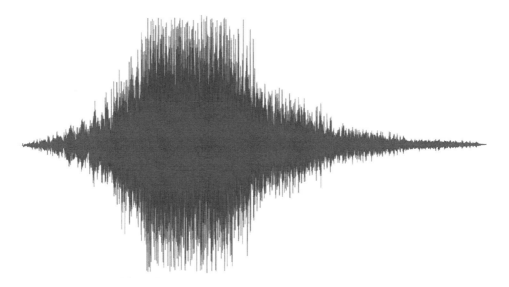

FIGURE 3.27: The waveform of the rattle and whistle sound heard in Ganon's Castle, showing the swelling dynamic profile of the sound.

low in the register. There is little sense of a coherent tonality but provides a distinct timbre to echo around the rooms.

This cue emphasizes low pitches, with very few mid-range or high sounds (with the exception of the occasional rattle). The low pitches create a sonically murky cue, but it also avoids competition with other elements of the soundtrack. Link has to visit each of the basement rooms to break a forcefield that prevents him from entering the tower. The forcefield makes a rising and falling glissando that oscillates between G3 and G4, higher than the other music in the cue. It is prominent and sounds continuously while Link is in the main castle area, until the barrier is removed. By avoiding that register in the cue, Kondo circumvents any potential sonic clashes between the cue and the sound effect.

In the Castle Basement, Kondo uses sounds to create an indeterminate fluctuating soundscape in low pitches. The echo effect is deployed to an even greater extent than heard previously and the other sounds are chosen for their ambiguity and mystery, both in terms of where they come from and how they are produced.

Ganon's Tower – A Gothic Statement of Villainy

As Link begins his ascent to face Ganondorf in the tower, a new cue begins. Gone are the low rumblings, uncertain timbres and shadowy sonics of the basement

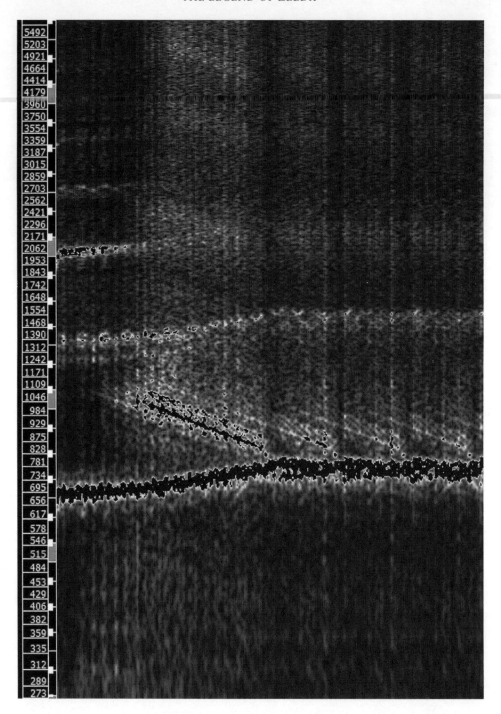

FIGURE 3.28: A spectrogram of the rattle and whistle sound heard in Ganon's Castle, showing the rising pitch of the whistle alongside the descending rasping rattle.

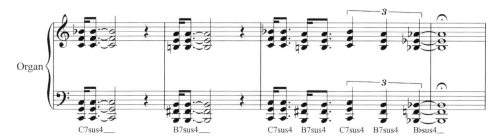

FIGURE 3.29: The chords that start Ganondorf's organ performance.

cue. Instead, the conventionality of the cue is striking and even rather surreal – it is a pipe organ solo.

The cue is in three distinct sections. First, it begins with arresting fanfare of repeated dominant seventh chords (Figure 3.29). These are tonal but dissonant. The chords move chromatically in parallel motion, without relieving the harmonic tension. Immediately, we know that this is no wedding march or celebration but a prefiguring of doom in the gothic tradition, a musical announcement of villainy.[48]

The second, and longest, part of the cue is a statement of Ganondorf's theme, heard earlier elsewhere in the game (see Chapter 4). It has a sense of indefatigable progression. Like a lurching monster, a bass part alternates between pitches of C and G. Above it, mismatched with a lumbering rhythm, an upper part plays a rising sequence, initially landing on B♭, but then rises in uneven steps to land on B, then D, then E. This sequence is repeated, then harmonized in fourths (clashing harmonically with the bass part, as shown in Figure 3.30), before the whole pattern is transposed up a minor third and heard twice. There is a deeply menacing quality to the unrelenting but unpredictable progression of the cue.

The final part of the cue is created from sustained chords. To up the ante even further, Kondo introduces another part that doubles the right hand of the organ,

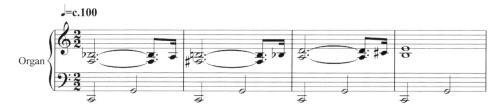

FIGURE 3.30: An iteration of the rising sequence from Ganon's Castle (Tower), illustrating the lumbering rhythm, sequence pattern and the dissonance.

just like an organist pulling out another stop to add an additional set of pipes to the volume of sound. These final chords provide some degree of resolution – they are straightforward minor chords. Nevertheless, they still operate in parallel motion, with a descending semitone motion in rising sequence, creating a musical climax that lands on a B minor chord, before the cue begins again from the start of the second section. Though the cue repeats and follows this same pattern, Kondo adds another mechanism to increase the musical tension for the repeat: he adds arpeggiation into the cue, where the slow-moving chords are instead articulated by arpeggios, rather than held pitches. This results in further rhythmic density and a full texture, without changing the fundamental materials of the cue.

The cue is initially mixed quietly in the soundscape – not that the performance is delicate, but rather, that it sounds distant. The tower segment of the dungeon involves Link investigating several rooms connected by a spiral staircase. As Link moves further up the tower, the organ cue becomes more prominent in the mix. Indeed, it is so powerful that it dominates other music: whereas an enemy attack would normally prompt a background cue to be displaced by a combat cue, here the organ music continues undaunted.

The final segment of the spiral staircase, up to the area where Ganondorf awaits, is particularly extensive. There is nothing to do on this long staircase but to direct Link to climb the staircase while the organ music fills the audio space – players here seem to be directed to listen to the music. The cue is part of the way the game generates escalating excitement as players anticipate the confrontation between Link and his nemesis.

Link finally enters the chamber where Ganondorf is revealed. As we have already guessed, it was he who was playing the organ (Figure 3.31). We will deal elsewhere with the use of Ganondorf's theme throughout the game, but this moment sounds as its most extensive sounding.

Julie Brown has discussed the association of the organ with villainy, and especially supernatural or horrific evil at that. She traces the tradition back to horror films of the 1920s and 1930s, and even earlier to Captain Nemo's organ in Jules Verne's 1870 novel *20,000 Leagues under the Sea*. She writes,

> The instrument's clear religious associations enable it to serve as a musical sign of religious ponderings [...] esoteric knowledge [...] and possible death followed by funerals [...] The organ's usual locations – inside churches and cathedrals, near crypts – alludes to the spaces of the Gothic novel, joining with tolling cathedral bells and choral voices in horror films in this respect. The immensity of the sound of a pipe organ seems well suited to a horror film's sense of monumentality, and its desire both to scare and to create larger-than-life characters. Its

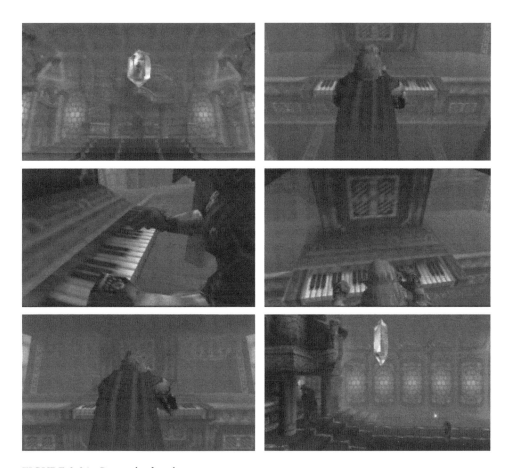

FIGURE 3.31: Ganondorf at the organ.

> effect might be likened to Edmund Burke's notion of the sublime [...] [where] huge objects evoke awe and terror – a sense of the sublime.[49]

The use of organ music for Ganondorf ties him into this tradition of gothic antagonists. He is typically found in, or near, high-walled stone castles. The organ helps to articulate his monumentality, power and the fear with which he is regarded, by drawing on this established history of the organ. Brown continues,

> In horror movies the organist is typically a weird male loner, with plans to exert some sort of power. This topos [...] may partly exploit the solitariness of the typical church organist who commands his immensely powerful instrument from his usually hidden loft.[50]

Ganondorf fits perfectly into this tradition: he is seen only briefly in the game, despite serving as the main antagonist. He certainly aims to exert power, and the room at the top of the tower serves as the organ loft, where he performs music heard below.

More specifically, the organ taps into the connection of both religious and sonic power. He aspires to wield the supernatural power that is woven into the mythology of Hyrule. Brown writes about Dr Jekyll in the 1931 film in terms equally applicable to Ganondorf:

> An almost god-like aura attaches to him [...] Having succeeded in controlling this immensely powerful musical instrument, he immediately attempts, god-like, to control nature.[51]

Just like Jekyll, Ganondorf's sonic power becomes an indication of his supernatural abilities. Irrespective of the difficulty of the boss battle to come, the musical sequence articulates Ganondorf's power – the message to the player is clear – this man is dangerous, be afraid. Ganondorf has similar aspirations of control to Jekyll. In the case of Ganondorf, Link stands in his way.

In the tower cue for the last dungeon, Kondo uses a surprisingly conventional trope: the organ-playing villain. But the result is still effective: aided by the N64's relatively convincing reproduction of an organ timbre, by drawing on established meanings, the organ's menacing cue helps to articulate Ganondorf's character. Though the character has few lines, this organ serves as a shortcut for rounding out his identity, putting him in a long line of evil antagonists. Crucially, however, it is way of illustrating his power, building up tension and anticipation, part of creating a thrilling experience for the player.

Dungeon cues come with particular demands, even beyond those normally associated with location cues. Three such challenges are particularly notable: distinguishing the environments, listener fatigue and representation of danger.

Like any location cue, dungeon cues must distinguish and evoke the environment. The dungeons, however, have similar designs: they all take the form of a series of discrete rooms, each containing a particular challenge. When elements of design are common across the dungeons, music is one of the ways that the areas are differentiated and variety is provided to the player.

Kondo uses distinctive timbres, rather than memorable melodies, to characterize the spaces and places. Beyond using generally unusual timbres (such as the

glassy sounds for the Ice Cavern and the synthesizer for the Deku Tree), he specifically uses timbres to represent material textures, such as, for example:

- bodily burps in the dungeon cue for Jabu-Jabu;
- wooden angklungs in the Forest Temple;
- rocky rumbling in Dodongo's Cavern; and
- grinding metallic sounds in the rusty Shadow Temple.

Such an approach helps to sonically realize the texture of the physical environment. We cannot touch the virtual space, so this is way of providing that sensory channel through the audio. Kondo also often uses reverb to emphasize the sonic space of these large enclosed dungeons.

Kondo also draws on other musical traditions, to add distinctive timbral colour (such as the Indian instrumentation in the Spirit Temple and verbunkos allusions in the Water Temple). This is perhaps exoticist, but Kondo does not aim to specifically emulate these styles, unlike, for example, the way that Lon Lon Ranch emulates country music.

Kondo uses fragmentary textures to avoid listener fatigue. Players are liable to spend long stretches of time in dungeons, often with great frustration as they attempt to solve the challenges in the dungeon (the notoriously patience-testing Water Temple floats to mind). Fragments are less ear-catching, difficult to predict and remember, and it is harder to identify the repetition of the looping cue when an atomized texture is used. These cues will frequently be interrupted by the battle cues when Link is threatened. Avoiding long melodies in favour of short phrases makes the swift musical change less jarring.

To create a coherent, but fragmentary texture, Kondo frequently uses the technique of providing improvisatory melodies in a free tempo over an ostinato, accompaniment or sonic backdrop (such as wind sounds that further represent Link's physical experience for the player). Often, limited scales are used and particular melodic phrases are repeated, to give a degree of consistency.

Kondo typically restricts the timbral selection of materials to avoid unpredictability falling into incoherence. This same balance is evident in the tonal aspects of the cues: harmonic progression is not typically prized, though there is often some logic to the movement or a limited selection of pitches, to help provide the cue with organization and consistency. Kondo has to walk a fine line between, on the one hand, blandness, and, on the other, annoyance.

Much of Kondo's music for dungeons might be described as 'ambient'. Ambient music (as a genre) is difficult to define precisely but it is typically described as 'unobtrusive electronic music, made using sustained tones, that fosters an atmosphere,

mood, or sense of place'.[52] It accommodates and rewards intense listening, but it is also designed for background, inattentive, listening. Ambient music is particularly associated with Brian Eno, who describes his ambient music as retaining a 'sense of doubt and uncertainty',[53] Victor Szabo claims that, to create a 'musical evocation of doubt [...] music would have to convey stability or assurance, while at the same time hinting that this assurance might be a false pretence'.[54] He goes on to suggest that ambient music does this

> by establishing a global sense of stability (through use of a limited range of melodic gestures, a narrow dynamic range, etc.), while remaining inconstant on the local level (through unpredictable entrances, shifts in colour, changes in harmonic quality, and so on). [...] [and] establishes 'constant inconstancy' of musical texture as a quintessentially Ambient mode of setting a doubtful or uncertain mood.[55]

This then, would seem perfectly suited to dungeons – environmental music which sets a mood of uncertainty and doubt.

The dungeons are the most dangerous and mysterious areas of the game. This mood also drives Kondo to use signifiers for horror and danger (such as the organ, voices and scrapes/rattles). The music is part of the evocation of threat and the thrilling emotional tension that comes with the knowledge that dangers await. The mixing of such cues, with half-heard sounds and instruments that fade in and out of aural perception, is one of the ways that Kondo trades on musical ambiguity in the service of portraying danger. This feature also provides a further sense of space (such as the animal-like calls in the Forest Temple, and the distant voices in the Spirit and Shadow Temples).

The textures also relate to the danger of these areas. Since enemies typically make sound in the world of *Zelda*, players (especially cautious players like myself) are constantly listening for the sonic indication of enemies that might threaten Link. The sparse soundscape textures allow players to successfully listen for such dangers. When I am in a dungeon, and listen for the tell-tale flapping of the Keese birds that attack Link, they are easily audible through the fragmented texture of the underscore, whereas a more consistently full texture may present a barrier to hearing the sound of enemies.

Kondo's dungeon cues are able to take these three considerations (among others) and create a diverse set of cues that fulfil the practical concerns without becoming formulaic. Though these cues may not be as well known as some of the other cues in the game, they remain an important part of the experience of playing *Ocarina of Time*, both musically and generally.

Towns

In *Ocarina of Time*, Link visits a variety of different types of locations. One kind of location is perhaps best described as a 'town'. These settlements are large areas where Link is not subject to any significant threat. In the houses and businesses of the town, Link will meet non-playable characters, who serve to enrich the fiction of the game with their backstories, and who will often set Link sidequests or challenges. As the *Legend of Zelda* official encyclopaedia puts it:

> The towns and villages of Hyrule are essential hubs for those who seek refuge from the world's wilder concerns – or just a good night's rest. Townspeople have a way of trading in information as well as useful items and equipment, with the information often supplied just for bothering to stop and talk. Link can learn an awful lot about a region or its people by visiting a village.[56]

A town typically features shops and sideshow attractions that serve as minigames. From the perspective of a gamer focused on the primary mechanics of the game, towns are less interesting than the challenge of the dungeons, but the fictional richness of these areas makes them some of the most enjoyable and fondly remembered spaces of the game.

'Towns' have been a part of computer role-playing games (RPGs) since at least *Ultima*, and while, as stressed earlier, *Zelda* is not an RPG, it inherits much of the fictional architecture of those games. The tradition of having a dedicated 'town theme' in an RPG extends back at least as far as *Ultima III* (1983) and became an established norm for Japanese RPGs in *Dragon Quest* (1986).[57] In *Ocarina of Time*, each of the towns has a different theme, communicating the nature of the environment, just like dungeon cues illustrate the danger of the underground lairs.

Kokiri Forest – Optimism and Ornamentation

Link's adventure begins in the village called Kokiri Forest. This lush forest area is Link's home. It is the first area of the game that the player encounters, beyond Link's small house. Because it has to serve as an area for the player to learn the basics of controlling the game, there is little here that is threatening. Instead, it is filled with friendly characters and provides a small landscape to explore. The Kokiri are a diminutive species with a child-like appearance. They live in homes made from hollowed-out tree trunks and fear straying beyond the boundary of the Forest. This tranquil and bucolic Neverland seems far from the evil brewing elsewhere in the world of Hyrule (Figure 3.32).

THE LEGEND OF ZELDA

FIGURE 3.32: The bucolic Kokiri Forest.

FIGURE 3.33: The ornamented melody of Kokiri Forest.

The cue for Kokiri Forest articulates a happy and jolly mood, presenting a woodland world of safety and optimism. It uses a clear melody and accompaniment texture. The playful and sprightly melodies are supported by a bouncing accompaniment pattern, using pizzicato strings and bassoon. The cue is in three main parts, each with its own melody. The first main section of the cue uses a melody played by piccolo and xylophone. As shown in Figure 3.33, the melody has a sense of lively movement because of the rapid jumps (but not wide leaps) and the decorative ornaments. Particularly notable is the mordent: the quick sounding of a note higher than the main pitch – here notated as the semiquavers in b.2 of Figure 3.33. Other woodwind parts play cheeky echoing phrases after the end of the melodic phrase.

In the second section, the strings move to sustained chords and the melodic interest is taken by the harpsichord. The harpsichord here contrasts with the gothic context of the Shadow Temple. Instead, it here seems to emphasize associations of the gentle, civil and delicate. The timbre of the harpsichord is well suited to the ornamentation of the melody; mordents and ornamentation are hallmarks of historical harpsichord repertoire. In the final section, the mordent figure serves as the main melodic idea, when it is imitated across different instrumental parts, maintaining coherence across the cue while still introducing a new melody. Kondo also uses tuned percussion for more decorative purposes: the xylophone adds tremolo as a coloristic effect over a minor third, and a glockenspiel plays an arpeggio. Kondo's deployment of the ornamented melodies gives a jaunty mood to the Forest. Much like the use of woodwind in the Forest Temple and Lost Woods, we might connect the emphasis on woodwind timbres and plucked strings (brass is entirely absent from the cue) to the gentle, wooded location, while still admitting the streak of magic sprinkled by the glockenspiel.

Each section of the Kokiri Forest cue features the accompaniment alternating between two chords in each bar. The first and third parts alternate C major and B♭ major, the second part alternates F major and G major. This jolly major mode cue provides melodic and harmonic interest without developing into extended progressions. The result is a kind of musical stasis, a neat allegory for the place that seems to exist out of time with the Kokiri who never grow up and avoid leaving the forest.

This cue is entirely upbeat and positive: it uses major modes, bright timbres, jolly rhythmic motion, decorated melodies and delicate colouristic effects. Beyond the general happiness and safety of the environment, the optimism of this cue serves another function. When playing as young Link, if the player saves in a dungeon, they will be returned to the start of the dungeon, otherwise they begin back at Kokiri Forest. Along with the house cue, the music for Kokiri Forest will be one of the most frequently heard pieces of the game and serves to encourage players as they return to the adventure, perhaps after suffering a defeat. The Kokiri Forest cue begins with a fanfare-like figure in the strings, which precedes the first main section of the cue. Particularly when heard after (re)starting the game, this fanfare announces the start of a new adventure.[58] The cue is part of the emotional engineering of the player's experience of the game, especially when this often revisited cue is contrasted with the grimy dungeon cues of Hyrule's most dangerous places.

Castle Town Market – Evoking European Traditions

After leaving Kokiri Forest, Link is told to go to Hyrule Castle to meet Princess Zelda. The castle complex constitutes several areas. Crossing the moat using the

drawbridge, Link finds the marketplace and a few small streets. Continuing past the market, he can approach the cathedral-like Temple of Time or make his way along the path to the castle proper.

The marketplace is a thriving bustling place in the 'child' timeline (Figure 3.34) We see the busy square with traders and dancers, and we hear the murmur of crowds and yapping dogs. We also hear the musical accompaniment of this area, which seems to be coming from somewhere in the square: it is mixed slightly more quietly when Link is in the side streets.

FIGURE 3.34: The Castle Town Market, showing the lively and busy location.

FIGURE 3.35: An extract from the first main melody of the Market cue, showing the accentuation of the compound metre by the rhythm in both the percussion and melody.

The market cue is strongly reminiscent of European folk music. One of the key ways this topic is communicated is by the compound metre, articulated by a tambourine and drum. The main melody of the cue is played by the dulcimer, which was used in folk and courtly musics across Renaissance Europe.[59] The G major melody recalls a jig by emphasizing the compound time signature and strong rhythmic pattern of the tune (Figure 3.35). The same eight-bar passage is repeated two more times, now with a pipe part, doubling the melody, with the addition of a brief rising glissandos to begin each phrase. The repetition of the catchy melody and the emphasis on balanced phrasing call to mind music for organized folk dancing. The melody is conjunct and fits within an octave without deviating from the G major key, thus suitable for an instrument with a limited range and limited ability to play chromatic pitches, like many a tin whistle or pipe.

The second half of the cue introduces a new set of instrumentation, though the tambourine and drum continue. Now, Kondo introduces a second melody, played on a reeded timbre underpinned by an octave drone on D that sounds every bar. Each time this accompaniment drone sounds, it precedes each note by very briefly sounding the note below it. The result is like a bagpipe when the airflow takes a moment to reach full power, resulting in a slight rising portamento as the pitch comes into tune. This passage resembles a bagpipe performance, with the repeated

drone and a melodic part above, though we could also imagine the melody to be a shawm or another reeded woodwind instrument. Though the second section uses a different rhythm to the first, the same emphasis on the compound metre remains, keeping the lively and jig-like nature of the cue.

When Link travels through time, he revisits the same areas, seven years apart. While many town areas have the same cue in both time periods, the market does not. Ganondorf has conquered Hyrule Castle and the market with it. As an adult, Link exits the Temple of Time to find the market derelict, with buildings partially destroyed and the town infested with zombie-like redead creatures (Figure 3.36). There is no Market cue. Instead, we hear the howling wind, the danger music as the redeads threaten Link and the moaning and screaming sounds the creatures emit. This a shocking moment, seeing the friendly bustling town reduced to ruin. It is made all the more arresting by the absence of the market music, testifying to the absence of the population and the fundamental change of the location under Ganondorf's reign.

The contrast between the past and future times makes the cue heard in the past all the more striking in its jollity and the way it implies a vibrant, safe and happy

FIGURE 3.36: The apocalyptic scene in the Market in the future time zone.

location. The game's debt to the European fantasy tradition is particularly clear in the castle area and the faux-Renaissance market square, so it is apt that the game should draw upon associations with traditional folk music.

Kakariko Village – A Wistful Safe Haven

Since many Zelda games are set in the same fictional world, it is unsurprising that some locations recur between games, even if they look very different in each incarnation. Kakariko Village has been featured in several games, including one prior to *Ocarina of Time*.

In *Ocarina of Time*, Kakariko Village is the home of the Sheikah, a race known for their secretive nature, powerful magic and dedication to the Royal Family of Hyrule. The village is dominated by its large windmill and is home to several sidequests that Link may undertake. When Link visits the village as a child, it is bustling with new investment and several buildings are under construction.

The cue for Kakariko Village replicates the musical material that accompanied the same place in *A Link to the Past* (1991) with some subtle reharmonization. Thematic recurrence like this is very useful for a game series: the musical return helps to assert that this is the same location familiar to players, even if the visual resemblance is minimal. *A Link to the Past* was a top-down game and for an earlier generation of console, so the version of Kakariko Village that features in *Ocarina of Time* is very different. Music is part of the way that the fictional identity is created and maintained between instalments of a series.

The Kakariko Village cue features a regular 6/8 arpeggiated accompaniment under a melody in three-time, creating a cross-rhythm that provides the cue with a lilting feel. The *Link to the Past* version is performed using woodwinds for the melody with accompanying strings. A glockenspiel later joins the melody to add colour. In the child time zone of *Ocarina of Time*, the cue uses a guitar for the accompaniment, with a harmonica for the melody, later joined by an ocarina when the melody repeats.

When Link visits Kakariko Village as an adult, he hears a different version of the same cue: the guitar has been replaced by strings, the harmonica by oboe and the ocarina by a piccolo. This orchestration is closer to the original *Link to the Past* cue but also stands as a development of the cue into a larger ensemble and thicker texture. This reflects the buildings that were under construction in the child era and are now complete. The new version of the cue helps to subtly articulate that time has passed in Kakariko Village, and that the world has changed, but that it is fundamentally the same location.[60] Kakariko Village is the only town with a cue heard in different variations between time zones. Perhaps this reflects that it is one of the very few sites in Hyrule to have prospered despite Ganondorf's reign.

The cue is in two sections – an A section, heard twice, and a B section. B serves as an interlude before the cue repeats and begins in the subdominant key, before working back to the tonic. In the B section of the cue, the ocarina harmonizes the melody.

In the cue's performance, Kondo programmes vibrato and rubato, which are especially noticeable at moments of climax in the melody, when the tempo will slow and the harmonica will waver in tone. This helps to provide an expressive performance and perhaps a more emotive experience for the player by avoiding the sterile artificiality that can often arise from computer-precise performance.

The cue has something of a bittersweet quality to it. The andante tempo encourages a reflective mood. Though the piece is in a major key and keeps a moderate tempo with rhythmic activity, there is a certain wistfulness. This musical quality is evident even beyond any lived nostalgia that the cue might trigger for players who had previously visited the village in the earlier game.[61] While there is no single explanation for why this piece has the tinge of the contemplative about it, a comparison with another musical tradition may provide some insight.

When the Kakariko Village cue uses the harmonica accompanied by a guitar, associations of America abound. Some of the features of the Kakariko Village cue are similar to those that have been identified as the root of the nostalgic style of the prolific American nineteenth-century composer Stephen Foster, whose songs like 'Beautiful Dreamer' hold a significant place in the American musical identity. Susan Key, among others, has identified some musical aspects of Foster's work that help to give it a bittersweet quality.[62] We can see some of these same features in the Kakariko Village cue. These features, as described by Key, include:

- an emphasis on a descending pentatonic gesture to conclude phrases, especially with a pause or sustain before the descent to a perfect cadence
 - o The conclusion of the main melody of A uses a descending pentatonic pattern and this rhythmic profile.
- hymn-like note-against-note harmonization
 - o The B section of the cue harmonizes the main melody with a second instrument playing the same rhythm.
- harmonic progressions that are closed and unit-based rather than extended chains of chords
 - o Section A is primarily based on a closed I–vi–ii–V repeated chord pattern.
- use of the subdominant, rather than dominant, for harmonic tension
 - o The B section starts on the subdominant before returning to the tonic.
- short-long rhythmic profile
 - o The main melody is characterized by a repeating short-long rhythmic pattern.

- climax on a non-dominant chord
 - Both Part A and B have a melodic climax on a G major chord, as an altered sixth chord of B♭.
- sighing gestures
 - Especially noticeable in the last phrase of the A section.
- independence of melody and accompaniment
 - The 6/8 accompaniment and 3/4 melody are rhythmically and textually distinct from each other.

These qualities of the cue are not a checklist for a nostalgic affect, but it does help to explain why this mood is evident in the piece.

The Kakariko Village cue is an evocative one, partly because of the reprise from the previous game, the effort invested in providing nuance to the performance of the cue and the musical features that help to provide a bittersweet or wistful mood to the cue. The overall affect of the cue implies that the player should take time to explore this safe area and enjoy the slow pace of life in the village.

Goron City – Sounding the Materials of the Mountain

High up in the mountain beyond Kakariko Village is Goron City. Here, Link meets the mountain rock folk, the rotund Gorons. These friendly creatures are powerful and resemble large boulders, with armoured backs that serve as protection. The city is carved out of the mountain. It is set over four horseshoe-shaped storeys, with tunnels and rooms around the outside of the edge of the levels. Decorations and walkways are also created out of rope and wood (Figure 3.37). In the centre of the town is a giant clay pot, which forms part of a puzzle. Link visits the city as both child and adult, and the cue is the same in both time zones, most likely because the city undergoes little change between the two visits.

The location cue for Goron City is characterized by its instrumentation – the whole cue consists of percussion. The ensemble consists of five instruments similar to particular real-world percussion: a cuíca (a Brazilian friction drum that makes a sound similar to a laugh), a djembe (a West African drum), a tablā drum (from the Indian subcontinent, which uses pitch bending as part of the performance), a balo (an African ancestor of the modern marimba, but with a buzzing quality to the sound) and a marimba. The percussive ensemble is taken from a wide geographic spread rather than attempting to replicate a particular musical tradition. The emphasis on wood-timbred percussion and sounds with a short decay suits the dry and rocky setting of Goron City – metallic, bright or mechanical sounds would be out of place in this area.

FIGURE 3.37: Goron City, showing the prominent wooden, clay and rope textures.

FIGURE 3.38: The interlocking untuned percussion accompaniment of the Goron City cue.

The balo and xylophone play the main melodic material of the cue, while the other instruments provide an interlocking rhythmic accompaniment (Figure 3.38).

The tuned instruments, the xylophone and accompanying balo, both play parts based on repeated phrases. The balo plays a series of one-bar U-shaped phrases throughout the cue, establishing a foundational background for the melody. Though the balo phrase changes subtly throughout the cue, it always starts on E4

and almost exclusively uses the notes E, G, C and B♭. This subtly changing accompaniment gives the constancy of an ostinato but avoids the potential monotony of unchanging repetition. The melody in the marimba exhibits a similar process. It is based on a descending E to C motif, harmonized note-for-note in sixths or thirds, and is repeated with subtle rhythmic variations. When the whole melodic passage is repeated, each bar is interspersed with the cuíca, creating a call and response across the ensemble, forming a varied presentation of the same melody.

The result of these processes is that the cue is constant throughout but has an infectious groove, as the rhythms play off each other in constantly shifting ways. The dry timbres are perfect for creating clear rhythmic interplay between instruments. It is consistent but not predictable.

Gorons are depicted as enjoying music, especially dance rhythms: as discussed earlier, Link cheers up the Goron leader by playing Saria's Song, which serves that function because of its dance rhythms. Unsurprisingly, then, the city cue also emphasizes these favoured qualities of rhythmic interest and a jolly, bouncy affect.

The materials that make up the Goron City location – wooden structures, clay decorations, cave-like excavations – match the materials in the instruments used in the cue. As discussed with respect to the dungeon cues, the sounds of the materials in the sonic sphere work in tandem with the textures depicted visually. This way, music helps to reinforce the virtual materiality of these locations.

Zora's Domain – A Safe Harbour

What the Goron are to the mountain, the Zora are to the lakes and rivers of Hyrule. Another mainstay of the *Zelda* series, the Zora provide the narrative premise for water-themed challenges. The Zora are humanoids with fish-like qualities: large webbed feet and fins extending from their arms. The Zora village, Zora's Domain, is a large cave centred around a subterranean waterfall and lake. Despite being underground, this is not a gloomy location but full of aquamarine colour and clear water, with bright patterns of light from the water reflecting on the cavern walls (Figure 3.39).

In this cue, Kondo uses a small ensemble consisting of steel drums, a guitar and synthesizer, supported by drums and shakers. The cue has a relaxed tempo and the bongo-like drums and shakers give the cue a laid-back affect befitting this serene place.

The melody for the cue is presented by steel drums and the synthesizer, and it is created from long held notes that float over the accompanying guitar and percussion. The languid main melody only consists of a four-note phrase, D–F#–D–E, heard four times. The melody for the second, shorter part of the cue, consists of a four-note chromatic descending scale played and harmonized by the synthesizer

THE LEGEND OF ZELDA

FIGURE 3.39: The aquatic world of Zora's Domain.

(A–G#–G–F#), moving one note per bar and repeated. These are slow, unhurried melodies in a limited range.

The steel drums play their characteristic tremolo pattern, quickly alternating between pitches to create a sustained sound. In this cue, the steel drums play chords in intervals of fifths or sixths to harmonize the main melody. The synthesizer pad uses a timbre similar to the shimmering metallic sound of the steel drums but with a greater attack at the start of each note to better articulate the melody and with a longer reverb to accentuate the echoing acoustic of the underground cavern. The guitar part sounds improvised as it plays irregular arpeggio patterns to articulate the chords presented by the synthesizer and steel drum parts, while also adding ornamentation to the melodic line. Even when the melody repeats, the guitar changes the accompaniment to ensure the cue does not become too repetitious.

The choice of instrumentation for this cue relates both to the mood and setting of Zora's Domain – as we have seen all along, the music connects the narrative, ludic and geographic concerns of an area. It implies the attitude to play that the gamer should adopt when engaging with this space. By using steel drums, an instrument associated with the island states of Trinidad and Tobago, the cue draws

on the water association already embedded in the instrument's cultural meanings. Beyond the cultural association, however, the slow attack and soft timbre of the steel drums is well suited to this location, especially when combined with the cue's major tonality and clear textures. The blurred oscillating timbre of the steel drum even seems to synesthetically imply the movement of gently undulating water or the glistening light on the cavern walls. We know that there is no immediate threat to Link but that he can rest awhile and explore this sanctuary. The lack of abrasive percussion and the leisurely ornamented acoustic guitar all help to promote the area's safety.[63]

Unlike Kakariko Village, when Link returns to the village in the future time period, the cue is the same as it was in the 'child' time zone. In the 'adult' time period, Zora's Domain has been frozen over by evil agents. Even here, however, the metallic timbres of the steel drum and the synthesizer part match the frozen, crystalline version of the area, much as we saw in the Ice Cavern. That said, perhaps the guitar is a less neat fit for the frozen 'future' version of the town. Kondo's choice of instrumentation is nevertheless serviceable in both incarnations of the same location.

The music for Zora's Domain draws on the associations of particular instruments from the Caribbean to match the water-themed area. The glimmering quality of instruments that feature undulating timbral qualities seem to imply fluid motion of water, even if that movement is not actually visually animated by the game. At the same time, the cue also uses a relaxed affect (through major tonality, rhythmically sparse percussion, slow-attack timbre and a languid melody) to convey the safety of the location.

Gerudo Valley – Hispanic Traditions in the Desert

The Gerudo Valley is to the West of Hyrule Field. Link visits this area on his way to the Spirit Temple. The music stretches across a huge area of the game's virtual world – it begins at a ravine area just beyond Hyrule Field and continues for the Gerudo Fortress across an extended desert (the Haunted Wasteland) and right up to the Desert Colossus that houses the Sprit Temple.

The cue for this area is played with a particularly distinct ensemble of instruments: two trumpets, three acoustic guitars (two playing rhythm parts, one playing melody), an acoustic bass and clapping hands. The melodic material is sounded by the trumpets and the solo guitar. The melodies are primarily created from one- or two-bar phrases which are repeated and transposed to match the changing chords of the accompaniment. The motifs that are repeated to make up the melodies use rapid rhythms of semiquavers and dotted quavers, often starting after the first beat of the bar, adding further rhythmic energy to the cue. Kondo often

FIGURE 3.40: The clapping ostinato parts of the Gerudo Valley cue.

uses semiquavers to form ornaments, such as mordents, around the main notes of the melody.

The piece clearly draws on Hispanic musical traditions for its inspiration, especially the Mexican mariachi and the Spanish flamenco. One of the striking features of the cue that clearly alludes to the flamenco tradition is the clapping accompaniment (palmas). There are two clapping parts, each clapping every semiquaver of the beat, but, as in much flamenco music, by emphasizing different beats of the bar, a rhythmically complex combination is created, especially when the clapped emphasis is different to the main beats of the bar (Figure 3.40).

The two clapping parts simultaneously present 3+3+2+4+4 and 4+4+3+3+2 rhythms, which helps to give the cue its propulsive drive.[64] This clapping accompanies the guitars which both articulate the harmony and add another layer of rhythmic interest. The cue is built from a repeating four-bar pattern, with one chord per bar: F# minor, D, E7, C#7. The bass part plays the steady crotchets to define the foundation of each chord, while the two rhythm guitars play a fast strumming pattern with thick chords that sound the harmonic progression. These elements all provide the accompaniment foundation to the cue, over which the main melody sounds. The cue gains its sense of motion through this layering of different rhythmic accentuations, the steady four-beat bass, the clapping accents and the strummed guitars.

Though the cue seems to draw on flamenco music (especially in the clapping), it does not precisely replicate a flamenco style. While flamenco is a broad musical style, with many different subcategories, some more or less specific in their definitions, the Gerudo Valley cue does not feature many of the important musical features typical of flamenco.[65] If anything, the style is perhaps similar to the four-time flamenco rumba, the result of musical influence from Latin America. However, the cue does show influence from another Hispanic musical tradition – mariachi.

The Gerudo Valley instrumentation fits the Mexican mariachi band well. The two trumpets are typical of the Mexican mariachi ensemble, and when they play ornamented figures, they evoke the *adornos* that decorate the melody in mariachi performance. The violins often found in mariachi music, however, are absent.[66] The guitars neatly map to the multiple guitars of the mariachi ensemble (rhythm

vihuela, bass guitarrón and guitar). Indeed, the use of complex strumming patterns is a point of commonality between Mexican and flamenco traditions. The rhythm of the guitars approximates the mánicos (strumming patterns) of the vihuela, and while the Gerudo Valley cue does not specifically replicate a particular archetypal mariachi rhythm, this does not discount the influence. As Daniel Sheehy notes, the mariachi repertoire and 'sound texture' is continually evolving: 'Mariachi arrangers [...] are constantly experimenting with new rhythms, harmonies, sounds, and forms.'[67]

It would be reductive to claim that the Gerudo Valley cue definitely fits into either mariachi or flamenco styles; it takes influence from both, much as we have seen Kondo selectively borrow musical influences from other traditions elsewhere in the game.[68] Considered one way, this might appear culturally insensitive – a kind of exoticism or orientalism whereby other musical cultures are homogenized and blurred into a generic 'other', or in this specific case, a generalized Hispanic music. We might accuse him of appropriating elements of precious cultural materials as generalized shorthand of the musically unusual. Viewed another way, however, given that *Ocarina of Time* does not attempt to depict real-world cultures, let alone claim any authenticity of representing a musical tradition, perhaps this combination of musical influences is not so problematic. In a game like *Ocarina of Time*, set in a fantastic world, we already understand that diverse cultural influences (musical, architectural, iconographic and so on) are drawn upon and combined to create the fictional worlds. Nevertheless, we might feel a little uneasy about the use of a Spanish-Mexican musical fusion to accompany a group of people known in the game as the 'noble thieves of the desert',[69] even if they ultimately come to aid and support Link.

The 'Gerudo Valley' music covers the desert areas of Hyrule. We might make a connection with the Chihuahuan Desert of North America or the desert areas of southeast Spain, such as the Tabernas Desert which has so often doubled for the American desert in film. Given that the Gerudo are almost entirely female, with only one male born every generation, perhaps the image of the powerful female flamenco dancer might tie into the notion of feminine authority.

The Gerudo Valley cue serves two important functions through its stylistic combination – the geographical associations of the music and the rhythmic propulsion. The desert area of this region of Hyrule might be neatly matched by the deserts in (at least some) regions in which the two musical styles originate, providing a connection in the popular imagination between the climate and the music. Second, these two musical styles are notable for rhythmic intricacy, which Kondo uses as a frame to layer differently accentuated layers upon each other. At the same time, the instrumental timbres of the genre do not result in a confused or unclear texture but instead maintain clarity, even when layered. The result is a propulsive

musical fabric. The sense of rhythmic drive is particularly important in this area of the game, both because the area is expansive (so Link must be encouraged to keep going), and because Link is often forced to repeat his steps. If he is caught by the guards of Gerudo Fortress before he has been awarded amnesty, or if he loses his way across the desert, he is returned to an earlier location and must repeat the section. Despite apparent setbacks, the rhythmic properties of the cue help to motivate the player for another attempt. Once again, the location cue demonstrates a combination of both ludic and fictional-aesthetic concerns.

We can draw direct comparisons between the cues for towns and dungeons, to show how the musical properties of each articulate their differences, both in ludic terms and in fictional terms (Table 3.8). They present opposite poles of musical stability and instability, which serves as a sign for safety and danger. It is, of course, entirely apt that the dungeon cues and the town cues should be so musically contrasting, given the different functions they serve in terms of the gameplay – these towns are less likely to be visited for extended periods, and they host different kinds of ludic challenge to the dungeons. The town cues not only enrich the fictional aspects of the universe by providing vivid colour to the places and drawing on musical topics and styles to depict the areas of the world, but they also effectively communicate to the player how the mode of play is different in these places. Dungeon music appears as all the more unstable, the area all the more threatening, through the contrast with the town themes.

Recurring Types of Location

So far, we have dealt with cues for specific places in Hyrule. However, Link will often encounter similar types of place in different geographic locations. For example, Link can visit a shop in Zora's Domain, Kokiri Village and Goron City (among others), and while the content of the shop may vary (as well as the shopkeeper), the interface will be identical. The music will also be replicated in each shop Link visits. The same is true for Fairy Fountains, sideshow games, houses and potion shops.

Shops – Hyrule's Consumer Soundtrack

The music for the shops is rather unexpected in style, given the fantasy setting of the game. It takes the form of a bossa nova. Over the bossa groove played by

Town	Dungeon
Stability and Safety	**Instability and Danger**
Consistent accompaniment patterns with specific harmonic outlines, often drawing in particular musical genres (e.g. the arpeggiating guitar of Kakariko Village, the folk-like drone of the Market cue, etc.)	Indeterminate drones and rumblings that provide a sonic backdrop for cues, or accompaniment patterns that are not closely coordinated with melodic material
Balanced and clear-cut melodic phrases	Apparently improvisatory and fragmentary melodies, often with little identifiably melodic material at all
Clear textures (usually melody and accompaniment)	Murky and blurred musical textures
Significant repetition of melodic material, both within musical sections, and across repeated sections. Generally clear organizational structure	Avoids ear-catching melodic material and disguises musical repetition
Clear harmonic organization	More ambiguous harmonic organization
Definite and clear ensembles which often approximate specific traditional musical instruments	Musical instruments that fade in and out of the texture, many without a close match to traditional musical instruments
Dance topics and emphasis on accentuated rhythms	Rhythmically unpredictable and irregular patterns, often with little sense of meter

TABLE 3.8: A comparison of dungeon and town cues.

cowbell, cabasa, bongos and acoustic bass, a guitar, bandoneon and brass play the melodic material. The cue is in two main sections; the first with the melody in the bandoneon, the second with it in the brass. Both melodies emphasize the bossa rhythm and are created by the sequential repetition of phrases that articulate the underlying chord. Though jolly, the melodies are not particularly distinctive, other than the way that they stress the bossa nova groove. The interest here is rhythmic rather than melodic.

Though of Brazilian origins, the bossa nova gained popularity in the United States in the 1960s. What is it doing in Hyrule? More than anything, the shopping music appears as a sly parody of piped music in modern retail

environments. More specifically, the style brings to mind music from the Muzak corporation, especially that of the company's 'stimulus progression' programming during the 1970s. Muzak rerecorded popular songs in jazzy or 'light classics' instrumental-only versions, usually featuring a small orchestra with a smattering of additional pop instrumentation. It prepared these recordings for mass consumption in industrial and retail spaces, including shopping malls. Since muzak was designed to provide a degree of stimulation, it often featured gentle percussion parts, sometimes in a Latin style, especially in the albums of the 1970s. While muzak did not use bossa nova as ubiquitously as popular stereotypes would have it, nevertheless, as David Treece notes, bossa nova 'acquired [...] connotations as the archetypal "background" muzak of airport lounges and shopping malls'.[70]

Kondo's faux bossa nova muzak serves two purposes – it is humorous, but it also takes advantages of the same kinds of practical concerns that muzak aimed to address. Kondo satirizes the ubiquity and uniformity of muzak, as well as the consistency of the shopping experience of the twentieth century. No matter where one goes in Hyrule, the shops all play the same music – it is inescapable. As Jonathan Sterne notes, 'generally speaking, stores within a particular chain all use the same or similar music programs to achieve a uniformity of corporate image'.[71] Its incongruence here betrays that muzak is for everyone in general and no one in particular. For all of the humour, however, Kondo would not use the cue if it did not function appropriately in the game.

As Ronald Rodano notes,

> Muzak arrangements communicate a sense of resolute calm and predictability [...] suggesting metaphorically the courteous pleasantries of polite public encounters. Muzak sounds 'happy', and only happy. [...] Muzak functions syntactically as a metaphor for the home; harmonic simplicity and predictability signify popular conceptions of a secure private world. [...] It functions as a special blanket of security.[72]

The same applies in the shop cue – wherever Link may be in Hyrule, the shop music provides comforting familiarity, signifying safety and indicating the function of the establishment, as well as the expected mode of interaction.

Muzak produced their recordings and engineered their programmes to 'produc[e] a psychological and physiological effect, culminating in a sense of forward movement which combats monotony, boredom, tension, and fatigue'[73] (or so they claimed). This is music designed not to be annoying but remain propulsive. For all its satirical edge, Kondo's cue serves much the same purpose, gently encouraging the player.

Kondo's shop cue seems to have it both ways. At once, it is a sly satire of muzak and a commentary on the tradition and challenges of creating music designed to be heard for long periods of time without creating irritation or boredom. And yet it also is able to utilize the same features of gentle motivation that Muzak aimed to produce.

Sideshow Minigames – The Fairground Connection

Some of the towns that Link visits feature sideshow attractions. These are games of skill or chance, such as target practice games or random choice tasks. Link is normally rewarded with a special item or currency for success. Just like the shops, sideshow attractions feature the same cue no matter where they are encountered.

Though the cue uses several different instrumental timbres, the overall impression is of one multifaceted instrument – a fairground organ. We hear timbres that sound like the pipes of a small organ or calliope and a texture that summons the image of a carnival. Above an oom-pah accompaniment that primarily alternates tonic and dominant chords, a decorated repetitive melody winds its way above the chord progression. Unlike some of the other cues in *Ocarina of Time*, Kondo avoids any expressive aspects of performance: no rubato, the parts are locked in mechanically precise homophony that implies an automated performance – even the melodic decorations are stiff and precise.

The cue is in the form of AAAB AAAB CC and so emphasizes repetition even within the one cue. This is a dangerous strategy for a video game cue that will be looped, but the stylistic model of the repetitious fairground organ, and the limited time for which this cue is likely to be heard, help to mitigate the problem.

Apart from the organ parts, the cue also features percussion in the form of glockenspiel, snare and a cymbal – all commonly found in fairground organs. The glockenspiel doubles the melody the second time the AAAB section is heard, the metallic timbres enhancing the image of automation. The snare drum rolls to a climax, punctuated by the cymbal crash, a pattern repeated twice, accompanying a repeated phrase in the melody (C). Even this snare drum roll, however, has the aura of artificial performance in the motoric precision of its rhythm.

The introduction to this cue, prior to the main repeating loop, is created from the end of the cue, fading in, as Link enters the sideshow building. Not only does this mixing give the impression of a diegetic source, it also implies continual repetition – the organ continues to repeat its jolly tune *ad infinitum*. Apart from this fading in, the cue is mixed very loudly in the soundscape and has little dynamic variation – again, this is typical of the organs designed to sound at a huge volume for fairs.

When Link enters some of the sideshow attractions, the function of the location may not be immediately apparent. This cue, both in its initial clear association of the fairground, and the established connection within the gameworld, help to indicate to the player what to expect of these sideshows. The carnivalesque atmosphere of the cue also indicates that these challenges are light-hearted and not crucial like dungeons (and who fittingly announce their own threatening seriousness sonically, as we have seen elsewhere).

Houses – A Musical Starting Point

When Link visits houses, including his own treetop house in Kokiri Forest, a particular musical cue plays. Since Link starts the game in his house, this is the first cue that players hear in *Ocarina of Time* while they are in control of the gameplay. They will also hear this cue frequently since, as noted earlier, when the player resets or returns to the game, if they last saved with Link as a child outside a dungeon, he will begin back at his house in Kokiri Forest. The house cue also returns for other domestic spaces that Link visits in the towns, in doing so, drawing on the associations established at the start of the game, and reinforced each time Link returns to his house.

The house cue seems to serve as a neutral musical home, from which other musical strategies can deviate, like calibrating a measuring scale to zero. The game starts by telling players what 'safe' and 'home' sound like, so that the musical exotica and danger to come may be all the more effectively contrasted.

The cue is jolly, unobtrusive, contains clear textures, consonant harmony and orchestral instruments. It is scored for pizzicato strings, clarinets, bassoon and piccolo in A major and 4/4 time. It is characterized by the quick exchange between the on-beat bassoon and the off-beat clarinets in thirds (Figure 3.41). This playful dialogue takes place over the plucked string bass which sounds a repeating pattern that includes both on-beat and syncopated rhythms. This bass part outlines the underlying harmony. The pattern repeats at different transpositions (D, C, B♭, A), before the whole eight-bar section repeats, this time with a decorative piccolo part to provide melodic interest.

From Table 3.8, it is obvious that this piece sits on the town/safe/stable end of the town versus dungeon spectrum. If it were not for the frequent recurrence, perhaps this cue, and its melody, would not be memorable. Equally, however, given that the cue will be heard so often, it likely aims to avoid potentially annoying material, especially at the beginning: if players restarting at Link's house are in a rush to leave, they can exit the room before the melody in the piccolo begins. The continued reminder of musical home, in the form of the house cue, is a point of reference for the musical departures elsewhere in the game. It is this cue's harmonic

LOCATION CUES

FIGURE 3.41: An excerpt of the house cue, indicating the interplay between parts.

secureness, structural clarity and easily identified melodies that will be contrasted later in the dungeon cues.

Potion Shops, Ghost Shops and Lakeside Laboratory – Little Shops of Horrors?

Some of the shops in Hyrule are a little out of the ordinary. Those with more exotic tastes can seek out the shops that deal in potions and ghosts. These alternative shops do not have the pleasant muzak bossa nova found in the other shops, but come with their own music. The same cue is used for the laboratory on the shore of Lake Hylia. Here, the eccentric scientist creates medicines and other concoctions.

The ensemble for the potion/ghost shops consists of chimes, a gong, a djembe and a dulcimer. The foundation of the cue is the accompaniment djembe and the main melodic material is supplied by the dulcimer. This cue is slower than the other shopping cue (mm=94 as opposed to mm=140), with a far sparser texture. The djembe plays a repeating pattern (Figure 3.42) that forms the rhythmic foundation of the cue and is sparsely decorated by the gong and chimes.

Part of the effectiveness of this cue comes from the contrast with the typical shop cue. We do not hear the safe consumerist bossa nova; this is a shop of a very different chain. The instruments are used for their distinctive unusual qualities, as an exotic 'other' to more familiar instrumentation.

FIGURE 3.42: Accompaniment rhythm for the Potion Shop cue. The final triplet figure alternates between two different articulations with each repetition, though the rhythm is the same.

The dulcimer plays musical phrases with irregular phrasing and grace notes, almost like an improvisation. It is limited to a specific set of pitches G, A, B♭, D, E♭ and F#, but every two-bar set (shown in Figure 3.42) begins with a G, providing a rigid frame and sense of regularity. The dulcimer emphasizes the D–E♭–F#–G region of the scale, accentuating the notes that give the harmonic minor its flavour. The melodies have irregular timing, though sonic space is always left for the G at the start of each two-bar unit, anchoring the period.

When we are dealing with synthesized sounds like those of the N64, the distance between the timbres as sounded, and the real-world counterpart that they reference, opens a gap for interpretation. In the case of this cue, Hyeonjin Park has suggested a different reading of the 'Potion Shop', instead identifying the model as Indian classical music. They write,

> Koji Kondo primarily draws inspiration from Indian classical music for this musical cue, which might be inferred from his utilization of a drone instrument. There is also the 'improvisatory' melody that is likely a veena or a sitar, depending on region. This is supported by a curious percussion section that most likely mimics the sounds of one of the main drums found in Indian classical music, a tabla or a mridanga, depending on region. [...]While it is unclear what percussion instruments were used for Kondo's cue, the strokes as well as the context of the other instruments is a good indicator that he was referring to one of the aforementioned drums.[74]

They go on to identify a cyclic tala in the repeated drum pattern and a raga in the melody, which opens up another dimension of interpretation. In any case, the cue clearly trades on alterity through the instrumentation and processes.

The instruments and improvisatory gestures in a limited mode might seem similar to the processes we observed in the dungeon cues. Yet the constant percussion rhythm, short cue duration, regularity of the two-bar cycle and continuity of the musical fabric are more coherent and regular than a dungeon cue. The result is that the cue sits midway between dungeons and the safe familiarity of the typical shop cue. Considering again the musical spectrum of

safety and danger established through the location cues, this potion shop cue mixes elements of the two. This is far more unusual than the normal shop cue – who knows what mysterious, powerful magical goods we might find within?

Fairy Fountain/Start Menu – Angelic Harps

One of the staples of the *Legend of Zelda* series is the presence of fairies in the world of Hyrule. Fairies are friendly and aid Link on his quest. They may restore his health or even grant him new abilities. Fairies come in a variety of incarnations. At one extreme, small fairies are luminescent spheres and can easily be stored in a bottle until their help is needed. At the other extreme, powerful Great Fairies are large and humanoid. In *Ocarina of Time*, Fairy Fountains are scattered across Hyrule. They are accessed through caverns or holes in the ground (like a water well) and they all share a similar form. They feature a paved area leading to a podium that contains a pool of bright water, framed by decorative stonework. Some Fountains feature a monopteros circular Greco-Roman colonnade in the pool area, calling to mind the structures used to host idols. The edges of the space cannot be discerned – we only see a black backdrop against which multitudinous bright streaks of light fall, like gentle rain (Figure 3.43).

These Fountains are united by a common location cue, which primarily takes the form of a harp duet. Though a string part quietly enters during the second half of the loop, the harps still dominate. After a one-bar introduction (in which the harps play ascending spread chords of C dominant ninth), the main eight-bar loop has three harp lines, which would require at least two harps to perform.

At a gentle andante tempo (mm=78), one harp part plays descending arpeggios every crotchet, while the second sounds a countermelody in semiquavers, as though responding to the first part. This second part always takes the form of an arch-shaped or rising gesture. These two parts play out over a bass line, sounding semibreves or minims that anchor the harmony. The overall effect is of an overlapping and complex texture, though the descending lines tend to dominate. It is a musical analogue to the 'rain'-like effects in the Fountain chamber (Figure 3.44).

In some respects, the cue is very straightforward – the arpeggios primarily move by step and the patterns set up in the first bar of the loop remain unchanged. Each bar articulates a different chord, especially emphasizing ninth chords (Figure 3.45). These chords displace what would be a clashing second by an octave, providing instead a sweet dissonance that propels the cue forward in a drive for resolution. The opening chord of the main loop, for example, is G minor (G–B♭–D) with an added major ninth (A), and a melody starting on A. Though the G and A would

FIGURE 3.43: The inside of a Fairy Fountain.

FIGURE 3.44: The rhythmic interplay of the Fairy Fountain harp parts.

FIGURE 3.45: Outline harmony of the Fairy Fountain cue.

normally clash, spacing the pitches at a ninth avoids harsh dissonance in favour of harmonic richness. Philip Tagg and Bob Clarida suggest that minor chords with an added major ninth evoke 'qualities of the bitter-sweet, sad, lonely and longing, at least in European classical (chiefly romantic) music, as well as in the idiom of traditional film music'.[75] While this characterization by no means applies in all cases of the chord, it does indicate the connection with the affect of longing which permeates the Fairy Fountain cue.

The Great Fairies are similar to deities. Together with the architecture of the Fountains, the harp perhaps evokes the lyre. This harp-like instrument is associated with antiquity and depicted on many a monument or ancient artefact. In Greek mythology, the lyre was created by a God, while the harp also has longstanding angelic associations, as well as its general use as an icon of Western artistic activity. The harp, then, is apt for these supernatural, kindly beings, especially when they are powerful enough to command life and death.

The Fairy Fountain cue is heard by players long before they find the Fountains. This same piece accompanies the game select menu, which players encounter each time they start the game, before gaining control of Link. In the context of the menu,

the cue's sense of 'longing', or movement that continually seeks resolution, serves the purpose of providing an impetus for players to begin the game. The lack of resolution is apt for this interstitial menu, providing a gentle harmonic drive to start the game. A soft timbre that avoids a grating or abrasive sounds helps to dent the risk that the cue will be annoying as players revisit this screen many times during their long journey through the game.

While the connection between the Fairy Fountains and the game select menu may not initially be obvious, perhaps the cue is appropriate when one considers the abilities of the fairies. When the fairies have the ability to heal and resurrect Link, this is similar to starting a new game, when a new iteration of Link is conjured into existence. The fairies are life-giving, and this menu also produces a new life for Link. Both the musical properties and the in-game associations make the piece suitable for the game select menu.

Even before starting *Ocarina of Time*, however, players may have encountered the piece before, especially if they are long-time devotees of the *Legend of Zelda* series. The Fairy Fountain cue has a history in the Zelda series. In *A Link to the Past*, the Fairy Fountain cue also serves as the game select menu cue and for the appearance of fairies, but also for the game over when Link runs out of health. Again, we can see a musical connection between life and death and the fairies. The melody of the Fairy Fountain cue is similar to Kondo's earlier cue for the water-themed World 3 of *Super Mario Bros. 3* (1988); perhaps the two are aptly linked because of the aquatic aspects of the environments.[76] The Fairy Fountain cue in *Ocarina of Time* uses the associations developed within the game, while also drawing on those established elsewhere.

After *Ocarina of Time*, the same cue would recur in nearly every subsequent game in the series, either for the game selection screen or for the fairies. In each case it is rearranged slightly to fit the technology of the console and setting of the game, but the distinctive harmonic and melodic material remains recognizable. This cue is one of the ways in which the series' identity is articulated.

The cues for the recurring types of location serve several purposes. They immediately indicate the function and type of location, even if it is not visually apparent. The recurrences tell the player what Link is supposed to 'do' in these places and the function these locations serve in the architecture of the game.

While the dungeon and town cues worked to individualize each location, the recurring location cues do the opposite: they show how geographically separate locations can serve the same function. There is a comforting familiarity and

certainty to encountering the same music in new locations, allowing players to orient themselves in the virtual word.

The recurring location cues help players understand the world of Hyrule not only in terms of geographical distance but in terms of gameplay function, too. We know we can restock on supplies at shops, heal at the Fairy Fountain and enjoy a non-essential sideshow game at the attractions. The cues mediate between the narrative world and the functions of the fictional places in the architecture of the game.

Music for Locations

It has long been recognized that music is an important tool that games use to build their virtual worlds. William Gibbons has noted how the songs played in *Bioshock* (2007) 'embody or reflect on the general dystopian environment'.[77] Andra Ivănescu has argued that the selection of music in *L.A. Noire* (2011) serves to create a hyperreal vision of 1940s Los Angeles,[78] while Kiri Miller has explained that, in the *Grand Theft Auto* games,

> The player-controlled radio stations not only increase the verisimilitude and immersive qualities of each gameworld, but also encourage players to associate particular music with particular characters and places.[79]

Ocarina of Time gives us further insights into how music is intertwined with the articulation of gameworlds.

The location cues are used to characterize areas of the virtual geography, providing a sense of variety and differentiation, even though the construction in terms of the programming is similar throughout Hyrule. In providing musical variety, the environments are distinguished. The diversity enhances the game's quest narrative, emphasizing the wide range of Link's journey across Hyrule, exploring music alongside landscape. The narrative and geography are thus bound together. This connection is particularly apparent with location cues that use ocarina songs and the trope of the gothic organ at the climax of Ganon's Castle. Not many characters in *Ocarina of Time* are given specific themes (see Chapter 4), but location themes seem to double up as character themes, such as the Lost Woods for Saria or the Lon Lon Ranch theme for Malon. These cues sound for particular locations but are also connected to specific characters who sing or play the melodies. The location cues link the narrative, sonic and spatial properties of the game.

More than simply responding to the visual aspect of the game, the music elaborates beyond what we see. One way this occurs is by providing audio representation of physical properties. Echo and delay effects conjure spaces in which music resonates, while wind sounds serve as iconic figures of physical phenomena. As

observed repeatedly in this chapter, musical timbres are often used to imply the material textures of the environments.

Kondo uses musical materials from a diverse range of musical traditions (including folk, historical and world musics). As well as providing variety to the music of the game, they are used for their exotic capital and to draw upon associations of real-world geographies and histories to further round out the visual aspect of the environments.

Listening to the music is part of how we engage with, and come to understand, the world of Hyrule. This applies not only to physical properties of the spaces but also the affective moods of the world. Kondo uses musical instability to indicate danger and stability for safety, and the game musically situates places along this spectrum between 'very dangerous' and 'very safe'.

The location cues encourage particular attitudes to the areas, helping to guide the player to respond to the location. This holds true from cues for dungeons right through to cues for shops and houses. Hyrule Field, as an overworld theme, gently motivates the player to keep moving, while Zora's Domain encourages gamers to explore the area at their leisure. The approaches to melody, harmony, timbre and texture are different, depending on the functionality and affective mood of the place in question. From feeling afraid in dungeons to wistful in Kakariko Village, music makes the landscape of Hyrule as much an emotional journey through the geography as it is a physical one.

Of course, *Ocarina of Time* follows the precedent of the genre in its use of location cues. As Elizabeth Medina-Gray has noted, music can be used to define a game's virtual landscape through musical continuity and change, effectively marking out territory.[80] Players quickly learn the relationship between the background cues and the geography. Musical continuity also works on a broader level, whereby location themes that recur between games help to assert that the same places are being represented, even if they look radically different between instalments.

Location cues are more than just musical signposts to indicate 'you are here'. They bind together the virtual space, the avatar and the player: the triggering, silencing and interruption of location cues are dependent upon Link's actions, for which the player is responsible. This connection was particularly obvious in the Hyrule Field cue, but even more generally, it is the player that causes the musical changes through directing Link to move between locations, engage in battle, and so on.

Steven Reale has discussed how moving across game landscapes can present musical journeys, as the music changes across the virtual world. He notes that 'since many video games establish virtual worlds of internally consistent geography, promoting highly spatial gameplay experiences, game composers are afforded unique

opportunities to create spatial listening experiences'.[81] He describes how *Ocarina of Time* helps to articulate the game's virtual geography, specifically the way that Hyrule Field serves as a tonal and geographic centre. Several of the locations directly neighbouring the field also use neighbouring keys. Hyrule Field is centered on G. The closest keys are C major (used for Kokiri Forest, Lost Woods, the Castle Courtyard and – weakly – Goron City) and D major (used for Zora's Domain and Lon Lon Ranch). Perhaps, in turn, movement to more distant keys like B♭ major (for Kakariko Village and the Fairy Fountain) and, even more remotely, F# minor (for Gerudo Valley) imply more extensive journeys. Beyond moving between neighbouring locations, some of the warp cues prepare the key of the background cue of the destination. Though this does not always happen, especially for Bolero of Fire and the Nocturne of Shadow, where the destination cues do not have strong tonal profiles, tonal preparation is evident in other cues (Table 3.9). Even without claiming intention on the part of Kondo, the gamer prompts these transitions through their (musical) actions.

The location cues add a magical sheen to the world of Hyrule. This is a fantastical world when music is 'in the air', often emanating from the world without any discernible source. The unrealistic qualities that music lends to the world is particularly obvious when the music appears to slip between diegetic levels. In the case of the location cues that use the ocarina songs, this slippage is another way that the narrative and environment are bound together, as each makes the other more meaningful.

Because the location cues guide players through the game, leading and shaping their interaction with the environment, they are part of the non-verbal design language of the game. The location cues indicate the functionality of a site, how dangerous it is, the kinds of challenges players should expect, how significant it

Warp Song	Destination Cue	Song Conclusion	Destination Cue Key
Prelude of Light	Temple of Time	D major	D minor/Dorian
Minuet of Forest	Lost Woods	E major	C major
Serenade of Water	Hyrule Field	D major	G major/ Mixolydian
Requiem of Spirit	Gerudo Valley	D major	F# minor

TABLE 3.9: The tonal journey presented by warp songs and destination background cues.

is for the plot, the likely gameplay challenge (or lack thereof) and so on. These cues even shape the mood the designers hope the players will associate with that area. The location cues are not the same kind of performed music that we saw with the ocarina in the previous chapter. Yet, such cues are still an element of the interface of the game. They are an important part of how we come to understand, and interact with, the game.

NOTES

1. Brian Massumi, 'Envisioning the Virtual', in *The Oxford Handbook of Virtuality*, ed. by Mark Grimshaw (New York and Oxford: Oxford University Press, 2014), pp. 55–70 (pp. 55, 57).
2. Elizabeth Medina-Gray, 'Modular Structure and Function in Early 21st-Century Video Game Music' (Ph.D. dissertation, Yale University, 2014), p. 152.
3. Karen Collins, 'An Introduction to Procedural Music in Video Games', *Contemporary Music Review*, 28 (2009), 5–15 (p. 9).
4. On modularity, see Medina-Gray, 'Modular Structure and Function'.
5. Winifred Phillips, *A Composer's Guide to Game Music* (Cambridge, MA: MIT Press, 2014), p. 188.
6. Jason Brame, 'Thematic Unity across a Video Game Series', *Act*, 2 (2011), 16pp. (p. 12).
7. Ibid., p. 5.
8. Ibid., p. 8.
9. Peer Schneider, 'The Legend of Zelda: Ocarina of Time Review', *IGN* (1998), https://uk.ign.com/articles/1998/11/26/the-legend-of-zelda-ocarina-of-time-review [accessed 14 January 2019].
10. Phillips, *Composer's Guide to Game Music*, p. 66.
11. Ibid., p. 161.
12. I have made this argument in more detail in *Understanding Video Game Music*, pp. 148–49.
13. The exceptions are tag 9, beginning on F over G in the bass, 7 and 8 starting on C and 11 on A♭.
14. Nicole Biamonte, 'Triadic Modal and Pentatonic Patterns in Rock Music', *Music Theory Spectrum*, 32 (2010), 95–110; Trevor de Clercq and David Temperley, 'A Corpus Analysis of Rock Harmony', *Popular Music*, 30 (2011), 47–50.
15. Gamers enjoy discovering hidden features and attributes of a game. For those players who do recognize how the music changes with Link's actions, they are rewarded with the revelation of this 'Easter Egg', encouraging them to continue to engage with the music.
16. Ben Abraham, 'Marty O'Donnell in Interview', Abraham's personal blog (seven parts, December 2008–February 2009), retrieved from http://drgamelove.blogspot.com/search/label/Interview%20with%20Marty%20O%27Donnell [accessed 8 July 2018].

17. Mark Sweeney, 'The Aesthetics of Videogame Music' (D.Phil. thesis, Oxford University, 2015), p. 169.
18. Ibid., p. 218.
19. Timothy D. Miller, 'Hawaiian Guitar', *Grove Music Online* (2013), https://doi.org/10.1093/gmo/9781561592630.article.A2241449.
20. John W. Troutman, 'Steelin' the Slide: Hawai'i and the Birth of the Blues Guitar', *Southern Cultures*, 19 (2013), 26–52 (pp. 27–28).
21. Daniel Neill, 'From Singing to Cryin': Towards an Understanding of the Steel Guitar in Country Music 1915–1935', *Canadian Folk Music*, 48 (2014), 1–8 (p. 4).
22. This jolly mood is further betrayed by the Lost Woods cue's passing similarity to 'Jupiter, the Bringer of Jollity' from Holst's orchestral suite, *The Planets*. The rhythmic profile and melodic shape are similar.
23. R. Murray Schafer, *The Soundscape: Our Sonic Environment and the Tuning of the World* (Rochester, VT: Destiny, 1994).
24. For an application of soundscape theory to games, see Elizabeth Hambleton, 'Gray Areas: Analyzing Navigable Narratives in the Not-So-Uncanny Valley between Soundwalks Video Games, and Literary Computer Games', *Journal of Sound and Music in Games*, 1/1 (2020), 20–43.
25. Megan E. Hill, 'Soundscape', *Grove Music Dictionary of Music and Musicians Online* (2014), https://doi.org/10.1093/gmo/9781561592630.article.A2258182.
26. Nicholas Cook, 'Methods for Analyzing Recordings', in *The Cambridge Companion to Recorded Music*, ed. by Nicholas Cook, Eric Clarke, Daniel Leech-Wilkinson and John Rink (Cambridge: Cambridge University Press, 2009), pp. 221–45 (p. 226).
27. Megan L. Lavengood, 'A New Approach to the Analysis of Timbre' (Ph.D. thesis, City University of New York, 2017), pp. 16–27.
28. Andrew Goodwin, *Dancing in the Distraction Factory* (London: Routledge, 1993), p. 59.
29. The Dodongo's Cavern cue is reused elsewhere in the game – for a mini-dungeon, the Gerudo Training Ground, as well as location music for Death Mountain Crater (near to Dodongo's Cavern) and a maze underneath Kakariko Graveyard. While Death Mountain Crater and the Gerudo Training Ground use similar visual textures to Dodongo's Cavern, it is difficult to identify a definitive reason for the cue's reuse.
30. Michael J. Field, 'Music of the Heart', *Lancet*, 376/9758 (2010), 2074.
31. A whale or large shark would have a heartbeat so significantly slower than that of a human that a more accurate replication of the heart rhythm would risk losing the sonic identity of a heartbeat at all.
32. For details of a comprehensive investigation into this topic, see *Pop Fiction Season 1 Episode 9: The Fire Temple Chants [Update 2]*, producer: Michael Damiani, editor: James Ondrey/Don Casanova, voice: Brandon Jones. Originally produced for the website *Game Trailers*. YouTube version, 27 September 2013, https://www.youtube.com/watch?v=U34MFcJdGCo [accessed 17 July 2018].

33. Email from Nintendo of America to *Game Trailers*, screen-captured and reproduced in video *Pop Fiction: Season 1 Episode 9*.
34. Heather Maxwell Chandler and Stephanie O'Malley Deming, *The Game Localization Handbook*, 2nd edition (Sudbury, MA: Jones and Bartlett Learning, 2012), p. 19.
35. Wesley Yin-Poole, 'Capcom Tweaks Street Fighter 5 Thailand Stage Due to "Unintentional Religious References"', *Eurogamer*, 27 April 2017, https://www.eurogamer.net/articles/2017-04-27-capcom-tweaks-street-fighter-5-thailand-stage-due-to-unintentional-religious-references [accessed 14 April 2019].
36. The dulcimer/cimbalom part also adds a little chromatic inflection with the use of a G#, but this is very brief and limited.
37. Shay Loya, 'The Verbunkos Idiom in Liszt's Music of the Future: Historical Issues of Reception and New Cultural and Analytical Perspectives' (Ph.D. thesis, King's College London, 2006), p. 10.
38. Ibid., p. 263.
39. Shay Loya, 'Beyond "Gypsy" Stereotypes: Harmony and Structure in the Verbunkos Idiom', *Journal of Musicological Research*, 27 (2008), 254–80.
40. Isabella van Elferen, *Gothic Music: The Sounds of the Uncanny* (Cardiff: University of Wales Press, 2012), pp. 68, 82, 159.
41. Philip Neuman, *Sirènes, Spectres, Ombres: Dramatic Vocalization in the Nineteenth and Twentieth Centuries* (Ph.D. dissertation, Boston University, 2009), p. 240.
42. Stan Link, 'Horror and Science Fiction', in *The Cambridge Companion to Film Music*, ed. by Mervyn Cooke and Fiona Ford (Cambridge: Cambridge University Press, 2016), pp. 200–15 (p. 207).
43. Noël Carroll, *The Philosophy of Horror or Paradoxes of the Heart* (New York and London: Routledge, 1990), p. 32.
44. Karen Collins, '"Like Razors through Flesh": Hellraiser's Sound Design and Music', in *Terror Tracks: Music, Sound and Horror Cinema*, ed. by Philip Hayward (London: Equinox, 2009), pp. 198–212; James Wierzbicki, 'The Ghostly Noise of J-Horror: Roots and Ramifications', in *Terror Tracks: Music, Sound and Horror Cinema*, ed. by Philip Hayward (London: Equinox, 2009), pp. 249–67.
45. The alteration sometimes occurs where the C is altered to a C#.
46. Reis Flora, 'Śahnāī', *Grove Music Online* (2001), https://doi.org/10.1093/gmo/9781561592630.article.51148.
47. The cue begins with an exceptional one bar of F and A, but apart from that, the other chords all sound at 4.8 seconds each.
48. Van Elferen, *Gothic Music*, pp. 38, 46, 70.
49. Julie Brown, 'Carnival of Souls and the Organs of Horror', in *Music in the Horror Film*, ed. by Neil Lerner (New York: Routledge, 2010), pp. 1–21 (p. 5).
50. Ibid., p. 5.
51. Ibid., p. 8.

52. Victor Szabo, 'Ambient Music as Popular Genre: Historiography, Interpretation, Critique' (Ph.D. dissertation, University of Virginia, 2015), p. 6.
53. Brian Eno, 'Ambient Music', liner notes to Ambient 1: Music for Airports, Editions E. G., AMB 001, LP, 1978, quoted in Victor Szabo, 'Unsettling Brian Eno's Music for Airports', *Twentieth-Century Music*, 14 (2017), 305–33 (p. 315).
54. Szabo, 'Unsettling Brian Eno's Music for Airports', p. 316.
55. Ibid. I am very grateful to Michiel Kamp for drawing my attention to Szabo's work.
56. Sao et al., *The Legend of Zelda Encyclopedia*, p. 108.
57. Gibbons, 'Music, Genre, and Nationality', p. 418.
58. I am grateful to Michiel Kamp for this suggestion.
59. David Kettlewell, 'The Dulcimer' (Ph.D. thesis, Loughborough University of Technology, 1976), pp. 65–102.
60. The Kakariko Village cue is also used for the fishing pond by the shores of Lake Hylia – another similarly serene, safe and relaxing location.
61. The melody for Kakariko Village has a passing resemblance to that of the slow movement of Beethoven's 'Pathétique' Piano Sonata, Op.13, noted for its poignant and tragic affect.
62. Susan Key, 'Sound and Sentimentality: Nostalgia in the Songs of Stephen Foster', *American Music*, 13 (1995), 145–66 (pp. 157–62).
63. Hyeonjin Park detects the influence of samba in the rhythms of the percussion accompaniment here. 'Melodies of Distant Realms: World Music in the Context of Video Games' (BA thesis, Mount Holyoke College, 2015), p. 62.
64. For a different interpretation of the clapping parts, see ibid., p. 70.
65. The rhythmic structure does not use the twelve-beat organization often found in flamenco, nor does it use the so-called tonal flamenco mode. Though the chord pattern uses similar elements to the i–VII–VI–V 'Andalusian' chord pattern of flamenco, it would be a stretch to identify it being used definitively here.
66. Daniel Sheehy, *Mariachi Music in America: Experiencing Music, Expressing Culture* (New York: Oxford, 2006), p. 21.
67. Ibid., p. 36.
68. For more on the reception of the mixed musical styles of Gerudo Valley, see Hyeonjin J. Park, 'Understanding the Musical Portrayal of the Desert in Video Games' (MA thesis, University of Bristol, 2016), pp. 33–36.
69. Sao et al., *The Legend of Zelda Encyclopedia*, p. 45.
70. David Treece, 'Guns and Roses: Bossa Nova and Brazil's Music of Popular Protest, 1958–68', *Popular Music*, 16 (1997), 1–29 (p. 2).
71. Jonathan Sterne, 'Sounds like the Mall of America: Programmed Music and the Architectonics of Commercial Space', *Ethnomusicology*, 41 (1997), 22–50 (p. 35).
72. Ronald M. Radano, 'Interpreting Muzak: Speculations on Musical Experience in Everyday Life', *American Music*, 7 (1989), 448–60 (pp. 451, 456).
73. Philip Carden, 'Muzak Prevents That Sagging Feeling', *Steel Times*, 199 (July 1971), p. 578.

74. Park, 'World Music in the Context of Video Games', pp. 65–66.
75. Philip Tagg and Bob Clarida, *Ten Little Title Tunes* (New York and Montreal: Mass Media Scholars' Press, 2003), p. 577.
76. This same melody holds some similarity to the accompaniment of Tatsuro Yamashita's song 'Morning Glory' (initially sung by Mariya Takeuchi, later recorded by Yamashita himself). The album featuring Yamashita's performance was very popular in the early 1980s in Japan.
77. William Gibbons, 'Wrap Your Troubles in Dreams: Popular Music, Narrative, and Dystopia in Bioshock', *Game Studies*, 11 (2011).
78. Andra Ivănescu, 'Torched Song: The Hyperreal and the Music of *L.A. Noire*', *The Soundtrack*, 8 (2015), 41–56.
79. Kiri Miller, *Playing Along: Digital Games, YouTube and Virtual Performance* (New York: Oxford University Press, 2012), p. 55.
80. Medina-Gray, 'Modular Structure and Function', p. 152.
81. Steven B. Reale, 'A Musical Atlas of Hyrule: Video Games and Spatial Listening' (paper presented at the annual meeting of the Society for Music Theory, St. Louis, MO, 29 October–1 November 2015).

4

Character Themes and Cutscenes

As with most video games, not every moment spent playing *Ocarina of Time* is interactive in the same way. The main gameplay is framed by dialogue sequences and dramatic action where the player does not directly control Link. These moments fall under the banner of cutscenes. The game's cutscenes range in duration and style, but most begin after Link succeeds at a challenge or engages with another character. In *Ocarina of Time*, cutscenes are either non-interactive videos or, more commonly, what Giles Hooper calls 'fixed dialogue' cutscenes, where the player must advance the sequence by pressing buttons on the controller to select dialogue options.[1]

This chapter focuses on music for cutscenes. These sequences, and their musical accompaniments, are primarily concerned with portraying the characters and story, though they can also recognize the player's achievement in reaching particular moments in the plot. Not all cutscenes have bespoke music; some sequences take place against the ambient sound effects, while others simply let the relevant location cue continue to loop in the background. It is all the more striking, then, when the cutscenes are specifically scored. Some cutscenes are accompanied by musical themes associated with particular characters.

Character Themes

Ocarina of Time features six definite character themes, all heard during cutscenes. The most prominent non-playable characters (NPCs), Ganondorf, Princess Zelda and her alter-ego Sheik, all receive themes. The game features three other character themes for minor characters (the Deku Tree, the witches and the wise owl). The characters that are given themes are mostly either those who are very important for the plot or those that need to be differentiated from their environments as opposed to those who are more synonymous with their contextual locations (such as Malon at Lon Lon Ranch, Darunia in Goron City and so on).

Zelda's Theme – Lilting Lullaby

The titular Princess's theme shares a melody with the ocarina song 'Zelda's Lullaby'. As noted in Chapter 2, the piece was initially composed as Zelda's Theme for the earlier game, *A Link to the Past*. Apart from improved instrument sounds and richer chords in the accompaniment, the version of Zelda's Lullaby heard in *Ocarina of Time* is very similar to that in *A Link to the Past*. The recurrence of the musical theme across games serves as a nostalgic prompt for players familiar with the earlier game. Further, however, it also helps to assert that the Zelda from *A Link to the Past* and the Zelda of *Ocarina of Time* are the same character, despite the two looking very different in visual style. This theme continues to recur throughout the *Zelda* series, acting as a connecting tissue that unites the franchise and links the different incarnations of Zelda.

Zelda's Theme is in 3/4. The cue is an AA'B format; the A section uses a slightly decorated version of Zelda's Lullaby, and the B section is characterized by a descending phrase, heard three times.[2] The harp accompanies Zelda's Lullaby with a rising arpeggio that provides movement when the melody is held and sustains notes when the melody is moving, giving the whole cue a lilting effect (Figure 4.1).

The cue uses one chord per bar and frequently creates harmonic movement by changing the pitches of a chord by tones or semitones. For example, the B section starts with the chord sequence of Fmaj7, Em7, Dm7, Cmaj7. The cue does not emphasize movement by fourths and fifths typical of classical harmonic drama. Instead, it uses a smoother progression with less propulsive forward motion.

Since lullabies and soothing songs vary considerably both across, and within, cultures, it is difficult to distil an essential 'lullaby' style. That said, the lilting accompaniment provides a consistent rocking-like rhythm with a regular pulse,

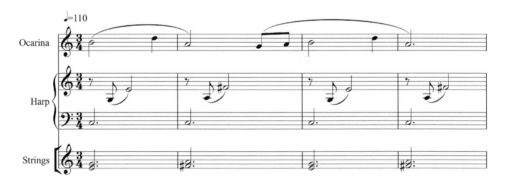

FIGURE 4.1: In Zelda's Theme, the rhythm of Zelda's Lullaby is complemented by the accompaniment arpeggio, so each part moves while the other is held (excerpt shown).

and the cue emphasizes arch-shaped or descending melodic contours. The regularity of the phrases are easy to predict and the form is clear. It has been repeatedly suggested that laments and lullabies are closely related.[3] This connection may be reflected in the emphasis on descending phrases in Zelda's Theme and which provide something of a bittersweet quality to the cue. Even if the actual practice of lullabies is diverse, Zelda's Theme deploys musical features that would seem characteristic of a lullaby.

Zelda's Theme is heard in two different orchestrations, which match the two different ages of Zelda in the game (Figure 4.2). One version is heard in the 'past' sections of the game, which features an ocarina and glockenspiel playing the melody, accompanied by harp and strings. With the exception of the glockenspiel, which comes with its own childhood and celestial associations, these are soft and blended timbres. This version of the cue is heard when Link first encounters Zelda as a youth in her private courtyard. The cue begins as soon as Link enters the courtyard, and so also serves as a location theme for this small area.

A second version sounds the melody in strings and flute, accompanied by piano, horns and strings. This setting of the theme is heard when Link meets Zelda as an adult (which helps to explain the more 'mature' orchestration omitting the ocarina and glockenspiel). The cue dramatically returns in the adult timeline when Sheik removes his disguise to reveal his identity as Zelda. At this moment, Zelda's

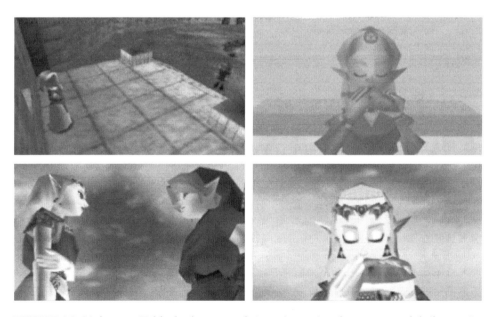

FIGURE 4.2: Link meets Zelda, both as a youth (top pictures) and as a young adult (lower pictures). In both time zones, Zelda plays the ocarina.

Theme interrupts Sheik's Theme, as Zelda is finally revealed in adult form, both musically and visually.

Zelda's Theme does not trade on traditional signifiers of royalty (trumpets, fanfares, ceremonial drums, etc.). Instead, her theme emphasizes her youth, benevolence and innocence through the lullaby topic. This characterization of Zelda might be guilty of reinforcing long-standing gendered musical stereotypes, such as the conjunct lyrical melody, soft dynamics, consonant harmony and lack of untuned percussion for the main female character. That recognized, the musical gender politics become more complicated when Sheik, as an alter-ego of Zelda, is also taken into account (of which more below).

Zelda's Theme helps to establish the identity of this important character, especially as a contrast (both dramatic and musical) to Ganondorf. In games, it is not uncommon for characters that are highly significant for the plot to have relatively little screen time. Though this is not a phenomenon exclusive to games, it is frequently evident when an NPC sends the hero off on a quest, or the player's character is charged with a rescue mission. In *Ocarina of Time*, despite lending her name to the title of the game, Zelda is seen only occasionally, and each meeting is brief. Similarly, even Link's arch nemesis, despite representing the great threat that motivates Link's quest, is only encountered a handful of times.

The rare encounters with important characters helps to make their appearances special – encountering Ganondorf is all the more chilling because of his scarcity – but it also means that the characters have a limited time to make a significant impression upon the player. We have to immediately understand the horrific danger of Ganondorf and the pure gentleness of Zelda. The music is one of the ways this characterization is quickly and distinctly established.

Ganondorf's Theme – Alarming Chords and Brooding Sequences

Ganondorf's Theme provides the musical material for the Ganon's Tower cue, heard in the last section of the final dungeon, discussed in Chapter 3. When encountered in other circumstances, however, the theme is played by strings and horns, as opposed to organ, and features a different introduction and conclusion.[4]

Whenever Ganondorf appears, his theme (in strings and horn) is preceded by an orchestra exclaiming a series of diminished major seventh chords (1, ♭3, ♭5, 7).[5] The diminished seventh chord has long served as a signifier of the demonic in Western music for drama, especially when it is accentuated. Particularly illustrative examples are found in Weber's opera *Der Freischütz* and Marschner's opera *Der Vampyr*.[6] These moments when Ganondorf suddenly appears, accompanied by a series of held diminished major seventh chords, walk a fine line between cliché and the effective deployment of a dramatic device. The effect is somewhat

melodramatic, especially when it is immediately synchronized with the appearance of Ganondorf. This process, while unsubtle, is certainly effective at accentuating his shocking presence – not only is he strikingly visually present but he is also unmistakably sonically present. This link is particularly noticeable because Ganondorf is often introduced into cutscenes by being revealed as standing behind Link: the camera pans to show him, at which moment the music breaks the musical silence with the diminished major seventh chords (Figure 4.3). We are left in no doubt of Ganondorf's evil credentials; his power is musically manifest. Like Zelda, for all of his importance for the plot, Ganondorf's encounters with Link are rare, so they must be made aesthetically significant (even if it comes at the expense of nuance). With musical material heard intermittently over a long playing time, the lack of subtlety is perhaps explicable by the impulse to quickly and obviously make a connection between the character and the music.

The observations made about Ganondorf's Theme in the context of the Tower cue hold here, even when the material is performed with strings and horns rather than organ. Ganondorf's Theme and Zelda's Theme seem to exist as contrasting twins, befitting their status in the plot. Both are scored for orchestral instruments (especially strings and horns) and have a distinct repetitive rhythmic pattern in both melody and accompaniment. The neat balanced melodic phrases of Zelda's Theme find their parallel in the uneven chromatic ascent of the upper part of

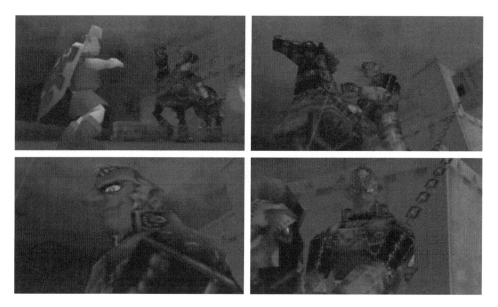

FIGURE 4.3: Ganondorf is revealed behind Link, when they encounter each other outside Hyrule Castle.

Ganondorf's Theme. Both themes use ambiguous or extended harmonies, but what appears as pleasant richness in the wide-spaced notes of Zelda's Theme becomes clashing dissonance in Ganondorf's Theme. These two themes are positioned as contrasting, yet with sonic connections, thus encapsulating the relationship between these two characters, bound together in their struggle against each other.

Ganondorf's Theme presents brooding malevolence entirely apt for the character. It is also used for the ghostly version of Ganondorf, Phantom Ganon, which serves as a dungeon boss. Despite the relatively few times Ganondorf appears in the game, the music is part of how we understand his role in the plot. Indeed, with the allusive dialogue in *Ocarina of Time*, the music is a huge element of our perception of him and his villainy. We know he is dangerous and demonic, whether or not we understand who is he is, in part because of the musical element of his character. The music helps strike fear in the hearts of players well before Link has to do battle with his nemesis.

Sheik – Atypical Warrior's Theme

Though Sheik is Zelda in disguise, the mystery is only revealed just before the final dungeon of the game. The music does not give away the dual identity of the lyre-wielding warrior; instead Sheik has his own theme. Sheik's Theme, which plays during his conversations with Link, is scored for violin and, unsurprisingly, harp (representing the lyre).

The main melody of the theme is carried by the violin and upper voice of the harp. It uses a major-mode pentatonic scale (B♭, C, D, F, G), split into five clear phrases that all finish with a pause, in the structure AA'BBC. The melody is remarkably conjunct. The phrases are created either by (1) running up and down the pentatonic scale in order, or (2) skipping over one note in the scale, only to then fill it in.[7] Together with the harp, these highly repetitive phrases invoke a style almost like a folk song.

One of the remarkable qualities of Sheik's Theme is the rubato programmed in the cue. Every crotchet beat has a tempo change, ranging from mm=105 to mm=50 (sometimes within the space of three beats). Phrases typically slow with expressive rallentando towards their conclusion and often accelerate in the middle. The exaggerated rubato serves as a signifier of emotional expressiveness.

Each note of the melody is accompanied by a chord in the harp, but some notes of the chord are slightly delayed to give the impression of a harpist plucking the chord. As well as being a style of playing characteristic of the harp, this effect helps to avoid an unnatural mechanical performance. These accompanying chords are rich: almost every chord adds a major or minor seventh, with a particular emphasis

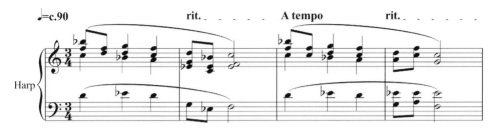

FIGURE 4.4: The opening phrases of Sheik's theme, with the melody in the uppermost part. Note the pentatonic design of the melody and the harmonic support of every note of the melody.

on the major seventh. This harmonic language is not dissonant but, much like the rubato performance, provides an expressive dimension to a piece which might otherwise tend towards the bland. Each phrase concludes on an F7 chord, which has the quality of sounding incomplete and anticipating a continuation; even if the phrases are melodically complete, the harmony implies that the cue is ongoing, which is useful for a cue that is programmed to loop (Figure 4.4).

Sheik and Link first meet directly after Link travels through time and is returned to the Temple of Time as an adult for the first time. Stepping out of the darkness, Sheik approaches Link. Obviously feeling threatened, Link draws his sword in defence. Sheik introduces himself with the enigmatic phrase: 'I've been waiting for you, Hero of Time [...]' At this moment, the cue begins (Figure 4.5). Sheik's Theme returns throughout the game to accompany the cutscenes when the mysterious character tracks down Link, provides advice about the next objective and teaches him one of the warp songs. The player spends more time with Sheik in the game than with Zelda.

Sheik's gentle theme immediately indicates his relationship to Link; for all his initially ominous appearance, the music affirms that he is not threatening, but a trustworthy ally. The harmonic and performative expressivity of the theme (as well as the lyric association of the harp/lyre) seems to emphasize the emotional qualities of the enigmatic character. Sheik has terse dialogue and the majority of his face is masked. The music seems to provide an expressive dimension not prominent in the visual representation. It is no great leap to ascribe some romantic dimension to this emotional expressivity, which provides an interesting reading in terms of the character's gender. Might we be hearing an expression of same-gender attraction? Certainly in the frequent moments when Sheik silently stares at Link, or recites words concerning love and passion, such an interpretation is not outlandish. Sheik's Theme is hardly in keeping with typical gender norms of character themes for the moving image (especially a male warrior). Perhaps, though, this theme is another element of Sheik's ambiguous gender presentation.[8] By creating

FIGURE 4.5: Link meets Sheik.

an expressive theme that articulates the character's role in the plot, Sheik's theme also subtly avoids neat reduction to specific romantic or gendered interpretation.

Kaepora Gaebora (The Great Wise Owl) – Authority and Levity

During his adventure, Link is periodically interrupted by a large owl who provides him with useful guidance, particularly in the 'young Link' sections of the game. The owl does not introduce itself by name, but elsewhere, he is identified as Kaepora Gaebora, the reincarnation of an ancient deity. Kaepora Gaebora's speech seems to address both the player and Link simultaneously: as well as telling Link where to go for the next part of the quest, he also explains how to use the map screen and interface of the game.

Whenever Kaepora Gaebora meets Link, the character's theme is heard. In this cue, a double reed woodwind instrument plays a solo part over accompaniment from strings and harp. The cue bears some resemblance to a courtly dance form, because of its rhythmic characteristics and the highly segmented structure.

In a stately duple time, after a one-bar introduction, the cue has two distinct sections, each formed of a four-bar passage that is repeated, creating the form AA′, AA′, BB′, BB′. The whole cue loops from the conclusion of B′ to the start of A. A is in C minor, while B is in the relative major of E♭. In the A sections, a bassoon has the melody accompanied by strings, and in B, an oboe plays the main

melody accompanied by harp and strings. The melody in A is supplemented by a violin countermelody to create A′. B is altered to make B′ by changing the harp accompaniment from chords to arpeggios and altering the final phrase to give a more definitive conclusion. The harmony, orchestration and melodic content thus all articulate a very strict form.

The phrases of the cue are highly segmented. Each bar is a phrase, every pair of bars forms an antecedent and consequent phrase, every two pairs forms a section, with the initial pair landing on a non-tonic chord and the second pair landing on the tonic. This strict periodicity is reminiscent of dance music patterns that are structurally clear to help dancers synchronize their steps with the phrase pattern of the piece.

Aside from the segmented phrase structure and regular periods, part of the cue's dance quality comes from a distinct rhythm in the melody that characterizes each section. In the A section, it is dotted rhythm; in the B section, it is a dactyl (long-short-short) pattern, much like that of the baroque bourrée dance (Figure 4.6). The clear pulse is maintained by the accompaniment (pizzicato strings in A, harp in B) that also defines the harmonic patterns of the cue. The overall impression is one of a certain formality, given the rigidity of musical procedures, but with rhythmic interest that provides a spirited levity.

The main function of the owl is to convey gameplay instructions to players. This potentially tedious process is clothed in the character of Kaepora Gaebora, which is more engaging than if the directions were simply presented as text to the

FIGURE 4.6: The melody of Kaepora Gaebora's theme, with the repeated rhythmic patterns of each section indicated.

player. The distinctive musical cue helps this supporting character to be clearly drawn for players and to become more than simply a mouthpiece for directions.

The depiction of Kaepora Gaebora is clearly designed to trade on cultural associations of owls with wisdom: the owl speaks to Link in a didactic manner. In alluding to an older formalized musical style, the character's age and propriety is implied, yet the jollity and upbeat nature of the cue helps to emphasize that the character is benevolent and not without humour. The double reed instrumentation invokes associations of the rustic and pastoral, apt for a natural creature. The cue balances signs of authority and seniority with positive optimism to provide the owl with an identity far beyond the simple information-delivery function that it serves in the game.

Great Deku Tree – Ancient Uncertainty

The game begins with Link in Kokiri Forest, a village under the guardianship of the Great Deku Tree. The Deku Tree has a significant amount of dialogue explaining Hyrule's mythology and backstory to Link and the player. For cutscenes of Link conversing with the Deku Tree, a specific cue sounds.

The Deku Tree is one of the oldest characters in the game. The age of the tree is accentuated by its dialogue which is littered with archaic words (in the English translation) producing faux-Shakespearian phrases like 'Verily, thou hast felt it …'. The Deku Tree's theme serves a blended purpose of being associated with the Deku Tree but also with the warnings of impending doom that the character describes. The cue is ominous and draws on signifiers of old musical traditions.

The Deku Tree's theme is scored for strings, split into two groups. Low strings hold bass pitches while upper strings form two melodic lines which move together. The music is segmented into clear phrases, each beginning with the low strings playing a pedal pitch in octaves, before the upper parts sound the melody. For the first two phrases, the upper parts move primarily in parallel fourths, while the latter two phrases have contrary motion counterpoint. The contrapuntal style, modal tonality, processional pace and clear phrases with sustained endings seem to invoke medieval music. Though the Deku Tree's cue is hardly a pastiche of an historical musical style, the material resembles medieval religious polyphonic organum. In this vocal tradition, a sustained lower note would be held, over which multiple voices would sing in note-against-note counterpoint (Figure 4.7).[9] This style emphasized consonant intervals of the octave, unison, fifth and fourth between the voices. The voices in the cue seem to refer to this tradition when they move in parallel fourths over a held lower pitch. Like composed organum, the Deku Tree cue also uses repeated phrases as part of a compositional process: the upper melody of the first phrase becomes an inner part of the third phrase. As in

FIGURE 4.7: The Great Deku Tree's theme, illustrating the organum-like texture and indicating the repeated phrase.

the organum model, the Deku Tree cue's harmonic content emphasizes the immediate note-against-note consonance rather than creating a coherent harmonic progression for the cue as a whole. The result is a piece that invokes an older conception of tonality.

The result of these stylistic qualities is to produce a cue that implies the age of the character, as well as reflecting the religious mythology that the Deku Tree explains to Link. The open parallel harmonies are sparse: they are uncertain and ambiguous, and so well-suited to accompany warnings of mysterious malevolent forces. Even if the historical style holds little associative meaning for the player, the use of musical processes with different organizing principles to modern polyphony still serves to signify a historically old 'other'.

Koume and Kotake – Squabbling Siblings

Most of the boss characters in *Ocarina of Time* are confined to the end-of-dungeon rooms where Link battles the villain in question. The exceptions are the twin witches Koume and Kotake, who are also Ganondorf's adoptive parents and

encountered by Link in the Spirit Temple. These witches are squabbling siblings, with one specializing in fire magic and the other in ice magic. Cutscenes featuring the witches are accompanied by character-specific music. Their music is last heard after Link defeats them in battle, and they slowly disappear into another dimension, all the while continuing to argue with each other.

The cue begins with the crash of a cymbal and a flourish from a plucked string instrument that sounds like a Japanese koto. The cue is based on a repeating accompaniment in orchestral strings. Lower strings play octaves which are then quickly harmonized by higher strings. It uses a repeated rising pattern and the overall impression is of a lurching motion. Over the top of this accompaniment, two flute-like instruments play rapid ornamented parts, sometimes in imitation, sometimes in parallel with each other (Figure 4.8). Clearly, these two reedy flutes are an analogue for the two witches, with the flutes swirling around each other and competing for sonic attention just as the witches fly in circles on their broomsticks and quarrel with each other. Even the way the witches imitate each other's speech is reflected in the two flutes that play the same musical gestures after each other.

Koume and Kotake are depicted as highly dangerous, but unlike Ganondorf, they are also humorous, especially in their petty rivalry with each other. The 'funny but dangerous' characterization is articulated through the rhythmic and instrumental frantic energy alongside dissonant music and a sense of unhinged disorganization. In the cue, the rhythms of the two flutes are rapid – they are mostly based on semiquavers and are ornamented scales. There is little clear direction to the flute melodies: they run up and down the A minor scale, turning back on themselves or repeating sections of the scale in uneven phrase lengths. Either the two instruments are heard in rapid exchanges that seem to interrupt each other or they both 'talk' at the same time, often in dissonant intervals. This is a chaotic clash of parts. The cue establishes its characterization of Koume and Kotake by combining signifiers that might be understood as jolly (rapid scalic gestures, sounded in flute instrumentation, cheeky imitation and playful counterpoint) with those of a more dangerous quality (dissonance, lack of predictability and staggering uneven accompaniment).

A Noticeable Omission

It is worth taking a moment to consider a major character in the game who does not receive dedicated musical material. Link receives no thematic material specifically identified as his. This choice is understandable since the player is so completely focalized through Link's point of view that the music is far more concerned with articulating other characters' relationships to Link rather than defining the character himself. Indeed, part of Link's function is to serve as an absent centre

CHARACTER THEMES AND CUTSCENES

FIGURE 4.8: Excerpt of Koume and Kotake's theme, showing the interplay between the flute parts.

through which players can insert themselves into the narrative, projecting their actions onto Link (kinaesthetic projection), rather than an 'other' with which players have to negotiate control and identity.

* * *

Like many films, television episodes and games before it, *Ocarina of Time* uses music as part of the depiction of characters. Though these characters may be visually blurry and pixelated, music helps to round out the characters beyond their dialogue, actions and appearances. It does so by deploying musical styles and materials to bring associations to bear on their portrayal. The range of associations that can be simultaneously invoked by musical material is very useful for providing complex characterizations (as in, for example, the comic and dangerous Koume and Kotake, or the serious but kind owl). The character themes use radically different styles from each other, with more stylistic diversity than one might typically find in, say, a Hollywood film score. That said, often the signification is rather unsubtle (such as the exclamatory gestures that open Ganondorf's Theme), but such obviousness is likely motivated by the necessity for such characterization to be quick, impactful and clear for players, as well as distinguishing characters from each other. The need for an immediate characterization is especially important when characters that are significant for the plot are seen only briefly.

Other Cutscenes

Beyond cutscenes that use character themes, some sequences have dedicated cues. These mark important moments in the story and help to engineer the emotional journey of the game.

Opening – An Unexpected Start

When players switch on their N64 console with *Ocarina of Time* inserted, they are first shown a Nintendo logo with no sound. Then, once the logo disappears, the screen 'fades in' on a landscape scene just before dawn, with the moon setting behind a hillside (Figure 4.9). We see Link riding Epona across Hyrule Field, and, alongside the sound of the horse's galloping hooves, we hear the first music of the game. We might expect the game to start with a stirring fanfare announcing the adventure to come (as in the first *Legend of Zelda* or *A Link to the Past*), or to begin in the middle of a dramatic scene with tumultuous music (as in the storm that opens *Link's Awakening*). Instead, the game begins with a piano slowly

FIGURE 4.9: Link rides Epona across Hyrule Field as dawn breaks, in the opening of *Ocarina of Time*.

announcing a rich F major 13th chord in the middle register, arpeggiated from bottom note to top. To sustain the chord, a soft string part sounds at a crotchet delay, bolstering the central pitches of the chord (Figure 4.10). The piano/string accompaniment alternates between F major 13th and C major 9th chords, over which an ocarina begins to play. The rhythm, instrumentation, tempo and harmony might remind a listener of Erik Satie's *Gymnopédie No. 1* (Figure 4.11), and while the similarity is nowhere near enough to be called a quotation, the two pieces share a mood of languorous reflection.

Above the accompaniment, an ocarina plays a long, wandering melody with chromatic inflections. It almost sounds improvisatory. The rubato and glissandos of the ocarina part enhance the expressiveness of the melody. Together with the image of the lone hero on his horse (Figure 4.9), it is not difficult to hear this as a wistful expression of solitude. Link is continually searching on his quest, just as the restless harmony never settles into a neat resolution. Though the game does not start with the main 'Zelda theme', it does start with music that has a history in the

FIGURE 4.10: The repeating chord sequence that begins the opening of *Ocarina of Time*.

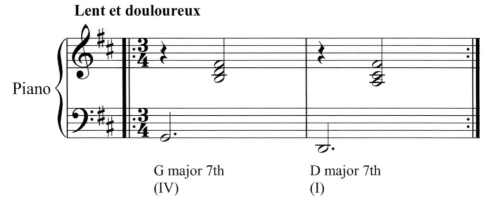

FIGURE 4.11: The repeating chord sequence that underpins Erik Satie's *Gymnopédie No. 1*.

Zelda series. The ocarina melody begins by playing a melodic phrase (Figure 4.12, bb.1^3–3^3), which is sounded four times in total, with slight variations in rhythm and pitch. These repetitions form the first half of the cue. The opening six-note phrase is a quotation from the first *Zelda* game: it is the tune played by the magic recorder that Link encounters. The motif was also subsequently used for a warp whistle in *Super Mario Bros. 3.* (1988), as well as recurring in later Zelda games including *The Wind Waker* (the Forbidden Woods) and *Minish Cap* (Wind Ocarina

CHARACTER THEMES AND CUTSCENES

FIGURE 4.12: The opening melody of the Introduction to *Ocarina of Time*, with the bracketed theme representing a quotation from the first Zelda game.

and Wind Ruins). Though the motif does not have the same concrete association as, say, Zelda's Lullaby or Kakariko Village, it immediately links the game with its tradition and rewards loyal players for their continued investment in the series.

The second, shorter part of the cue for the opening video departs from the variations on the quoted phrase. Instead, the melody becomes a crotchet-dotted minim rhythm that plays two notes per bar, normally a rising or falling fourth. Each bar holds a chord, which alternates between F major 7 and G major, before a cadence via B♭6 returns us back to the chord pattern of the opening bars. The image and music fade out together. After the cue ends, the screen shows short snippets of cutscenes in the game, to whet the player's appetite, before the whole sequence starts again with Link riding in front of the setting moon and the cue begins anew.

Soon after the cue begins, the title logo appears over the images of Link riding across Hyrule, shortly followed by the instruction to players, 'Press Start', while the action and cue continues. Pressing the start button prompts the cue and video to fade out and give way to the menu screens. When the player presses the start button, a short musical phrase is triggered, sounding in a triangle wave, sonically contrasting with the acoustic timbres of the underscore.

The sound triggered by pressing start is a rapid rising arpeggiation of an A minor 7 chord (Figure 4.13). Since the player can press start at any moment after the first few seconds of the opening cue, it is not possible to accurately predict when this cue will sound over the background cue. Kondo approaches this challenge by choosing a chord for 'Press Start' that is compatible with the

FIGURE 4.13: The 'Press Start' arpeggiated chord.

195

harmony of the opening cue. By alternating F major 13 (F/A/C/D/E) and C major 9 (C/E/G/B/D), the Am7 chord (A/C/E/G) always shares three pitches with the harmony.[10]

Though the second part of the cue is more harmonically adventurous, at least one pitch in the accompaniment chord is always shared with the A minor 7 'Press Start' chord, and the cue emphasises notes that are compatible with an A minor tonality. While Am7 never precisely matches the underscore chord (it is, after all, supposed to indicate a development and departure), Kondo designs the cue to avoid unintentional harmonic clashes when the player presses the start button.

This cue is hardly the rousing beginning we would expect from a game with this narrative genre, legacy and significance (*Ocarina of Time* was hotly anticipated). Instead, by avoiding sensationalist musical qualities in favour of an understated lyrical introduction, the game seems to announce its intention to be understood in a contemplative, reflective way, almost making a claim for artistic interpretation rather than using brash stirring musical pyrotechnics to awe the player.

This cue is one of the most frequently heard pieces of music in the game. Though the melodic line may not initially be very memorable, it is repeated so frequently that the melody becomes familiar to players. Perhaps the avoidance of a musically ostentatious approach also helps to mitigate the risk of player annoyance at the repetition of the cue each time the game is started.

Flying – Musical Sequences for Beating Wings

Link does not have the ability to fly, but sometimes, Kaepora Gaebora can provide him with aerial transportation. When Link flies through the sky with the owl, a 'flying' cue is heard. It is also used early on in the game when we briefly see the world from the point of view of Navi, searching out Link on the Deku Tree's instructions.

The flying cue is scored for strings, harp and glockenspiel. The cue uses rapid figurations and sequences to accentuate the impression of movement. The flying cue's melodic design is straightforward, based on a series of 'episodes' characterized by sequences. These are small musical fragments repeated at different transpositions. They are, in order:

(1) a sequence of descending major seventh arpeggios;
(2) a three-note rising sequence on a Phrygian E;
(3) descending arpeggios on E♭; and
(4) rapidly alternating major third intervals.

Yet what gives the cue its energy and motion is its metre. It uses unusual rhythmic groupings that subtly disrupt the anticipated 4/4 metre, providing a sense of unexpected propulsion. For example, the second and third episodes are in a time signature of 13/16 and insert a brief pause before each sequence begins with renewed vigour. It is perhaps an analogue for the way that the beat of a bird's wings produce a sudden force of thrust.

Though the flying cutscenes are brief and incidental to the plot, the charming interludes mark the moments as special. The cutscene is simply a programmed camera movement through the environment, but by using a dedicated cue that features a flurry of melodic sequences and musical motion, the game aims to encourage players to accept the cutscene as a moment of flying.

Legends, Spirits and Goddesses

Hyrule is a world with its own history and legends. Kondo uses a set of four interrelated cues to portray aspects of the game's plot grounded in the (sometimes confusing) mythology of Hyrule. All of these cues accompany cutscenes that feature supernatural characters.

Legends of Hyrule – Musical Creation Myth

Link learns of Hyrule's legends when they are explained to him (and the player) by Zelda, Sheik and the Deku Tree. In these sequences, the player sees cutscenes depicting the origin myth of Hyrule, while the narrating character provides a commentary. The most extensive explanation of the creation story is told to Link by the Deku Tree early in the game. This cutscene shows the formation of Hyrule by the combined efforts of three Goddesses, who also forged an incredibly powerful object, the Triforce. The Triforce appears at the end of this cutscene.

The cutscene is scored for voices singing an open vowel 'aah', accompanied by harp and glockenspiel. The harp and glockenspiel play an arpeggiating pattern in fifths, alternating between one based on C and another on A♭, though both use chromatic pitches to avoid implying a specific chord too strongly and thus maintaining an air of uncertain mystery (Figure 4.14). Beyond what is shown in Figure 4.14, a glockenspiel also doubles the main harp motif an octave higher, while a second harp part plays the pattern an octave higher but at a delay of about 0.1 second, as an echo effect. The result is a glistening accompaniment emphasizing high pitches and metallic timbres – perfect signifiers of celestial divinity. The timbres and arpeggios are similar to the Fairy Fountain cue, discussed in Chapter 3. The similarity is apt given the mysterious and god-like powers of the fairies.

FIGURE 4.14: Accompaniment ostinato for the Legends of Hyrule and Sacred Realm cutscenes. Harp octave doubling at 0.1 second delay not shown.

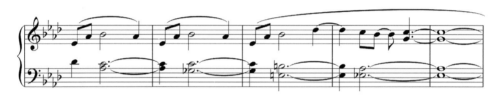

FIGURE 4.15: The moment in the Legends of Hyrule cue when all of the vocal parts coalesce and produce a musical quotation. The harp and glockenspiel parts are not shown. The three voices here split into four at the end.

As a whole, the cue depicts the establishment of order out of ambiguity – it presents a creation narrative musically. The three Goddesses are represented by the three vocal parts. Each voice begins as an independent line, harmonically and rhythmically separate from the accompaniment. They sound a wandering, chromatic line that seems to move aimlessly in a vaguely circular pattern. However, as the cue continues, the vocal lines become increasingly coordinated. By midway through the cue, the upper two parts are rhythmically aligned and producing harmonically consonant chords, even if the third part is still independent. In the final moments of the cue, all vocal parts come together to produce a startlingly clear E♭7 chord. Now, with all of the parts aligned, united together, the cue sounds a clear musical quotation that ties to the legacy of the *Zelda* games, just as the Triforce appears on screen (Figures 4.15–4.16).

CHARACTER THEMES AND CUTSCENES

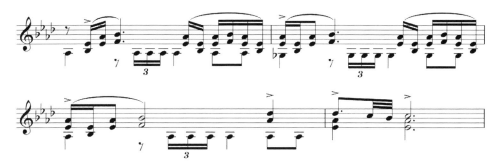

FIGURE 4.16: An excerpt from the title screen to *A Link to the Past*.

The melody is a rhythmically simplified quotation of the one that is heard in the title screen of *A Link to the Past*. It is even in the same key. Each time players start *A Link to the Past*, the players see the Triforce forged from the three constituent pieces which spin across the screen and combine to form the sacred object. When the pieces meet, a fanfare motif sounds, the same as the one heard here at the end of the Legends of Hyrule cue. *Ocarina of Time*'s creation myth cutscene is one of the very few where the timing is strictly controlled. Unlike most cutscenes where the player must press a button to indicate that they have read the on-screen text to continue the sequence, here, the cutscene advances at its own pace. This ensures that the Triforce appears at the end of the cutscene just as the voice parts coalesce together and the musical quotation is heard.

The cue, then, sonically charts the creation of Hyrule, culminating in the Triforce. Even if the player does not quite follow the explanation of Hyrule's history, the music makes clear the overall message of the story – Hyrule's genesis by deities and the powerful Triforce that represents the culmination of their power.

The same cue is used another two times in the game – once when Zelda elaborates on the creation myth to Link in the castle, and near the end of the game, when Sheik explains the mechanics of the Triforce. The stories tell of the Triforce being sealed away in a 'Sacred Realm' to prevent misuse. Both times, the cutscene is shorter and the cue fades out before the musical quotation can be announced, which is perhaps apt given that the stories refer to the inaccessibility of the Triforce.

Sacred Realm/Chamber of Sages – A Place of Stasis

In *Ocarina of Time*, Link visits the Sacred Realm mentioned in the creation myth. He finds himself in a mysterious space, on a floating platform in a room without apparent limits. During the second half of the game, when Link completes

dungeons to rescue the Sages, he is returned to the chamber for a cutscene after conquering each dungeon. Every time Link finds himself in this space, the same cue plays. Though it is clearly related to the Legends of Hyrule cue, it is not identical.

The cue for the Chamber of the Sages uses the same instrumentation and accompaniment as the Legends of Hyrule cue. We find the same alternating arpeggio pattern in the harp, doubled at the fifth by a glockenspiel, and at the octave at a slight delay by an upper harp part (Figure 4.14). There are six visits to the Chamber of the Sages (as well as a further reprise when Ganon is banished at the end of the game). These cutscenes are of varying and indeterminate length, because of the different amount of exposition required in each visit, and that these cutscenes rely on the player to indicate that they have read each section of the on-screen text before the action continues. As a result, unlike the temporally fixed Legends of Hyrule, this cue has looping point.

The main difference between the Chamber of Sages and the Legends of Hyrule is the treatment of the voice parts. Because this cue is designed to loop, the coalescing design of the Legends of Hyrule cue would not be suitable. Instead, the vocal parts are held in a middle-ground state where they are not entirely independent, but not precisely coordinated either. Only two vocal lines are used (the third never appears), and while there is evidence of imitation between the parts, some rhythmic alignment and repeated gestures, it is difficult to grasp any overall harmonic or motivic design. It is, like the Chamber of Sages, suspended outside time and incomplete.

By using the same distinctive musical accompaniment as the Legends of Hyrule, the connection between the origin myth and the location that Link encounters is made obvious to players. The music helps to indicate the special mystical qualities of this place and its relationship with the ancient power (Triforce) that the Deku Tree and Zelda mentioned earlier in the game. The continued association of harp arpeggios with the magical powers of Hyrule's deities is also reinforced by the location cue for the Fairy Fountains encountered throughout the span of the game.

The Rainbow Bridge and the Seal of the Sages – Musical and Magical Unity

If the Sacred Realm seems to be held in a moment of stasis, then two other cutscenes provide a degree of musical and plot resolution. Once Link has freed the Sages, near the end of the game, they combine their powers in two moments to help him. One is to build a rainbow bridge to reach the final dungeon (Ganon's Castle) and another is to give Link extra power to defeat Ganon.

Ganon's Castle is built on a plateau that hovers above a whirlpool that swirls in a fiery abyss. There is no obvious way for Link to traverse the void between the mainland and the Castle. The Sages, however, use their combined power to build an iridescent bridge so that Link may access the castle. This moment is reminiscent

of the end of Wagner's opera *Das Rheingold*, where gods also conjure a rainbow bridge to reach a castle. Just as the revelation of Wagner's bridge is a musically significant moment, so it is for Kondo. To accompany the brief cutscene that depicts the creation of the bridge, the game directly reprises the end of the Legends of Hyrule cue – the passage discussed above that quotes the material from *A Link to the Past* (complete with the harp/glockenspiel arpeggios).[11] The Sages are now restored and united in power, so the music that represents such unity of deities may again sound.

The final musical moment that explicitly concerns the Sages is another moment of sonic and magical unity. Link has nearly defeated Ganon, but to land the final blow and imprison Ganon in the Sacred Realm, he needs the assistance of Zelda and the Sages. In a short cutscene, each sage is pictured in turn giving their power to incarcerate Ganon. As each sage is shown on-screen, a pitch sounds in a synthesized vocal sound and held. With each sage, a new note is added to the chord, making obvious the association between the vocal parts and the Sages, which had been implied since the first Legends of Hyrule cutscene. Six notes build up a cluster chord that eventually resolves on an E minor major 7 chord,[12] sustained as Ganon is banished. The power of the Sages is here musically presented. A short reprise of the Sacred Realm cue accompanies Ganon's threats of revenge as he is sealed away.

The group of cues that consists of the Legends of Hyrule, the Sacred Realm, the Rainbow Bridge and the Seal of the Sages work together as part of a shared musical strategy that establishes a soundworld for Hyrule's myths and the spaces in which the gods exist. By creating a distinctive accompaniment with harp and glockenspiel that is first heard in the stories of Hyrule's genesis, this material is then drawn upon for Link's encounter with the Sacred Realm, obviously connecting the two. The vocal parts are used to represent the powerful gods, and when they quote music from an earlier *Zelda* game, they link the history of the game series with the fictional history of the world. The direct association of the voices with the gods is reinforced throughout the game, in both the musical and visual components. The repetition of musical material across the game helps to portray the mythology of Hyrule and situate Link's (and the player's) adventure within it.

Rewards and Milestones

Like many games, *Ocarina of Time* uses cutscenes to mark important moments in the player's progression through the game, rewarding players for reaching milestones. With special sequences often come unique music, helping to accentuate the distinctive nature of such events. The music of these cutscenes is similar to ludic success cues (see Chapter 5), since both cues celebrate player achievement,

but here, we will consider examples of one-off cutscenes which monumentalize particular points in the plot.

Zelda Turns Around – Meeting the Princess

To indicate the importance of Link's first encounter with Zelda as a child, a special cue interrupts the underscore to accompany the game's first full presentation of Zelda. Link meets Zelda in the private courtyard and her theme plays from the moment he enters the space. Zelda initially has her back to Link, but upon approaching her, she turns to face him. The cutscene in which she turns around is accompanied by harp, strings, horns and bassoon articulating a chord progression with ascending major triads on D–E–F–G. This ascending sequence is similar to other rising chord patterns used for moments of achievement elsewhere in the game (see Chapter 5). After this short cue, which only lasts 3.5 seconds, Zelda's Theme fades back in and continues to accompany the cutscenes of their conversation.

Door of Time – A Musical Dialogue

We have noted how ocarina melodies are integrated into cues for locations and cutscenes. One notable example of this process is the cutscene that accompanies the opening of the Door of Time. Once Link has learned the Song of Time, he may go to the Temple of Time, play the song and open the Door of Time to reveal the room that will eventually let him travel through time. As we have already discussed, the Temple of Time sounds the Song of Time melody in the underscore. Here, then, Link (and the player) is entering into a kind of musical dialogue with the location by performing the melody heard as an underscore cue. In response to Link playing the melody on the ocarina, a cutscene plays which depicts the door opening. Accompanying this sequence, a new cue interrupts the choral location cue for the Temple. A string variation the Song of Time plays, as a reciprocal response to Link's performance of the same melody. Unlike the monophonic performance on the ocarina and in the unseen voices of the location cue, the melody is here harmonized.

In the same key as the location cue, the Song of Time melody is played but altered into a steady rhythm and harmonized with a descending bass part in a chorale style (albeit with strings). The melody is truncated and concludes prematurely with a perfect cadence and embellished 4-3 suspension, evoking a contrapuntal tradition of religious choral music that is entirely in keeping with the grandiose and sacred surroundings. The significance of the occasion is marked with a cymbal crash and rolling bass drum. We know that this is an important culmination of the first part of Link's adventure and that important events await.

CHARACTER THEMES AND CUTSCENES

Ranch Escape – Celebrating Liberation

Like the Door of Time, another milestone moment in the game is the liberation of Epona from Lon Lon Ranch. The music recognizes the importance of the event, both in terms of the plot and the new gameplay possibilities of riding the horse (after all, riding Epona across the world has been teased for the player since they first turned on the game and saw Link traversing Hyrule Field on horseback). Trapped inside the ranch, Link must ride Epona at high speed towards the boundary of the ranch to escape.

The cue takes the form of a short brass-led celebratory cue that accompanies a cutscene of Epona leaping over the wall of the ranch. Like the Hyrule Field cues, it makes reference to the well-known main 'Zelda theme' without using a direct quotation. The Escaping the Ranch cue uses a descending and then rising fourth, copying the outline of the 'Zelda theme' (G–D–G–D') to form a fanfare figure (Figure 4.17). The same melodic shape is repeated (C–A–C–F) before resolving onto G major, ready for the Hyrule Field cue to continue. The cue concludes with a drum roll, triumphantly celebrating Link and the player's success. Though only a brief moment in the game, such small musical cues indicate that the game is recognizing the player's accomplishment and indicating the significance of the event in both narrative and ludic terms.

End Credits – Finale Ultimo

After Link delivers the final blow to Ganon, the game has been completed and the ludic challenges surmounted. The many hours that the player has invested in the game are coming to an end. Now that the interactive portion of the game has finished, what remains is for the plot of the game to be concluded in a long and lavish sequence that rewards the players for their dedication and demonstration of skill. After Link bests Ganon, a series of cutscenes is triggered which run for around twelve minutes in total. These are segmented into seven distinct sections. Throughout this entire sequence, no sound effects are heard. At the end of this musically rich game, the audio is given over entirely to music.

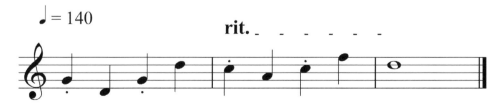

FIGURE 4.17: Variation on the 'Zelda theme' heard for escaping the ranch.

1.

The 'Seal of the Six Sages' (see above) plays when the spirits use their combined energy to transport Ganon between planes of reality, and then the Sacred Realm cue plays as Ganondorf descends into his prison, cursing Link as he floats out of sight.

2.

Zelda confirms that Ganon has been imprisoned and thanks Link for his service. This is accompanied by Zelda's Theme, in the orchestral version heard for the older Zelda, which plays until Zelda's dialogue finishes, when it fades out.

3.

Zelda performs Zelda's Lullaby on the ocarina to send Link back to his original time. Her performance is initially unaccompanied, though she plays the more elaborate version of the melody used for Zelda's Theme rather than the ocarina version that Link plays. As the magical light of transportation surrounds Link, harp and strings start to accompany the ocarina for the repetition of the melody. The piece is left incomplete, slowing to halt on a sustained D7 chord at the end of the A′ section, perhaps reflecting the chronological rupture we witness as Link travels through time. The image fades to black.

4.

After a moment's pause, the image fades in. As dawn breaks over a now peaceful Hyrule, we see scenes of the landscapes we have come to know so well, the camera moving gracefully across the serene vistas. The game's credits are overlaid upon these images, while a gentle three-time cue begins with a harp delicately plucking an accompaniment pattern with spread chords. It is soon joined by violins playing sustained pitches in a high register that serve as a countermelody for an oboe which shortly starts to play a new, lyrical pastoral melody.

After the adrenaline-pumping Ganon battle and the ecstasy of victory just a few moments ago, the mood has now changed significantly and abruptly. This is no rousing victory lap for Link. Instead, with the relaxing cue and the calm but largely deserted landscapes, the player can now bask in their success, reflecting on their long journey through the game.

Finishing games is a bittersweet experience – the game, with all of its emotional extremes, is now coming to an end and the interactive connection between

player and game is being dissolved (albeit through winning, rather than losing). The andante cue, with a solo oboe and a violin part that emphasizes descending lines, has an air of the melancholy to it, for all of the major tonality of the cue.

The new oboe melody only lasts a short while before a new section begins that is a reprise of Zelda's Theme. This theme dominates the credits, but it is altered each time it sounds to provide variation. The theme is repeated with increasingly elaborate orchestration and greater rhythmic density – as shown in Table 4.1. In each successive section, more instruments begin to play and the accompaniment pattern exchanges held chords for repeatedly sounded chords with more notes. The performance also uses other musical features to emphasize the emotional climax – the B section is introduced by a rallentando slowing the tempo, while rising scales and sliding portamento ornament the melody, all serving as signs of an emotionally invested, expressive performance.

Next, Kondo uses a short interlude to change key, so that Zelda's Theme can return again, transposed a tone higher. While it might be tempting to criticize Kondo for using the well-worn (perhaps clichéd) technique of repeating a melody a tone higher in the service of dramatic progression, it is worth remembering that players have spent a long time with this theme, in cutscenes, locations and on the ocarina. It has always been heard in the same key, until this modulation, which makes the effect all the more significant. No hackneyed key change, the repetition implies evolution and development at the conclusion of the game.

Kondo then repeats the same structure of Zelda's Theme in Table 4.1, using a similar pattern of instrumentation (Table 4.2).

Section of Zelda's Theme	A	A′	B
Melody	Harp	Harp and solo violin	Strings (group)
Accompaniment	Clarinets, in thirds, one chord per bar	Horns, in thirds, one chord per bar	Horns, in three-note chords, sounding every quaver
	Harp arpeggio	Harp arpeggio	Harp arpeggio
		Mid-range strings in unison, one chord per bar	String arpeggios

TABLE 4.1: The varied orchestration of Zelda's Theme in the fourth part of the credits sequence (first phase).

Section of Zelda's Theme	A	A'	B
Melody	Solo voice	Chorus voices with strings (group)	Chorus voices with strings (group)
Accompaniment	Clarinets, in thirds, one chord per bar	Horns, in thirds, one chord per bar	Horns, in three-note chords, sounding every quaver
	Harp arpeggio	Harp arpeggio	Harp arpeggio
		Mid-range strings in unison, one chord per bar	String arpeggios

TABLE 4.2: The varied orchestration of Zelda's Theme in the fourth part of the credits sequence (second phase, a tone higher).

The A section uses a solo voice with portamento sliding between notes. This is the same sound used for Malon singing earlier in the game, so it is easy to imagine that it is her voice we hear, even though we do not see any humanoids. The B section's melody uses a vocal chorus sound, but the pitches are so high (up to A7, beyond the typical soprano range) that they challenge realism, partly because of the range, partly because of the strange timbral effect when that voice sound is adjusted to such a high pitch. We are left with an odd sound, celestially unreal in timbre. Perhaps, though, such a sound is appropriate for a sequence that involves time travel and magical elemental spirits. Realism is hardly a high priority in this ending.

<center>5.</center>

After the end of the vocal reprise of Zelda's Theme, held on a sustained A7 chord, the music pauses while the visual track fades to black again. The fifth sequence begins as we fade in on a night-time celebration at Lon Lon Ranch, where we see a gathering of the supporting cast of *Ocarina of Time*, singing and dancing to mark the end of Ganondorf's reign of terror. Befitting the lively festivities, the music is based on the jolly up-tempo Lost Woods cue, which is treated to a set of variations.

Initially, the music is indistinguishable from the vivacious Lost Woods location cue. Then, a guitar part begins, playing a syncopated strumming pattern to add drive to the cue and horns enter to broaden the timbral palette. Later, strings

double the melody and a harp ostinato begins which is offset against the metre, which all help to give a busy, vibrant festive texture.

As the camera pans over the party, we see, among the crowd, nine of the carpenter characters, standing in a line, apparently singing together. Sure enough, a low synthesized vocal part is added. The carpenters sing in two-part harmony, matching the changing chord pattern. Soon they are joined by Malon, now on-screen, singing a countermelody.

This musical moment encapsulates the appeal of this scene – characters from across the game celebrate together in a scene that is light-hearted and even a little silly (with apologies to the chorus of singing carpenters). After all of the gloomy drama of the final conflict, this is a joyful moment that emphasizes the player's success and provides emotional release after the drama of the past few hours of gameplay.

The ending is not without an element of sadness. Some characters have moved on to another plane of existence, leaving loved ones behind. At the edge of the party sit two dejected figures: King Zora, whose daughter has left, and Mido, whose friend Saria will not return to this reality. During this part of the cutscene, a variation on the Lost Woods cue is heard – the melody is absent but the same chord sequence is reprised with only an accompaniment pattern in the strings and bassoon, alongside percussion. The absence of the melody in this part of the cue effectively portrays loss, indicating the emotional state of the characters and hinting at the source of their unhappiness. Though the melodic parts return for the B section, the slow-moving sustained chords of the accompaniment strings are mixed considerably higher than the melody parts, implying an emotional and physical distance from the festivities and the melancholy of these characters. Eventually, the melodic parts disappear entirely leaving only the string accompaniment.

This section of the finale shows how *Ocarina of Time* aims to create an emotionally significant and diverse experience for players. It tries to tug on feelings of sadness amid the ultimate victory. This music is part of how the game provides a complex emotional ride, mixing sadness amid victory, loss with achievement, rather than simple uniform emotions. Like the introduction which began the whole game, it seems to assert its status as a mature and significant artistic experience.

Over the strings, a familiar musical element fades in – the distinctive ostinatos of the harp and glockenspiel patterns of the Sacred Realm. Small specks of light float across the field, capturing the attention of Mido and King Zora. As the orbs float away from the ranch party, the camera follows them, panning over a hillside. Now that Hyrule is at peace, whereas the vocal parts for the Sacred Realm cue had been dissonant and misaligned, now the voices are harmonious. The two parts are rhythmically aligned in parallel sixths, reflecting the order that has been restored to the world. The brief passage lands on a D major chord, and, with the

roll of a drum, sudden contrary motion scales in strings and a crash of the cymbals, the lights transform into the Sages.

The Sages witness the rejoicing of the party and exchange glances with each other, evidently pleased at the success of their mission, while dawn breaks over Hyrule. This moment of triumph is accompanied by the beginning of another statement of the B section of Zelda's Theme in its most grandiose setting yet.

At a slow mm=76, strings, choir and glockenspiel announce the melody in full voice, with the upper strings harmonizing the melody in sixths. Low strings and voices use the familiar accompaniment arpeggio, while the brass announce triads on every quaver beat apart from the first of each bar, providing a sense of movement alongside the sustained parts. The result is a stately rendering of the theme with a wide pitch range (from the high glockenspiel to the low strings), in a combination of sustained and repeated chords and a full harmonization. The significance is further accentuated by the crashing cymbals and rolling drums. Midway through the statement an ocarina is added, further bolstering the melody and expanding the timbres used. The theme does not return to the A part but finishes with the rolling of drums and crashing cymbal on a sustained G major chord as the camera pans up to the now sunny sky and fades to white.

6.

For the sixth part of the credits, the scene fades in on Link replacing the Master Sword in the pedestal in the Temple of Time. We return, too, to the A section of Zelda's Theme. It is orchestrated the same way as the statement in Table 4.2. The theme, however, ends abruptly midway through the A' statement.

Link has returned to his original time safely. Navi, her mission complete, must now leave Link. After a moment's pause in which Link and Navi look at each other one last time, she begins to fly away from him, rising up to a high window in the Temple of Time. As she moves away, trailing sparkles, the music mickey-mouses her movement by playing a series of short rising sequences high in harp, glockenspiel and strings. As well as drawing on long-standing signifiers of music and magical movement, this passage is similar to the 'flying' theme discussed earlier. The musical episode sonically articulates Navi's departure. What could have been easily overlooked in the visual depiction is accentuated as an important moment in the plot.

Navi gone, Link turns away and leaves the Temple of Time, while the camera focuses in on the Master Sword and the text 'Presented by Nintendo' appears on the screen. For this triumphal ending, the music announces a series of chords with strings, brass and chorus in tutti. The sequence is given significant ritardando,

finally coming to rest on a held C major chord. The harp plays ascending glissandi while cymbals crash and timpani roll. The final passage is also accompanied by two tolling church bells. The result of the prolonged resolution and the united musical forces is an overdetermined ending like that of a stereotypical nineteenth-century symphony. Particularly with the tolling bells and huge tutti chords, the sequence bears more than a passing resemblance to the penultimate section of Tchaikovsky's *1812 Overture*, when full orchestra announce the opening theme in huge chords while timpani and bass drums sound with chiming bells. The topic of success after conflict is common to both of these pieces. And just as the chiming bells in the *1812* were alluding to a physical building, so they here reflect the church-like building of the Temple of Time.

It would be easy to point out the lack of subtlety in this triumphal ending, just as the ending and penultimate passage of the *1812* has been criticized as overblown. Yet it is harder to imagine a game with grander ambitions than *Ocarina of Time*: it is a long, complicated game with a plot that hops across dimensions and time zones, while engaging a challenge with cataclysmic stakes. If any game earns an ending with orchestral overkill, this is it. Besides, the player is so swept up in the emotional release of ultimate success (at long last), and the bittersweet ending, that they may be willing to surrender to the overwhelming aesthetic effect and revel in the sensationalism of the conclusion. Indeed, for a game so sonically reliant on loops and temporal indeterminacy, reaching this moment of harmonically pure resolution and bombastic musical conclusion is affecting in its decisive emotional honesty.

<div style="text-align:center">7.</div>

For all of the apparent finality of the ending, both in musical and visual rhetoric, *Ocarina of Time* has one last sequence for us. After a moment's silence and a black screen, we fade in again for an epilogue. Under a bright blue sky, we are back in Princess Zelda's courtyard as a child. A string sustained note sounds (G5), and it becomes clear that we are witnessing again the moment in which Link and Zelda first met. Harp and strings play the familiar accompaniment pattern of the opening measures of Zelda's Theme as an introduction before the theme begins proper. The theme never develops beyond this simple orchestration of strings and harp, and we only hear to the end of the A' section. The end of the A' section is altered – rather than rising to a D, the melody first plays a C for a bar and then a D. This is a very small melodic change, but since the player has heard this theme so often (not least in the preceding sections of this credits), it is noticeable. The effect is a neat analogue for the action. As the visual freeze-frames, Link is implied

to be warning Zelda about Ganondorf, in order for the villain's rise to power to be avoided. Link is altering the timeline, just as the theme is subtly changed. Zelda had previously admitted that it was partly her actions that facilitated Ganondorf's tyranny. Maybe altering the music and timeline are one and the same: now the fall of Hyrule will be circumvented, articulated through the divergent theme. Finishing on a D7 chord also sounds unfinished, implying the continuation of the action beyond what is seen by the player.

Ocarina of Time 3D

This is the end of the game for the N64 version, but the 2011 3D remake has a further credits cue, which accompanies the scrolling list of credits for the revised version of the game. This orchestral cue lasts about two and a half minutes. Reports from the producers reveal that it has been recorded with a live orchestra, the only cue of its kind in the game.[13] It takes the form of a medley:

(1) Zelda's Theme (A section with a varied ending);
(2) Hyrule Field (Day opening 1), Day 2, Day 3, Reflective 1, Reflective 2;
(3) 'Zelda theme'.

The final minute of the cue is taken up with a performance of the 'Zelda theme'. This piece, missing from the original game, finally provides what some players had felt was absent from the N64 version. This is also the perfect point to deploy this theme, as a musical reward for completing the game. After the musical allusions to the theme throughout the game, the implication is made explicit in these final moments, neatly tying the conclusion of the game to fulfilling a musical suggestion proposed earlier in the game, and perhaps even thirteen years earlier, when the original game was released.

This long finale sequence is a spectacular prize recognizing the player's achievement and investment in the game. It rewards players by aiming to provide them with a spectrum of emotional moods, from the celebratory to the melancholy, articulated through the music. The sequence asserts the game's significance and maturity in demonstrating the range of affective modes, as well as highlighting the importance of the player's success. We have come to the end of Link's adventure. We cannot quite believe it is over. But the music helps us revel in the epic experience, reflecting on our long journey and time with Link in Hyrule, before we say goodbye. It provides a satisfying and substantial conclusion to our quest.

Music for Cutscenes

Giles Hooper warns that we should not dismiss cutscenes as mere asides to the gameplay – they are an important part of the experience of playing the game. He writes,

> Certainly cutscenes proffer an efficient and information-rich aid to narrative progression [...] Yet [...] they can clearly do more than this: develop character, promote emotional investment, contextualize choices to be made by the player, reveal the consequences of choices already made, and even add to, rather than detract from, immersion.[14]

In *Ocarina of Time*, the cutscenes use music to help fulfil the functions that Hooper outlines.

- Communication of information

 The character cue for Kaepora Gaebora helps to make the delivery of factual information about the gameplay mechanics aesthetically substantial, attractive and striking.

- Narrative progression

 Cues are provided to monumentalize major events in the plot (such as the musical fanfare for the Rainbow Bridge) and to depict the background mythology of the universe through musical allegory (Legends of Hyrule).

- Character depiction

 The music helps to establish the significance of the characters that motivate the plot (even if they are only encountered briefly). It also helps to depict some of the supporting cast and can quickly articulate complex characterizations, such as the 'funny but dangerous' Koume and Kotake and the 'serious but friendly' Kaepora Gaebora.

- Emotional investment

 The music in cutscenes is used to accentuate their emotional content. Encounters with Ganondorf are made all the more shocking through the exclamatory music. The accumulated emotional significance of Zelda's Theme is deployed

at the end of the game to create a cathartic, emotionally rich ending, dominated and articulated by music.

- Contextualizing player choices

 Choices and actions in the game are recognized by special music, such as the choice to prompt a flying sequence and open the Door of Time, or rewarding the player's achievement (like meeting Zelda and the Ranch Escape). By connecting gameplay choices with events in the plot, the player's actions are imbued with greater significance.

- Immersion

 The music helps to forge the world of the game in cutscenes (especially in the Sacred Realm and Legends of Hyrule cues), and through the recurrence of themes across games (Zelda's Theme, the magic recorder theme, the 'Zelda theme' in the 3DS version). Even the music for the opening of the game encourages a particular mode of attention to the game.

The music for the cutscenes helps to integrate the two game modes: the normal gameplay and the cutscenes. It does so through:

- Transferring melodies across game modes

 Cutscenes cite location themes (Lost Woods, Ganon's Tower) and ocarina songs performed by the player/Link (Zelda's Lullaby in Zelda's Theme)

- Responding directly to game action

 E.g. opening the Door of Time

- Using music to depict characters seen in other game modes

 E.g. Ganondorf, Koume and Kotake

- Musically responding to player input

 E.g. the 'Press Start' arpeggio, and generally waiting for player confirmation before cutscenes progress and the music changes

- Introducing moments of musical interactivity/player performance

 E.g. Sheik's cutscenes provide a musical transition from the underscore to the sequences when Sheik teaches Link the melody, and during which the player must musically respond to Sheik

- Producing musical reactions to cutscene action like the dynamic responses in the main gameplay. In some cutscenes, the music seems to 'react' to the events, emulating the musical processes of the main gameplay.

 E.g. in cutscenes featuring Ganondorf, the music responds to his sudden appearance, like the battle themes

Overall, then, the music in cutscenes, whether serving as a reward for players, articulating the plot or drawing characters, serves to contribute to the experience of playing the game as a whole: the cutscenes enrich, and are enriched by, the main gameplay.

NOTES

1. Giles Hooper, 'Sounding the Story: Music in Videogame Cutscenes', in *Emotion in Video Game Soundtracking*, ed. by Duncan Williams (Cham: Springer, 2018), pp. 115–41 (p. 117).
2. When the Lullaby is played as part of Zelda's Theme, two additional quavers are inserted to decorate the melody at the start of the second phrase and the melody is given a slightly different ending. The first time, in A, the melody is extended by an extra bar, with the final D descending to an A. The second time, in A′, the final D is instead played up an octave and held, ready to lead into the B section.
3. See, e.g., Clare O'Callaghan, 'Lullament: Lullaby and Lament Therapeutic Qualities Actualized through Music Therapy', *American Journal of Hospice and Palliative Medicine*, 25 (2008), 93–99.
4. Unlike in 'Ganon's Tower', the transposed repeat is not heard elsewhere, and the cue instead cuts directly to the sustained final chords.
5. These diminished major sevenths are distinct from the dominant sevenths with sustained fourths that begin his organ performance.
6. Arnold Whittall, for example, describes the diminished seventh as 'Romantic music's most graphic embodiment of shock and horror: usually because, although not strongly dissonant in itself, it disturbs the more stable musical context into which it intrudes'. Arnold Whittall, 'Musical Language', in *The Wagner Compendium*, ed. by Barry Millington (London: Thames and Hudson, 1992), pp. 248–61 (pp. 253–54). See also Derek Hughes,

'"Wie die Hans Heilings"': Weber, Marschner, and Thomas Mann's Doktor Faustus', *Cambridge Opera Journal*, 10 (1998), 179–204 (pp. 181–84; 197–99).
7. Only one part of the C phrase does not conform to this pattern, as the melody approaches its conclusion.
8. For more on the complicated gender identity of Sheik, see Chris Lawrence, 'What if Zelda Wasn't a Girl? Problematizing Ocarina of Time's Great Gender Debate', in *Queerness in Play*, ed. by Todd Harper, Meghan Blythe Adams and Nicholas Taylor (Cham: Palgrave, 2018), pp. 97–114.
9. Richard Hoppin, *Medieval Music* (New York: Norton, 1978), pp. 235–41; Mark Everist, 'The Thirteenth Century', in *The Cambridge Companion to Medieval Music*, ed. by Mark Everist (Cambridge: Cambridge University Press, 2011), pp. 67–86 (pp. 72–77).
10. We might guess that Kondo anticipates that players are most likely to press start either soon after the instruction appears on the screen, or wait until the end of the sequence. That way, harmonic departure in the latter part of the cue is less likely to cause clashes. If the player presses start before the logo for the game has completely faded in, the chord is heard to acknowledge this input, and again to actually start the game, so it sounds twice.
11. Though the musical language of Kondo and Wagner are distinctly different, the use of rapid repeated sextuplet arpeggiation and an emphasis on the harp mean that the two cues are not quite so sonically remote as one might initially imagine.
12. Perhaps, this major seventh chord is a sonic link to Ganondorf's theme, which featured that particular chord extensively. I am grateful to Stephanie Lind for this suggestion.
13. Satoru Iwata, 'Iwata Asks: The Legend of Zelda: Ocarina of Time 3D – 4. Orchestral Sound in the Nintendo 3DS System', *Nintendo*, 27 July 2011, https://www.nintendo.co.uk/Iwata-Asks/Iwata-Asks-The-Legend-of-Zelda-Ocarina-of-Time-3D/Vol-1-Sound/4-Orchestral-Sound-on-the-Nintendo-3DS-System/4-Orchestral-Sound-on-the-Nintendo-3DS-System-231403.html [accessed 14 April 2019].
14. Hooper, 'Sounding the Story', p. 127.

5

Ludic Cues

Beyond cues that are concerned with the fictional world and the story of the game, *Ocarina of Time* also features music that is specifically connected to the gameplay mechanics. This includes music associated with winning, losing, collecting items, fighting monsters and many other game events. A good place to start is with some of the most obvious gameplay challenges: the enemies.

Play: Ludus/Paidia

Play is a complicated and multifaceted phenomenon. Roger Caillois's influential discussion of 'play' presented different types of play on a spectrum between *ludus*, which deals with rules and mechanical processes of play, and *paidia*, concerned with aspects of fantasy and acting as 'a primary power of improvisation and joy'.[1] Games and music typically combine multiple dimensions of play, as we saw in Chapter 2 in the context of the functions of Link's ocarina. This chapter is concerned with music anchored in the ludic rules and processes of play.

Combat Music

Link's adventure is not a peaceful one. In the dungeons and open spaces in the game, Link is often threatened by monsters. These enemies come in a huge diversity of visual designs, modes of attack and levels of threat. One does not need to play *Ocarina of Time* for very long to notice that a musical change almost always occurs when an enemy creature begins to threaten Link. Here, we will explore the music used throughout *Ocarina of Time* for combat sequences.

Ocarina of Time uses six cues for situations when Link is under attack. These are, in order of increasing threat:

- Battle cue (*c.*0:05 intro, 0:53 loop) – a generic theme for when enemies seek to attack Link. This is heard throughout Hyrule (inside and outside dungeons) and across the complete playing time of the game. It is one of the most frequently heard cues of the game and interrupts the location cue in most situations when Link is attacked by an enemy.[2]
- Miniboss cue (*c.*0:02 intro, 0:58 loop) – when journeying through dungeons, Link may encounter a special enemy that is more challenging than those of the typical roster of enemies in the dungeon. Nevertheless, these creatures are not quite as dangerous as the bosses. Minibosses include, for example, the pyrotechnic Flare Dancer, or Dark Link – a shadowy mirror image of Link with red glowing eyes. The miniboss theme interrupts the background dungeon cue.
- Boss cue (*c.*0:06 intro, 1:10 loop) – at the end of each dungeon, Link faces off against a spectacular foe. These are powerful enemies capable of dealing a huge amount of damage and are typically very large. Each boss, however, attacks in a set pattern and has a particular weakness. The player must identify and exploit the vulnerability of the enemy in order to win the battle. The bosses vary in difficulty but are often the most challenging moments of the game, especially when players have yet to learn the boss's patterns of attack or work out a strategy for defeating the enemy.
- Fire boss cue (*c.*0:06 intro, 0:55 loop) – most of the dungeon bosses share the same theme to accompany the battle. There are two exceptions, King Dodongo, a giant fire-breathing lizard of Dodongo's Cavern (second dungeon), and the lava dragon Volvagia, who serves as the boss of the Fire Temple (fifth dungeon). It is unclear precisely why these two bosses should have different themes, other than to provide variation. The two bosses are linked, however: both are found in the fire-themed dungeons near the volcanic Death Mountain, and both terrorize the Goron people.
- Ganondorf battle cue (*c.*0:02 intro, *c.*1:03 loop) – as the primary antagonist of the game, the battle with the 'King of Evil' is no ordinary fight. He is one of the most difficult bosses of the game. The struggle between Link and Ganondorf has been the main driving thread of the plot, so the significance of the showdown in narrative and ludic terms is recognized with a dedicated boss cue.
- Ganon battle cue (*c.*0:10 intro, *c.*1:24 loop) – like many a good movie villain, even though Ganondorf is thoroughly defeated by Link at the top of his castle, he miraculously and inexplicably returns for one final attempt at victory, rising from the rubble of the ruins. Rather than being a re-resurrected Ganondorf,

he transforms into a demonic horned humanoid beast, Ganon. This is the final battle of the game.

These combat cues clearly exhibit a degree of family resemblance, though they also musically represent a spectrum of ludic challenge and plot significance, extending from the easily defeated generic enemies through to the confrontation with Ganon. The cues feature similar musical techniques and all serve comparable functions in the game. By tracing coherence and difference across the set, we can examine Kondo's style of 'combat music'.

Musical Features of Combat Cues

Kondo's combat cues use orchestral instrumentation with a large percussion section. One of the main distinguishing features of the cues is the prominence of the percussion: all of the combat cues feature a persistent snare drum playing a rapid, regular pattern. Some cues add symphonic cymbals, bass drum and timpani to create rhythmic accents. This instrumentation puts the combat themes closer to the orchestral style associated with the cutscenes rather than the obviously synthesized sound of the interface or the localized musical styles of individual areas of Hyrule. Sometimes, voices are also included in battle cues, and these are prominent in the final two climactic battles. The orchestral style seems to invoke Hollywood film music and even the trope of climactic or grandiose scenes accompanied by choir with orchestra.[3]

Rhythm and Texture

One of the defining characteristics of the combat music is the treatment of rhythm. Kondo creates a particular effect in his combat themes by using a propulsive rhythmic drive, but which is then treated to dislocation and textural layering to disrupt (or introduce ambiguity into) the pulse. Overall, the result is a manic, off-kilter effect. Beyond the insistent snare mentioned above, all of the boss themes are founded on an ostinato, or set of ostinatos, that underpin the textures (Table 5.1). These are often layered with other patterns or repeating fragments that do not align neatly with the repetition period of the ostinato. With the exception of the Ganon cue, the ostinatos also use short rhythmic subdivisions to supply urgency to the cue, even if the pulse is disrupted.

Across the spectrum of cues, Kondo uses different kinds of rhythmic ambiguity and disruption, both through the rhythmic properties of the ostinatos and through the textural-structural processes of layering. As the bosses become more dangerous and narratively climactic, the rhythmic effects become more disorienting.

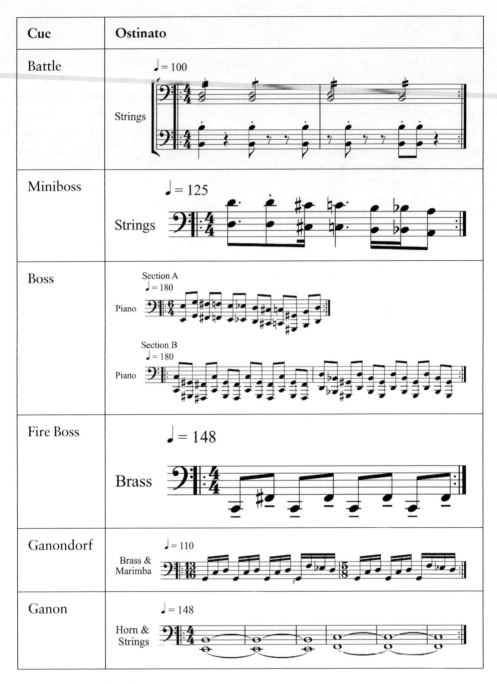

TABLE 5.1: Combat theme ostinatos.

In the generic battle cue, the two-bar ostinato (Table 5.1) is created from a cello that sounds every semiquaver on the same pitch (B) while a double bass plucks octave Bs at irregular rhythmic intervals across the two bars of 4/4, either on the beat or at a quaver displacement. Though the spacing of the bass part is irregular within those two bars, the loop remains unchanged throughout the cue. The rest of the parts serve to reinforce the rhythm of the 4/4 time signature. In the miniboss cue, the ostinato in the lower strings fits neatly into one 4/4 bar, and while it uses a more disruptive dotted rhythm, it remains constant (transposition aside) for the entire cue. Repetition periods of phrases above the miniboss ostinato, however, vary between one and five bars in length.

In the general boss cue, the ostinato repeats quavers in the lower register of the piano. The pattern of pitches repeats after six beats, giving the impression of 6/4. The parts above the ostinato, however, align more clearly with 4/4. The rhythmic interplay becomes even more complicated later in the cue when the ostinato moves to three quavers, further disrupting the pulse. The fire boss cue has a simpler ostinato, alternating two pitches in a regular rhythm. Here, the upper parts initially reinforce the 4/4 pulse. However, later in the cue, this pulse is challenged by accents and layered melodic parts that provide emphasis against the prevailing time signature.

The most rhythmically complicated ostinato is in the Ganondorf battle cue. It uses repeated semiquavers, but the melody implies an unusual rhythm. The pattern repeats after 23 semiquavers. The contour of the melody and the emphasis from the percussion implies a 3+3+3+4/3+3+4 grouping. Even when, later in the cue, the melodic pattern changes, the rhythmic grouping remains. However, though this rhythm remains constant, and is reinforced by the percussion, the upper parts disrupt it: the Ganondorf battle cue features a repeated melodic phrase in strings, wordless voice and brass. The phrase is varied slightly in repetition and transposition, but it is identifiably the same when it returns. This phrase fits into the rhythmic period of the ostinato figure of 23 quavers, but the melody uses different rhythmic emphasis to the ostinato. Figure 5.1 and Table 5.2 show how the rhythmic patterns interfere with each other, yet maintain the overall rhythmic period of the cue.

The final Ganon battle cue is slightly different – the rhythms of the Ganondorf battle cue leave little room for further subdivision and dislocation without risking incoherence. So the Ganon cue takes an approach from the other extreme. Here, rhythmic interest is created from the very long held chords that stretch over several bars, while simultaneously, the snare drum sounds every semiquaver. Whereas the other boss cues used ambiguity in short subdivisions of a bar, here, the ambiguity occurs through the organization on a far broader level – the chordal movement that is so slow that it is rhythmically difficult to follow. As in other boss cues, the other parts do not change at the same period and pattern as the ostinato, further disguising the repetition, disorienting the listener.

THE LEGEND OF ZELDA

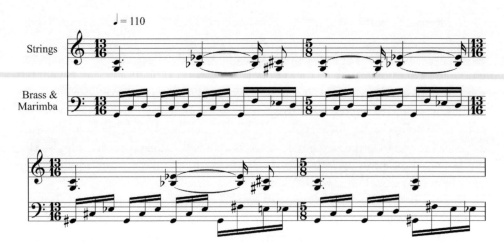

FIGURE 5.1: The ostinato and melody parts of the Ganondorf battle cue, showing the rhythmic/melodic interaction between parts.

All of the combat cues create a sense of propulsion by using percussion to mark the small rhythmic subdivision, but then use ostinatos and repeated patterns to provide motoric drive. In the cues for more dangerous encounters, by using unusual rhythmic groupings and layers that do not align, Kondo provides motion and perhaps even a mood of alarmed panic, without the musical texture disintegrating into incoherence. Kondo maintains clarity of the lower division of the rhythms, but the higher level groupings are often ambiguous.

Rhythm is not the only factor in play. In the combat cues, Kondo avoids long melodic phrases in favour of short fragments that can be more easily repeated in different rhythmic alignments and transpositions than a longer melody. In the boss cue, for example, fragmentary trumpet phrases sound over the ostinato (Table 5.1). These fragments are also discrete enough to be layered in imitation across two trumpet parts generating an echo effect. They do not align neatly with the ostinato and often seem improvisatory. Other examples of this process include

	1	2	3	1	2	3	1	2	3	1	2	3	4	1	2	3	1	2	3	1	2	3
Ostinato	X			X			X			X				X			X			X		
Melody	X						X						X	X					X			

TABLE 5.2: The rhythmic accents of the ostinato and melodic parts of the Ganondorf battle cue.

the rapid scalic fragments in the fire boss cue and a marimba/flute arpeggio in the miniboss cue. Other melodies, even if they are relatively long, use an angular melodic contour and uneven rhythm to avoid predictability – the parts shown above in the Ganondorf battle (Figure 5.1) are one such example, as is the brass melody in the generic battle cue, which begins with a descending tritone and features a dotted-rhythm meandering chromatic line that does not have a clear sense of direction.

The textures of the combat cues rely on the creation of distinct and stratified musical layers. The rhythmic density is forged from a lack of long held notes in favour of repeated notes (with the notable exception of the Ganon battle cue). Nevertheless, the structural process is not simply one of adding layers in turn – not least because, when the cue loops, the impression of a decrease of danger must be avoided. Instead, then, the layers of musical elements tend to be featured in substitution, rather than in a purely additive way.

The miniboss cue is a clear example of this process: apart from the ostinato part shown in Table 5.1 that sounds throughout (sometimes in transposition), there are three other musical elements – a brass motif with rapid repeated notes, a chordal string figure and a marimba/flute part that plays an arpeggio figure. Each of these three additional parts, however, sound in turn over the ostinato and are not layered upon each other. In this way, textual clarity is maintained, as well as variety through an episodic form.

In general, combat cues tend to emphasize lower registers. For instance, the general battle cue never reaches higher than the D above middle C. In boss cues, higher registers are reserved for occasional use by the melodic fragments mentioned earlier, which in turn, help these figures to stand out.

Harmony and Structure

With dissonance as a traditional signifier of danger in music for the screen, it comes as no surprise that Kondo's combat cues in *Ocarina of Time* often make extensive use of dissonant, chromatic and ambiguous harmonies.

4	1	2	3	1	2	3	1	2	3	1	2	3	4	1	2	3	1	2	3	1	2	3	4
	X			X			X			X				X			X			X			
	X						X					X		X						X			

The battle cue is fundamentally all founded on B, with a strong emphasis on B minor and B diminished 7 chords. There is some chromatic undulation, but effectively, the whole cue remains on this foundation (anchored by the ostinato shown in Table 5.1 that never moves from B). By using chromatic decoration, the static nature of the harmony is disguised. Since this cue accompanies the easier enemies in the game, it is particularly likely to be silenced quickly, so a static harmonic underpinning is apt. Though such harmonic constancy in a cue could become monotonous, this risk is low in such a briefly heard cue.

The miniboss cue takes a similar approach – it stays primarily grounded on D, with an ostinato that descends from D to A (Table 5.1). The upper string layer, however, consists of stacked fourths, moving in parallel. This is quartal harmony, which emphasizes the interval of the fourth, rather than the third which underpins much traditional Western classical harmony. The effect is to create harmonic movement on the surface, but there is little fundamental change in the tonal centre. Like the battle cue, surface elaborations provide interest without much harmonic movement, handy for a cue that could be cut short at any moment.

The first part of the boss cue demonstrates another of Kondo's techniques, what we might call 'momentary harmonization'. The ostinato is highly chromatic and fast-moving. The low brass plays sustained minor third chords in an irregular pattern. One of these pitches harmonizes with the note simultaneously played in the ostinato (either in an octave or at a third), but because the ostinato is so fast-moving, the notes quickly become dissonant. It harmonizes, but only for a moment.

The latter part of the boss cue with the second ostinato (Table 5.1) based around two tritone axes is resistant to a stable tonal centre, but in a similar way to the first part of the cue, the accompanying trumpet figures land on pitches that either duplicate those of the ostinato, or harmonize midway between the tritone interval. In essence, then, Kondo uses the upper layers to pick out pitches that harmonize with fast-moving and chromatic ostinatos but become dissonant when they are sustained.

The Fire Boss cue uses the ostinato noted above (Table 5.1) to emphasize the tritone. The upper parts pivot between those two key areas: between C and F# and, when it modulates, D and G#. It is at once stable in its consistency but also ambiguous in the fluctuation of opposed keys.[4]

The Ganondorf cue, like the miniboss cue, emphasizes the interval of a fourth. Above the ostinato, a melody in strings and brass is harmonized in parallel perfect fourths. The ostinato and melody part have an awkward harmonic relationship: sometimes, the two are neatly harmonically concordant, especially when notes of the rapid ostinato are doubled in the melody, but then the ostinato will shift by a semitone for a cycle of repetition, creating a dissonant and heterogeneous texture, before switching back into more consonant harmony again. The

result gives the impression of a system out of synchronization, as though processes are misaligned. The last part of the cue is created from whole tone rising sequences in octaves, which further provides a sense of a freewheeling, unanchored tonal centre.

The Ganon cue, in contrast, is far more harmonically clear. Apart from the percussion, the cue is constructed from a slow-moving chordal texture. The sequences are of varying lengths, but all move from an F major chord to E (major or open fifth). All of the chords are either E or F in basis. Harmonic interest is created from the long suspensions and the use of additional pitches, as in F with added major 6, 7, 9 or 11. These dissonances are never harsh, not least because of careful spacing that avoids clashes in the same register. Though it might be counter-intuitive to have the most harmonically transparent cue for the climax, it is this very contrast that makes the cue so startling and markedly different.

Kondo's approach to harmony in the combat cues eschews long-range harmonic processes. Instead, he prefers to deploy techniques that include (1) minimal harmonic movement decorated by chromatics and added pitches to provide a sense of motion and uncertainty, (2) momentary harmonization and (3) repetitious patterns that move in and out of harmonic consonance with each other.

Implementation in the Game

It would be easy to write off combat music as unimportant: after all, players have more pressing concerns than the appreciation of the music. Yet, these cues serve both communicative and dramatic ends in the game, fusing the ludic and aesthetic qualities of the video game medium.

The miniboss and battle cues serve a clear function. As soon as the battle cue begins, even if the enemy is not immediately visible, players are put on their guard. This is a very common way of programming video game audio, which allows music to warn players of enemies.[5] When the tremolo strings begin to sound, players use their learned knowledge of musical signs to understand this cue as indicating threat. The battle cue remains constant across the duration and world of the game, ensuring that the meaning is always obvious. After playing the game for a while, it only takes the first quiet notes of the cue to play for the implication to instantly register for the gamer. The musical response acts as a sixth sense for both the players and, by extension, Link, by allowing them to 'detect' an enemy approaching beyond the visible dimension of the game. (That the cue fades in with proximity to the threat reinforces the impression of this cue serving as a radar or additional sensory channel for the player.) By consistently using the general battle cue, it contrasts with the other combat cues. This way, players know that the threat indicated by the general battle cue is not as dangerous as a miniboss or bosses.

Players are taught to interpret the music not only as indicating the presence of an enemy but also the type of threat.

The minibosses, in contrast, are typically far more obvious when they approach Link. When the miniboss cue sounds, rather than the general combat cue, by virtue of the musical difference, the player immediately knows that this enemy is not one of the typical game enemies. Instead, it presents a significant risk and must be approached with care. Unlike the general battle cue, the miniboss cue begins with a rapid rising chromatic scale, sounding like an alarm. This beginning and the special musical material frames the battle as a distinct episode and setpiece, an effect even more pronounced in the boss battles.[6]

Since bosses are encountered at the climax of a dungeon, in a special arena for the showdown, it is absolutely clear to the player that the battle is underway and that the threat is significant. These cues instead ratchet up the dramatic tension, monumentalizing the sequence and using rhythmic propulsion, repetition and harmonic dissonance to encourage an emotional response from players. Many of the sequences that introduce the bosses trade on this dramatic potential. Link will normally enter the boss room and find it suspiciously bare. The dungeon cue will fade out leaving an ominous and striking musical silence. We hear sound effects that accentuate the dangerous qualities of the environment (molten lava, bubbling water) or announce the approaching boss (the electric zapping of Barinade, Bongo Bongo beating his drum, the scuttling sound of Gohma). The tension is broken with the revelation of the boss. Some bosses, like Phantom Ganon or Koume and Kotake, begin with a short cutscene and a statement of their character themes before the boss battle begins. The boss battle themes start with an ostentatious brass-led musical flourish, almost like a fanfare indicating that battle should commence.

Players do not unanimously agree on the difficulty of the bosses in *Ocarina of Time*, often claiming that other bosses are more challenging than Ganondorf or Ganon. The music, however, responds to the plot climax of the game as much as the ludic challenge – asserting that these are the most important enemies of the game.

Boss events are telling because they are both important narrative events and significant ludic challenges. These are major points in the storyline of *Ocarina of Time* as well as moments in which the gamer's playing skill is tested. They structure the overall playing experience of the game, like marking chapters in a story. Aptly enough, the battle cues emphasize the orchestral timbres prioritized in the narrative cutscenes of the game rather than the environment-specific materials of the dungeons. These cues, then, link the ludic challenge with the narrative structure of the game.

The Ganon cue is particularly striking in this respect. Irrespective of the actual ludic qualities of the boss, players are made keenly aware of the dramatic

denouement this battle represents with the music. The grandiose cue that accompanies this final conflict emphasizes the scale of the enemy and the narrative climax. While the player may expect more of the rhythmically tense, dissonant and chaotic musical style that has come to characterize battles in the game, the Ganon cue announces the importance of the battle by defying this expectation. Instead, the cue's surprising rhythmic-harmonic process is to deploy serene and slow-moving vocal parts. The wordless choir invokes tropes of epic film while the sense of magnitude is accentuated by the contrast between the dense rapid snare drum rhythms and the long sustained chords and slow-moving suspensions.[7] Part of the joy of playing as the hero of the *Zelda* games comes from taking on the role of a narrative hero, and this kind of musical strategy makes the fantasy all the more fulfilling.

Boss Victory Cue

If Link fails in defeating a boss, the music abruptly halts and the game over cue that is heard throughout the game is triggered (see later). When Link succeeds in defeating a boss, with the exception of Ganon and Ganondorf, a short celebratory cue sounds that contrasts with the preceding boss music. It is a fanfare by strings and brass doubling each other in tutti chords, playing in strict synchronization. This cue is designed to provide emotional release and celebrate the player's success after the tense battle. The fanfare topic clearly salutes the player. The rhythmic profile is markedly different to the boss cues: the ubiquitous snare drum is silent, and the sustained homophonic chordal texture, with all parts moving steadily together, is a counterweight to the rhythmically dense boss cues.

Rather than fragmentary and looping structures, the boss victory cue has an obvious gestural shape providing a definite ending – the fight is clearly over (Figure 5.2). The chordal construction of the cue is based on a series of minor triads in first inversion with an added major second. The parts move primarily in parallel motion, with some chromatic adjustment to aid the sense of resolution at the

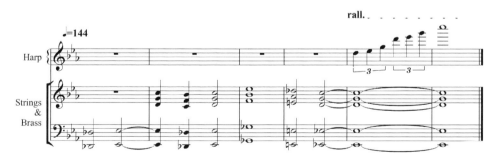

FIGURE 5.2: The boss victory cue, showing the parallel chordal movement.

end of the cue (landing on a sustained C minor chord, also with a major second, decorated by a rising piccolo and harp arpeggio). The wide-spaced pitches give a clarity of texture and the harmonic definition is obvious. Again, the contrast with the harmonically ambiguous boss cues is striking.

Though this is a fanfare, complete with crashing cymbals and rolling timpani, the harmony stops the cue from being entirely celebratory. The emphasis on minor chords and stacked fourths do not provide a simplistic joyful conclusion. Link is dignified in victory, with the result sounding more like a ritualistic indication of success, allowing the player to relax in their moment of triumph.

After the boss has been defeated and the victory cue has finished, a portal appears, ready to transport Link back outside the dungeon. This portal emits a soft, clear sonorous major third chord (B♭ and D) in a sine wave timbre. When Link steps into the portal, the interval is inverted to a sixth, using the same pitches and raised an octave. The pitches slowly glide upwards (by about a semitone) and fade out as Link levitates and is carried away beyond the player's point of view, a little like a reverse Doppler effect. With the sonic clarity of the portal and warping, the whole boss sequence charts Link's efforts as restoring sonic order to the musical chaos of the boss's domain.

* * *

The combat cues of *Ocarina of Time* deploy specific processes and techniques. Kondo's approach to rhythm, texture and harmony are particularly apparent. To give the sense of urgency, all of the cues use a rapid snare drum pattern and bass ostinatos, often with unusual rhythmic groupings. Above this foundation, melodic fragments are layered but often misaligned with the ostinatos. The effect is a dense rhythmic texture that confounds and defies listener expectations while retaining consistency because of the repetition. Not only does this rhythmic density serve as a warning to players about the danger, but it also helps to stimulate an emotive response.

These combat cues will be heard multiple times by players, both by recurring across the game and through repeated attempts at bosses. Like the dungeon cues, the fragmentary, angular melodies lack a clear direction or structure. The process avoids melodies that are easily memorable, mitigating against the potential for listener fatigue as well as furthering the principle of avoiding easily predictable musical patterns. The cues tend towards episodic structures rather than additive processes which would result in a decrease of tension when cues repeat.

Kondo's boss cues exhibit several harmonic strategies. For the easier bosses, when the cue is likely to be heard only briefly, Kondo deploys surface harmonic movement and chromaticism to decorate a static harmonic basis. This way, harmonic interest is maintained, but the sudden silencing of the cue does not result

in an unfinished progression. In cues expected to run for a longer duration, the dissonance/consonance balance is created by the process of momentary harmonization. The result is an out-of-sync effect. Similarly, the emphasis on repeated tritones at once introduces harmonic ambiguity, hovering between two equidistant pitches, but it is also consistent in the repetition and focus on those pitches. Kondo is able to balance unpredictable dissonance that indicates danger with processes that provide a degree of coherence. The short-range or non-directional harmonic patterns are created with the awareness that the cue could be interrupted at any point in the looping cue.

The communicative intent of these cues is obvious, even on first sounding. The repetition allows players to learn the meaning of particular pieces of music and notice musical substitutions, such as when minibosses are distinguished from enemies, and when the last two bosses use bespoke music. The placement of cues in the game, and their repetition, helps to structure the game experience as a whole, based on the frequency and context of the combat cues. This repetition stretches from the frequently repeated general battle cue, through the lesser-heard boss fight themes that delimit distinct stages of the player's progression through the game, right up to the unique cues for Ganondorf/Ganon.[8]

The range of combat cues distinguishes the hierarchy of battles. While Kondo does not articulate a specific spectrum of musical properties that change with boss difficulty, the more significant battles tend to use larger ensembles, are more likely to use voices, feature greater rhythmic dislocation or ambiguity and deploy longer harmonic progressions. Whether or not a player finds Ganon a more difficult foe than one of the minibosses, the music indicates his significance, articulating the narrative structure of the game (as well as implying the ludic difficulty of the boss).

All of these battle cues hold communicative meaning for players, providing specific information about the gameplay challenge, but they also use musical techniques to try to stimulate an emotive response from players. Kondo deploys unpredictable and destabilizing repetition patterns, propulsive rhythms, dissonant harmony and ear-catching sonic features to generate a contagious musical affect of high-stakes alarm that easily infects the player with the same panicked mood. The combat cues are thus emblematic of the video game as a whole, blending narrative, ludic and aesthetic concerns together.

Cues for Treasure and Challenges

Ocarina of Time has many short cues for other ludic aspects of the game. These include music for finding treasure, music related to solving puzzles, music for losing and cues for minigames and special sequences.

1. Acquisition Cues

Link travels Hyrule in a state of perpetual kleptomania, constantly collecting a wide variety of objects and treasures. His perpetual drive to acquire more items is encouraged by the cues that celebrate him discovering them.

Opening Treasure Chests – A Musical Gesture

The dungeons and landscapes of *Legend of Zelda* games contain many prizes and secrets. Whatever the setting, volcano, ice cavern or fish stomach, treasure chests will be strewn throughout the world, ready to surrender their valuable contents to anyone bold enough to open them. Some of these chests contain optional bonuses or currency, while others yield items essential for completing the game. When Link is directed to open a large chest, the location cue falls silent to make way for a cue to accompany Link raising the lid of the box. Then, one of two fanfares plays as Link holds his winnings aloft (Figures 5.3 and 5.4).

The cue for opening the chest is three bars long and consists of a rising sequence. The unit of the sequence is a four-note rising whole-tone scale, initially sounding on G. The scales start on progressively higher pitches, moving up a semitone each time. Initially played only by strings, more instruments are added as the sequence rises. This rising sequence is a neat gestural match for Link opening the lid of the treasure chest. A glockenspiel plays a fast accompanying ostinato at a very high pitch throughout the cue, adding a metallic timbre which alludes to the potential glittering delights hidden in the chest.

As well as increasing the tempo, texture and pitch as the cue progresses, a sense of climax is also generated by ascending in pitch more rapidly: initially the sequence rises every minim, but later, every crotchet beat. The whole-tone scale is useful here since it lacks the strong pull to a tonal centre, and, instead, the sense of movement

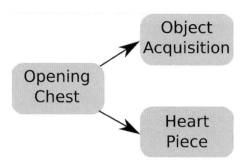

FIGURE 5.3: The treasure chest cue design. Each of the continuation cues are also heard separately.

LUDIC CUES

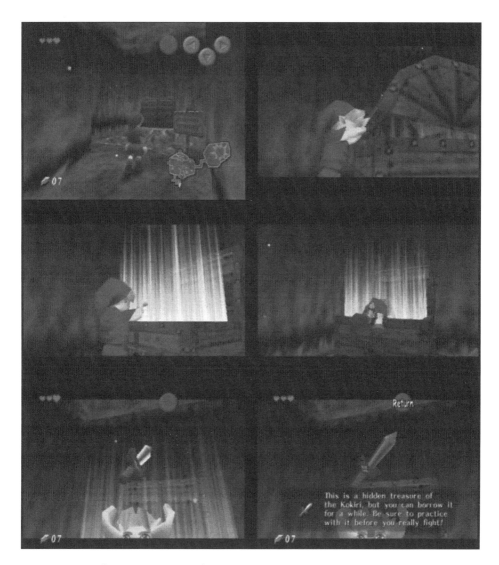

FIGURE 5.4: Link opens a treasure chest.

comes from the ascending scalic figures rather than a harmonic resolution. After finishing on the final scale (starting on a D, landing on a G#), and a moment's pause while the player is held in suspense, the cue can continue in one of two ways.

Object Acquisition – A Legacy of Success Sounds

If Link uncovers an item in the box, he is accompanied by a brassy fanfare marked by cymbal crashes and concluded by a drumroll. The fanfare consists of four

229

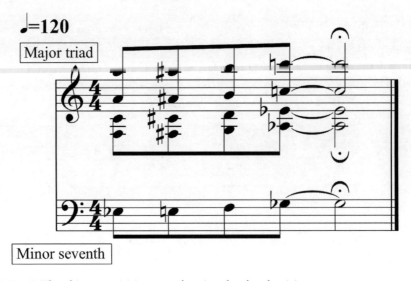

FIGURE 5.5: The object acquisition cue, showing the chord voicing.

dominant seventh chords which rise chromatically from F7. The upper brass play major triads while the lower play the minor seventh pitch. The series begins with the uppermost part playing an A, carrying on the chromatic trajectory from the previous chest opening cue which landed on G#. The last chord, A♭ dominant seventh, is held for dramatic effect (Figure 5.5). Minor rewards are sometimes housed in small chests that do not prompt the same ballyhoo as the larger chests. In these situations, the second part of the cue begins without the open chest cue.

Both the object acquisition cue and the music for opening the treasure chest are found in other games of the *Legend of Zelda* series. The fanfare figure for obtaining an item is not new to *Ocarina of Time* but extends all the way back to the first entry in the series. In the original *Legend of Zelda*, when Link receives a treasure, the same four-chord chromatic rising gesture appears (albeit with fewer notes per chord, given the limitations of the earlier console). Later *Zelda* games also use the phrase for the moments when Link acquires treasure. Just as *Ocarina of Time* copies music from earlier games, the cue for opening the chest, first heard in this game, would later also be used by adapted by subsequent titles including *The Wind Waker* and *Twilight Princess*. The replicated music ties the game into the franchise lineage and immediately draws upon accumulated (perhaps even nostalgic) meanings.

Heart Piece/Skulltula Token Acquisition – A Completed Fanfare

Among the most prized treasures in *Zelda* games are the 'pieces of heart'. Since Link's health capacity is directly connected to the ludic challenge of the game,

LUDIC CUES

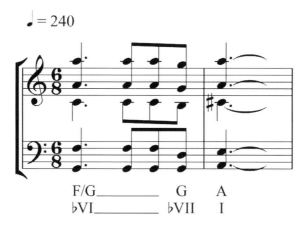

FIGURE 5.6: Heart piece and gold skulltula token acquisition fanfare, showing the chord progression.

acquiring heart containers (or parts thereof) is very important. Link may unlock pieces of heart in treasure chests. After the end of the chest opening cue, if Link has found a heart piece, we hear a different fanfare to the one described above. This is characterized by a dotted rhythm (Figure 5.6) accompanied by crashing cymbals and drum rolls.

The cue for opening the chest had finished on G#, so the A in the top voice continues this melodic line, just as in the general item fanfare. An F major chord is heard over G, repeated in a dotted rhythm and we hear a quick cadence via G major to finish on A major. By virtue of the harmony, this conclusion sounds more complete than the general item variation. It also replicates the ♭IV→VII–I cadence we have seen Kondo to favour elsewhere in this game and in the victory cue for *Super Mario Bros.*

The cue is quite similar to the object acquisition cue and does not suggest any significantly different musical meanings. But simply by being different to the expected music, the moment of finding the heart piece is marked as special. Sometimes heart pieces are found floating freely, and so this cue must exist independently of the chest opening cue. The self-contained harmonic progression helps the cue to have a sense of conclusion and coherence, even when it is heard on its own. The music for the heart pieces is shared with another of Hyrule's recurring items, the skulltula tokens.

Golden Skulltulas – Realism Need Not Apply

One of the other collection tasks in *Ocarina of Time* is the gold skulltula challenge. One hundred special spiders, gold skulltulas, are hidden across Hyrule.

If Link finds and defeats one, it will surrender a token, which can be traded for rewards. When the skulltula releases its token, an arch-shaped musical motif plays (B♭4–F5–B♭5–B♭6–F5). This is performed in a synthesized tone, almost the kind of chime would expect as accompanying a system message on a computer. The timbre is apt for the unrealistic conceit of a creature leaving behind tokens: it is obvious that this is narratively absurd but part of the ludic challenge of the game. The artificial timbre is well matched to the unapologetically unrealistic quality of the game mechanic.

Upon collecting the skulltula token, the same cue as the heart piece acquisition is used, and it never requires the preamble of the chest opening passage. The skulltula tokens and the heart pieces are similar in that they both need multiple copies of the items to unlock the reward: four heart pieces are needed for a whole new heart, many skulltula tokens are needed to unlock the associated rewards.

Minor Object Acquisition – Chime of Success

Not all objects are as important as the treasure in the chests. For acquiring minor items, a rapid arpeggio figure sounds in a solo part. There are two variations of this kind of cue. The short version is a D♭ major arpeggio in octave 5, while the longer version begins the same but continues on to articulate a IV–V–I cadence in A♭ major. In both, the timbre is obviously artificial (a triangle wave) and does not aim to emulate an acoustic instrument. This is not monumentalized in a long cue or structured as a narratively significant event with the use of a non-diegetic orchestra but simply a musical cue to mark and indicate the player has found a reward, albeit not a very significant one. This electronic chiming sound is similar in timbre to the interface sounds discussed in Chapter 6.

Master Sword – A Tradition of Heroic Success

The Master Sword is a feature of several *Zelda* games, and acquiring the sword is a recurring rite of passage for Link. In *Ocarina of Time*, after the Door of Time opens, Link finds the Master Sword in a pedestal. The player can direct Link to extract the sword. In the cutscene that follows (Figure 5.7), Link pulls the sword out of the stone plinth, which prompts him to travel through time.

Prior to *Ocarina of Time*, the sword had been featured in *A Link to the Past* and would subsequently appear in many other *Zelda* games including *The Wind Waker*, *Twilight Princess* and *Skyward Sword*. In each game, the moment when Link extracts the sword from the pedestal is accompanied by a very similar cue. Though the instrumentation and harmonization differs between games, the cue is always in the same two parts.

FIGURE 5.7: Link obtaining the Master Sword.

The first part consists of a rising crotchet melody. It is accompanied by a repeated rapid ascending arpeggio (normally in glockenspiel). The second part consists of four dramatic held chords. Major chords ascend chromatically (A♭, A, B♭, B), while, at the same time, a bass part chromatically descends in the opposite direction (B♭, A, A♭, G). This all creates an expansive climax, resulting in a dramatic unresolved false relation between the G-naturals in the bass and the F#s in the upper voices. (Figure 5.8). We can read this cue as a developed version of the object acquisition cue, which also used chromatically ascending major triads and finished with an unresolved dissonance.

In *Ocarina of Time*, in the first part, a glockenspiel accompanies strings playing the rising melody, before strings and horns sustain the climactic chords. The effect is a melodramatic musical statement that accentuates the heroic status of Link, accomplishment of the player and the significance of the sword. Just like recurring location and character themes, the repetition of the same music throughout the series helps to reward loyal players who recognize the theme, as well as implying that the sword is the same artefact that recurs from game to game, part of building a shared franchise world.

Heart Container Acquisition – A Lesser-Heard Success Cue

In special moments, Link can collect a whole new heart container. These are rewards for defeating an end-of-dungeon boss and are found floating in the

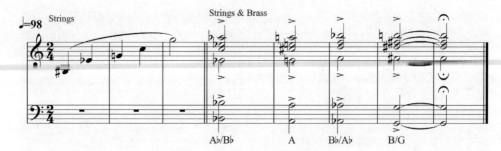

FIGURE 5.8: Reduction of the Master Sword cue, showing the two sections and the contrary motion of the final chord sequence.

boss room after the battle. Collecting them prompts a specific cue. Again, the cue is very short, lasting only two bars. It consists of a rising arpeggio of a B♭ dominant 9 chord in minor thirds, over a bass part that rises from A♭ to B♭. Like the other acquisition cues, it is concluded by a drum roll. The cue is no more particularly joyful or celebratory than the other acquisition cues; its purpose is more one of being distinct, in order to emphasize how special these heart containers are.

The heart container cue also reappears elsewhere in the game, in an unexpected place. Along the shores of Lake Hylia, Link can visit a shack and pay to fish. The mechanics of the game are straightforward – cast a line, lure a fish and reel it in. To win the prizes, Link must net a sufficiently large fish. Whenever Link catches a fish, we hear an acquisition cue, though rather unexpectedly; it is the heart container cue that sounds for a fish. This is rather a confusing choice. Read one way, it can be seen as comedic: the same success sounds for one of the most valuable and unrealistic items in the game as one of the most mundane (especially when the fish is tiny). Another possible motivation is the promise of reward – a piece of heart is one of the prizes available. Additionally, perhaps the decision to deploy a less frequently used acquisition cue is a pragmatic choice to provide variation from the other more common acquisition cues in the game, even if the association between fish and heart containers is a little unusual.

Learning a New Song/Fairy Ocarina – Musical Education as 'Success'

When Link successfully learns a new song on his ocarina, a brief musical cue is heard that celebrates the song being added to his repertoire and the melody's abilities being 'unlocked' by the player. The cue is very straightforward – a three chord progression of F major, G major, A major by a small ensemble of strings and harp, with a solo ocarina that plays an arpeggio of each chord. The ocarina

is clearly non-diegetic, since Link has stopped playing by this point. Once again, this matches the ♭VI→♭VII—I cadence seen in the Heart Piece/Skultulla acquisition cue.

The cue is used in the first part of the game, when Link learns the earlier tunes and upon receiving the fairy ocarina from Saria. This cue does not sound when he is taught melodies by Sheik, because Sheik's theme is heard instead. This short positive musical celebration shows that learning a song is a major milestone in the game, both in terms of the game's plot and as a ludic accomplishment. Perhaps this is why the cue is not used later in the game – by the time Sheik appears, players have already come to understand the importance of the songs.

Obtaining the Spiritual Stones and Medallions – Unusual Celebrations

As a reward for completing the dungeons, Link is given mystical objects. For the first three dungeons, those are 'Spiritual Stones' given by the Deku Tree, Darunia and Princess Ruto in gratitude for Link's assistance. In the latter dungeons, 'Medallions' are awarded for completing dungeons by the Sages.

When Link is given one of the Stones, a short cue acts as a celebration. Four bars long, it consists of horns, strings, woodwind and timpani playing a series of parallel major chords, while glockenspiel and harp add decorative arpeggios. The cue is harmonically curious (Figure 5.9). Though it is built exclusively on major triads, the progression is difficult to predict. It starts on B♭ major and ends up on A major, by way of E, G, B♭ and A.[9] The harmony is clear in the chords but odd in the way they are deployed. Though the cue has many of the trappings of a celebratory fanfare, the result is mysterious. As we have seen elsewhere in the game, Kondo may also be using unexpected harmonic processes to evoke old traditions. It certainly marks the Stones as unusual in comparison to the more straightforward fanfares of the heart piece and heart container.

Link receives the medallions to a rather more conventional fanfare cue led by brass and supported by strings. Again, a glockenspiel adds rapid arpeggios to lend the aura of treasure and magic. Here, the brass takes a far more prominent

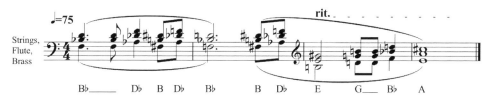

FIGURE 5.9: A reduction of the Spiritual Stone acquisition cue. The harp (not shown) provides arpeggios on the chords.

THE LEGEND OF ZELDA

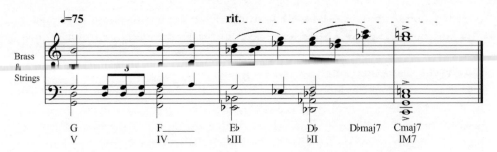

FIGURE 5.10: A reduction of the Medallion cue showing the harmonic movement.

role and crashing cymbals further indicate the significance of the achievement. In comparison with the cue for the Spiritual Stones, the melody is a much clearer rising sequence. Harmonically, the cue presents a V–I journey, moving from G major to resolve on C major 7; it is a satisfying musical resolution (Figure 5.10). Part of the expansive sense of conclusion is built on contrary motion: while the brass melody ascends, the bassline descends. The two stone/medallion fanfares have similar orchestration and rhythmic profiles, so they sit as a pair. But each cue is particular to that object, marking them out as special. In a game with a huge amount of repeated material, that exclusivity distinguishes these objects as important.

* * *

In the myriad success and acquisition cues in *Ocarina of Time*, several trends are apparent. Unsurprisingly, rising gestures dominate. A sense of harmonic conclusion is sometimes used as a substitute for a rising profile. The more significant acquisition cues tend towards a fanfare topic. Often, orchestral timbres will be used, or, if the reward is less realistic (such for the skulltula tokens), an artificial chime, closer to interface sounds, will be used. Perhaps it is the number of different acquisition cues that is striking. The selection of cues distinguish the different kinds of objects Link can find, and provide sonic variety. The music recognizes and celebrates the player's success and differentiates the items, so they avoid becoming indistinguishable tokens or icons.

2. Music for Puzzles

Music is sometimes involved in the puzzle mechanics. It can indicate success or provide information on the progress of the puzzles.

Timed Puzzles – Marking Time

In the dungeons, Link is frequently challenged to complete tasks within a time limit. Very often, Link has to activate a switch that changes the configuration of a room, but after a particular time, the switch will release and the room resets. Link must take advantage of the changed state before the time runs out. Many such switches are indistinguishable from those without time limits and there is no visual indication of how long the timer has remaining. Instead, these two aspects are communicated to the player audibly. Upon activating the switch, a tick-tock pattern is heard in a timbre somewhere between a squelch and a mechanical click. The loop consists of two 'tick-tock' patterns, where each 'tick' is higher than the 'tock', but the second pair begins higher than the first. This sound immediately tells the player that the switch is on a timer, and they must move quickly.

As the timer begins to run out, the tick-tocks begin to sound ever faster. There are three variations on the pattern: the time between each beat becomes shorter with each of the variations ($c.0.38$, $c.0.19$ and $c.0.09$ seconds, respectively). As time begins to run short, the pattern sounds at a faster tempo. The audio creates a sense of urgency and communicates to the player that the time limit is approaching.

In other situations, an on-screen display indicates time limits. For example, in one sidequest, Link must deliver goods from one end of Hyrule to the other, before the materials spoil. When an on-screen timer is used (showing minutes and seconds), sound is still used to inform the player. A short triangle-wave beep (A5) is heard initially every 10 seconds, while a sawtooth wave beep (C5) marks each minute. This same sawtooth beep then sounds every 2 seconds during the final minute, but for the final 10 seconds, the octave higher C is added to the sound at a slight delay. As time runs short, the beeps become more frequent and use a more angular waveform – the increasing need for urgency is sonically impressed upon the player. Of course, as well as upping the dramatic ante, the beeps indicate the time without the player needing to look away from navigating the complicated virtual environment. Both of the timing cues unite dramatic and practical functions and become part of how the player engages with the timed aspects of the ludic challenges.

Silver Rupees – Musical Design Language

Another dungeon puzzle mechanic asks Link to collect special silver rupees from difficult-to-reach places in an area. He must collect them all to activate a secret or unlock a door. Rather than the normal trilling chime associated with collecting

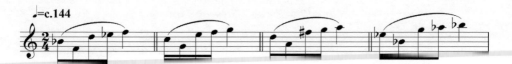

FIGURE 5.11: The short motifs heard in sequence when collecting the silver rupees.

traditional rupees, these silver rupees have a short musical phrase consisting of five notes in a whistle-like timbre.

The silver rupees come in sets of five. Each time a rupee is collected, one of the phrases sounds (Figure 5.11). No matter which order the rupees are collected, the phrases always sound in the order indicated in Figure 5.11 – that is, with each fragment ascending in pitch for the first four rupees.

Players are not given instructions how to solve the puzzles in *Zelda* dungeons – they have to work out what the challenge is and then the solution. This means they are reliant on all sort of visual and audio cues to understand the task at hand. The little motifs for the silver rupees are part of *Zelda*'s design language that guides players through the process of exploring the rooms and puzzles of the dungeons. Immediately, by using a different sound to the normal rupee collection sound effect, the game marks these rupees as special and implies their significance for the puzzle at hand. By using pitched musical phrases, the designers can easily create a sequence that is consistent across the rupees but progresses incrementally as each is collected. By sounding the sequences transposed, it implies a trajectory towards a conclusion – it seems to say to the player, 'Keep going, you're on the right track!' When the final rupee has been collected, the player hears the 'puzzle solution' melody (Figure 5.12) to let them know that they have successfully completed the challenge and should now move to the next aspect of the puzzle.

Puzzle Solution – A-Ha!

In the dungeons of *Ocarina of Time*, most of the rooms either involve defeating a villain or solving some kind of non-verbal puzzle. When Link has successfully completed a challenge, a solo musical motif often sounds (Figure 5.12). This fragment originated in the first *Legend of Zelda* game. It even sounds at the same pitches in *Ocarina of Time* as it did in its initial incarnation. It has also found repeated use in the interim and subsequent games of the series, as part of the series' identity (as we have already noticed with other cues).

The melody can be interpreted in several ways, but the gesture seems to model movement from ambiguity to clarity – an 'a-ha' responding to the player unlocking a mystery or solving a problem. The initial descending gesture is tonally ambiguous

LUDIC CUES

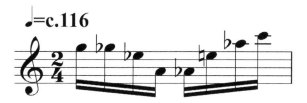

FIGURE 5.12: Puzzle solution/secret cue.

(perhaps implying a half-diminished chord on A), while the second half articulates a clear augmented A♭ triad. The pitches of the second half sound as raised alterations of the first three notes, which, along with the augmented chord, implies the opening of possibility. We end up higher than where we started, with the musical progression an analogue for ludic progression. It is a mini journey from confusion to order, closing to opening, lower to higher.

As well as recognizing and rewarding the player's actions, the cue serves a distinctly practical purpose: in the 3D environments and given the moving camera, the effects of Link's actions are not always visible or immediately apparent. The puzzle solution cue makes it obvious to players that they have caused a change in the environment and the game state. They are then prompted to work out what the effect of their action has been and how that has solved the puzzle at hand.

The puzzle solution uses a strict pulse wave. Figure 5.13 shows a zoomed perspective on the waveform that is used for the melody in Figure 5.12: this is the first note, and the image represents the first 0.017 seconds of the sound. Here, the rectangular shape of the waveform is particularly obvious. It is this quality that gives the solution cue its clearly artificial timbre. The timbre connects the cue to *Zelda*'s history. The first *Zelda* game had limited options for musical timbres given the console hardware, but melodies were typically played in pulse waves. Not only does *Ocarina of Time* use the same motif as the earlier game, but it even replicates the same timbre to ensure complete fidelity to the original.

Why might designers maintain the clearly artificial timbre of the original cue? After all, there is no attempt to do the same for other pieces borrowed from *Zelda*'s musical history (Kakariko Village, Zelda's Lullaby). The answer may

FIGURE 5.13: The waveform of the puzzle solution cue, showing the distinctive square wave shape.

lie in the relationship between the cue and the game reality: unlike cues that primarily deal with plot events or constructions of the fictional world, this cue is concerned explicitly with the ludic challenge of the game. It is not connected to a place or a character; it exists specifically for the purpose for indicating and rewarding the player's success at the puzzles and defeating the enemies. The dungeons are not naturalistic anyway, with arbitrary tasks, enemies that appear from nowhere and mechanical movement powered by unexplained means. The cue deals with this same level of admitted artificiality, indicating success at the obviously unrealistic challenges. It sits abstracted from the gameworld and indicates ludic success, closer to the interface sounds than the diegetic music or location cues. For that reason, the clearly artificial timbre is apt for the function it serves.

Correct Action/Correctly Play Ocarina Song – Success!

The puzzle solution cue has a shorter sibling, with the same timbre, used to indicate that Link has performed the correct action: this can include playing an ocarina song at an appropriate moment or giving the correct item to another character. It is the melodious 'correct' to the dull clunking metallic 'dong' (a detuned B♭) mentioned in Chapter 2 that indicates an incorrect performance. This rising arpeggio (Figure 5.14) is not harmonically ambiguous like the longer cue, but it nevertheless avoids a strict major/minor tonality. The rising gesture implies an opening of possibility – a reward but an overture for things to come.

** * **

The miniature cues for puzzles blend practical and aesthetic purposes. They often convey information to help players, but even if that fact is also communicated another way, it perceptually accentuates that information. We will see similar effects in the musical sound effects (Chapter 6), which also, like these cues, emphasize obviously artificial timbres.

FIGURE 5.14: Correct action arpeggio.

3. Music for Losing – Game Over

Just as video games provide opportunities for success, players will also expect to experience failure. Like many games, in *Ocarina of Time*, losing is often tied to the death of the player's avatar. There are two main modes of losing in *Ocarina of Time*. The first is associated with situations of instant death or failure at particular challenges. It occurs when Link falls off platforms into bottomless abysses, when he is caught by a trap in a dungeon or when he loses a minigame. In these situations, the image rapidly fades to black accompanied by a descending continuous glissando in a wavering whistling sound, lasting a second, and covering a little over an octave (from B5 to about G#4), before a 'fade in' finds Link reset to the start of the room or area.[10] Aptly enough, the fade in cue is the mirror image of the fade out, presenting a rising glissando in the opposite direction, albeit even quicker (*c*.0.7 seconds). The two parts of the cue, in combination with the visual presentation, are similar to the cartoon stereotype of an audio/video rewind sound, with the glissandi approximating the sound of a tape player rewinding. Now returned to the start of the area, Link can try again, almost like another 'take' of a film.

Players experience 'game over' when Link loses all of his available health points (represented by the hearts) and there are no fairies to revive him. In game over situations, the moment of loss is meditated upon for far longer than in the instant death situations. Upon taking the last available point of damage, all sound suddenly ceases and the scene fades to black with the exception of Link and Navi. As he falls to the ground, making a gasping noise, a musical cue sounds, before players are given the option to restart the game.

The game over cue is scored for strings and harp. Lower strings play five chromatically descending minor chords in first inversion. It is followed by a final minor chord that adds a major second. This chord is held while a harp plays a rising arpeggio above it. The harp plays the same chord as the strings but avoids the minor third in favour of the major second (Figure 5.15).

FIGURE 5.15: A reduction of the game over cue with the chords marked.

Game over cues have to strike a tricky balance: they must respect and indicate the significance of losing but must not do so to the extent that the experience is unpleasant to the player. Music must provide commiseration, not taunt the player. The cue should also encourage players to continue playing. The game over cue in *Ocarina of Time* charts this move from failure to invitation to try again. The chromatic descent of the strings in this cue is similar to the 'wah-wah-wah' muted trumpet that accompanies the misfortune of cartoon characters, but the strings are less evocative of schadenfreude than a trumpet. It still, however, evokes failure. The descent of the strings is countered by the ascending harp arpeggio at the end. When the harp plays the major second, rather than the minor third, the effect is to lighten the mood into a softer optimism (and perhaps a desire for resolution by restarting the game). The bright timbre even seems to say, 'Oh dear, have another go …'. The cue helps to chart the ideal emotional journey of the player losing the game – frustration or disappointment at defeat, and then a new resolve to try again. For all that the game logic is responsible for the player's failure, this seems like encouragement on the part of the game, part of the 'voice' of the game design.

4. Minigames – Frivolous Fun

Beyond the main quests of *Ocarina of Time*, Link can enjoy several other optional minigames, which are replayable self-contained 'games within games', much like the fishing mentioned earlier. Minigames typically use specific cues to demarcate them from the main gameplay. For the diving challenge in Zora's Domain and the chicken hunting game in Lon Lon Ranch, a new cue displaces the general location music to indicate the minigame has started.

This cue, heard for diving and chasing the chickens, is a fast major-key cue (mm=185) written for a small group of instruments, primarily double reed woodwind, strings and percussion. It resembles late-nineteenth and early-twentieth century circus music, particularly the galop, a short energetic dance with insistent rhythms, which was used to accompany acts or cover entrances/exits. The cue's emphasis on tuned percussion and its motoric rhythmic profile that emphasizes every quaver calls to mind pieces like Gustav Peter's 'Souvenir de Cirque Renz', a circus galop. Though this cue is perhaps not quite as fast or rhythmically intricate as a typical galop, it has a sense of light-hearted, high-spirited energy.

The cue only lasts 30 seconds, and the repetition and insistent rhythms of the cue could have the potential for annoyance if heard for extended periods of time. This issue is mitigated by the game context – the time-limited minigames are rare and brief, so the accentuated rhythms are only heard in short doses. The cue not only tells the player to act quickly, but the jovial nature of the cue implies that this is a light-hearted task. In alluding to the tradition of the circus and fairgrounds,

the music helps us to understand that this is not a serious challenge, but a fun distraction. The stakes are not high and it exists at a different register than some of the other challenges in the game (like the bosses), even if the ludic difficulty is high. By creating different moods of play, the contrast is accentuated when the game does wish to invoke a dramatic affect.

Horse Minigames – Epona's Hoedown

Three minigames take place on horseback: horseracing, an obstacle course and a horseback archery challenge. These use a specific cue. If the Lon Lon Ranch was a slow pastiche of American country ballads, the horse minigames are modelled after uptempo bluegrass. The cue is scored for a typical bluegrass ensemble: banjo, violin, guitar, string bass and harmonica.

The driving rhythm is at the heart of this sprightly cue (mm=155). While the bass plays steady crotchets, the guitar strums the key chord on the off beats. The banjo also articulates the chords, but plays a constant pattern of a quaver and two semiquavers. The result is a galloping rhythm which creates a propulsive drive to the piece but also serves as an analogue for Epona's movement. The music helps to enhance the sense of movement when riding the horse, as the rhythm of the hooves and the musical rhythm intermingle.

The violin plays the melody, double-stopping to produce chords (especially thirds and fifths), and even uses subtle pitch bending to give an idiomatic and folksy touch to the performance. It plays a melody with the structure of AA'AB, suitably copying the bluegrass tradition of song structures and clear, memorable melodies.

The cue is based on a chord sequence in F major lasting eight bars. It starts with one chord per bar of I–IV–I–V–I–IV before a quick I–V–I cadence and the sequence repeats. This pattern is played twice with the violin melody, and a further time with what sounds like an improvised harmonica solo, before the cue loops. It approximates the structural approach of bluegrass music, where members of the band take turns at improvising solos. This cue also includes an ending that immediately interrupts the cue when Link crosses the finish line. This two-bar tag uses a I–V–I cadence, complete with banjo fast-strummed rising glissando as a flourish to finish. The bluegrass style is well suited to these minigames, partly on account of the topical association with rural culture and ranching, and partly on account of the rhythmic aspects of the genre that admit the propulsive drive so well.

One of the horse minigames is a race around Lon Lon Ranch. Link must beat the villain Ingo in a horserace, in order to win Epona from him. During the race, the horse minigame cue plays. If Link successfully wins the race against Ingo, after the race, rather than returning to the location cue (Lon Lon Ranch), we instead hear a slow variation on the horse race cue. This cue loops the A section of the

theme at a significantly slower tempo (mm=80). Not returning to the location cue helps to indicate that players have unfinished business after beating Ingo – the situation is not back to normal. Though Ingo, true to his word, gives Epona to Link, he locks the ranch to prevent Link from leaving. The slow version of the horserace cue subtly hints to players what their next move should be – escape the ranch by galloping on Epona to the jump over the ranch walls.

Both the minigame cues serve similar functions in different ways. First, they are both stark and attention-grabbing musical statements, which helps to delineate the minigame as a different mode of play. Second, they both emphasize rhythm: the normal minigame through the insistent quavers, the horse minigames through the bluegrass rhythmic patterns. For these cues, the short duration allows a more insistent musical rhythm and approach than would be wise for cues heard for longer periods without a break. Third, both are upbeat and jolly, emphasizing a major tonality, in order to indicate the relative levity of these situations.

5. Special Sequences

The minigames represent moments in *Ocarina of Time* when the mode of gameplay is slightly different from the typical interaction elsewhere in the world. These examples are distinctly segmented from the main gameplay. Not all such examples are so clearly distinguished from the main play mode. Nor are they optional to successfully completing the game. Over the course of *Ocarina of Time*, players will encounter two special sequences. While the controls of Link are unchanged, the parameters of gameplay are subtly altered. Each has a dedicated musical cue to help indicate that new gameplay logic is in effect. Furthermore, both represent important moments in the plot of the game.

Castle Courtyard – Low-Stakes Sneaking

The first such special sequence is found near the start of the game in the castle courtyard. Link seeks Princess Zelda and has to sneak into the castle. He must avoid being noticed by the guards. The game has already established the gameplay mechanic of avoiding the guards: to even approach the castle, Link must exploit the large areas of the castle grounds that guards leave unattended. These posted guards are stationary, but the courtyard ups the ante. In a radical innovation of Hyrule's security strategy, these soldiers move. Nevertheless, the guard recruitment process still seems to favour strikingly unobservant candidates. The player has to watch the guards, learn the patrol pattern and then direct Link through the courtyard without being noticed. That the music changes when entering this area demarcates this sequence as distinct. The cue is stylistically

curious. Though it is scored for flutes, clarinets, harp and strings (i.e. orchestral/classical instruments), the harmonic pattern is a twelve-bar blues on C. The first half the loop consists of flutes or clarinets playing thirds in cheeky antiphonal exchange with pizzicato strings. The second half uses held chords in the harp and strings underneath a clarinet melody that becomes explicitly bluesy by emphasizing appogiaturas and chromatic alterations to provide 'blue note' harmonies. The blues harmony and form sits oddly with the medieval courtyard, but the affect and stylistic contrast with the other music makes the intention clear: this is a low-stakes moment of gameplay that requires a slightly different mode of engagement by the player.

Ganon's Castle Crumbles – An Impression of Drama

The second special sequence is at the opposite end of the game. After Ganondorf is defeated at the top of his castle tower, the building starts to collapse. Zelda guides Link back down through the tower to the entrance. Link has three minutes to escape but needs to keep up with Zelda as she leads him to safety. This is a thrilling and dramatic moment – flaming rocks rain down on the fleeing duo and enemy creatures still seek to frustrate their exit.

Much like Ganondorf's theme, the cue begins with a series of brass chords. Here, a tritone and augmented seventh are stacked on a rising sequence of descending semitones, creating a highly dissonant harmony. The rest of the cue is dominated by a propulsive driving semiquaver rhythm. At mm=125, the piano and snare drum constantly mark semiquavers, urging the player to move quickly.

The rhythm and texture is at the core of this cue's affect. There are two distinct layers. One layer features brass, piano and timpani playing repeated semiquavers in an almost mechanistic style. The pattern mostly stays repeating the same note, though it sounds a tone lower on the second beat of the bar. The other layer consists of strings playing minim or semibreve held chords constructed from tritones. These chords move by semitone in parallel motion but not in alignment with the movement of the brass/piano/timpani part. With different musical parts moving by step, but not aligned to each other, a sense of regulated chaos in motion is formed, much like the boss themes and quite apt for the crumbling tower. The cue has a twelve-bar introduction followed by twelve further bars that play as a loop. The long introduction is used to introduce the layers in turn, before the loop maintains this consistency of texture.

Though the sequence for escaping the tower is spectacular, the ludic challenge is not especially hard: compared to other sections in the game, the time limit is reasonably generous. However, the music asserts dramatic urgency. The rhythmic density is key for this project. The ensemble for this cue is not unusually large, but

it is rhythmically intense, with the unrelenting semiquaver pulse of the snare and piano spurring the player on.

Both of these special sequences in the game marry important plot moments with subtle changes to the way gamers must play the game. During the escape from the castle, the player's main job becomes following Zelda to safety. Similarly, in the courtyard, stealth game strategy suddenly comes the main mode of gameplay. The combination of narrative significance and subtly different emphasis of gameplay warrant new music. In turn, the musical change helps to indicate that a change of playing strategy might be needed.

Aestheticizing the Ludic

It is easy to focus on the way that music in games articulates the fictional and narrative aspects of games – the characters, worlds and stories with which we interact. Here, however, it is clear that listening to the music is also part of the way we interact with the rules and ludic properties of the game. Music is an element of the design language of games when it helps us to understand how to engage with interactive mechanics. In *Ocarina of Time*, cues like the silver rupees chimes and the puzzle solution musically represent a change of game state through music. The musical content can communicate ludic qualities even if there are few visual clues – the general battle theme tells me that a creature has targeted Link, even if I have yet to spot it. Similarly, the miniboss cue indicates that the enemy I am battling is more dangerous than the typical foe. In the case of the timer 'tick-tock' cue, information on the status of the puzzle mechanic is delivered musically. Since these moments are musically marked, even if they are also evident in other ways too, the music is nevertheless an element of how these changes and qualities are represented for the player.

The music can also lead me to play in a certain way. When the dungeon cue is displaced by a boss cue, I am urged to adopt quick movements and an aggressive posture. The Castle Courtyard cue, in contrast, seems to suggest that Link should move cautiously. This latter example also illustrates how music can frame sections of the game: the unique cue marks this sequence as special and distinct, not just another part of the general environment. The same is true of the escape from Ganon's castle, where we are urged to flee the crumbling building. As observed with the combat cues, the placement and repetition of cues structure the game experience by segmenting gameplay, marking achievements/failures and encouraging different modes or styles of play.

Video games are both narrative and ludic – they combine sequences of events in fictional worlds with rule-based systems of interaction. The cues described in this chapter ('ludic cues') mediate between these two dimensions of the medium. Acquiring an object is both a narrative and ludic event: for example, when Link finds the slingshot, it is part of the story that he has found that item, but it also represents a ludic achievement for the player. The spectrum of boss cues not only indicates the narrative position each holds in the game's plot but also betrays the apparent ludic challenge of the enemies, helping to structure the game.

In general, the timbres in the ludic cues reflect the degree to which the events are anchored in the fictional conceit of the game. Combat cues, with enemies attacking Link, use orchestral or acoustic timbres. In contrast, the puzzle solution and correct action cues are not anchored to visible characters or items in the world and use obviously artificial timbres. Many ludic cues are heard repeatedly throughout the game. Players quickly learn the signification of these short cues, especially when they are heard frequently. Indeed, since many ludic cues are heard repeatedly and the associations are established clearly, the game uses unique or infrequently heard cues to indicate the importance of bosses or some acquisitions.

Perhaps the most important function of these cues is the way that they transform the ludic states or events into aesthetic experiences. Moments such as achieving an object, winning a battle or losing are treated in terms of music. They are not just rule-based outcomes of the game mechanics; they become aestheticized into celebrations and commiserations. The game over cue, for instance, does not simply communicate the factual state that the player has lost; it uses the affective aspect of music to help losing become an aesthetic experience that moves from commiseration to encouragement. Similarly, the correct solution cue does more than reinforce the ludic state of solving the puzzle; it actively celebrates with the player. This process helps to emphasize the emotional dimension of the interactive mechanics. Of course, these ludic events cause emotional results anyway – I do not need music to help me feel frustrated at a lost game – but music is part of the aestheticization of the ludic states within the game itself, a process that seeks to manipulate and enhance the player's experience of the game. It is because of this fusion that the ludic cues often seem to adopt a narrator or companion's voice that addresses the gamer. These pieces seem to celebrate with players, commiserate their defeats, encourage them to continue, warn them of danger and so on.

There is no reward for playing *Ocarina of Time*. The only prize to win is the achievement and experience in itself. The game supplies its own way of recognizing and responding to player success. Small wonder, then, that there are so many acquisition cues, all helping to differentiate the collection of objects, marking and celebrating the player's progress as significant. The cues use ascending gestures

and/or harmonic completeness to make an affective moment of celebration that recognizes the player's achievement. The use of rising gestures to indicate success and provide encouragement are not exclusive to ludic cues – they are clearly evident in the 'Escaping the Ranch' cutscene and the 'Press Start' chord (to name just two) – but the association of ascending pitch profiles with success and descending with failure is continually reinforced throughout the game by these frequently heard ludic cues.

The process of aestheticizing ludic events allows music to serve as a reward: hearing a piece, such as a victory cue, the stone/medal acquisition cues or even music for cutscenes, is an aesthetic prize won for besting the ludic challenge, especially when that cue is heard only rarely in the game.

When Koji Kondo was asked about his favourite cues in *Ocarina of Time*, he singled out the Castle Courtyard cue.[11] At first glance, this is a surprising choice. It is heard only in this specific sequence in the game, devoid of grandiose musical gestures, and does not feature any of the main themes or melodies from the game. He says,

> KONDO: It sounds like a game of hide-and-seek. It represents that feeling of final relief you get when you're able to hide from the guards by carefully making stealthy steps. [...]
>
> IWATA: It sounds like the value of the music for you, Kondo-san, is less about how the melody is appreciated by itself than how well the sounds serve their purpose in the context of the game.
>
> KONDO: That's right.[12]

When Kondo explains that the music 'sounds like a game', he appears to allude to this process of aestheticizing the ludic dimension of the gameplay.

This chapter has outlined the many ways that the game's music engages with the ludic processes. From the musical features of the combat cues, to the acquisition cues, and the other pieces that relate to gameplay progress (or lack thereof), the common theme has been how the music treats these rule-based and mechanical aspects of the game in aesthetic terms. They are realized for us in music, which rewards, commiserates, warns, encourages and celebrates with us. Kondo knows that game music gets right to the heart of the appeal of games. Games are ludic and narrative entities that encourage us to play for the aesthetic experience of both dimensions of the medium. Music is a microcosm of the video game. It serves to create that aesthetic experience, combining and bolstering both ludic and narrative aspects. Even though we might interpret ludic mechanics as primarily factual and the 'real' aspect of the game, as opposed to the 'fictional' dimension,[13] these examples illustrate that both are emotional and affecting qualities of the medium.

Whether we are winning or losing, running or sneaking, collecting or fighting, music helps us to feel emotionally engaged as we play.

NOTES

1. Roger Caillois, *Man, Play and Games*, trans. by Meyer Barash (Urbana: University of Illinois Press, 2001), p. 27.
2. Though this cue is heard in most situations, there are moments when it is not used – e.g. during the day, the Hyrule Field cue plays 'battle' variations when Link is attacked (as discussed in Chapter 3).
3. Isabella van Elferen, 'Fantasy Music: Epic Soundtracks, Magical Instruments, Musical Metaphysics', *Journal of the Fantastic in the Arts*, 24 (2013), 4–24 (p. 6). Philip Neuman's survey of wordless voice in film reveals that it is commonly used during moments of heightened emotion and unrealistic action. He explains, 'Dramatic vocalization's *topoi* that evolved over the course of the twentieth century in film scores have included the supernatural, the exotic, the religious, the numinous, the otherworldly, astonishment, and enlightenment.' He also highlights how dramatic vocalization can serve to apply 'the sensation of suspense'. Philip Neuman, *Sirènes, Spectres, Ombres*, p. 257.
4. Later in the cue, Kondo sometimes intermittently adjusts one of the ostinato pitches to produce a perfect fifth, rather than augmented fourth, especially when melodic upper parts are introduced, perhaps to add a greater degree of harmonic stability and coherence alongside the chromatic upper parts. Even then, passages that exploit the tonal ambiguity of the tritone are still used in the intervening bars.
5. See, for other examples of this effect, in *Resident Evil 4*, Van Elferen, '¡Un Forastero! Issues of Virtuality and Diegesis in Videogame Music', 30–39; in *Splinter Cell*, Simon Wood, 'Video Game Music', in *Sound and Music in Film and Visual Media*, ed. by Graeme Harper, Ruth Doughty and Jochen Eisentraut (New York and London: Continuum, 2009), pp. 129–48; and in *Silent Hill*, Zach Whalen, 'Case Study: Film Music vs. Video-Game Music', in *Music, Sound and Multimedia*, ed. by Jamie Sexton (Edinburgh: Edinburgh University Press, 2007), pp. 57–81. Some games use the same basis to mislead players. See for this in *Dead Space*, Mark Sweeney, 'Isaac's Silence: Purposive Aesthetics in *Dead Space*', in *Ludomusicology: Approaches to Video Game Music*, ed. by Michiel Kamp, Tim Summers and Mark Sweeney (Sheffield: Equinox, 2016), pp. 172–97 (p. 191).
6. The game even uses the miniboss cue's alarming start and indication of threat as part of a joke: in one of the later dungeons, by which time the player has already encountered several minibosses, Link triggers the activation of a miniboss, Iron Knuckle, which resembles a hulking armoured statue. True to form, the alarmed cue begins when the boss springs to life and advances towards Link. However, the cue quickly fades out and the boss stops – something is wrong. The boss has forgotten its weapon. Snapping its fingers, a huge axe appears for Iron Knuckle to wield, and the cue restarts as the boss advances again towards

Link and the battle proper begins. This is only a brief moment in the game, but the comedic misfiring of the cue when the enemy is unarmed indicates the close connection between the battle threat and the music.

7. Mark Brownrigg describes the 'mythologizing choir' trope in war films, noting that '[c]hoirs tend to enter the proceedings during the latter stages of a film, and typically vocalise rather than sign actual words. [...] They lend proceedings nobility, a sense of great dignity, strength and power, imparting a feeling of divine legitimation of both conflict and sacrifice. The choir also seems to add a mythic dimension to the events'. Mark Brownrigg, *Film Music and Film Genre* (Ph.D. dissertation, University of Stirling, 2003), p. 209.
8. Phantom Ganon does not receive a unique boss cue, unlike the real Ganon/Ganondorf battles. This implies that the Phantom Ganon encounter is not a fight with the 'real' antagonist of the game, but just another boss, even if Ganondorf's theme sounds in the pre-battle cutscene.
9. The chromaticism of the harmony may partly be driven by the notes available to the timpani, which are drawn from the MIDI standard orchestral percussion map. Though a full scale is available, the region from A to D♭ are often the most sonically successful.
10. For the very quick deaths, the glissando only descends as far as F#5.
11. Satoru Iwata, 'Iwata Asks: The Legend of Zelda: Ocarina of Time 3D – 6. Our Favourite Songs', *Nintendo*, 27 July 2011, https://www.nintendo.co.uk/Iwata-Asks/Iwata-Asks-The-Legend-of-Zelda-Ocarina-of-Time-3D/Vol-1-Sound/6-Our-Favourite-Songs/6-Our-Favourite-Songs-231508.html [accessed 14 April 2019].
12. Ibid.
13. This is the position of Jesper Juul, who casts games as half-real objects, where the rules are real but the fictions not. Jesper Juul, *Half-Real: Video Games between Real Rules and Fictional Worlds* (Cambridge, MA: MIT Press, 2005), pp. 133, 176.

6

Interfaces and Sound Effects

So far, we have focused on specific musical cues in *Ocarina of Time*. Though these cues have sometimes been very brief, or included sounds of indeterminate pitch, the sonic units are, by and large, readily identifiable as pieces of music. They have been presented as either stemming from musical performance or as underscore. This, however, only paints part of the picture of the musical properties of *Ocarina of Time*.

To engage with *Ocarina of Time* is to interact with a game brimming with musical qualities, where even audio not obviously presented as a piece of music seems to have a musical dimension. While any sound has the potential to be understood as musical, the sound effects for *Ocarina of Time* are remarkable for the degree to which they emphasize a clear-pitched quality in a frequency range often used by musical instruments. The result is that these sounds appear to articulate particular notes or rising/falling glissandi. Not all of the sound effects in *Ocarina of Time* exhibit such prominent 'musicality' – it is difficult to argue that the rustling of grass obviously registers as musical, for example – but it is striking how many of the game's sounds readily adopt pitches, timbres and gestures that invite interpretation as musical. Here we will focus on four main areas of the musicality of *Ocarina of Time*'s sound effects: (1) earcons for interfaces, (2) musicality and magic, (3) sound and motion, and (4) enemy sound effects.

1. Earcons for Interfaces

Menus and Dialogue

Discussions of informative sound in games have often distinguished between auditory icons, based on a reference point in our everyday reality, and earcons, which

instead 'rely upon musical conventions such as pitch, timbre and dynamics to communicate information'.[1] The audio signs related to the interface can be described as earcons because they feature a readily identifiable musical dimension and are not based on a sound from our world.

The musicality of *Ocarina of Time*'s sound effects is particularly noticeable in the sounds for the menus. When the player moves a cursor or chooses an option in the menus, the game responds with a sound. We have already noted the 'Press Start' arpeggio chime, for instance, with notes that concord with the underscore. After this moment, interrupting the opening video, players encounter the main menu which allows them to organize their saved games. This menu is accompanied by the Fairy Fountain location cue.

The main menu's interface sounds present a clearly unified set of sonic elements. Presented in a timbre that blends a harp and a chime, the sounds for moving the menu cursor, selecting an option, choosing alphabet letters to name a file and cancelling the selection all sit as a coherent group. The sound that indicates an error (such as attempting to create a new save file without a name) carefully contrasts in pitch and gesture with the otherwise coherent sounds. Table 6.1 shows how the musical gestures and pitch choices are deployed in the menu.

Repeatedly emphasizing the pitch of A gives a coherence to the sounds, and the rising gestures reinforce the affirmatory quality, much like the success cues discussed earlier. The error sound is the only overall descending gesture, indicating the illegality of the choice. The focus on the pitch of A is appropriate, given that the menu is accompanied by the Fairy Fountain cue that uses A6 as the origin pitch of the melody (and to which it returns when the cue loops).

Action	Gesture	Main Pitch Profile
Move cursor	Rising octave	C4–C5
Select option	Fast rising arpeggio	D5–G5–A5–A6
Select letter for filename	Rising octave	E5–E6
Cancel	Octave dip	A5–A4–A5
Error	Descending semitone	A#3–A3

TABLE 6.1: Musical sounds for the main menu.

INTERFACES AND SOUND EFFECTS

Progressing through the menu, the player causes a musical output that moves upwards in pitch: from C5 (moving the cursor) to A6 (selections), perhaps via E6 (naming the file). Moving closer to playing the game more frequently emphasizes A6, while choices away from the game either sound lower (cancel, A5) or move the pitches in the wrong direction (error, A#3–A3). It seems as though the player is being sonically encouraged towards play by the rising pitch of these micro-cues.

The sound for erasing a game file is the odd one out. It is a combination of two sounds found elsewhere in the game – one for the crystal switches found in dungeons and the descending glissando when Link is instantly killed in the game (see Chapter 5). The latter sound is obviously appropriate for erasing a file containing a particular version of Link, but it also sonically contrasts with the other menu cues because of the harsh timbre and less stable expression of pitches. Erasing a file is not an action endorsed by the game.

Beyond the specifics of the sounds, the use of clearly pitched musical material for the menu establishes the pattern for a musical interface that continues throughout the rest of the game. Most often, menu sounds resemble the plucking of a harp. The harp timbre is sonically clear and short, yet not sonically abrasive – thus perfectly suited to being triggered repeatedly and in rapid succession, without risking annoyance. For instance, opening the minimap prompts a harp-like earcon consisting of a rising fourth (A4 to D5), and hiding it causes the reverse interval to sound. The pause menu and the dialogue interface also both primarily use harp-like timbres.

The pause menu is very frequently activated by players. This multiscreen menu allows players to view the map, select equipment, view the progress of the quest, browse the directory of ocarina songs, save the game and so on (Figures 2.7 and 6.1).

The earcons for opening and closing the menu are in harp timbres and clearly present rising and descending scales on B♭ major. Both are accompanied by a quiet swooping portamento that rises from G to F. The cue that sounds as the player shifts menu screens is played by a solo harp, though it pans between the stereo speakers, depending if the player is moving clockwise or anticlockwise around the carousel of menu screens. Those three cues clearly present the player's menu journey in terms of starting with a B♭ major scale, moving to the dominant (F) for changing screens before returning to B♭ for closing the menu. This pattern matches the tradition of Western classical harmony that casts the tonic-dominant-tonic movement as the archetypal harmonic journey of departure and return.

In between the bookended opening and closing cues, D is emphasized in moving the cursor (the third pitch of B♭ major, sixth of F), though the 'select' phrase is disruptive and stands out with B and E naturals. The select cue also uses a harp-like timbre, but the cursor sound features a harsher, more angular

FIGURE 6.1: The musical phrases of the pause menu in *Ocarina of Time*, showing the symmetry and coherence of pitch choices.

and artificial waveform, making it sonically distinct. The select and cursor move cues, however, are not exclusive to this menu and are also featured in another part of the interface.

Ocarina of Time has very little recorded dialogue. Instead, the dialogue is shown as on-screen text. Across the (wide) demographic of *Ocarina of Time*'s target audience, the reading speed of players will vary considerably. For such reasons, apart from a few cutscenes, characters 'speak' in short phrases and pause before continuing, until the player presses a button to indicate that they have read the text.

When the player presses a button to confirm that they have read the text, a harp plucks a single note. Once the character has reached the end of their stream of dialogue, a three-note descending phrase is played by the harp automatically. When acknowledged by the player, a rising arpeggio responds (Figure 6.2), which is the same as the select cue from the pause menu.

The dialogue continuation and conclusion shows a clear line of melodic resolution. In C major, the melody moves from G to C, providing a conclusion to the text. The confirmation, in contrast, launches out to the next sequence, with a rising open gesture and emphasis on A. On the occasions when the player is presented with an option of how to respond to the dialogue, the interface uses the same cursor sound as the pause menu.

Why should the menus and dialogue options use sounds with distinctly pitched qualities? One motivation might be the continuity with previous games in the series. Earlier *Zelda* games also featured sonic responses to cursors, dialogue and menu choices. On consoles like the NES and Game Boy, these sounds were produced using the same audio chips that generated the music, so these sounds often

INTERFACES AND SOUND EFFECTS

FIGURE 6.2: Harp cues for the presentation of dialogue in *Ocarina of Time*, showing the pitch trajectories.

took the form of pitched materials. Even though the Nintendo 64 hosts the menu/dialogue sounds as acoustic sound files (i.e. not as MIDI data like the underscore cues), the decision has been made to retain the approach of earlier games. Because *Ocarina of Time* is clearly capable of producing sound effects that are not particularly musical (explosions, clangs, footsteps, etc.), the decision to use sounds that emphasize melodic contour is all the more obvious.

The musical responses accentuate the game's response to the player – it reacts to the player's actions, not only through visual change, but also by audio acknowledgement. Of course, that is not a trait exclusive to musicalized sound, but by responding in such a way that has musical properties, it distinguishes itself as playful. Unlike when I operate functional technology in everyday life that acknowledges my interaction with a single beep (like a credit card machine or multimedia projector), by producing musical phrases, and by creating at least some degree of tonal cohesion, the game asserts its playful agenda. By its 'unnecessary' elaboration, the game shows that it is an experience engaged in for aesthetic reward, not pure functionality. The musicality of response helps to assert that fact.

Some of the musical sound effects in *Ocarina of Time* serve rather more practical purposes. When the player uses the menu and dialogue systems, there is no other simultaneous action to distract them. However, during the main gameplay, musical sound cues serve the purpose of drawing attention to, or communicating, aspects of the game state that might otherwise be lost in the busy flow of gameplay. These are sounds that Kristine Jørgensen would characterize as 'emphatic' sounds since they provide information about, or otherwise augment, elements of the gameworld.[2]

One illustrative example is the way that, when Link's health is dangerously low, a pulsing C#6 starts to sound a heartbeat-like rhythm in a sawtooth wave (Figure 6.3).[3] The heartbeat rhythm connotes the biological corporeality of Link and the obviously artificial timbre brings to mind the technological beep of an electrocardiograph monitoring a patient's heart. Since this sound is based on a real-world sound, we can classify it as an 'auditory icon'.

The sound stands out against the soundscape with its insistence, pitch and timbre. Though Link's health is indicated in the top left corner of the screen, it

FIGURE 6.3: The rhythm of the low health 'heartbeat' sound played in a sawtooth wave.

is easy to miss the moment when the damage sustained becomes life-threatening. The sound effect draws player attention to this important ludic information.[4] The rhythmic regularity, clear pitching and artificial timbre distinguish this component from the other sound effects: these qualities that help to make the sound fulfil its function are also those that enhance the impression of musicality.

This same sonic distinction from the underscore is also useful when the sound is used to confirm the collection of an object in the game. For instance, when Link collects a heart by walking through it, or picks up a rupee, the sound accentuates that the collection was successful. Both of these situations use solo musical phrases. In the case of the former, the player hears a sine wave playing pitches A4, A5 and A6 in quick succession. For the latter, a quick B♭7–F7–B♭7 motif in a sawtooth voice sounds. Combined with the visual presentation, the audio punctuates the moment of collection, recognizing and confirming Link's collection of the item.

Even if the audio accentuates something that is already shown elsewhere on the screen (currency, life meter, etc.), this aural communication is very useful since it does not require players to divert their attention from one part of the screen to another to receive the information. In the heat of a climactic battle, I do not need to check the heart display to know if Link's health is critical – the audio already indicates this. Similarly, I do not need to look at the on-screen values for health or currency if the audio reassures me that I have collected those objects. When I am riding Epona at speed over Hyrule Field, the energy level of the horse is indicated by on-screen carrots, which I can use up to boost the speed. The rising glissando (C5–C6) that indicates the carrots have recharged informs me that I can urge on Epona, without distracting my attention from elsewhere on the screen. As Kristine Jørgensen writes, 'Due to its temporal quality, and the fact that it is neither material nor visible, sound is an effective way of communicating game information in an unremarkable yet perceptible manner, because it utilizes a different channel of perception and does not get into the way of visual attention.'[5]

Targeting System

One of the great technical successes of *Ocarina of Time* was the lock-on targeting system (known as Z-targeting). By pressing the Z button on the controller, Link can lock on to characters and objects near him. When locked on to a gameworld entity, Link will direct his attention to that object. For example, one can 'Z-target' an adversary, at which point, Link will aim his attacks at that enemy. Z-targeting need not be offensive – it is also used to examine benign objects and to talk with other characters. The Z-targeting interface prompts sounds with distinct musical qualities when it is activated and cancelled.

When the Z-target is activated, a different sound plays depending if the target is an enemy or a non-threatening object/character. If the target is an enemy, the sound is a long raspy descending glissando with a phasing effect, while if the target is neutral or friendly, a harp-like sound plays a rapid decorated figure in a limited range (D4–G4–F#4–G4). The two sounds are very different in timbre and register, though both are mixed quite loudly in the game. This contrast helps the two lock-on sounds to serve their function: they are easily aurally recognized and distinguished. The musical response to the lock even helps to indicate to the player if the entity is dangerous or not (if that is not already obvious).

Link's lock-on is indicated by arrows that encircle the target. In a chaotic battle, with several enemies and spectacular visual effects on-screen, the Z-targeting can become lost in the whirlwind of visual indicators and entities. The aural signs, however, are able to indicate that the lock has been engaged and whether it is targeting an enemy. When the Z-lock is cancelled, players are again notified by the audio: a square wave sounds B4–F#4–B4 so quickly that it sounds like a chord.[6] Players can use the sound to help them, supplementing visual indicators and making audible their engagement with the game interface.

Just as audio is used to tell players that something has happened or changed, so it is used to indicate when an attempted action has failed. When players try to use a weapon out of ammunition, miss certain targets or attempt to undertake a forbidden action, the game plays an 'error' sound, a monophonic sawtooth wave playing two E3 pitches in quick succession. This kind of error sound is very important, because it indicates that the player's input has been recognized, but the action is not possible, or the attempt has failed, rather than there being a problem with the communication of that action through the game system. It serves as a response, albeit a negative one, rather than not responding to the player at all. For example, in the battle with Ganondorf, to defeat the King of Evil, it is necessary to stun him with light arrows. When my arrows miss him, the error sound tells me that I was not successful. Ganondorf is not stunned, I should not approach him and instead ready myself for another attack. For some puzzles, the sound is also

used to indicate that the action and mode of interacting with the puzzle is correct, though the specific solution is not yet right (as in one of the puzzles that involves directing the reflection of the sun in the Spirit Temple). The error sound helps to remove ambiguity of communication between the game and player.

The interface cues accentuate the response of the game to the player: the game is not just visually reacting to the player but obviously sonically doing so, too. It confirms that actions and instructions have been recognized and either successfully deployed or failed. In this sense, the sound enhances the communication of particular game events and properties, especially given the sometimes crowded visual display. As we observed when discussing the ludic event cues, many of these interface chimes and sounds often (though not exclusively) use timbres that are obviously artificial rather than emulating musical instruments. This helps to distinguish the sounds from the underscore and indicates that they relate directly to the architecture of play, rather than the story and locations of the game.

Musical Sound for Interfaces and Information

Empirical studies of human-computer interaction have repeatedly suggested that earcons are a valuable way of aiding user interaction with computers, including navigation through menu systems.[7] More specifically, 'syntactic features of a musical language of representation can be used as meaningful navigation cues. [...] [T]he specific meaning of musical motives can be used to provide ways to navigate in a hierarchical structure'.[8] Further experimentation found that earcons designed around musical organization of pitches and gestures were particularly effective in allowing users to learn the association of sound and the function it signified.[9] Perhaps we are witnessing a similar functional dimension to the musicality of the menu/interface sound effects in *Ocarina of Time*.

Yet the situation is less clear in the particular context of games. Some experimental investigations have suggested that the sonic communication of information, such as earcons or auditory icons, helps to improve player performance in the game.[10] However, these observations are not consistent across all studies. Some results showed that audio improved player performance in multiplayer, but not single-player, conditions,[11] while others reported that unrelated background music could provide better results than the built-in audio.[12] Certainly, there is no shortage of the practice of games using earcons and auditory icons to communicate with players in games,[13] but the precise conditions and effects are yet to be fully documented. As James Robb and his co-authors put it, '[W]e have yet to determine the exact associations between particular aspects or features of game sound and specific experience qualities.'[14] Irrespective of whether it improves player performance, however, there is consensus that earcons can serve informative ends, and 'providing redundant auditory feedback for key

gameplay events is preferred by players and may assist in their enjoyment of gameplay'.[15] In other words, even if the earcons do not improve the player performance, such audio cues are important for gamers and can help to make the game enjoyable.

We have noted how *Ocarina of Time* uses short, timbrally clear motifs (chimes/harps or obviously artificial waveforms), sounded loudly, to provide information and response to the player. There is an element of coherence in pitches, and gestural shape of the earcons also seems significant. Descending gestures imply closure (dialogue ending, closing the menu, deleting a file), while rising gestures imply progression, renewal or beginning (dialogue continuation, opening the menu, starting the game, menu selection, collecting health, reviving Epona's carrots). Nevertheless, it is important not to overemphasize the coherence of the sound effects. While we can identify principles and trends in the sound design, this is not a process driven by purely functional demands, nor completely internally consistent logic, but it is a way of creating a further aesthetic dimension to the interface. These sounds deal with communicating gameplay-relevant information to the player and musicalizing gamer interaction with the interface. Other sounds in the game feature prominent musical qualities and are especially associated with magic.

2. Musicality and Magic

Ocarina of Time's sound design often associates musicality with magic. On his quest, Link encounters many magical objects and phenomena, including Spiritual Stones, medallions, spells, fairies and so on. One of the ways that magical power is communicated is through the sounds that these entities make.

In particular, the game consistently associates sine waves in octaves 4, 5, 6 and 7 with magical properties. All of the sacred objects in *Ocarina of Time* have a similar sonic profile of piercing sine waves (often with an additional secondary audio element that sounds at the same time). These consist of:

- Triforce – either a major third chord (F5/A5) or solo pitch (G#4)
- The Medallions (F#7 pitch)
- The Spiritual Stones (C6)
- The Sages (B7 pitch)
- Magical appearance of a treasure chest (A#6)

The Triforce, medallions and stones serve as markers of the player's progress and plot devices rather than having any bearing on the gameplay. The audio serves as a way of articulating the special magical properties of the objects, even though players never get to use them directly. Instead, they are given a sonic aura to

indicate their special status. For instance, even once the Spiritual Stones have been deposited in the Temple of Time, when Link walks past them, we can still hear them emitting the same shimmering pitched sound.

The association of magic and musicality is frequently reinforced for the player. When Link's magic meter is filled (as it does when a saved game is loaded), it is accompanied by a chromatic rising scale, rising from C4. When Link handles magic objects, the introduction of the musical element of the sounds helps to indicate that supernatural forces are at work and distinguish those items from mundane non-magical versions. For example, when charging arrows with magical properties, this is articulated sonically through a rising glissando. Very often, rising profiles are associated with magic activation, while descent is associated with release or dissipation: for instance, charging the sword or mirror shield up with magic prompts a rising glissando, while discharging the sword's energy is accompanied by a descent in pitch.

Even when magic is not explicitly shown to be in play, these audio properties indicate a magical presence. One such example is the hover boots, which allow Link to float in the air for short periods of time. When Link is hovering, a pitch (E5) implies that some magic is in play, because sine waves of that register have already been associated with magic elsewhere in the game. We do not need to seek an explanation for how the boots work; the audio tells us – they are magical.

Unsurprisingly, then, magic spells and fairies are also accompanied by sound effects with distinct pitched qualities. When fairies (great and small) appear, they produce an ascending glissando in a shimmering timbre, and the Great Fairies disappear to a descending glissando. The Great Fairies bestow gifts upon Link, enhancing his abilities. This is sonically represented with a sound effect that uses a vocal sound in major thirds, which glides in pitch up from E4/G#4 to F4/A4 as Link gains the new ability. Link encounters many magical forces in his quest, which, as we have come to expect, articulate their magical properties sonically. The shield spell 'Nayru's Love' and the fire spell 'Din's Fire' both present rising glissandi when they are cast. In Chapter 3, we noted how, in Ganon's Castle, a magical forcefield is audially represented by overlapping sine waves that portamento up and down, oscillating between two pitches at different rates of period repetition. Throughout Hyrule, whether controlled by the villains or heroes, the deployment of magic is also the deployment of distinctly musical pitched materials.

Though this is a different kind of informational content than the interface sounds indicated above, the principle is similar. As Kristine Jørgensen writes, 'When we hear a sound, we do not think of it as an isolated sound but part of an event [in the game] that may also materialize in visual properties. In this context,

sound, visuals, and action together form an informational whole that is greater than the sum of the stimuli itself.'[16] Here, the entities and powers come with a musical aura to represent their magical power. Since our daily life does not normally involve objects that emit sound in the same way, this property marks them out as magical and unusual.

3. *Sound and Motion*

In Link's world, movement of objects and characters is often accompanied with distinct pitched gestures in the sound effects. Doors opening and closing present rising and falling pitch profiles, the scarecrow bounces with a 'boing', a character (Darunia) jumping down from a height is accompanied by a descending whistle (F7 to F5) and gates, elevators and platforms match their vertical spatial movement with rising and falling pitch movement. When Link plants a magic bean, the growing plant makes the sound of a rising slide whistle, and the flying plant that it ultimately produces makes a wavering C5 pitch. Even re-centring the camera position outside a dungeon prompts a swooping glissando (C4 to A5).

Teleporting between places, whether through the warp songs, the Farore's Wind spell or other portals, is typically accompanied by a glissando or sequence of some kind. The direction of the glissando is not consistent across the game: warping away when using an ocarina song and Link's transportation through time prompt a rising sequence, but other warp portals (such as to a Fairy Fountain), or falling into an endless abyss, prompt a descending gesture. The glissando seems more likely dictated by Link's vertical position, whether he warps 'up' or 'down', rather than his position relative to the camera.

There would seem to be two main reasons for the creative decision to saturate Link's world with movement that is accompanied by musical qualities. First, much like the magical properties discussed above, having a world filled with sounds with distinct and coherent musical properties helps to accentuate the fantastic quality of the universe. Though, in our physical world, we are familiar with sounds produced by doors, elevators, jumping and so on, these sounds in our world are not as consistent or musical as the swoops, slides and glissandi of the movement in Hyrule. Second, through the learned association of the pitched gestures and movement,[17] not least through the legacy of cartoons, the sounds synchronized with movement help the impression of motion in the game. Given the limited visual capability, by combining the visual movement with sound, the motion is accentuated and highlighted.

4. Enemy Sound Effects

On his quest through Hyrule, Link has to deal with a great variety of enemies. Some, like bosses, he will only encounter in one particular place, while others recur throughout the world. Most monsters have their own repertoire of sound effects, tailored to the species in question. Though there is a huge diversity of monsters, it becomes apparent that there are some commonalities across the sound effects.

In particular, two kinds of sound effects have similar pitch shapes across enemies. These are, first, the monster's sound when Link lands a blow on the creature, and second, the final death screech of the enemy.

When Link's attack hits a creature successfully, the sound follows a downward pattern. Figures 6.4–6.7 show pitch spectrograms of a selection of 'hit' sound effects. The individual timbres are very different, and the contour not identical in each case, but the similarity is striking.

Though the enemies are dramatically different, from wolves to giant disembodied hands, and even if the sounds vary in timbre, duration and pitch, they make sounds with a similar profile when Link lands a blow.

A similar process occurs with the death sounds of the creatures. These sounds are closer to arch-shaped, though they are longer in duration and typically extend over a further pitch range than the 'hit' sounds. Figures 6.8–6.11 show the profiles of death sounds from across the game, revealing the similarity of shape.

This similarity of pitch profiles is an important part of the communication with players. Even if the enemy is being encountered for the first time, players can recognize if they have successfully attacked the foe (and thus they should continue whichever tactic is working) and if the creature has been successfully bested. In *Ocarina of Time*, the audio helps to distinguish between attacks that have been blocked by the enemy and those that have landed. Similarly, when many enemies in the game are able to disappear and reappear, the death sound indicates that the creature has been conclusively defeated, not just forced into retreat. Different creatures will have distinctly contrasting sound designs, but these pitch qualities can be adopted across a huge variety of sonic contexts, adjusting to whatever the sound design of that creature might be. The sounds, and specifically the pitched qualities, are part of the design language of the game, aiding players in their battles and helping to communicate the action of combat.

FIGURE 6.4: The pitch profile of the Wolfos creature's 'hit' sound effect.

Conclusions

Ever since the first generation of video games with audio, it has been difficult to draw a hard and fast line between music and sound design in games. In early game consoles, sound chips had to handle all the audio in a game, blurring the distinction between sound effects and music. Examples like *Ocarina of Time*, however, illustrate that later games chose to continue this cross-pollination

FIGURE 6.5: The pitch profile of the Redead creature's 'hit' sound effect.

INTERFACES AND SOUND EFFECTS

FIGURE 6.6: The pitch profile of the Baby Dodongo creature's 'hit' sound effect.

FIGURE 6.7: The pitch profile of the Bongo Bongo boss's 'hit' sound effect.

INTERFACES AND SOUND EFFECTS

FIGURE 6.8: The pitch profile of the Armos creature 'die' sound effect.

FIGURE 6.9: The pitch profile of the Dead Hand creature 'die' sound effect.

INTERFACES AND SOUND EFFECTS

FIGURE 6.10: The pitch profile of the Freezard creature 'die' sound effect.

FIGURE 6.11: The pitch profile of the Twinrova creature 'die' sound effect.

of music and sound effects, even though the same technological limitation did not apply. This aesthetic decision has several motivations and results.

The use of chimes for the menu systems, dialogue boxes and interface obviously serve some utilitarian purposes. They demonstrate that the player's input has been recognized and accentuate the game's audiovisual feedback to the gamer, replying both audially and visually to their actions. The sounds respond to the player's navigation of the interface and provide a sense of coherence to the audio reactions. The resulting sounds bolster the structure of the menus and the chimes serve as punctuation to the dialogue, articulating the rhythmic segmentation of the game's written text.

In several situations, musical sound communicates distinct information to the player that could help them with the gameplay challenges. In these situations, like Link's health warning and the sound for Epona's carrots replenishing, the musical timbres help to set the sounds apart from the other audio in the world and game. The preponderance of higher pitches, distinct timbres (such as the chimes or obviously artificial sounds) and the prominence of such sounds in the mix all helps to ensure players can easily aurally parse the information by keeping the sound clear, distinct and audible.

As noted from empirical studies on this subject, however, the potential practical advantages for sonification of information is only one aspect of using audio in this way. Just as important is the affective result of the sound, emphasizing the fun agenda of games. The musicality of the sound accentuates the playfulness of the interaction, irrespective of the actual gameplay advantage it provides for players. For similar reasons, we might suggest that nostalgia and continuity with past games is another reason for the use of musicalized sound in the interfaces.

In a different, less obviously utilitarian way, sound effects with a distinctly musical quality were used to indicate the presence of magic. In particular, sine waves are common in *Ocarina of Time*. These sounds, especially when anchored to the magical objects in the gameworld, present the impression of a magic aura. The process further emphasizes the fantastic, unrealistic setting of the game, allowing the player to participate in a world of shimmering magic.

Especially given the small screens *Ocarina of Time* was designed for, the visual representation of motion can be limited. Objects and characters in motion are provided with sound with distinct gestures that help to portray and accentuate movement through space. Much like the 'magical' use of musical sound, providing the pitched properties to the sounds for these objects also helps to present the world as light-hearted and fantastic.

The sounds for the enemies tie together many of these features. As the creatures snarl and screech at Link, the pitched gestures of the sounds provide the

player with information about their attacks, enhance the fantastic nature of these monsters and give a sense of motion to the beasts recoiling from Link's weapons.

The sound effects are not strictly part of the musical score of *Ocarina of Time*. Yet, they represent musical aspects of the game. They indicate yet another way in which musicality is part of the experience of *Ocarina of Time* and the degree to which musical properties are used in the service of the game's aesthetic design. It is yet another part of the rich musical-sonic fabric of Hyrule.

NOTES

1. Patrick Ng, Keith Nesbitt and Karen Blackmore, 'Sound Improves Player Performance in a Multiplayer Online Battle Arena Game', in *Artificial Life and Computational Intelligence*, ed. by Stephan K. Chalup, Alan D. Blair and Marcus Randall (Cham: Springer, 2015), pp. 166–74 (p. 167). See also, on issues of terminology, Manne-Sakari Mustonen, 'A Review-Based Conceptual Analysis of Auditory Signs and Their Design', *Proceedings of the 14th International Conference on Auditory Display*, 24–27 June 2008, Paris, France.
2. Kristine Jørgensen, 'Gameworld Interfaces as Make-Believe', in *Digital Make-Believe*, ed. by Phil Turner and J. Tuomas Harviainen (np: Springer, 2016), pp. 89–99 (p. 91).
3. This is very similar to a heartbeat rhythm. For more, see Field, 'Music of the Heart', p. 2074.
4. For more on health indicator sounds, see James Robb, Tom Garner, Karen Collins and Lennart E. Nacke, 'The Impact of Health-Related User Interface Sounds on Player Experience', *Simulation & Gaming*, 48 (2017), 402–27.
5. Kristine Jørgensen, 'Emphatic and Ecological Sounds in Gameworld Interfaces', in *The Routledge Companion to Screen Music and Sound*, ed. by Miguel Mera, Ronald Sadoff and Ben Winters (New York: Routledge, 2017), pp. 72–84 (p. 77).
6. This technique of producing a rapid arpeggio that implies a chord resembles the well-established method of simulating a chord using only a monophonic voice. This approach was ubiquitous in earlier generations of game audio and, as such, perhaps serves as a subtle sonic link to the past tradition. See Kenneth B. McAlpine, *Bits and Pieces: A History of Chiptunes* (New York: Oxford University Press, 2018), p. 100.
7. Stephen Brewster, Peter Wright and Alistair Edwards, 'An Evaluation of Earcons for Use in Auditory Human-Computer Interfaces', in *Conference on Human Factors in Computing Systems*, ed. by Stacey Ashlund, Kevin Mullet, Austin Henderson, Erik Hollnagel and Ted White, 24–29 April 1993 (Amsterdam: IOS Press, 1993), pp. 222–27. See also David McGookin and Stephen Brewster, 'Earcons', in *The Sonification Handbook*, ed. by Thomas Hermann, Andy Hunt and John G. Neuhoff (Berlin: Logos, 2011), pp. 339–61.
8. Grégory Leplâtre and Stephen A. Brewster, 'An Investigation of Using Music to Provide Navigation Cues', *Proc. ICAD '98*, British Computer Society, Glasgow, Scotland.
9. Pietro Polotti and Guillaume Lemaitre, 'Rhetorical Strategies for Sound Design and Auditory Display: A Case Study', *International Journal of Design*, 7 (2013), 67–82. See

also Doon MacDonald, *The Development and Evaluation of an Approach to Auditory Display Design Based on Soundtrack Composition* (Ph.D., Queen Mary University of London, 2017).

10. Daniel Ramos and Eelke Folmer, 'Supplemental Sonification of a Bingo Game', *Proceedings of the 6th International Conference on Foundations of Digital Games*, 29 June–1 July 2011, Bordeaux, France, 168–73.

 Keith Nesbitt, Paul Williams, Patrick Ng, Karen Blackmore and Ami Eidels, 'Designing Informative Sound to Enhance a Simple Decision Task', *The 22nd International Conference on Auditory Display (ICAD-2016)*, 2–8 July 2016, Canberra, Australia.

11. Ng et al., 'Sound Improves Player Performance'.

12. Siu-Lan Tan, John Baxa and Matthew P. Spackman, 'Effects of Built-In Audio versus Unrelated Background Music on Performance in an Adventure Role-Playing Game', *International Journal of Gaming and Computer-Mediated Simulations*, 2 (2010), 1–23.

13. Patrick Ng and Keith V. Nesbitt, 'Informative Sound Design in Video Games', *IE '13 Proceedings of the 9th Australasian Conference on Interactive Entertainment*, 2013.

14. Robb et al., 'Health-Related User Interface', p. 404.

15. Ibid., p. 423, corroborated by Keith V. Nesbitt and Ian Hoskens, 'Multi-Sensory Game Interface Improves Player Satisfaction but not Performance', *9th Australasian User Interface Conference (AUIC2008)*, January 2008, Wollongong, NSW, Australia.

16. Jørgensen, 'Emphatic and Ecological Sounds', p. 77.

17. Zohar Eitan and Roni Y. Granot, 'How Music Moves: Musical Parameters and Listeners' Images of Motion', *Music Perception*, 23/3 (2006), 221–48. Egil Haga, 'Correspondences between Music and Body Movement' (Ph.D. thesis, University of Oslo, 2008).

7

Ocarina Afterlives

This final chapter considers the legacy of the music of *Ocarina of Time* beyond the game itself. Music from film, television and video games is not simply limited to the playing time of the media. It can transcend the boundaries of the original texts to gain afterlives far beyond the original incarnation. *Ocarina of Time* has such a high status in game culture, and music is so important to the game, it is unsurprising that its music has been extracted, copied, adapted and performed in innumerable ways. So prolific is the legacy of the game's music, it would be futile to try and document every subsequent reincarnation of the score. Instead, this chapter will take a broader perspective. It will outline some of the main traditions of the game's musical afterlives and what these might tell us about the relationship between music and video games.

Later Games

Perhaps one of the most straightforward legacies of *Ocarina of Time*'s music is found in subsequent *Zelda* games. Just as we have observed the game using musical materials introduced in earlier games, so later games draw on *Ocarina of Time*'s music. In particular, musical recurrences are used to connect places and characters across games.

Leitmotif

The phrase 'leitmotif' has a long and complicated history. It can be generally characterized as a short phrase or melody which is associated with a particular place, object, character or concept in music for a fictional narrative. Strictly

> speaking, a leitmotif is more than just a 'theme tune' for a character. Instead, it is the representation, encapsulation or expression of that entity. Leitmotifs are typically treated to variation, development and combination with other musical materials. It is through that musical change that the leitmotif's ability depict the evolution and development of characters and drama lies.

Little musical material in *Ocarina of Time* undergoes significant melodic development over the course of the game (with the possible exception of the adaptations of ocarina songs to location cues and the melodies associated with Ganondorf and Zelda). Instead, Kondo tends to avoid reprising material between cues, perhaps since so much of the music will be heard repeatedly anyway, given the number of looping cues. However, when the music is developed between games, leitmotivic processes become clearly evident on the scale of the franchise as a creative musical force making links across media and texts.

Parallel World – *Majora's Mask*

The game immediately following *Ocarina of Time*, *Majora's Mask*, reused many of the game's materials including character models, the game's architecture and the interface. *Majora's Mask* follows Link as he becomes lost in a parallel reality to Hyrule called Termina. Befitting an alternative reality, some aspects of Termina are identical to Hyrule, others are completely unique, and some characters and places appear in a slightly different form. The music helps to articulate this mirror world.

Some cues are used just as they are in *Ocarina of Time*: cues for generic places like the shop, house, Fairy Fountain and sideshow return, as do certain ludic cues like the minigame cue and the treasure chest and acquisition sounds. When Kaepora Gaebora, Kotake and the organ grinder from Kakariko Village reappear, they do so with their themes from *Ocarina of Time*.

Reused music also helps to indicate parallels between the worlds and characters of Hyrule and Termina. In particular, location cues are often used this way: the Woods of Mystery in Termina have the Lost Woods cue, Romani Ranch is accompanied by the Lon Lon Ranch location cue, the Goron Shrine is accompanied by the Goron City cue and the Zora Hall by the music for Zora's Domain. For the player familiar with *Ocarina of Time*, the reprised music makes these places both familiar and curiously unfamiliar at once. It accentuates the similarities and uncanny differences between the two worlds.

Majora's Mask also includes a game mechanic of performing music both on the ocarina and other instruments. Some songs recur from *Ocarina of Time*, including Epona's Song, the Song of Storms and the Song of Time. These pieces are joined by

new songs, including an adaptation of the Nocturne of Shadow that becomes the Song of Healing.[1] There are also new variations on some songs, including the Song of Double Time (a version of the Song of Time with each note repeated) and the Inverted Song of Time (where the note sequence of the Song of Time is reversed).

The game also produces variations on some underscore cues. The opening of Hyrule Field is replicated here as the start of Termina Field, but after the opening passage, the two cues are completely different. The horse race cue reappears, and additionally, a new variant is created, when the cue is re-orchestrated for wooden tuned percussion when Link must race as a Goron. By reusing existing music for new locations and creating variations on well-known cues, the game deploys the musical materials as leitmotifs; these musical elements build connections between fictional entities and worlds. The music helps to encapsulate and articulate the 'familiar but different' setting of the game.

Selective Franchise Continuity

Games after *Majora's Mask* continued to draw on music from *Ocarina of Time*. In doing so, music creates intertextual connections to enrich the sequels and to provide new frames for interpreting the original game. Such musical references can be more or less explicit.

The more obvious examples of recurrence include ludic cues, such as the treasure chest opening cue, reprised in *The Wind Waker* and *Twilight Princess*, or the game over cue, heard in *A Link Between Worlds*. The opening of Hyrule Field recurs in games to depict or indicate sunrise, including *The Wind Waker* and *Twilight Princess*.

In sequels to *Ocarina of Time*, Link sometimes finds himself revisiting locations and meeting characters from the earlier game. It is not uncommon for the musical material to return along with these places and people. When Link returns to Goron City in *Breath of the Wild*, the Chamber of the Sages in *A Link Between Worlds*, the windmill in *Oracle of Seasons*, Zora's Domain in both *Twilight Princess* and *Breath of the Wild*, and the Temple of Time in *Twilight Princess* and *Breath of the Wild*, the same musical materials are heard as in *Ocarina of Time*, albeit often in very different arrangements and orchestrations. When Link meets Malon in Lon Lon Ranch in *Minish Cap*, she sings a few notes of Epona's Song to him, and Ganondorf's theme returns in *Breath of the Wild* in association with Ganon. There is not, however, the expectation that recurring places and characters should always be accompanied by thematic reprise, not least because the appearance of the characters and geography of these sites changes so significantly between games.

Twilight Princess is very closely modelled on *Ocarina of Time*. Cues for places and characters sometimes draw on music from the earlier game: the Sacred Grove

OCARINA AFTERLIVES

is given a variation on the Lost Woods cue, while the Zora Queen, Rutela, is given a theme based on the Serenade of Water. The house cue is also reprised from *Ocarina of Time*. Epona returns in this game, complete with Epona's Song, which Link can again use to call the horse to him. The game also allows Link, while transformed into a wolf, to howl certain functional melodies, including some of the ocarina songs from *Ocarina of Time*. Recurring from game to game, these songs seem to exist as part of the furniture of Hyrule, like rupees, the Master Sword or Epona. They provide consistency to the universe and franchise of Zelda, but they develop and change between incarnations.

Perhaps the more interesting examples are when thematic recurrence is more subtle and/or unexpected than returning cues for revisited places and recurring characters. *The Wind Waker* is set across a series of islands. As the Zelda Encyclopedia puts it, 'The world of *Ocarina of Time* is submerged beneath the sea in *The Wind Waker*, and the music was designed to reflect this, returning to many of the same melodies first used in the Nintendo 64 classic.'[2]

Sure enough, it does not take long for references to cues from *Ocarina of Time* to be heard in *The Wind Waker*. Even in the first area of the game, Outset Island, a reference to Kokiri Forest is included in the underscore. Here, midway through the cue an allusion to the shape of the Kokiri Forest theme later becomes a full quotation (Figure 7.1).

A similar quotation from Kokiri Forest also appears in the Forest Haven and Dragon Roost Island uses some of the characteristic sounds from Dodongo's Cavern. A few phrases from the Minuet of Forest are disguised in the Ballad of Gales from *The Wind Waker* and the battle music for Phantom Ganon is similar to the battle music for Ganondorf in *Ocarina of Time*.[3]

These recurrences will go undetected by players unfamiliar with the music of *Ocarina of Time*. But for those who know the earlier game, they add another layer of meaning to the locations and characters, putting the games in dialogue with each other and fuelling speculation about how locations of the sunken world of

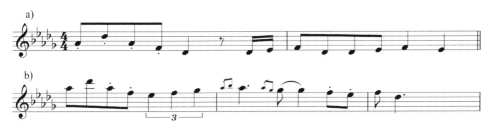

FIGURE 7.1: Two excerpts from the Outset Island cue from *The Wind Waker*, first alluding to (a), then quoting (b) the Kokiri Forest theme from *Ocarina of Time*.

277

Ocarina of Time correlates to the islands and story of *The Wind Waker*. It serves to enrich the game for dedicated and musically attentive players.

Music serves as part of the connecting tissue of this franchise, drawing upon players' familiarity with the series history. Robert Alan Brookey argues that intertextual references are 'part of the reward system' of engaging with franchises.[4] Here, creators use leitmotivic references to address fans. This is one way that player dedication to the series is rewarded, even if each game must necessarily stand as an individual entity.

Sometimes, Link appears in games beyond the main *Zelda* franchise. Such games include the *Hyrule Warriors* spinoff and the *Super Smash Bros.* series of fighting games. In both cases, music from *Ocarina of Time* comes with him. When music moves between games, sometimes it can be transported from one game to another with very little alteration. In *Super Smash Bros. Melee*, for example, the version of the Lost Woods cue is very similar to the version heard in the original game. In contrast, *Super Smash Bros. Brawl* includes a newly arranged medley of music from *Ocarina of Time* and a version of the Song of Storms in an 80s synth-rock style with an interpolation of the Serenade of Water. In *Hyrule Warriors*, a 'hack and slash' game based on the *Dynasty Warriors* series, Link and other player-controlled characters take part in chaotic large-scale battles that pit our heroes against a great number of enemies at once. This game uses music from *Ocarina of Time*, particularly the boss and fire boss cues, but adapts them to the heavy rock musical style of the *Dynasty Warriors* series by adding electric guitars and drums alongside the orchestral instruments.

The music from *Ocarina of Time* (along with musical materials from other *Zelda* games) is used to build connections between games. In a franchise when characters, settings and aesthetic styles are all in flux, music is a useful way to unite the franchise as the properties morph between incarnations. In doing so, musical materials are serving as leitmotifs, creating meaning and encapsulating characters and places. By addressing players who are familiar with the score, recurring music serves as a way to reward dedicated gamers for their engagement with the franchise (and attentive listening), as well as giving additional dimensions for interpreting the games.

Decontextualizing Music

Of course, covers and adaptations of Kondo's music for *Ocarina of Time* are by no means limited to the reuse of the music in games. YouTube and other game music fansites are teeming with covers and rearrangements of music from *Ocarina of Time* for almost every conceivable ensemble. While players perform music as Link in the virtual world of the game, fans and enthusiasts have been inspired

by the game to take the musical performance from Hyrule to 'our world'. Even a brief search on YouTube returns musical activities including:

- A tesla coil playing the Temple of Time cue
- Dubstep remixes of The Lost Woods, including one with a rap
- Covers of Gerudo Valley for
 - Mariachi band
 - Three players on a marimba
 - Harp
 - Heavy rock band
 - Piano duet
 - Flute
 - Ocarina with guitar accompaniment
 - 8-bit chiptune
 - Big band
 - String quartet
 - A cappella voices
 - Pipe organ
 - A set of floppy disk drives programmed to use the mechanical buzzing as pitches
 - Kalimba (thumb piano)
 - Autotuned dog sounds
- Covers of the Song of Storms
 - On music box
 - On hurdy-gurdy
 - On piano trio
 - With added lyrics as a song
 - On multitracked French horn
 - On ukulele
 - On kazoos
 - Mashed up with the title theme for *Game of Thrones*
 - On two melodicas
 - In a reggae style
- A mash-up of The Beatles' 'Eleanor Rigby' with Saria's Song
- A tutorial for playing a medley of music from *Ocarina of Time* on the piano
- A medley of cues from *Ocarina of Time* in a supposedly 'Russian' style
- A carillon performance of the Castle Courtyard cue

YouTube also hosts numerous copies of music extracted from the game as well as the official soundtrack CD, alongside licensed cover albums, such as those by the

Materia Collective label. A huge amount of activity is dedicated to listening to, sharing, reworking and performing music from *Ocarina of Time*. Of course, these examples all sit as part of a general game music culture,[5] but the prominence of music of *Zelda* and *Ocarina of Time* is notable.

Aside from fan activity, *Ocarina of Time* has had official soundtrack album releases (both for the original game and the 3DS remake). A number of other promotional CDs and limited-run discs have included music from the game, often as part of broader *Zelda* collections.

Music from *Zelda* games have long been a staple of video game music symphonic concerts, and in 2012–17, Nintendo endorsed a large touring concert production dedicated to the music of the series, *Zelda: Symphony of the Goddesses*. At these events, music from *Zelda* games was arranged into quasi-symphonic suites, rather than being performed as individual cues.

Sheet music of cues from *Ocarina of Time* have been published, most notably the DoReMi collection of *Zelda* music,[6] similar compilations by Alfred Publishing[7] and a piano arrangement of the suites from the *Symphony of the Goddesses* concerts.[8] These sheet music publications, side-by-side with fan transcriptions, further encourage fan performance and rearrangement.

A Multivalent Musical Medium

Why, however, has this kind of musical activity been so prominent with respect to game music, and *Zelda/Ocarina of Time* specifically? I would suggest that aspects of music in the video game medium (especially evident in *Ocarina of Time*) make it particularly suitable as a site for musical engagement of this nature.

Just as in film music, the process of extracting the music out of the game is necessarily one of adaptation: the music is being removed from its multimedia context and isolated from the rest of the audio output.[9] Film music recordings on CD albums are rarely precise duplications of the scores heard in the film and have most often been edited or rearranged for listening pleasure. But while this adaptation is often less obvious on film and television soundtrack albums, it is far clearer to listeners in the case of game music.

The process of extracting music from a game into a performed or recorded unit removes the interactive quality so distinctive of the medium. Even in the case of a game that loops one cue until the game ends, arrangers/performers must decide how many repetitions to include. The situation is even more apparent for music that reacts to play, when the recorded/performed music may be very different to that heard in the game. The game *Halo: Combat Evolved* used a music

system that included many possible variations of the same cue. In the liner notes to the soundtrack album, the composer, Martin O'Donnell, explains,

> [We] developed a complicated system that involved alternative endings for cues, alternative sections of the looped middle of cues, and other effects and changes that might take place as the level develops. These musical changes are anchored to the player's progress through the level.
>
> [...] [The] [t]hemes, moods and even the duration of these pieces will change and adapt with each player's Halo experience. I took the liberty of remixing and rearranging all the music in order to make listening to the soundtrack more enjoyable. Perhaps a piece of music that you remember hearing won't be found here [on the CD]. That might be because you played Halo in a way I never anticipated.[10]

The most obviously comparable situation in *Ocarina of Time* is the Hyrule Field cue discussed in Chapter 3. Any performance of this piece must choose whether to begin with the 'Sunrise' tag or the 'Entering the field' tag, as well as which tags should be included and in which order. Will reflective variations be included? Will battle tags? How long will the danger last? Listeners familiar with the game and cue will immediately be aware of the choices made by the performer/arranger and how other potential variations of the cue are possible.

Arguably, this kind of structural intervention is less prominent in more fixed musical cues like the ocarina songs, but the lack of player interactivity is still obvious in these situations, not least in the removal of player performance for triggering the songs.

In adaptations of game music, because it is obvious that the music has been arranged and player agency removed, it is clear that no single performance or recording of the game's music can stand for all eventualities. There is no one definitive performance/recording of a game's music.

The obvious process of adaptation and lack of an all-encompassing single edition of a game's music opens out the potential for more musical possibilities, leading to space for many different variations and versions of the game's music. It is a highly multivalent musical medium.

A further technological factor might also contribute to this notion of musical possibility. Like many games, *Ocarina of Time* does not use a score created from live performance. It features obviously synthetic timbres and sounds that appear to emulate acoustic instruments/voices (albeit not always in very realistic ways). When games use artificial and unrealistic timbres, there is a great degree of possibility for how those timbres should be rendered and interpreted in performance outside the game. Musicians must ask themselves: Should the original synthesized

sounds be used? Should we try to match the synthesized sounds to acoustic instruments? Or, if we are not to copy the timbres of the original, should we try more unusual interpretations? This effect is particularly obvious with even older games. Consider, for example, the overworld for the original *Legend of Zelda* game – the limited waveforms of the NES are clearly non-realistic and so can be interpreted in any number of ways, from orchestral timbres to kazoos or tesla coil sparks.

This variety of interpretations has been evident from some of the earliest game soundtrack albums. The *Dragon Quest* soundtrack CD (1986) contains multiple versions of the same music – an orchestral performance, the version as sounded on the console and a synthesized version using more advanced samples. It demonstrates the multiplicity of interpretations, even within one CD. As games began to include more musical material, these different versions became individual albums in themselves. Now a game might easily prompt several albums of different arrangements of the musical material, from an 'original soundtrack' to piano arrangements, live orchestral recordings and so on. Perhaps some of the appeal of these different versions might also be the ability to re-hear the original music in light of these contrasting arrangements: each cover provides a different frame to re-encounter the music of the original game, as the game and the covers are put in dialogue with each other.

Of course, acoustic recordings of film music can easily be reinterpreted in any number of ways, but the music in the film sets a predefined precedent for performance. Adaptations of older game music have to at least consider the questions of instrumentation and arrangement in a way that is often a foregone conclusion for acoustic recordings.

To put it simply, because of the interactive qualities of the medium and the artificial timbres of much game audio, there is a clear diversity of ways in which the music may be interpreted, with no single version able to attain absolutely definitive status. This situation prompts musicians and players to become involved with the musical possibilities obviously available to them, causing a great proliferation of different arrangements.

This tradition of adapting and performing game music is part of the activity of an online community. As Melanie Fritsch, Jared O'Leary, Evan Tobias, Kyle Stedman and others have described, online geek culture serves as a participatory cultural site for game music activity to thrive.[11] Websites like YouTube provide a forum for musician fans to easily share their performances of game music with a receptive audience who will understand the significance and meanings of the pieces. Social networks are created through this musical exchange, as music circulates online. Music helps to build such fan communities, providing game materials to discuss, share and debate. In particular cases like chiptune music, or even Mario Paint Composer videos, a community of fans has developed to support each other and share knowledge.[12] Of course, not all fan musical labour has to be specifically

concerned with performing music. It might take the form of the extraction of music from the games, plans for 3D printing an ocarina, discussions of music on forums or sheet music transcriptions/arrangements of cues.

A ready-made audience for game music encourages the continual creation and re-creation of musical performances and materials. On this basis, sites like Over-Clocked Remix have flourished, not only continually providing fan productions of video game music but also disseminating multiple different covers of the same pieces.[13] Some fans even propose new music for the games. One such composer, MattMVS7, found himself the subject of both celebration and ridicule when his idiosyncratic a cappella suggestions for the Forest Temple (aka Eh Reh) spread among the online *Zelda* fandom. Fans continue to find new ways to play, and play with, the music of *Ocarina of Time*.

As noted above, musical activity is not limited to cyberspace. Video game music cover bands play live to enthusiastic audiences.[14] Like the concerts mentioned above, these are moments at which the virtual culture shares a moment of physical offline connection.

For any one fan, there are likely several motivations for engaging with video game music. Of course, nostalgia may play a role, as they remember their time in the past playing the games. Music can conjure memories of time spent in the company of Link. In the film *Scott Pilgrim vs. the World* (2010), a film suffused with references to video games, director Edgar Wright persuaded Miyamoto to grant permission to include music from the *Zelda* games in the film, explaining, 'This music is like nursery rhymes to a generation.'[15] Though *Scott Pilgrim* draws primarily from *A Link to the Past*, the same reasoning holds for *Ocarina of Time*, for a younger generation. Musician Graeme Clark, who produced an album of music called 'ZELDAWAVE', based on remixes and adaptations of music from *Ocarina of Time*, describes his motivation like this:

> After going through *Ocarina of Time* footage and listening to the music over and over again I began experiencing feelings of reflection [...] [I] tried to pick cutscene clips that reflected growing up, like 'leaving the forest' and 'memory of younger days.' I only later realized how the idea of changing from a kid in a 'happy overworld' to an adult in a 'dark overworld' is strangely reflective of our nostalgic experiences.[16]

The journalist Luke Winkie, reviewing Clark's work, along with several other musicians creating music from materials based on Nintendo 64 games, writes,

> I'm 27 and spent most of the '90s attached to an N64, so I've already done the unconscious, emotional work annexing the innocence and chastity of my

childhood to those old Nintendo overworlds. It doesn't take long to realize that Clark's music is written in tribute of that heritage, and that he too spent a ton of time chasing his tail in the Lost Woods. However, that's not to say that this is a phenomenon exclusive to my generation. […] Everyone has their own foundational text, and now it's millennials' turn to establish the canon.[17]

For Winkie, and many others, those texts include games, and *Ocarina of Time* is foremost among them.

It may also be the case that familiarity plays a part in players' attachment to the music of games. *Ocarina of Time* provides the potential for players to invest tens of hours of play into the game. Over this long duration, like many expansive games, we become intimately familiar with the music, especially with cues that are used frequently or feature in often-visited areas. With such repetition, we have the opportunity to build relationships with pieces of music, especially when they sound in response to player agency.

Players' personal attachment to the music need not rely on nostalgia and the familiarity with the music. It might also lie in the significance of music to the video game experience and the interactive bond created when music responds to the player's actions. This can occur in a very specific way (through dynamic music and menu interfaces), but even more generally, interacting with a game prompts events and responses that typically lead to musical changes, even those is as simple as starting or stopping a cue.

We have seen how music is a significant part of the experience of playing *Ocarina of Time*. Some of these aspects of music are by no means exclusive to *Ocarina of Time*. Many games use music to build characters, articulate ludic events, accentuate and structure the response from the interface, and so on. But *Ocarina of Time* goes to lengths to teach players to attend to the music, to listen and engage in musical activities. *Ocarina of Time* does so (in part) through the mechanics of the ocarina. But it also encourages listening to music through using striking and unusual musical aesthetics, making the music prominent and rewarding players' attention to the music (either through utility or simply the aesthetic reward of listening to the music). *Ocarina of Time* remains notable for the degree to which it asks players to listen. It is this kind of listening attention that ultimately leads to fan engagement with the games and their music.

Take, for example, the YouTuber and Switch Streamer MonotoneTim, who documented his experience playing *Ocarina of Time* using an ocarina. By creating an interface that detected pitches performed on an ocarina, and mapping them to buttons on the gamepad, he was able to control Link though performing on a physical ocarina. Perhaps the most interesting moment is when MonotoneTim controls Link playing the ocarina, by playing the ocarina. He plays Zelda's Lullaby

simultaneously as Link and as himself. The musical performance fuses worlds together. He says, 'That's so *good*. You're just playing the songs. [...] It even works with speed; you don't just have to do like one note fumbling around at a time [...] It's perfect.'[18] His sense of satisfaction seems to come from the close correspondence between realities when Link's actions are projected onto his physical reality as they play together as one. It is the game's emphasis on musical interaction that prompted this project, and the sense of personal connection between player and game, through the music, that provides satisfaction.

As noted in Chapter 2, Katherine Isbister has described the emotional power of 'social signals' in games.[19] I suggested that music-making in *Ocarina of Time* is one such signal. Isbister further considers how games can themselves become vehicles for social interaction between players. They can become 'nonconversational exchanges that reveal who we are and how we feel about each other' and which 'strengthen [our] social fabric'.[20] Music from video games can also serve this function, as it circulates beyond the boundaries of the game. The music from *Ocarina of Time* binds players not only to the world of Hyrule but also to other players in our universe, as it flows from the fiction of the game out into the non-fictional world. The sharing of music between players mirrors the sharing of music in the game, both with the result of building social bonds. As players broadcast and exchange performances, transcriptions, remixes or even just comments about the music, social relationships are created, fuelled by the music of the game.

Ocarina of Time has also inspired other music that does not directly quote the original source material. Jazz pianist Dominic J. Marshall's composition 'Deku Tree' is featured on his album, *The Triolithic*. Unlike the covers noted above, Marshall is not producing a cover of the Deku Tree's theme or dungeon cue. Instead, he uses the character/setting as a more generalized point of reference. It is not too much of a leap to suggest that games like *Ocarina of Time* are now inspiring musicians in much the same way that composers have been inspired by poems (Debussy's *Suite Bergamasque* after Paul Verlaine and *L'après-midi d'un faune* after Mallarmé), paintings (Rachmaninoff's *Die Toteninsel* ['Isle of the Dead']) and even comics (Michael Daugherty's *Metropolis Symphony*). The game is a rich and involving artistic experience, fusing visual art, written dialogue, narrative and sound with the dimension of interactivity. Small wonder that musicians should find inspiration in such work. These artists may respond as specifically by creating covers of cues from the game, creating music using sonic materials from the game (as with Graeme Clark), or being inspired in a more generalized way (in the case of Dominic J. Marshall).

Game music has inspired musical practices beyond the game. Aside from the aesthetic appeal of the musical materials on their own terms, I have suggested additional several factors why this might be the case. These include the lack of a

definitive recorded version of the score, technological properties that encourage multiple variations, nostalgia, the amount of time spent with the musical material, the importance of music in the game's story, the aesthetic prioritization of music in the game and the interactive bond created between player and game music. *Ocarina of Time* can be seen to engage with each of these aspects. It is perhaps unsurprising, then, that the music of this game continues to be re-created and enjoyed over and over again.

NOTES

1. The triggering phrase for the Song of Healing is also a reversed version of the notation for Saria's Song.
2. Sao et al., *The Legend of Zelda Encyclopedia*, p. 261.
3. The direct sequel to *The Wind Waker*, *Phantom Hourglass*, is set on the same sea. Here, Goron Island is accompanied by the music from Goron City in *Ocarina of Time*.
4. Robert Alan Brookey, *Hollywood Gamers: Digital Convergence in the Film and Video Game Industries* (Bloomington: Indiana University Press, 2010), p. 29.
5. Collins, *Playing with Sound*, pp. 121–42.
6. Nintendo, *The Legend of Zelda Best Collection* (Tokyo: DoReMi, c.2002).
7. Koji Kondo, Shinobu Amayake, Kozue Ishikawa, Toru Minegishi, Kenta Nagata and Akito Nakatsuka, *The Legend of Zelda Series for Piano* (New York: Alfred, c.2009). This collection is also available in an 'Easy Play' edition. Selections from this collection are widely available through digital sheet music retailers.
8. Kondo, Koji, Asuka Hayazaki, Toru Minegishi, Kenta Nagata and Hajime Wakai, *The Legend of Zelda: Symphony of the Goddesses* (New York: Alfred, 2015).
9. See, for an excellent case study on the CD albums of *Gone with the Wind*, Steen Kaargaard Nielsen, '"And Incidentally, the Score is Quite Beautiful": Work Conceptual Reflections on the Phonographic Remediations of Max Steiner's Symphonic Film Score for *Gone with the Wind* (1939) as Soundtrack Album', *Danish Yearbook of Musicology*, 35 (2007), 51–69.
10. Martin O'Donnell, 'Liner Notes', *Halo: Original Soundtrack* SE-2000–2, Microsoft, 2002.
11. Melanie Fritsch, 'It's a-me, Mario!: Playing with Video Game Music', in *Ludomusicology: Approaches to Video Game Music*, ed. by Michiel Kamp, Tim Summers and Mark Sweeney (Sheffield: Equinox, 2016), pp. 92–115; Jared O'Leary and Evan Tobias, 'Sonic Participatory Cultures within, through, and around Video Games', in *The Oxford Handbook of Music Making and Leisure*, ed. by Roger Mantie and Gareth Dylan Smith (New York: Oxford University Press, 2017), pp. 541–64.
12. McAlpine, *Bits and Pieces*; George Reid, 'Chiptune: The Ludomusical Shaping of Identity', *Computer Games Journal*, 7 (2018), 279–90; Dana M. Plank, 'Mario Paint Composer and Musical (Re)Play on YouTube', in *Music in Video Games*, ed. by Michael Austin (New York: Bloomsbury, 2016), pp. 43–82.

13. Kyle D. Stedman, 'Remix Literacy and Fan Compositions', *Computers and Composition*, 29 (2012), 107–23.
 Jared O'Leary, 'A Corpus-Assisted Discourse Analysis of Music-Related Practices Discussed within Chipmusic.Org' (Ph.D. thesis, Arizona State University, 2018).
14. Sebastian Diaz-Gasca, 'Super Smash Covers!: Performance and Audience Engagement in Australian Videogame Music Cover Bands', *Perfect Beat*, 19 (2018), 51–67.
15. Nancy Miller, 'Director Edgar Wright, Actor Michael Cera Crack Wise about Scott Pilgrim', *Wired.com*, 22 April 2010, https://www.wired.com/2010/06/ff_cerawright/ [accessed 14 April 2019].
16. Clark, quoted in Luke Winkie, 'Nintendo 64 Has Inspired a New Wave of Surprisingly Sad Music', *Kotaku.com*, 1 November 2018, https://kotaku.com/nintendo-64-has-inspired-a-new-wave-of-surprisingly-sad-1830140957 [accessed 15 April 2019].
17. Winkie, 'Surprisingly Sad Music'.
18. MonotoneTim, 'Zelda: Ocarina of Time – Played only with an Ocarina!', *YouTube*, 18 January 2016, https://youtu.be/UtJl7hivQCs?t=22921 [accessed 15 April 2019].
19. Isbister, *How Games Move Us*, p. 10.
20. Ibid., p. 110.

Epilogue

Hey, Listen!
Yes, Navi.

But I've been listening all along. It was by listening to the music that I found the mischief in the Lost Woods. It let me know that I was safe in Kokiri Forest. The music made me shiver in the Shadow Temple and wonder at the ominous organic textures of the Deku Tree. It created the sonic space of Dodongo's Cavern and the Temple of Time. It allowed me to relax in Zora's Domain and spurred me on through Gerudo Valley. It made me afraid of Ganondorf but helped me to understand our allies Kaepora Gaebora and Sheik. It conveyed the magic of the Sages and the Spiritual Stones. It was alarmed with me in battle. It celebrated with me when we found secret objects and it commiserated us on losing. It guided me to solve puzzles and warned me of approaching danger.

And it made me a hero. It attached itself to Link and to me. It responded to me and my actions controlling Link. When I played the ocarina, Link played, too. It allowed me to take on the avatar of Link in my quest and journey through Hyrule. It followed me throughout the world, nearby but invisible. Music transformed the landscape into a site for adventure. I learned to play an ocarina and cause magical, powerful effects in the world. Music was sympathetic to me, somehow anchored to me, and yet a distinct 'other'. It was a medium for my relationship with Link and the world of Hyrule. It bound together me, Link, the universe, the ludic structures and the narrative story.

In this volume, we have identified many of the specific musical approaches and strategies evident in *Ocarina of Time*. In the process, we have also shown how music is engaged in nearly every element of game's text and the gaming experience. In particular, we have seen music's relationship with geography, characters (including the avatar), narrative, interfaces, ludic mechanics and even the sound design of the game.

Earlier, in Chapter 2, I quoted Christopher Small's definition of 'musicking' as 'tak[ing] part, in any capacity, in a musical performance'.[1] Perhaps, then, when music is engaged with so many aspects of the game, to video game is 'to music'. Games, especially those like *Ocarina of Time*, provide us with empowered ways of engaging with music, opening up the rewards of musicking, while emphasizing the importance of fun and play.

Historian and cultural theorist Johan Huizinga famously saw play as fundamental to the human condition. He saw 'play as a distinct and highly important factor in the world's life and doings [...] civilization arises and unfolds in and as play'.[2] Video games are part of that cultural expression and fuse together musical play and game play into an amalgam, each constituting a part of the other.

When we game, when we play *Ocarina of Time*, we laugh, we cry, we feel emotions from joy to anger, as we succeed and fail. And all the while, we listen and we music.

NOTES

1. Small, *Musicking*, p. 9.
2. Johan Huizinga, *Homo Ludens: A Study of the Play Element in Culture*, trans. by R.F.C. Hull (London, Boston and Henley: Routledge and Kegan Paul, 1949 [1938]), p. i.

Bibliography

Abraham, Ben, 'Marty O'Donnell in Interview', Abraham's personal blog (seven parts, December 2008–February 2009) http://drgamelove.blogspot.com/search/label/Interview%20with%20Marty%20O%27Donnell. Accessed 8 July 2018.

Altice, Nathan, *I Am Error: The Nintendo Family Computer/Entertainment System Platform* (Cambridge, MA: MIT Press, 2015).

Anon, 'Upcoming Assignments', *Film Score Monthly*, 3 (1998), 9–10.

Anon, 'Top 100 Beste Games Aller Tijden', *Power Unlimited* (2015), https://www.pu.nl/artikelen/feature/top-100-games-aller-tijden/. Accessed 9 August 2019.

Audissino, Emilio, *John Williams's Film Music* (Madison: University of Wisconsin Press, 2014).

Biamonte, Nicole, 'Triadic Modal and Pentatonic Patterns in Rock Music', *Music Theory Spectrum*, 32 (2010), 95–110.

Blacking, John, 'Problems of Pitch, Pattern and Harmony in the Ocarina Music of the Venda', *African Music*, 2 (1959), 15–23.

———, 'Towards a Theory of Musical Competence', in *Man: Anthropological Essays Presented to O. F. Raum*, ed. by E. J. de Jager (Cape Town: C. Struik, 1971), pp. 19–34.

Borowiecka, Renata, 'Via Crucis and Resurrectio by Paweł Łukaszewski: In the Circle of Christian Culture', in *Sounds, Societies, Significations*, ed. by Rima Povilionienė (Cham: Springer, 2017), pp. 97–114.

Bouterse, Jan, 'A Wooden Ocarina', *FoMRHI Quarterly*, 113 (2009), 19–23.

Brame, Jason, 'Examining Non-Linear Forms: Techniques for the Analysis of Scores Found in Video Games' (Master of Music thesis, Texas Tech University, 2009).

———, 'Thematic Unity across a Video Game Series', *Act*, 2 (2011), 16pp.

Brewster, Stephen, Peter Wright, and Alistair Edwards, 'An Evaluation of Earcons for Use in Auditory Human-Computer Interfaces', in *Conference on Human Factors in Computing Systems*, ed. by Stacey Ashlund, Kevin Mullet, Austin Henderson, Erik Hollnagel and Ted White, 24–29 April 1993 (Amsterdam: IOS Press, 1993), pp. 222–27.

Brookey, Robert Alan, *Hollywood Gamers: Digital Convergence in the Film and Video Game Industries* (Bloomington: Indiana University Press, 2010).

Brown, Maurice J. E., and Kenneth L. Hamilton, 'Nocturne (i)', *Grove Music Dictionary of Music and Musicians Online* (2001), https://doi.org/10.1093/gmo/9781561592630.article.20012.

Brown, Julie, 'Carnival of Souls and the Organs of Horror', in *Music in the Horror Film*, ed. by Neil Lerner (New York: Routledge, 2010), pp. 1–21.

Brown, Royal S., *Overtones and Undertones* (Berkeley: University of California Press, 1994).

Brownrigg, Mark, 'Film Music and Film Genre' (Ph.D. thesis, University of Stirling, 2003).

Caillois, Roger, *Man, Play and Games*, trans. by Meyer Barash (Urbana: University of Illinois Press, 2001).

Caplin, William E., *Analyzing Classical Form* (New York: Oxford University Press, 2013).

Carden, Philip, 'Muzak Prevents That Sagging Feeling', *Steel Times*, 199 (July 1971), 578.

Carroll, Noël, *The Philosophy of Horror or Paradoxes of the Heart* (New York and London: Routledge, 1990).

Citron, Marcia J., *Gender and the Musical Canon* (Cambridge: Cambridge University Press, 1993).

———, 'Women and the Western Art Canon: Where Are We Now?', *Notes*, 64 (2007), 209–15.

Cook, James, 'Playing with the Past in the Imagined Middle Ages: Music and Soundscape in Video Game', *Sounding Out!*, 3 (2016), https://soundstudiesblog.com/2016/10/03/playing-with-the-past-in-the-imagined-middle-ages-music-and-soundscape-in-video-game/. Accessed 11 March 2020.

Collins, Karen, 'An Introduction to Procedural Music in Video Games', *Contemporary Music Review*, 28 (2009), 5–15.

———, '"Like Razors through Flesh": Hellraiser's Sound Design and Music', in *Terror Tracks: Music, Sound and Horror Cinema*, ed. by Philip Hayward (London: Equinox, 2009), pp. 198–212.

———, *Playing With Sound* (Cambridge, MA: MIT Press, 2013).

Cook, Karen, 'Beyond (the) Halo: Plainchant in Video Games', in *Studies in Medievalism XXVII: Authenticity, Medievalism, Music*, ed. by Karl Fugelso (Cambridge: D.S. Brewer, 2018), pp. 183–200.

Cook, Nicholas, 'Methods for Analyzing Recordings', in *The Cambridge Companion to Recorded Music*, ed. by Nicholas Cook, Eric Clarke, Daniel Leech-Wilkinson and John Rink (Cambridge: Cambridge University Press, 2009), pp. 221–45.

Dahlhaus, Carl, *Foundations of Music History*, trans. by J. B. Robinson (Cambridge: Cambridge University Press, 1983).

de Clercq, Trevor, and David Temperley, 'A Corpus Analysis of Rock Harmony', *Popular Music*, 30 (2011), 47–50.

Desler, Anne, 'History without Royalty? Queen and the Strata of the Popular Music Canon', *Popular Music*, 32 (2013), 385–405.

Dessy, Ray, and Lee Dessy, 'The Clay Pot That Sings', *American Recorder*, 42 (2001), 9–14.

DeNora, Tia, *Music in Everyday Life* (Cambridge: Cambridge University Press, 2000).

deWinter, Jennifer, *Shigeru Miyamoto: Super Mario Bros., Donkey Kong, The Legend of Zelda* (New York: Bloomsbury, 2015).

Diaz-Gasca, Sebastian, 'Super Smash Covers!: Performance and Audience Engagement in Australian Videogame Music Cover Bands', *Perfect Beat*, 19 (2018), 51–67.

Edwards, Peter, 'The Music of György Ligeti and his Violin Concerto: A Study in Analysis, Reception and the Listening Experience' (Ph.D. thesis, University of Oslo, 2005).

Eitan, Zohar, and Roni Y. Granot, 'How Music Moves: Musical Parameters and Listeners' Images of Motion', *Music Perception*, 23/3 (2006), 221–48.

Everist, Mark, 'The Thirteenth Century', in *The Cambridge Companion to Medieval Music*, ed. by Mark Everist (Cambridge: Cambridge University Press, 2011), pp. 67–86.

Field, Michael J., 'Music of the Heart', *Lancet*, 376/9758 (2010), 2074.

Fitzpatrick, Alex, John Patrick Pullen, Josh Raab, Lev Grossman, Lisa Eadicicco, Matt Peckham, and Matt Vella, 'The 50 Best Video Games of All Time', *Time*, 23 August 2016, https://time.com/4458554/best-video-games-all-time/. Accessed 9 August 2019.

Flora, Reis, 'Śahnāī', *Grove Music Online* (2001), https://doi.org/10.1093/gmo/9781561592630.article.51148.

Frith, Simon, 'Towards an Aesthetic of Popular Music', in *Music and Society*, ed. by Susan McClary and Richard Leppert (Cambridge: Cambridge University Press, 1987), pp. 133–50.

Fritsch, Melanie, 'It's a-me, Mario!: Playing with Video Game Music', in *Ludomusicology: Approaches to Video Game Music*, ed. by Michiel Kamp, Tim Summers and Mark Sweeney (Sheffield: Equinox, 2016), pp. 92–115.

Game Trailers, *Pop Fiction: Season 1 Episode 9: The Fire Temple Chants [Update 2]*, YouTube version, 27 September 2013, https://www.youtube.com/watch?v=U34MFcJdGCo. Accessed 17 July 2018.

George, Richard, 'Behind the Scenes of Zelda: Skyward Sword', *IGN*, 10 November 2011, https://uk.ign.com/articles/2011/11/11/behind-the-scenes-of-zelda-skyward-sword. Accessed 19 August 2019.

Gervais, Nicholas, 'Harmonic Language in The Legend of Zelda: Ocarina of Time', *Nota Bene: Canadian Undergraduate Journal of Musicology*, 8 (2015), 26–42.

Gibbons, William, 'Wrap Your Troubles in Dreams: Popular Music, Narrative, and Dystopia in Bioshock', *Game Studies*, 11 (2011).

———, 'Music, Genre and Nationality in the Postmillennial Fantasy Role-Playing Game', in *The Routledge Companion to Screen Music and Sound*, ed. by Miguel Mera, Ronald Sadoff and Ben Winters (New York: Routledge, 2017), pp. 412–27.

Goodwin, Andrew, *Dancing in the Distraction Factory* (London: Routledge, 1993).

Haga, Egil, 'Correspondences between Music and Body Movement' (Ph.D. thesis, University of Oslo, 2008).

Haigh-Hutchinson, Mark, 'Classic Postmortem: Star Wars: Shadows of the Empire', *Gamasutra.com* (April 2009 [1997]), http://www.gamasutra.com/view/news/114010/Classic_Postmortem_Star_Wars_Shadows_Of_The_Empire.php. Accessed 4 January 2018.

Halfyard, Janet K., and Victoria Hancock, 'Scoring Fantasy Girls: Music and Female Agency in Indiana Jones and the Mummy Films', in *The Music of Fantasy Cinema*, ed. by Janet K. Halfyard (Sheffield: Equinox, 2014), pp. 175–92.

Hambleton, Elizabeth, 'Gray Areas: Analyzing Navigable Narratives in the Not-So-Uncanny Valley between Soundwalks Video Games, and Literary Computer Games', *Journal of Sound and Music in Games*, 1/1 (2020), 20–43.

Healy, Paul F., Carrie L. Dennett, Mary Hill Harris, and Arnd Adje Both, 'A Musical Nature: Pre-Columbian Ceramic Flutes of Northeast Honduras', in *Musical Perceptions – Past and Present*, ed. by Ricardo Eichmann, Ellen Hickmann, and Lars-Christian Koch (Rahden: Verlag Marie Leidorf, 2010), pp. 189–212.

Hill, Megan E., 'Soundscape', *Grove Music Dictionary of Music and Musicians Online* (2014), https://doi.org/10.1093/gmo/9781561592630.article.A2258182.

Hilliard, Kyle, 'Reader's Choice Top 300 Games', *Game Informer*, 19 March 2018, https://www.gameinformer.com/b/features/archive/2018/03/19/readers-choice-top-300-games-of-all-time.aspx. Accessed 9 August 2019.

Hoffert, Paul, *Music for New Media* (Boston, MA: Berklee Press, 2007).

Hooper, Giles, 'Sounding the Story: Music in Videogame Cutscenes', in *Emotion in Video Game Soundtracking*, ed. by Duncan Williams (Cham: Springer, 2018), pp. 115–41.

Hoppin, Richard, *Medieval Music* (New York: Norton, 1978).

Hughes, Derek, '"Wie die Hans Heilings": Weber, Marschner, and Thomas Mann's Doktor Faustus', *Cambridge Opera Journal*, 10 (1998), 179–204.

Huizinga, Johan, *Homo Ludens: A Study of the Play Element in Culture*, trans. by R. F. C. Hull (London, Boston and Henley: Routledge and Kegan Paul, 1949 [1938]).

Isbister, Katherine, *How Games Move Us: Emotion by Design* (Cambridge, MA: MIT Press, 2017).

Ivănescu, Andra, 'Torched Song: The Hyperreal and the Music of L.A. Noire', *The Soundtrack*, 8 (2015), 41–56.

Iwata, Satoru, 'Iwata Asks: Wii Music', *Nintendo*, 16 December 2008, https://www.nintendo.co.uk/Iwata-Asks/Iwata-Asks-Wii-Music/Volume-1-The-Joy-Of-Playing-Music-For-All/1-Shigeru-Miyamoto-s-Early-Encounters-with-Music/1-Shigeru-Miyamoto-s-Early-Encounters-with-Music-236997.html. Accessed 2 January 2019.

———, 'Iwata Asks: The Legend of Zelda: Ocarina of Time 3D – Bonus: Zelda 25th Anniversary Concert', *Nintendo*, 27 July 2011, https://www.nintendo.co.uk/Iwata-Asks/Iwata-Asks-The-Legend-of-Zelda-Ocarina-of-Time-3D/Vol-5-Mr-Shigeru-Miyamoto/Bonus-Zelda-25th-Anniversary-Symphony-Concert/Bonus-Zelda-25th-Anniversary-Symphony-Concert-224892.html. Accessed 14 April 2019.

———, 'Iwata Asks: The Legend of Zelda: Ocarina of Time 3D – 4. Orchestral Sound in the Nintendo 3DS System', *Nintendo*, 27 July 2011, https://www.nintendo.co.uk/Iwata-Asks/Iwata-Asks-The-Legend-of-Zelda-Ocarina-of-Time-3D/Vol-1-Sound/4-Orchestral-Sound-on-the-Nintendo-3DS-System/4-Orchestral-Sound-on-the-Nintendo-3DS-System-231403.html. Accessed 14 April 2019.

———, 'Iwata Asks: The Legend of Zelda: Ocarina of Time 3D – 5. "I'm Envious of First-Time Players!"', *Nintendo*, 27 July 2011, https://www.nintendo.co.uk/Iwata-Asks/Iwata-Asks-The-Legend-of-Zelda-Ocarina-of-Time-3D/Vol-1-Sound/5-I-m-Envious-of-First-Time-Players-/5-I-m-Envious-of-First-Time-Players--231463.html. Accessed 14 April 2019.

———, 'Iwata Asks: The Legend of Zelda: Ocarina of Time 3D – 6. Our Favourite Songs', *Nintendo*, 27 July 2011, https://www.nintendo.co.uk/Iwata-Asks/Iwata-Asks-The-Legend-of-Zelda-Ocarina-of-Time-3D/Vol-1-Sound/6-Our-Favourite-Songs/6-Our-Favourite-Songs-231508.html. Accessed 14 April 2019.

Jørgensen, Kristine, 'Gameworld Interfaces as Make-Believe', in *Digital Make-Believe*, ed. by Phil Turner and J. Tuomas Harviainen (np: Springer, 2016), pp. 89–99.

———, 'Emphatic and Ecological Sounds in Gameworld Interfaces', in *The Routledge Companion to Screen Music and Sound*, ed. by Miguel Mera, Ronald Sadoff and Ben Winters (New York: Routledge, 2017), pp. 72–84.

Juslin, Patrik N., 'Seven Ways in Which the Brain Can Evoke Emotions from Sounds', in *Sound, Mind and Emotion*, ed. by Frans Mossberg (Lund: Sound Environment Centre, 2009), pp. 9–36.

Juul, Jesper, *Half-Real: Video Games between Real Rules and Fictional Worlds* (Cambridge, MA: MIT Press, 2005).

Kamp, Michiel, 'Four Ways of Hearing Video Game Music' (Ph.D. thesis, Cambridge University, 2014).

Katz, Jared, 'Digitized Maya Music: The Creation of a 3D Database of Maya Musical Artifacts', *Digital Applications in Archaeology and Cultural Heritage*, 6 (2017), 29–37.

Katz, Willi, and Israel J. Katz, 'Bolero', *Grove Music Dictionary of Music and Musicians Online* (2001), https://doi.org/10.1093/gmo/9781561592630.article.03444.

Kent, Steven L., *The Ultimate History of Video Games* (New York: Three Rivers, 2001).

Kettlewell, David, 'The Dulcimer' (Ph.D. thesis, Loughborough University of Technology, 1976).

Key, Susan, 'Sound and Sentimentality: Nostalgia in the Songs of Stephen Foster', *American Music*, 13 (1995), 145–66.

Kohler, Chris, *Power-Up: How Japanese Video Games Gave the World an Extra Life* (Indianapolis, IN: BradyGames, 2005).

———, 'VGL: Koji Kondo Interview', *Wired.com* (2007), https://www.wired.com/2007/03/vgl-koji-kondo-/. Accessed 5 January 2019.

Kondo, Koji [and anon. interviewer], 'Natural Rhythms of Hyrule', *Nintendo Power*, 195 (2005), 56–58.

Kondo, Koji, Shinobu Amayake, Kozue Ishikawa, Toru Minegishi, Kenta Nagata, and Akito Nakatsuka, *The Legend of Zelda Series for Piano* (New York: Alfred, c.2009).

Kondo, Koji, Asuka Hayazaki, Toru Minegishi, Kenta Nagata, and Hajime Wakai, *The Legend of Zelda: Symphony of the Goddesses* (New York: Alfred, 2015).

Lamb, Brendan and Barnabas Smith, 'From Skyrim to Skellige: Fantasy Video Game Music within a Neo-Mediaevalist Paradigm', *Musicology Australia*, 40 (2019), 79–100.

Lavengood, Megan L., 'A New Approach to the Analysis of Timbre' (Ph.D. thesis, City University of New York, 2017), pp. 16–27.

Lawrence, Chris, 'What if Zelda Wasn't a Girl? Problematizing Ocarina of Time's Great Gender Debate', in *Queerness in Play*, ed. by Todd Harper, Meghan Blythe Adams, and Nicholas Taylor (Cham: Palgrave, 2018), pp. 97–114.

Ledbetter, David, and Howard Ferguson, 'Prelude', *Grove Music Dictionary of Music and Musicians Online* (2014 [2001]), https://doi.org/10.1093/gmo/9781561592630.article.43302.

Leinberger, Charles, *Enno Morricone's The Good, the Bad and the Ugly: A Film Score Guide* (Lanham, MD: Scarecrow, 2004).

Leplâtre, Grégory, and Stephen A. Brewster, 'An Investigation of Using Music to Provide Navigation Cues', *Proc. ICAD '98*, British Computer Society, Glasgow, Scotland.

Lerner, Neil, 'Mario's Dynamic Leaps: Musical Innovations (and the Specter of Early Cinema) in *Donkey Kong* and *Super Mario Bros.*', in *Music in Video Games*, ed. by K. J. Donnelly, William Gibbons, and Neil Lerner (New York: Routledge, 2014), pp. 1–29.

Levitin, Daniel J., *This is Your Brain on Music* (London: Atlantic, 2006).

Liggins, David, 'Ocarina', *Grove Music Online* (2001), https://doi.org/10.1093/gmo/9781561592630.article.20239.

———, 'Ocarinas: The Secret to 3D Sounds', *Music Mark*, 4 (2014), 13–15.

Liggins, David, and Christa Liggins, *The Ocarina: A Pictorial History* (Kettering: Ocarina Workshop, 2003).

Lind, Stephanie, 'Active Interfaces and Thematic Events in *The Legend of Zelda: Ocarina of Time*', in *Music Video Games*, ed. by Michael Austin (New York: Bloomsbury, 2016), pp. 83–106.

Link, Stan, 'Horror and Science Fiction', in *The Cambridge Companion to Film Music*, ed. by Mervyn Cooke and Fiona Ford (Cambridge: Cambridge University Press, 2016), pp. 200–15.

Loya, Shay, 'The Verbunkos Idiom in Liszt's Music of the Future: Historical Issues of Reception and New Cultural and Analytical Perspectives' (Ph.D. thesis, King's College London, 2006).

———, 'Beyond "Gypsy" Stereotypes: Harmony and Structure in the Verbunkos Idiom', *Journal of Musicological Research*, 27 (2008), 254–80.

Lynar, Emily, Erin Cvejic, Emery Schubert, and Ute Vollmer-Conna, 'The Joy of Heartfelt Music: An Examination of Emotional and Physiological Responses', *International Journal of Psychophysiology*, 120 (2017), 118–25.

MacDonald, Doon, 'The Development and Evaluation of an Approach to Auditory Display Design Based on Soundtrack Composition' (Ph.D. thesis, Queen Mary University of London, 2017).

Manent, Mathieu, *Nintendo 64 Anthology*, trans. by Cain Garnham and Jade Roxanne Garnham (Paris: Geeks Line, 2016).

Marks, Aaron, and Jeannie Novak, *Game Audio Development* (Clifton Park, NY: Delmar, 2009).

Massumi, Brian, 'Envisioning the Virtual', in *The Oxford Handbook of Virtuality*, ed. by Mark Grimshaw (New York and Oxford: Oxford University Press, 2014), pp. 55–70.

Mawer, Deborah, *The Ballets of Maurice Ravel: Creation and Interpretation* (Aldershot: Ashgate, 2006).

Maxwell Chandler, Heather, and Stephanie O'Malley Deming, *The Game Localization Handbook*, 2nd edition (Sudbury, MA: Jones and Bartlett Learning, 2012).

McAlpine, Kenneth B., *Bits and Pieces: A History of Chiptunes* (New York: Oxford University Press, 2018).

McGookin, David, and Stephen Brewster, 'Earcons', in *The Sonification Handbook*, ed. by Thomas Hermann, Andy Hunt, and John G. Neuhoff (Berlin: Logos, 2011), pp. 339–61.

McKee, Eric, 'Influences of the Early Eighteenth-Century Social Minuet on the Minuets from J. S. Bach's French Suites, BWV 812–17', *Music Analysis*, 18 (1999), 235–60.

Medina-Gray, Elizabeth, 'Modular Structure and Function in Early 21st-Century Video Game Music' (Ph.D. thesis, Yale University, 2014).

Miller, Kiri, *Playing Along: Digital Games, YouTube and Virtual Performance* (New York: Oxford University Press, 2012).

Miller, Nancy, 'Director Edgar Wright, Actor Michael Cera Crack Wise about Scott Pilgrim', *Wired.com*, 22 April 2010, https://www.wired.com/2010/06/ff_cerawright/. Accessed 14 April 2019.

Miller, Timothy D., 'Hawaiian Guitar', *Grove Music Online* (2013), https://doi.org/10.1093/gmo/9781561592630.article.A2241449.

MonotoneTim, 'Zelda: Ocarina of Time – Played only with an Ocarina!', *YouTube*, 18 January 2016, https://youtu.be/UtJl7hivQCs?t=22921. Accessed 15 April 2019.

Moseley, Roger, *Keys to Play: Music as a Ludic Medium from Apollo to Nintendo* (Berkeley: University of California Press, 2016).

Mustonen, Manne-Sakari, 'A Review-Based Conceptual Analysis of Auditory Signs and Their Design', *Proceedings of the 14th International Conference on Auditory Display*, 24–27 June 2008, Paris, France.

Napolitano, Jayson, 'Koji Kondo Talks Ocarina of Time, Gives Details on Skyward Sword', *Original Sound Version*, 21 June 2011, http://www.originalsoundversion.com/koji-kondo-talks-ocarina-of-time-gives-details-on-skyward-sword/. Accessed 19 August 2019.

Neill, Daniel, 'From Singing to Cryin': Towards an Understanding of the Steel Guitar in Country Music 1915–1935', *Canadian Folk Music*, 48 (2014), 1–8.

Nesbitt, Keith V., and Ian Hoskens, 'Multi-Sensory Game Interface Improves Player Satisfaction but not Performance', *9th Australasian User Interface Conference (AUIC2008)*, January 2008, Wollongong, NSW, Australia.

Nesbitt, Keith, Paul Williams, Patrick Ng, Karen Blackmore, and Ami Eidels, 'Designing Informative Sound to Enhance a Simple Decision Task', *The 22nd International Conference on Auditory Display (ICAD–2016)*, 2–8 July 2016, Canberra, Australia.

Neuman, Philip, 'Sirènes, Spectres, Ombres: Dramatic Vocalization in the Nineteenth and Twentieth Centuries' (Ph.D. thesis, Boston University, 2009).

Newman, James, 'Kaizo Mario Maker: ROM Hacking, Abusive Game Design and Nintendo's Super Mario Maker', *Convergence*, 24 (2018), 339–56.

Ng, Patrick, and Keith V. Nesbitt, 'Informative Sound Design in Video Games', *IE '13 Proceedings of the 9th Australasian Conference on Interactive Entertainment*, 30 September–1 October 2013, Melbourne, Australia.

Ng, Patrick, Keith Nesbitt, and Karen Blackmore, 'Sound Improves Player Performance in a Multiplayer Online Battle Arena Game', in *Artificial Life and Computational Intelligence*, ed. by Stephan K. Chalup, Alan D. Blair, and Marcus Randall (Cham: Springer, 2015), pp. 166–74.

Nielsen, Kristina, and Christophe Helmke, 'A Case Study of Maya Avian Ocarinas from Pook's Hill, Belize', in *Flower World – Mundo Florido, Vol 4*, ed. by Matthias Stöckli and Mark Howell (Berlin: Ekho Verlag, 2015), pp. 79–98.

Nielsen, Steen Kaargaard, '"And Incidentally, the Score is Quite Beautiful": Work Conceptual Reflections on the Phonographic Remediations of Max Steiner's Symphonic Film Score for *Gone with the Wind* (1939) as Soundtrack Album', *Danish Yearbook of Musicology*, 35 (2007), 51–69.

Nintendo, *Nintendo 64 Programming Manual* (np: Nintendo, 1996 [1995]).

——, *The Legend of Zelda Best Collection* (Tokyo: DoReMi, *c*.2002).

——, 'Consolidated Sales by Region', *Nintendo.co.jp* (2010), http://www.nintendo.co.jp/ir/library/historical_data/pdf/consolidated_sales_e0912.pdf, retrieved from https://www.webcitation.org/5nXieXX2B. Accessed 2 January 2019.

O'Callaghan, Clare, 'Lullament: Lullaby and Lament Therapeutic Qualities Actualized through Music Therapy', *American Journal of Hospice and Palliative Medicine*, 25 (2008), 93–99.

O'Donnell, Martin, 'Liner Notes', *Halo: Original Soundtrack* SE-2000–2, Microsoft, 2002.

O'Leary, Jared, 'A Corpus-Assisted Discourse Analysis of Music-Related Practices Discussed within Chipmusic.Org' (Ph.D. thesis, Arizona State University, 2018).

O'Leary, Jared, and Evan Tobias, 'Sonic Participatory Cultures within, through, and around Video Games', in *The Oxford Handbook of Music Making and Leisure*, ed. by Roger Mantie and Gareth Dylan Smith (New York: Oxford University Press, 2017), pp. 541–64.

Olsen, Dale, 'The Flutes of El Dorado: Musical Effigy Figurines', *Imago Musicae*, 3 (1987), 79–102.

Park, Hyeonjin J., 'Melodies of Distant Realms: World Music in the Context of Video Games' (BA thesis, Mount Holyoke College, 2015).

———, 'Understanding the Musical Portrayal of the Desert in Video Games' (MA thesis, University of Bristol, 2016).

Pestelli, Giorgio, *The Age of Mozart and Beethoven*, trans. by Eric Cross (Cambridge: Cambridge University Press, 1984).

Phillips, Winifred, *A Composer's Guide to Game Music* (Cambridge, MA: MIT Press, 2014).

Plank, Dana M., 'Mario Paint Composer and Musical (Re)Play on YouTube', in *Music in Video Games*, ed. by Michael Austin (New York: Bloomsbury, 2016), pp. 43–82.

Polotti, Pietro, and Guillaume Lemaitre, 'Rhetorical Strategies for Sound Design and Auditory Display: A Case Study', *International Journal of Design*, 7 (2013), 67–82.

Pressing, Jeff, 'Relations between Music and Scientific Properties of Time', *Contemporary Music Review*, 7 (1993), 105–22.

Pugh, Tison, and Angela Jane Weisl, *Medievalisms: Making the Past in the Present* (London: Routledge, 2013).

Radano, Ronald M., 'Interpreting Muzak: Speculations on Musical Experience in Everyday Life', *American Music*, 7 (1989), 448–60.

Ramos, Daniel, and Eelke Folmer, 'Supplemental Sonification of a Bingo Game', *Proceedings of the 6th International Conference on Foundations of Digital Games*, 29 June–1 July 2011, Bordeaux, France, 168–73.

Reale, Steven B., 'A Musical Atlas of Hyrule: Video Games and Spatial Listening' (paper presented at the annual meeting of the Society for Music Theory, St. Louis, MO, 29 October–1 November 2015).

Reid, George, 'Chiptune: The Ludomusical Shaping of Identity', *Computer Games Journal*, 7 (2018), 279–90.

Robb, James, Tom Garner, Karen Collins, and Lennart E. Nacke, 'The Impact of Health-Related User Interface Sounds on Player Experience', *Simulation & Gaming*, 48 (2017), 402–27.

Rosen, Charles, *The Romantic Generation* (Cambridge, MA: Harvard University Press, 1995).

Rowland, David, 'The Nocturne: Development of a New Style', in *The Cambridge Companion to Chopin*, ed. by Jim Samson (Cambridge: Cambridge University Press, 1992), pp. 32–49.

Rushton, Julian, 'Tierce de Picardie', *Grove Music Dictionary of Music and Musicians Online* (2001), https://doi.org/10.1093/gmo/9781561592630.article.27946.

———, 'Music and the Poetic', in *The Cambridge History of Nineteenth Century Music*, ed. by Jim Samson (Cambridge: Cambridge University Press, 2001), pp. 151–77.

Russell, Tilden A., 'The Unconventional Dance Minuet: Choreographies of the Menuet d'Exaudet', *Acta Musicologica*, 64 (1992), 118–38.

Ryan, Jeff, *Super Mario: How Nintendo Conquered America* (New York: Portfolio, 2012).

Ryan, Zach, et al., 'Top 100 Video Games of All Time', *IGN* (2019), https://uk.ign.com/lists/top-100-games/25. Accessed 9 August 2019.

Sao, Akinori, 'Developer Interview: The Legend of Zelda', *Nintendo.com* (c.2016), https://www.nintendo.com/nes-classic/the-legend-of-zelda-developer-interview. Accessed 9 January 2019.

Sao, Akinori, Ginko Tatsumi, Chisato Mikame, and Ben Gelinas, *The Legend of Zelda Encyclopedia* (Milwaukie, OR: Dark Horse, 2010).

Schafer, R. Murray, *The Soundscape: Our Sonic Environment and the Tuning of the World* (Rochester, VT: Destiny, 1994).

Schartmann, Andrew, *Koji Kondo's Super Mario Bros. Soundtrack* (New York: Bloomsbury, 2015).

Schneider, Peer, 'The Legend of Zelda: Ocarina of Time Review', *IGN* (1998), https://uk.ign.com/articles/1998/11/26/the-legend-of-zelda-ocarina-of-time-review. Accessed 14 January 2019.

Sheehy, Daniel, *Mariachi Music in America: Experiencing Music, Expressing Culture* (New York: Oxford, 2006).

Small, Christopher, *Musicking: The Meanings of Performance and Listening* (Middletown, CT: Wesleyan University Press, 1998).

Sterne, Jonathan, 'Sounds like the Mall of America: Programmed Music and the Architectonics of Commercial Space', *Ethnomusicology*, 41 (1997), 22–50.

Stedman, Kyle D., 'Remix Literacy and Fan Compositions', *Computers and Composition*, 29 (2012), 107–23.

Stevens, Richard, and Dave Raybould, *The Game Audio Tutorial* (Burlington, MA: Focal, 2011).

Sugiarto, Marilyn, 'A Rhizomatic Reimagining of Nintendo's Hardware and Software History' (MA thesis, Concordia University Montreal, 2017).

Summers, Tim, *Understanding Video Game Music* (Cambridge: Cambridge University Press, 2016).

Sutton, J., 'The Minuet: an Elegant Phoenix', *Dance Chronicle*, 8 (1985), 119–52.

Sweeney, Mark, 'The Aesthetics of Videogame Music' (D.Phil. thesis, Oxford University, 2015).

——, 'Isaac's Silence: Purposive Aesthetics in Dead Space', in *Ludomusicology: Approaches to Video Game Music*, ed. by Michiel Kamp, Tim Summers, and Mark Sweeney (Sheffield: Equinox, 2016), pp. 172–97.

Szabo, Victor, 'Ambient Music as Popular Genre: Historiography, Interpretation, Critique' (Ph.D. thesis, University of Virginia, 2015).

——, 'Unsettling Brian Eno's Music for Airports', *Twentieth-Century Music*, 14 (2017), 305–33.

Tagg, Philip, and Bob Clarida, *Ten Little Title Tunes* (New York and Montreal: Mass Media Scholars Press, 2003).

Tan, Siu-Lan, John Baxa, and Matthew P. Spackman, 'Effects of Built-In Audio versus Unrelated Background Music on Performance in an Adventure Role-Playing Game', *International Journal of Gaming and Computer-Mediated Simulations*, 2 (2010), 1–23.

Temperley, Nicholas, 'John Field and the First Nocturne', *Music & Letters*, 56 (1975), 335–40.

Tong, Kin-Woon, 'Shang Musical Instruments: Part Two', *Asian Music*, 15 (1983), 102–84.

Treece, David, 'Guns and Roses: Bossa Nova and Brazil's Music of Popular Protest, 1958–68', *Popular Music*, 16 (1997), 1–29.

Troutman, John W., 'Steelin' the Slide: Hawai'i and the Birth of the Blues Guitar', *Southern Cultures*, 19 (2013), 26–52.

Unverricht, Hubert, and Cliff Eisen, 'Serenade', *Grove Music Dictionary of Music and Musicians Online* (2001), https://doi.org/10.1093/gmo/9781561592630.article.25454.

van Elferen, Isabella, '¡Un Forastero! Issues of Virtuality and Diegesis in Videogame Music', *Music and the Moving Image*, 4 (2011), 30–39.

——, *Gothic Music: The Sounds of the Uncanny* (Cardiff: University of Wales Press, 2012).

——, 'Fantasy Music: Epic Soundtracks, Magical Instruments, Musical Metaphysics', *Journal of the Fantastic in the Arts*, 24 (2013), 4–24.

Whalen, Zach, 'Case Study: Film Music vs. Video-Game Music', in *Music, Sound and Multimedia*, ed. by Jamie Sexton (Edinburgh: Edinburgh University Press, 2007), pp. 57–81.

Whittall, Arnold, 'Musical Language', in *The Wagner Compendium*, ed. by Barry Millington (London: Thames and Hudson, 1992), pp. 248–61.

Wierzbicki, James, 'The Ghostly Noise of J-Horror: Roots and Ramifications', in *Terror Tracks: Music, Sound and Horror Cinema*, ed. by Philip Hayward (London: Equinox, 2009), pp. 249–67.

Winkie, Luke, 'Nintendo 64 Has Inspired a New Wave of Surprisingly Sad Music', *Kotaku.com*, 1 November 2018, https://kotaku.com/nintendo-64-has-inspired-a-new-wave-of-surprisingly-sad-1830140957. Accessed 15 April 2019.

Winters, Ben, *Erich Wolfgang Korngold's The Adventures of Robin Hood* (Lanham, MD: Scarecrow, 2007).

——, 'The Non-Diegetic Fallacy: Film, Music, and Narrative Space', *Music and Letters*, 91 (2010), 224–44.

——, *Music, Performance and the Realities of Film* (New York: Routledge, 2014).

Wood, Simon, 'Video Game Music', in *Sound and Music in Film and Visual Media*, ed. by Graeme Harper, Ruth Doughty, and Jochen Eisentraut (New York and London: Continuum, 2009), pp. 129–48.

Yin-Poole, Wesley, 'Capcom Tweaks Street Fighter 5 Thailand Stage Due to "Unintentional Religious References"', *Eurogamer*, 27 April 2017, https://www.eurogamer.net/articles/2017-04-27-capcom-tweaks-street-fighter-5-thailand-stage-due-to-unintentional-religious-references. Accessed 14 April 2019.

Index

See also 'Index of Cues' for specific pieces.

acquisition cues 228–36
adaptations, of music from *Ocarina of Time* 274–87
Adventures of Robin Hood, The 11
advertising, for *Ocarina of Time* 19n25
Africa, musical traditions of, 22–23, 153
albums, of game music 279–82
ambient music 143–44. *See also* soundscape
animal sounds, emulated in music 119–21, 144. *See also* birdsong
Armos 267
arrangements and rearrangements, of game music 274–87
attack music *See* combat music
auditory icons *See* earcons and auditory icons
avatar *See* Link

Baby Dodongo 265
battle music *See* combat music
Beatles, The 279
Beethoven, Ludwig van 177n61
birdsong, allusion to 43, 119–21
bluegrass 243
blues 244–45
bolero 53–55
Bongo Bongo (boss) 130, 224, 266
boss music *See* combat music

bossa nova 160–63, 165
Bottom of the Well *See* Shadow Temple
bourrée 187
Brame, Jason 58, 84–90
Brookey, Robert Alan 278
Brown, Julie 140–42
Brownrigg, Mark 250n7

Cadence of Hyrule 10
Caillois, Roger 215
canons, in game music studies 2, 3n2
Caribbean 155–57
Carroll, Noël 131
cartoons, music in 242, 261
Castle Courtyard 81, 173, 244–46, 248, 279
Castle Town Market 78, 81, 147–51
Chamber of the Sages *See* Sacred Realm
chant (musical tradition, including cantus firmus and plainchant) 39, 60–61, 106–08. *See also* organum
character themes 179–92
chicken minigame 242–43
chiptune music 282
Chopin, Frédéric 57
circus music 242–43
Clarida, Bob 169
Clark, Graeme 283–85
Collins, Karen 83
combat music 99–102, 215–27, 247–48, 249n2, 288. *See also* enemy sound effects

commercials, for *Ocarina of Time* 19n25
composition, by players in *Ocarina of Time* 62–65, 68, 70–71
Conan the Barbarian (1982 film) 19n23
concerts, of music from *Ocarina of Time* 280, 283
country music (American) 104–06
Courtyard *See* Castle Courtyard
covers, of music from *Ocarina of Time* 274–87
Crosby, Bing 21, 23, 25, 71
Cruis'n World 124
cutscenes 179–214, 254–55

Dark Link 216
Darunia, see Gorons
Daugherty, Michael 285
Dead Hand 268
Death Mountain 53, 78, 81, 82, 175n29, 216
Debussy, Claude 131, 285
Deku Tree 7–8, 111–15, 117, 119, 143, 179, 118–89, 197, 200, 235, 285, 288
Desert Colossus 59, 132–33, 135, 157. *See also* Spirit Temple
dialogue 253–55, 259, 271. *See also* cutscenes
diegesis and music 44–45, 67, 69–70, 78–80, 110–11, 163, 170–74, 288
d'Indy, Vincent 131
diving minigame 242–43
djembe 130, 153, 165
Dodongo's Cavern 115–17, 119, 121, 125, 136, 143, 175n29, 216, 277, 288. *See also* Baby Dodongo
Donati, Giuseppe 23, 24
Dragon Quest (game series) 17, 80, 145, 282
dulcimer 149, 165–66, 176n36
dungeons

in game structure 6, 8, 25, 50, 49, 81, 145, 147, 164, 184, 189, 200, 226, 235. *See also* combat music
Kondo's style for 82, 142–44, 160–61
music and puzzle mechanics in 36, 38–39, 55–56, 237–41, 253
music for 79, 111–44, 155, 164–66, 170, 172, 182, 224, 246, 285
ocarina songs and 36–39, 55–56, 58
Dungeons and Dragons 6

earcons and auditory icons 251–59
Easter Egg 174n15
end credits 203–10
enemy sound effects 150, 262–70
Eno, Brian 144
Epona 36, 40–42, 65, 81, 83, 92, 104–06, 192–93, 203, 243–44, 256, 259, 271, 275–77
error sound 252–53, 257–58

Fabulous Five Froggish Tenors, The 65–66
Factor 5 16
fairground music 163–64, 242–43
fairies 1, 7, 36, 47, 167–70, 197, 241, 259–61. *See also* Fairy Fountain *and* Navi
Fairy Fountain 160, 167–71, 173, 197, 200, 252, 261, 275. *See also* menus *and* Sacred Realm
Fairy Ocarina 25–26, 34, 234–35
fanfare 11, 37, 92–93, 95, 98–99, 139, 147, 182, 192, 199, 201, 203, 311, 224–26, 228–31, 235–36
fans and fandom 38, 274–87
Fantasy (genre) 6–7, 17, 28, 62, 102, 151, 160, 225, 261. *See also* genre, of games, *and* medievalism
Field, John 57
fighting, music for *See* combat music

film music *See* Hollywood film music
Final Fantasy (game series) 17, 80
fire boss 216, 218–19, 221–22, 249n4, 278
Fire Temple 8, 79, 121–25, 129, 131, 216
fishing pond 177n60, 234, 242
flamenco 157–60, 177n65
Flare Dancer 216
Flora, Reis 135
Forest Temple 8, 79, 119–21, 143–44, 283. *See also* Minuet of Forest *and* Sacred Forest Meadow
Foster, Stephen 152–53
Freezard 269
Freischütz, Der (opera) 182
Frozen II 131

game mechanics, music and 215–50
Game of Thrones (TV series) 279
game over 241–42, 247, 250n10, 276. *See also* losing
Ganon/Ganondorf (character) 7–9, 39, 43, 45–46, 130, 139–42, 150–51, 179, 182–84, 189–90, 192, 200–01, 203–04, 206, 210–13, 214n12, 216–27, 250n8, 257, 275–77, 288
Ganon's Castle
 basement 136–37, 245–46, 260
 escape from 245–46
Ganon's Tower 137–42, 171
genre, of games 6, 17, 80, 145, 172, 196
geography 22, 45, 55, 62, 78–81, 87, 102–04, 132, 135–36, 153, 156, 159–60, 170–74, 276, 288
Gerudo Training Ground *See* Dodongo's Cavern
Gerudo Valley 157–60, 173, 279, 288
Gervais, Nicholas 49–50, 53, 56
Goldsmith, Jerry 131
Good, the Bad, and the Ugly, The 24

Gorons and Goron City 8, 45, 109, 122, 124, 153–55, 160, 173, 179, 216, 235, 261, 275–76, 286n3
gothic (aesthetic) 106–08, 131, 139–42
Great Deku Tree *See* Deku Tree
Great Fairy *See* Fairy Fountain *and* fairies
Great Wise Owl *See* Kaepora Gaebora
Guru–Guru *See* organ grinder

Halo: Combat Evolved 102, 280–81
health, of Link 8, 40, 47, 167, 170, 230–31, 241, 255–56, 259, 271
heart piece *See* piece of heart
heartbeat 117–19, 175n31, 255–56, 272n3
Hispanic music 157–60
Hollywood film music 11, 14, 19n25, 21, 23–25, 44, 72–73, 92, 99, 104, 131, 140–42, 169, 192, 217, 225, 249n3, 250n7, 274, 280, 282–83
Holst, Gustav 131, 175n22
Hooper, Giles 179, 211–13
horror, musical tropes of 130–32, 140–42, 144, 182, 213n6
horse *See* Epona
houses 145, 148, 164–65, 172, 275, 277
hover boots 260
huân (instrument) 23
Huizinga, Johan 289
hun (instrument) 23
Hungary, music of 128–30
Hyrule Castle 38–39, 81–82, 136, 147, 150, 183, 192–93, 244–45. *See also* Castle Courtyard
Hyrule Field 42–43, 50, 65, 79–104, 157, 172–73, 203, 210, 249n2, 256, 276, 281
Hyrule Warriors 10, 278

Ice Cavern 8, 125–28, 132, 143, 157
Impa 31, 35

improvisation, in *Ocarina of Time*, by players 26–31, 62–65, 68–71, 215
India, music of 134–36, 166
Indiana Jones film series 11
Ingo 40–41, 243–44
interface, of Link's ocarina 26–33, 68, 74n20, 284–85
interfaces, music and 174, 217, 232, 236, 240, 251–73, 284, 288
intertextuality *See Legend of Zelda, The* (franchise)
Iron Knuckle 249n6
Isbister, Katherine 72, 285
Islam 123–24, 132

Jabu-Jabu 8, 117–19, 121, 125, 145, 228
Janáček, Leoš 24
Java, music of 119
jig 149–50
Jørgensen, Kristine 255–56, 260–61
Juul, Jesper 250n13

Kaepora Gaebora 32–33, 44, 179, 186–88, 192, 196, 211, 275, 288
Kakariko Graveyard *See* Dodongo's Cavern
Kakariko Village 36, 46, 79, 81, 108–09, 114, 130, 151–53, 161, 172–73, 175n29, 177n60–61, 195, 239, 275
Kakariko Windmill 31, 46–48, 108–09, 275–76
Kakuto Chojin 124
Key, Susan 152–53
kinesonic congruance 72–73
Kokiri Forest 7, 25–26, 40, 78, 80, 109, 145–47, 164, 173, 188–89, 277, 288
Kondo, Koji, relationship with the *Zelda* franchise 2, 5, 9–11, 86–87, 248, 245. *See also individual types of cue*
Korngold, Erich Wolfgang 11, 92
Kotake *See* Koume and Kotake

Koume and Kotake 189–92, 211–12, 224, 275

lab *See* lakeside lab
Lake Hylia 36, 55, 62, 78, 81, 165–67, 177n60, 234. *See also* Fishing Pond *and* Hyrule Field
lakeside lab 165–67
landscape 102–04, 170–74, 275–76, 288. *See also* geography
Legend of Zelda, Majora's Mask, The 9, 11, 21, 84, 87, 275–76
Legend of Zelda, The (first game) 4, 9, 18n4, 54, 84–86, 192, 194–95, 212, 230, 238–39, 282. *See also* 'Zelda theme'
Legend of Zelda, The (franchise) 4–12, 17, 27, 87, 151, 170, 195, 198, 212, 230, 233, 238–39, 254–55, 274–78, 280
Legend of Zelda: A Link Between Worlds, The 10, 37, 84, 276
Legend of Zelda: A Link to the Past, The 9, 21, 37, 84, 151–53, 170, 180, 192, 198–99, 201, 232
Legend of Zelda: Breath of the Wild, The 10, 276
Legend of Zelda: Link's Awakening, The 21, 84, 182
Legend of Zelda: Ocarina of Time 3D, The (3DS version) 10, 12, 19n25, 30, 74n20, 210, 212, 280
Legend of Zelda: Ocarina of Time, The
 artistic aspirations of 196, 207, 210, 212
 general music implementation 16–17
 plot of 7–9
 reception and legacy 1, 3n1, 274–87
 versions of 122–25
Legend of Zelda: Oracle of Seasons/Ages, The 84, 276
Legend of Zelda: Phantom Hourglass, The 286n3

INDEX

Legend of Zelda: Skyward Sword, The 10, 232

Legend of Zelda: The Minish Cap, The 194–95, 276

Legend of Zelda: The Wind Waker, The 11, 37, 80, 194–95, 230, 232, 276–78, 286n3

Legend of Zelda: Twilight Princess, The 37, 230, 232, 276

leitmotif 274–78

Ligeti, György 24

Lind, Stephanie 35–38, 72

Link, character of 6–9, 11, 21, 54, 61, 70, 142, 145, 164, 179–86, 193, 201, 203–10, 228, 233. *See also* acquisition cues, Ganon/Ganondorf, Zelda, *and other characters*
 comparison to Mario 10–11
 lack of theme for 190, 192
 life and death of 169–70, 230–31, 233–34, 241–42, 253, 255–56, 271
 performances of See ocarina songs *and* interface, of Link's ocarina
 player connection to 12, 31, 33–34, 45, 49, 69, 72–73, 143, 170–72, 202–03, 210, 212–13, 223, 246–47, 257, 261, 272, 278, 283–85, 288. *See also* combat music
 spatial exploration of 17, 62, 78–80, 102–04, 110–11, 172. *See also* Hyrule Field

Liszt, Franz 128

locations, music for 78–178

Lon Lon Ranch 40–41, 79, 104–06, 111–12, 143, 171, 173, 179, 203, 206–07, 242–44, 248, 275–76

Lord of the Rings, The 6

losing 241–42, 247, 249, 253, 276, 288

Lost Woods 43–46, 66–67, 80, 109–11, 147, 171, 173, 206–07, 212, 275, 277–79, 284, 288

Lost World: Jurassic Park, The (1997 game) 13

Loya, Shay 129

ludus 215

Łukaszewski, Paweł 24

lullaby 35–38, 41, 43, 65, 70, 180–82, 195, 204, 212, 213n2, 239, 284

magic, music and 23, 25–26, 31–33, 43–45, 70, 111, 147, 173, 194, 200–01, 206, 208, 212, 235, 259–61, 271, 288. *See also* fairies, medallions, Sacred Realm *and* Spiritual Stones

Malon 31, 40–41, 70, 104–06, 111, 171, 179, 206–07, 276

Mariachi 157–60

Mario (game franchise and character) 4 to 5, 10–12, 170, 194–95, 231

'Mario Cadence' 58, 231, 235

Mario Paint Composer 282

Market See Castle Town Market

Marschner, Heinrich 182

Marshall, Dominic J. 285

Master Sword 8, 36, 208, 232–34, 260, 277

Materia Collective 280

MattMVS7 283

Maya Civilization 23, 25

McKee, Eric 51–52

medallions 235–36, 259

medievalism 6, 18n10–11, 39, 60–62, 188–89, 245. *See also* chant *and* renaissance

Medina–Gray, Elizabeth 80, 172

menus 33–35, 64, 69, 167–170, 195–96, 251–59, 171, 284

Mexico, music of 157–60

Microsoft 124

MIDI 13–16, 25, 255

miniboss See combat music

minigames 145, 163–64, 241–44, 275

307

musical 65–67
minuet (genre) 51–53, 55
mirror shield 260
Miyamoto, Shigeru 3, 9, 283
modularity, see Medina-Gray, Elizabeth *and* tags
MonotoneTim 284–85
monsters, sounds of 262–70
Morricone, Ennio 24
movement
 and music, connected to objects 48, 117, 157–60, 261, 271–72
 and music, of Mario 10–11, 19n18
 flying 196–97, 208
 Link's 72, 92, 96–99, 102–04, 172, 237, 241, 243, 245–46
 music and our reality 70, 72, 261
 musical 50–54, 92, 110, 146, 161–62, 170, 180, 190, 208, 220, 222–23, 226, 228–29
 urging player movement 237, 245–46
 exploration 78, 80, 102–04, 172–73
musical performance, significance of in video games 69–73
musicking, and video games 22, 69, 73, 288–89
MusyX 16
Muzak 160–63

narrative 1, 5–8, 10–11, 17, 44–45, 47, 92, 108, 155–56, 171, 173–74, 232, 235, 240, 244–48, 257–58, 260, 274, 278, 285–86, 288
 and cutscenes 179–213
 and ocarina songs 21, 34–49, 69
 of boss fights 132, 216–17, 224–25, 227
Navi 1, 2, 7, 45, 131–32, 196–97, 208, 241, 288. *See also* fairies
Neill, Daniel 105–06
Nintendo 64 12–16, 20n36, 25–29, 33, 255

Nintendo, corporate history and strategy of, 4–7, 87. *See also Legend of Zelda, The* (franchise)
nocturne 56–59
nostalgia 34, 70, 87, 152–53, 180, 230, 271, 283–84
NPCs, music as connection with 33–36, 45, 56, 62–72, 87, 106, 142, 171, 179–92, 197, 207, 211–13, 224, 254, 257, 261, 274–78, 284–85, 288

ocarina songs
 and locations 104–11, 173–74
 learning 31–34, 234–35
 plot-advancing and assistance melodies 35–48
 the melodies 35–65
 warp songs 48–62
ocarina, history of 21–25. *See also* interface, of Link's ocarina
O'Donnell, Martin 102, 281
Omen, The 131
organ grinder 31, 46–48, 108–09, 275–76
organ, fairground 163–64
organ, pipe organ 139–42
organum 188–89. *See also* chant
OST *See* soundtrack albums
OverClocked Remix 283
overworld *See* 'Hyrule Field' cue *and* 'Zelda theme'
owl *See* Kaepora Gaebora

paidia 215
Park, Hyeonjin 166, 177n63
pause menu 33–34, 253–54
Penderecki, Krzysztof 24, 74n18
Peter, Gustav 242–43
Phantom Ganon 184, 224, 250n8, 277
Phillips, Winifred 90
piece of heart 66, 230–35

Pierre *See* scarecrows
PlayStation *See* Sony PlayStation
plot *See* narrative
Poledouris, Basil 19n25
potion shop 165–67
prelude (genre) 50–51
puzzles
 music and 236–42, 257–58, 288
 musical 65–67

queer reading 54, 185–86

Rachmaninoff, Sergei 285
Ravel, Maurice 53–55, 131
Reale, Steven 172–73
realities, see diegesis
Redead 130, 264
religion, musical references to 39, 59–61, 106–08, 123–25, 141–42, 188–89, 202
renaissance 149–51
reward, music and 201–03, 247–48, 288
Rheingold, Das 201
Robb, James 258–59
Robin Hood 6, 11
Rodano, Ronald 162
Rodgers, Jimmie 105–06
role–playing games 6, 17, 80, 145
RPGs *See* role–playing games
rupees, collecting 256
Rushton, Julian 57

Sacred Forest Meadow 36, 51
Sacred Realm 198–201, 204, 207, 212, 276, 288
Sages 8–9, 199–201, 204, 208, 235, 59, 276, 288
śahnāī 134–35
Saria (character) 7, 26, 31–32, 34, 36, 43–45, 70, 171, 207, 235
Satie, Erik 193

scarecrows 62–65, 68–69
Scott Pilgrim vs. the World 283
Sega Saturn 12–13
serenade (musical genre) 55–56, 75n49
Shadow Temple 56, 58, 130–32, 288
Sharp the Elder and Flat the Younger 43
Sheehy, Daniel 157–60
sheet music, of music from *Ocarina of Time* 280
Sheik 8, 31, 48–61, 70, 181–82, 184–86, 197, 199, 213, 214n8, 235, 288
shops 160–63
sideshows *See* minigames
Skull Kids 45–46, 66–68
skulltulas 114, 230–32, 236
Sony PlayStation 12–13
sound effects 13–15, 17, 79, 112, 117, 137, 144, 179, 203, 224, 238, 240, 251–73. *See also* texture, material
soundscape 82, 111–12, 117–19, 121, 130–31, 136–37, 140, 143–44, 163, 175n24, 255. *See also* ambient music
soundtrack albums 279–82
Spain, music of 157–60
spells 6, 131, 259–61
Spirit Temple 8, 37, 59–60, 132–36, 143–44, 157, 190, 258
spiritual stones 235–36, 259–60, 288
staff roll *See* end credits
Star Wars: Episode I – Battle for Naboo 16
Star Wars: Shadows of the Empire (1996 game) 14–15, 20n32
start menu 167–70, 252–53
steel drums 155–56
story *See* narrative
Street Fighter 5 124
Super Mario (series) see Mario
Super Smash Bros. (series) 278
Superman (1978 film) 11
Sweeney, Mark 103

309

Symphony of the Goddess (concert series) 280
Szabo, Victor 144

Tagg, Philip 169
tags 82–104, 174n13, 243, 281
Takeuchi, Mariya 178n76
targeting system and sound, in *Ocarina of Time* 257–58
Tchaikovsky, Pyotr 209
Temple of Time 8, 36, 39, 50, 104, 106–07, 111, 116, 132, 148, 150, 173, 185, 202, 208–09, 260, 276, 279, 288
texture
 material 112–19, 125–28, 142–44, 147, 153–55, 157, 167, 172, 288
 musical, in other locations 163–65, 167
 musical, in cutscenes 189–207
 musical, in dungeons 111–12, 117, 119–21, 123, 125, 128, 140, 143–44, 161, 172
 musical, in ludic music 217, 220–26, 228, 245
 musical, in songs 52, 57, 99
 musical, in towns 145, 151, 157, 159, 161, 172
Tezuka, Takashi 5
The Black Onyx 6
timbre
 challenges for adaptation 281–82
 deliberately artificial 195, 206, 226, 232, 236–40, 247, 256, 271
 of interfaces and sound effects 251–53, 256–58, 262–71
 of the ocarina 24–26, 68
 signification of 79, 98, 104, 110, 116, 119–20, 129, 131, 134–35, 142, 147, 155–57, 163, 166, 170, 181, 197, 224, 228, 242, 260

analysis of 112–15, 125–27, 136–38, 239–40, 247, 253–71, 281–82
Tony Hawk's Pro Skater (game series) 14
towns 145–61, 164, 170. *See also* houses *and* minigames
treasure 26, 35, 47, 227–36, 259, 275–76
Treece, David 162
Triforce 8, 37–38, 197–200, 259–61
tsuchibue (instrument) 23
Twinrova 270. *See also* Koume and Kotake

Ultima (series) 6, 17, 80, 145

value *See* canons
Vampyr, Der (opera) 182
van Elferen, Isabella 44, 48, 72
Venda (South Africa) 23
villages, see towns
voice
 chanting 121–25, 130–32, 136, 144, 175n32
 moaning of Redeads 150
 of Navi 1, 288
 on the Nintendo 64 13–14, 281
 sung material in cues 31, 39, 104–06, 111, 130–32, 136, 197–202, 206–08, 217, 219, 225, 227, 249n3, 250n7, 260
 vocal adaptations of music from *Ocarina of Time* 279
 vocal traditions 55, 61, 140, 188

Wagner, Richard 201, 214n11
Wakai, Hajime 10
warning, music as 102, 104, 223–24, 226, 247–48, 255–56, 271, 288
warp songs and teleportation 32, 35–37, 48–62, 68, 70, 74n21, 106, 173, 185, 194, 226, 261
Water Temple 8, 36, 38, 55, 128–30, 132, 143

Weber, Carl Maria von 182
Whitall, Arnold 213n6
Williams, John 11, 14
windmill *See* Kakariko Windmill
Winkie, Luke 283–84
Winters, Ben 72–73
wise owl *See* Kaepora Gaebora
Wizard of Oz, The 23, 131
Wizardry 6
Wolfos 263
Wright, Edgar 283

xun (instrument) 22–23

Yamashita, Tatsuro 178n76

YouTube 278–79, 282

Zelda (character) 7–9, 25–26, 31, 35–38, 40, 87, 147, 179–85, 197, 199–212, 204, 209–10, 212, 244–46, 275. *See also* Zelda's Lullaby *and* Zelda's Theme
'Zelda theme' 11, 54, 84–90, 93–101, 104, 193, 203, 210, 212, 282. *See also Legend of Zelda, The* (first game)
Zelda's Courtyard 74n23, 181, 202, 209
Zora people 117, 207, 277
Zora's Domain (location) 65, 79, 155–57, 160, 172–73, 242, 275–76, 288
Zora's Fountain (location) 81, 125
Zora's River 65–66, 81

Index of Cues

Bold pages indicate the main discussion.

'Zelda Theme'
11, 54, **84–90**, 93–101, 104, 203, 210, 212, 282

Character Themes
Ganondorf's Theme **182–84**, 211–12, 213n4 n. 4–5, 214n12, 275, 288. *See also* Ganon's Tower *and* Ganondorf Battle
Great Deku Tree 117, **188–89**
Kaepora Gaebora **186–88**, 211, 275, 288. *See also* Flying
Koume and Kotake **189–90**, 211–12, 275
Sheik 181–82, **184–86**, 214n7, 288
Zelda's Theme **180–82**, 204–12, 213n2. *See also* Zelda's Lullaby *and* End Credits

Combat Music
Boss Battle **215–25**, 246–47, 278
Battle Theme 140, **215–25**, 246, 249n2, 288. *See also* Hyrule Field
Fire Boss Battle **215–25**, 249n4, 278
Ganon Battle **215–25**
Ganondorf Battle **215–25**
Miniboss **215–25**, 246, 249n6

Cutscenes
3DS Staff Credits 210
Door of Time **202**, 212
End Credits **203–10**
Flying **196–97**, 208, 212
Legends of Hyrule **197–99**, 211–12
Opening **192–96**, 214n10. *See also* Press Start
Rainbow Bridge **200–01**, 211, 214n11
Ranch Escape **203**, 212, 248
Sacred Realm **199–200**, 204, 207, 212, 276, 288
Seal of the Six Sages **201**, 204, 214n12
Zelda Turns Around **202**, 212

Dungeons
Dodongo's Cavern 119, **115–17**, 121, 125, 136, 143, 175n29, 277, 288. *See also* Fire Boss
Fire Temple 79, **121–25**. *See also* Fire Boss
Forest Temple 79, **119–21**, 214
Ganon's Castle **136–37**, 176n47, 260
Ganon's Tower **132–42**, 182–84, 212
Ice Cavern **125–28**, 143
Inside Jabu–Jabu's Belly **117–19**, 121, 143
Inside the Deku Tree **112–15**, 143
Shadow Temple **130–32**, 143, 288
Spirit Temple **132–36**, 176n45. *See also* Koume and Kotake
Water Temple **128–30**

312

INDEX OF CUES

Interface

Press Start **195–96**, 212, 214n10, 248, 252. *See also* Opening

Locations with Ocarina Songs

Lon Lon Ranch **104–06**, 173, 275–76. *See also* Epona's Song *and* Ranch Escape

Lost Woods 43–46, **109–11**, 173, 175n22, 206–07, 212, 275, 277–79, 288. *See also* Saria's Song

Temple of Time **106–08**, 173, 276, 279, 288. *See also* Song of Time *and* Door of Time

Windmill 46, **108–09**, 275–76. *See also* Song of Storms

Overworld

Hyrule Field 78, **81–102**, 172–73, 174m.13, 174n15, 203, 210, 276, 281. *See also* Sun's Song

Ludic Events

Boss Victory **225–26**
Correct Action **240**, 247
Game Over **241–42**, 247, 250n10, 276
Heart Container **233–34**
Heart Piece/Gold Skulltula Acquisition **230–31**. *See also* Skulltula Token
Horse Minigames **243–44**, 276
Horse Race Win **243–44**
Learning a New Song/Fairy Ocarina **234–35**
Master Sword **232–34**, 260
Medallion Acquisition **235–36**, 259
Minigame **242–43**, 275
Minor Object Acquisition **232**
Object Acquisition **229–30**, 275
Puzzle Solution **239**–38, 246–47, 257–58
Silver Rupees **237–38**, 246
Skulltula Token **231–32**. *See also* Heart Piece/Gold Skulltula Acquisition
Spiritual Stones **235–36**, 250n9, 259, 288

Timer **246**
Treasure Chest Opening **228–29**, 275–76

Ocarina Songs

Bolero of Fire **53–55**, 56, 70, 173
Epona's Song **40–42**, 65, 70, 275, 277. *See also* Lon Lon Ranch *and* Ranch Escape
Minuet of Forest **51–53**, 56, 58, 75n43, 173, 277
Nocturne of Shadow **56–59**, 76n57, 173, 276
Prelude of Light **50–51**, 173
Requiem of Spirit **59–61**, 173
Saria's Song **43–46**, 65, 70, 279, 286n1. *See also* Lost Woods
Scarecrow's Song **62–65**, 76n59
Serenade of Water **55–56**, 58, 173, 277–78
Song of Storms **46–48**, 65–66, 275, 278–79. *See also* Windmill
Song of Time **38–39**, 65, 275–76. *See also* Temple of Time *and* Door of Time
Sun's Song **42–43**, 65, 90. *See also* Hyrule Field
Zelda's Lullaby **35–38**, 65, 70, 74n23, 180–82, 204, 212, 239, 275. *See also* Zelda's Theme *and* End Credits

Locations

Castle Town Market 78, 81, **147–51**
Gerudo Valley **157–60**, 173, 279, 288
Goron City **153–55**, 173, 275–76, 286n3
Kakariko Village 49, 79, **151–53**, 173, 177n60 n. 60–61, 239
Kokiri Forest **145–47**, 173, 277, 288
Zora's Domain 79, **155–57**, 172–73, 275–76, 288

Recurring Types of Location

Fairy Fountain **167–70**, 173, 252, 261, 275. *See also* Legends of Hyrule
Houses **164–65**, 275, 277
Potion Shops **165–67**

313

Shop **160–63**, 275. *See also* Potion Shops
Sideshow **163–64**, 275

Special Sequences
Castle Courtyard 81, 173, **244–45**, 246, 248, 279

Ganon' Castle Crumbles **245–46**
Won the Race **243–44**